Peter Henry Emerson

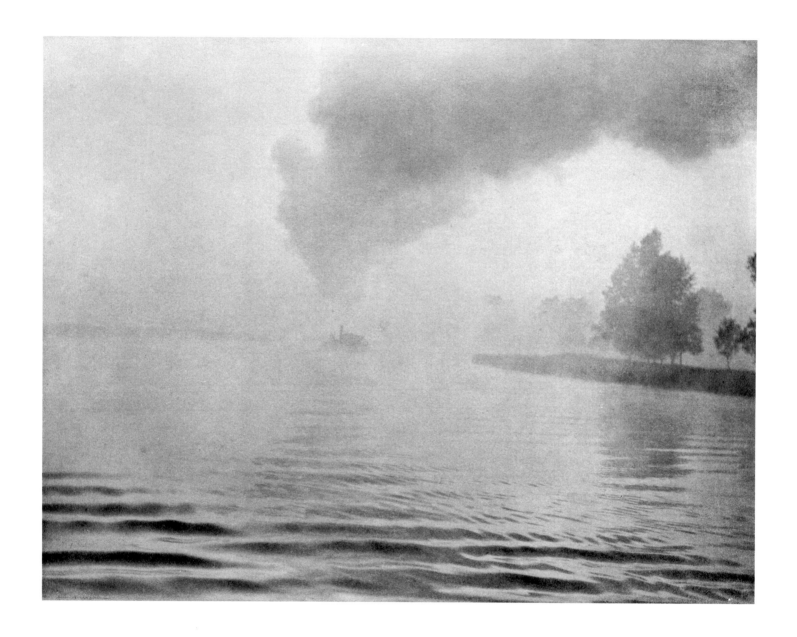

The Misty River

P. H. EMERSON

The Fight for Photography as a Fine Art

By NANCY NEWHALL

An Aperture Monograph New York

Dedicated to
BEAUMONT NEWHALL
who as a very young art historian
rediscovered the forgotten P. H. Emerson
recognized his importance and his greatness
and generously gave to me
always with his unstinting and invaluable help
the exciting task of this monograph.

P. H. Emerson: The Fight for Photography as a Fine Art
is published to accompany a major exhibition
of British photographers prior to 1915
to be presented by The Alfred Stieglitz Center
of The Philadelphia Museum of Art in 1978.
It is published as a catalogue for the exhibition
as Aperture Volume 19, Numbers 3 & 4,
and as a book for general distribution.
It was printed by A. Colish & Halliday Lithograph Corporation
and bound by Sendor Bindery.

Aperture, Inc., publishes a Quarterly of Photography,
portfolios and books to communicate with
serious photographers and creative people everywhere.
A complete catalogue will be mailed upon request.
Address: Elm Street, Millerton, New York 12546

CONTENTS

PART ONE

P. H. Emerson: His Life and the Fight for Photography as a Fine Art

I. IMAGE IN THE GROUND GLASS

"Dr. Emerson? Wasn't he that irritating man—sort of a fanatic, really—who preceded Stieglitz?"

Thus dimly, faceless, the almost forgotten image of Peter Henry Emerson comes down to us, ringed in the tongues of fire of his own rhetoric.

"*He* the founder of contemporary photography?" Who else, before, had proclaimed that photography was an independent and potentially great art form capable of expressing thoughts and emotions beyond the scope of the other and older art forms? It was Emerson who was the first to work out an aesthetic based on its unique powers and its then limitations, which he believed might soon be overcome. It was he who wrote the first manual on straight photography as an art in its own right, *Naturalistic Photography for Students of the Art,* 1889, which was aptly described as "a bombshell dropped at a tea party." Indeed, apart from the scientists, British photography was at that time quite as polite and superficial as a tea party. But Emerson was a scientist, a naturalist, a physician, and an artist: he was real, and in deadly earnest.

With all his force he believed in pure photography and its power to convey "truth to Nature." Marring photography in any way, from flattering retouching to imitations of painting, sculpture, etching, engraving, drawing or other handwork, was to him an abomination worthy of his most devastating eloquence. Any evasion of truth to Nature or truth to "sentiment" brought down the thunderbolts of his wrath. Nor was mere excellence of technique enough; the photograph must say something, mean something, or it was nothing—dismissed perhaps as "topographical."

He went further, suggesting radical changes in exhibition techniques which have since been adopted by nearly all the museums and galleries in the world.

With the power inherited from the Puritan preachers in his ancestry, he indicted fashionable fakers and their little tricks advertising a certain product, commercial manufacturers of shoddy goods, and above all those who claimed to be "artists" because, by all kinds of fakeries and dodges, they were imitating bad popular art. Nor did he forget the painters who used photographs without credit to the source.

When asked to review an exhibition, he said exactly what he thought; no sacred cows were spared. The famous found their concoctions described as "vapid, bigger and more inane than ever." The stupid were lambasted with satire. Those who had fallen from grace were lamented. True talent was praised and new, unknown, possible genius hailed with joy. The heretofore revered were agape with outraged amazement.

Worse, his lectures were all S.R.O. and they were all heresy. People might have come to listen to a tall, fair young man, with the build and fresh complexion of a fine athlete, with the look of power like a cloak around him, and those strange, intensely blue eyes with large black irises which one moment saw everything, missing nothing, and were the next withdrawn to inward thought; people might have come to hear the roll, growl, thunder and snap of his oratory (try some of his speeches yourself and see if you can get away with a weak, meek delivery), but these alone would not from the first have filled the halls. No. His photographs had been speaking for him, fresh and startling as a sea breeze in the stuffy artificialities and plain dull boredoms of the exhibitions.

More loudly still his publications spoke for him. His first large gravure, "Gathering Waterlilies," was a sensation. "If Mr. Emerson had never produced any other photograph, this alone would entitle him to rank as an artist of ability. It . . . is at once a specimen of good composition, excellent photography, and effective engraving." His first album, *Life and Landscape in the Norfolk Broads, 1886,* was hailed as "epoch-making . . . because such perfection of photography, such perfection of reproduction process and such perfection of artistic feeling have never before been brought together." This sumptuous album, bound in green morocco and white vellum with titles in gold, was actually illustrated by forty platinum prints. Incipient friend and premonitory foe had to go see and hear, find out what he was like and why he did, thought and achieved what he did.

When a man like this starts a crusade, his ideas do not stay hidden under a barrel; Emerson started not merely a crusade but a revolution, and still more, a recurring one. Whenever people neither gifted nor strong enough to become good photographers or good painters or good anything else start "improving," "freeing" or "imitating" even photography itself, the revolution explodes in their faces. Call it a war if you like. The roll call of warriors, starting with Emerson himself, includes Alfred Stieglitz, Frederick H. Evans, Edward Steichen

(in his later years), Paul Strand, Edward Weston, Ansel Adams, Eliot Porter, Henri Cartier-Bresson, Brassaï, André Kertesz, Walker Evans, Dorothea Lange, Imogen Cunningham, W. Eugene Smith, Minor White, Harry Callahan, Aaron Siskind and many others, living or dead. Of those who died before Emerson began, let us vote in by acclaim Julia Margaret Cameron, Robert Adamson, recently proved the creator as well as technician of those portraits posed against the walls of Rock House traditionally attributed to David Octavius Hill, and Atget, who though alive in Emerson's time paid no attention to photographers' ideas and arrived at the same goal by instinct, as did some of "Brady's men" such as T. H. O'Sullivan.

Some of the above never heard the name P. H. Emerson. (Why? That tragic and absurd story is told here.) Many of the photographers listed above—including, rather surprisingly, Stieglitz, Strand and Weston—had played about with the manipulative processes and then finally found themselves face to face with the severest challenge in all the arts, stright photography. It is you facing yourself. You are the lens, and you the camera and the sensitive film. You cannot hide behind the sensuous appeals of the other arts: the brush stroke, the impasto, the glaze; the tyranny over time in music and the range from thunderous, crashing chords to a delicate solo; the weight, thrust and soar of sculpture and architecture. If these are felt in your photographs, they are reflections of what you feel. For you are the poet whose silence is music to the eye.

And let us face the greatest importance of P. H. Emerson: *he was probably the first true photographer-poet—the first to whom the beauty of the image on the ground glass, the moods and emotions it aroused, were more important than the subject, however important in itself.*

For centuries people had been amazed by the miraculous image of the camera obscura or camera optica, those painter's tools, and like William Henry Fox Talbot wished for a way to fix these "fairy pictures, creations of a moment and destined as rapidly to fade away." Since Talbot's paper calotype process and Daguerre's silver daguerreotype, and most of all the cum-

bersome wet-collodion process, which required crates of glass plates and of chemicals for sensitizing and developing them, plus a dark tent where they could be processed within fifteen minutes of sensitization, photographers had traversed most of this Earth. They had made portraits of queens and emperors, tinsmiths, mountebanks, peasants; had looked on the vast ruins of the past, gone to India, China, Yucatán, climbed the Alps, the Rockies and the Andes, descended into the Grand Canyon and sailed into the Arctic to photograph the chill hollow sculpture of icebergs. They were there at the coronation, at the massacre, at the execution, on the battlefields, in the hospitals and the scientific laboratories. They had photographed the moon. Sometimes they caught the impact of *presence:* the living man, the terrible living moment, the incredible cliff face in the living sun—documents of immense value to mankind. But for nearly all the subject came first; it had to. The beauty, if there was any, came second and was often accidental. For time was imperative: the Queen must go on to the next ceremony, the burial parties are coming at last, the Indians tell us the nearest good water is thirty miles away and the mules haven't had a drink in two days, this flood is rising so fast we'll be drowned in fifteen minutes if we don't get out of here, the ice floes are closing in for the winter, this is the equinox and beginning of the six months' night. We must go!

P. H. Emerson had dreamed of such expeditions: he was a born naturalist, a versatile athlete, an excellent physician, an acute observer of man, his ways and customs, with an ear as good as his eye, a natural leader, a writer of unusual eloquence and accuracy.

But instead of going off to the Amazon or the Himalayas, or setting up an elegant consultancy on Harley Street, Emerson fell in love with East Anglia, the Netherlands of England, and, while making a poetic documentary of it, wielded so mighty a fight for photography as an art that for more than six years he kept the photographic world on both sides of the Atlantic in an uproar.

We have seen little of his work: all his photographic albums were issued in limited editions; moreover, by arrangement with his publishers, he afterwards destroyed both negatives and printing plates, and he was a very thorough man. Fortunate indeed are those to whose ancestors—friends or family—Emerson gave a platinum print. May they step forward! For a great retrospective exhibition of his work is long overdue. The museums, libraries and collectors who own his albums are exceedingly reluctant to unbind these beautiful and very rare books, and yet not even he, for his great 1900 retrospective at the Royal Photographic Society, could do otherwise than take his albums apart.

He was a pioneer in the medium of words-and-images. Rarely is his acute and detailed, as well as expressive, documentation in words a literal description of the photograph, and seldom do the photographs illustrate the words. They cast a spell over the book; they live in your mind as you read. Together those albums and portfolios are a remarkable interpretation of a place and its people, worthy to rank beside Atget's Paris, the geological surveys of the American West and the Farm Security Administration's America in the 1930's. To the English they must be nostalgic; to historians of every type they must be inexhaustible sources for study.

But that is not why they live: they live because they are beautiful. When the image on the ground glass caught his breath, he made the picture immediately. If, as often with Emerson, the subject was people in action, when they, undirected and of their own accord, moved naturally into the image, *then* he made his photograph. Sometimes the fusion *was* the image, but Emerson—even when hampered by boat, tripod and view camera—was, as many silver cups attested, one of the fastest men alive.

Early and late, in the misty sparkle of early summer or the dark light of snow, Emerson was abroad. And he could wait until the image on the ground glass was like a phrase of music, a line of poetry, to live in the memory long after the moment, the people and even the place had gone.

The play of light on the gnarled stems, the bed of new fallen leaves, the snow-laden spikes, the moist-shadowy outlines of the spikes on a grey day in autumn, the water-beads after an April shower, now clear as glass, now shining like the sun as the light is reflected from them, who can tell of these?

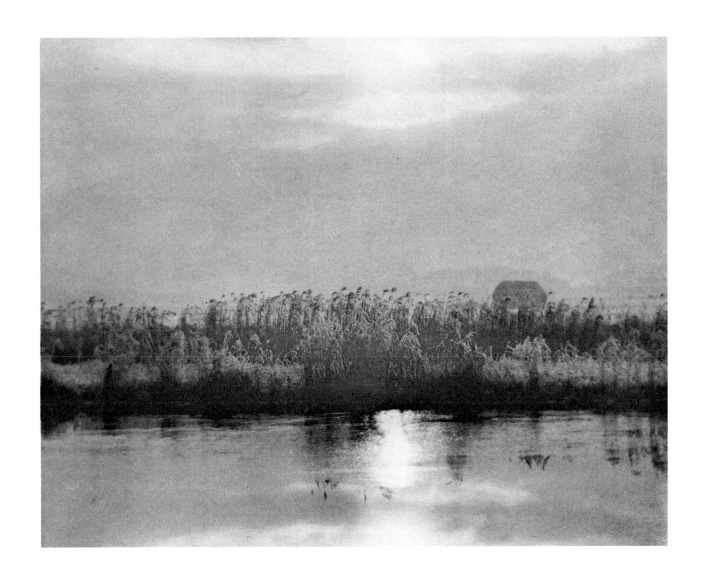

Man must become refined when he is constantly living before such exquisite pictures . . . Nature is the great refiner, the poor man's poet and painter.

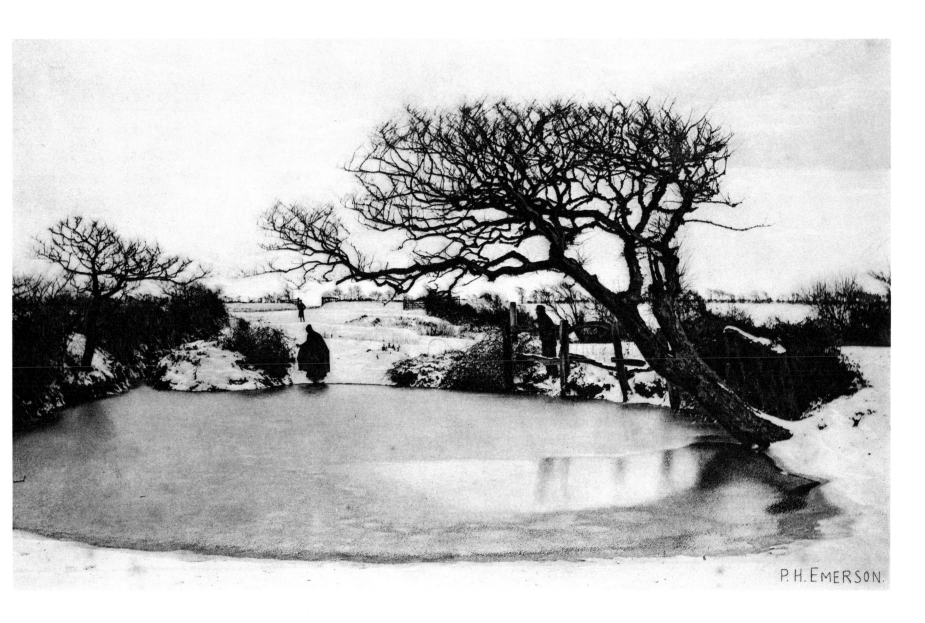

The Pond in Winter 9

. . . one long joyous prayer.

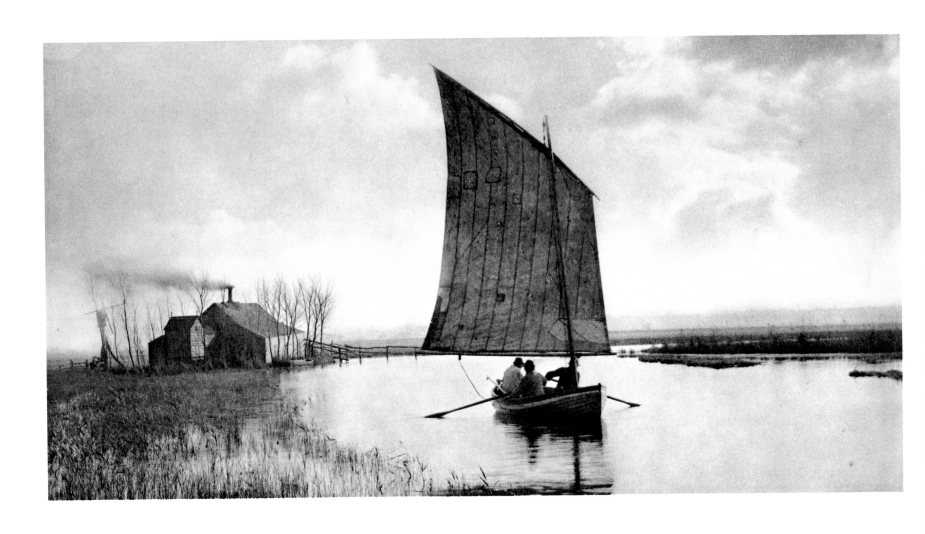

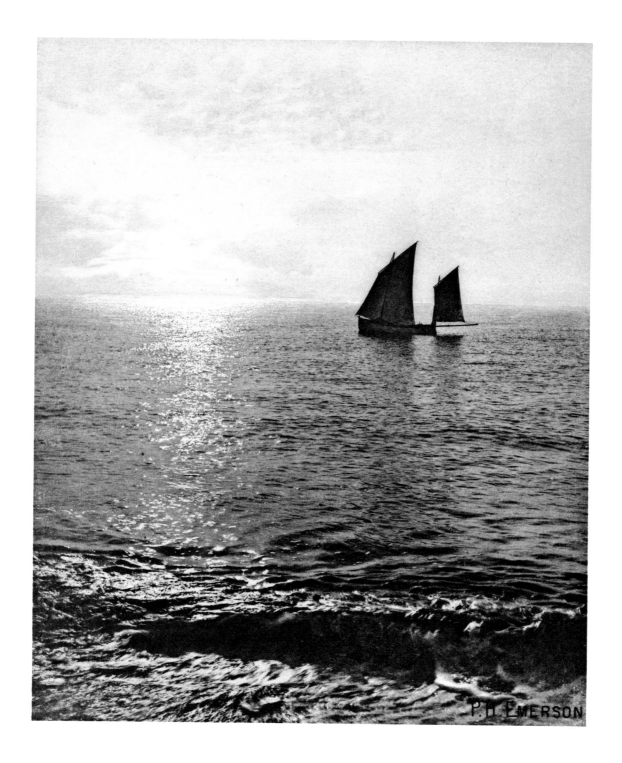

12 *Sunrise at Sea*

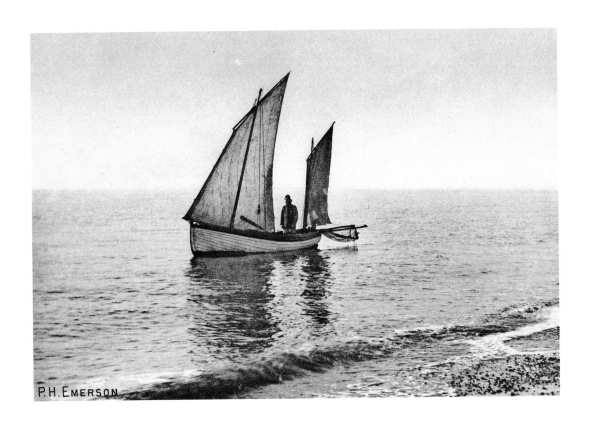

A Misty Morning on the North Sea 13

II. MR. ROBINSON'S TEA PARTY

In the 1880's, the walls of photographic exhibitions were crowded from floor to ceiling with huge frames often containing all of each exhibitor's entries. A few, of almost mural size, were precise topographical renditions of, say, the Matterhorn, the Alhambra, or some ruined priory—enormous, accurate bores, devoid of light, cloud or mood unless faked up by people in cowls and crucifixes, or lederhosen and alpenstocks, with a sky that happened elsewhere at some other time. The majority of the exhibits, however, pointed morals, related anecdotes and jerked tears. Titles ran like this: "An Old-World Bit," "End o' Day," "Crewel (Cruel) Work," "He Never Told His Love." Combination printing (piecing together bits of several negatives to make one "masterpiece") ran riot, and the aim was to imitate as closely as possible the genre painters who had recently flourished in England, Germany and even America. Some canvases, especially in Munich, were painted under magnifying glasses and were expected to be enjoyed in the same fashion—how else perceive the crystal goblet and the Rhenish wine in the monk's hand? (This favorite Munich theme became so pervasive in the homes of American millionaires that it has been dubbed "The School of the Tippling Monk.")

England was very accomplished and sentimental: Landseer's "Monarch of the Glen," the huge buck with his many-pointed antlers, the lions in Trafalgar Square which Emerson called "tabby cats" and was unexpectedly proved right—Landseer's model *was* a tabby cat. And all those faithful dogs. William Frith's vast canvas, "Derby Day," with its foreground of interwoven anecdotes—beggars, coach parties with hampers of champagne, oysters, lobsters and roasted partridges, starving mountebanks, well-fed bourgeois families and flirtations of various intents—was an all-time winner. So were little girls in their best finery gazing with tears in their eyes at the raindrops on the window: "No Walk Today."

In America things were coarser, fresher, less accomplished and more imaginative. It is still difficult to discern whether the lithographers Currier and Ives reflected American popular art or it reflected them. They missed, it seems, nothing the people really wanted to look at. Political cartoons like Lincoln as "The Rail Splitter," the burning of the New York Crystal Palace, portraits of the great race horses and the finishes of the trotting horse races—always with legends full of names, dates, times. Portraits of famous men, from Washington on. Steamboats on the Mississippi racing under the moon, sparks flying in the black smoke from their tall crowned stacks, or led by torchlight through a bayou, or rescuing people from rooftops afloat in the floods, or blazing up during the Civil War. Express trains at twilight, sparks flaring from their huge funnel stacks and the windows of the cars lighted as they leave the junction. Hunting and fishing scenes, often in the Adirondacks—"The Home of the Deer," for instance, a doe and her fawns beside a lake in mist, with the spires of firs rising above. A cartoon of Women's Rights, with cigar-smoking women in bloomers, one of whom has thrust her yowling infant at her meek, astounded husband: title, "The Age of Brass."

No clipper ship ever left New York Harbor without having her portrait taken by Currier and Ives—simply getting under way off the Battery, or perhaps caught among icebergs off the Horn, or in the disaster that sank her. They are all there: the *Great Republic*, lithograph dedicated to her designer and builder, Donald McKay, the *Flying Cloud*, the *Nightingale*, the *Red Jacket*, and to ship lovers possibly the finest of all: that rakish New York pilot boat, the yacht *America* at Cowes sailed hard for as "The *America*'s Cup." The *Great Eastern*, giant of steam and sail ships. "The Regatta of the New York Yacht Club" at the start in the Narrows. Rustic life. Life in the Prairies: the Buffalo Hunt. View of San Francisco from Telegraph Hill. "The Martyr John Brown" turning to kiss a black baby; "The Martyred President Lincoln Lying in State in New York." And all those pretty, sentimental maidens arranging flowers or out in an elegant cabriolet alone, driving matched and spirited black horses. An ideal portrait of Queen Victoria, by no means the sharp-nosed autocrat of her photographic portraits. Sarah Bernhardt in laces.

Stemming from the vast popularity of Currier and Ives there was the painter J. G. Brown, the Norman Rockwell of the time, with his barefoot newsboys and other such appealing phenomena. The leading imitator in photography was John E. Dumont, sometimes compared to the English photographer H. P. Robinson. That the present writer has no high regard for Robinson's imitations of academic art will soon be quite evident, but to compare the inept and tasteless Dumont with Robinson is a slur I resent: Robinson did know how to do his little tricks and he had what his audience in mid-Victorian times considered "good taste."

But there were other American painters, classed perhaps at the time as "genre"—but by no means "genre" in the European sense. They were not looking down, or into the past, but straight at what was happening in the immediate moment in front of them. George Caleb Bingham's "Election Day" is awkward and exuberant, like the event itself. His "Fur Traders Descending the Mississippi," with the black bear cub chained to the bow and the swift, sliding lights of the immense river behind in the distances, is a haunting vision to us now. So are Catlin's gorgeous portraits of the Indians in all their native power, beauty and imagination: he might be less good at the dances and other ceremonials, but his plea for "a nation's park" where the Indian and the buffalo might, on endless plains backed by enormous mountains, gallop forever unchanged, still haunts us too, for we cheated the Indian out of "the park" and left him, we hoped, to perish. Then there is William Sidney Mount's "Eel Spearing at Setauket," with the little boy at the oars and the great black woman in the bow with her spear poised. There is much of Emerson in these—not surprising, since he was a young boy in that America—and much that he might have liked if he ever saw them. They make one wish sometimes that Emerson had stayed in America. But there were some good photographers here, tackling the far unknowns. So were there in England and Europe, but a revolution in taste was needed, particularly in photography, and it took an American of Puritan descent, who had decided he was British, to start the fire, and an American of German-Jewish descent, who

was proud to be an American, to carry the torch until it illumined every fresh achievement in the arts of the twentieth century.

Emerson, when he was emerging from sports and science, could see only two Americans in the European art sky: Whistler and Sargent, both expatriates, both skyrockets in any sky. They were shocking then because of their use of light, like the other Impressionists, and their often unconventional subject matter; they have been accused of superficiality and bravado by later ages deep in depression and inevitable wars. Is it possible now to enjoy them, just as painters? The one with great slashes of light, the other with subtle harmonies?

But British photographers were learning nothing, from America, the Empire, or that ridiculous revolutionary painting business across the Channel. They muddled along in Victorian comfort, emulating in glossy sepia prints and ornate frames the Royal Academicians. In the universal sharpness and slickness, no picturesque detail—no spectacles on Grandpa's nose, no patch on the seat of the pants, no snarls the kitten was making in Auntie's knitting basket—was spared the spectator. As one man observed, the comment "It's not a bit like a photograph" was to be taken as a compliment.

The "uncrowned king" of pictorial photography in England, as he had been for nearly thirty years, was Henry Peach Robinson. Exhibitions were scarce, yet Robinson, had he chosen, could have covered himself with the hundred or so medals he had won. His combination print "Autumn" was "the most-be-medalled photograph in the world." The large prints—averaging eighteen to twenty-four inches in size—which he issued annually to subscribers were each regarded as the photographic event of the year. Before taking up photography Robinson had been a painter, so precocious that the Royal Academy accepted his paintings for exhibition before he was twenty-one. And the confusion in photography in the eighties, as well as earlier and later, was largely due to painters.

Up to 1853, the photographic image was regarded with the awe and reverence due a miracle. It was still imperfect: red tended to record as black and blue as white, and photographers called

forth all their powers of lighting and composing to meet the problems of freckles, pale eyes and white skies. To be sure, the great daguerreans sometimes tinted their best portraits so subtly that the colors seem almost in the eye of the beholder, and D. O. Hill occasionally enlivened a dull background by sketching in a craggy waterfall. In 1845 an American named Mayall caused a furor by exhibiting in his London studio ten allegorical daguerreotypes illustrating the Lord's Prayer. (Unfortunately, these have disappeared.) Generally speaking, however, those were, in Robinson's words, "the bad old days when it was considered fraudulent to improve your picture in any way; when the fine old crusted purists would prefer to have a photographed face peppered over with black spots almost invisible in nature, or a blank sky also untrue to fact, rather than have the sacred virginity of the negative tampered with."

But in 1853 Sir William Newton stood up to address the inaugural meeting of the Photographic Society of Great Britain (hereinafter referred to by its present title, "the Royal"). Sir William was a painter of miniatures and he found the studies he made with his camera too sharp, too detailed, and too lacking in atmospheric lost-and-found to help him with his painting. He proposed that such studies, made by artists for their own use, should be a little out of focus, "thereby giving a greater breadth of effect and consequently more suggestive of the true character of nature." He was "particularly desirous" of making this proposal "because it has recently been stated in this room that a Photograph should always remain as represented in the Camera, without any attempt to improve it by art." "In this," he continued, "I by no means agree, and therefore I am desirous of removing such false and limited views as applying to the artist, or, indeed, to any person having the skill and judgement requisite"—and stated that it was not only permissible but laudable to paint in skies and otherwise remedy the defects of the process.

This caused great excitement and protest in the Royal. The great corps of Victorian letter-writers went into action. One man suggested imperfect lenses as a means of attaining soft-focus. At one memorable meeting, Sir William, who, as vice-president, happened to be in the chair, suggested differential focus—throwing various planes of the subject into sharper or softer focus—as an artistic control. At this, several simmering members boiled over and the meeting became disorderly. Sir William used his authority to quell it. He refused to argue, restating that he recommended soft-focus only to artists and closing the discussion with this sage and liberal statement: "Photography is a wide field; each may take from photography what he requires, he is not bound or tied to any rule that I know of; let him take his own course, by which not only photography will be advanced but Art will be considerably improved."

The course taken was logical enough, but it is doubtful if either art or photography benefited to any extent. Sir William left photography at the mercy of the painters, and painters were not slow to exercise their license. Mayall's allegories had been straight daguerreotypes of posed figures; now, with the advent of wet collodion, the photo-painters had negatives that could be masked out when printing. Why not add to the posed figures a nice bit of sky, or a glimpse of bosky woods, just as in painting one combined many sketches—figures, backgrounds, details—into one enormous "machine"? A certain amount of handwork was necessary, of course, but after all they were spared the labor of drawing and shading. The strained, theatrical effects thus achieved did not worry them unduly. They wanted photography to be an easy way of making pictures, not an independent medium, and felt they were doing the gangling child a favor by subduing its harsh and terrible truthfulness into civilized airs and graces.

In 1857, the Swedish painter and photographer O. G. Rejlander exhibited his moral allegory "The Two Ways of Life." In one version it was composed of thirty-three negatives. In another, thirty-one—all of the same two or three models in different poses, and resembling in stage management the Babylonian orgies of an early super-colossal movie. Queen Victoria bought a print of it. A year later, Robinson's "Fading Away" caused a storm. It was made up of only five negatives, but the subject —a young girl dying—was considered too painful to be repre-

Rejlander, O. G. *Head of St. John the Divine on a Charger*

Sometimes a model will suggest a picture. Every photographer knows
the story of Rejlander and the model for his wonderful "Head of St. John
the Divine on a Charger." Rejlander saw this head on the shoulders of a
gentleman in the town in which he then resided. The curious thing is that
he did not so much see the modern gentleman as always the picture which
the head suggested. It was some months before the artist ventured to ask
the model to lend his head for his purpose, and years before he obtained
his consent. The result, from an art point of view, was splendid, and,
considered photographically, a mystery.

— Adams, W. I. Lincoln, *In Nature's Image* (New York, 1898)

sented by photography. (Robinson later confessed that the
subject was due to a dare: How sick could a fourteen-year-old
girl of exuberant health and vitality be made to look through
photography?)

Combination printing flattered the taste of the art-conscious
public. It swept into popularity and carried Robinson, the
most skillful and charming of its practitioners, along with
it. In 1860 he was asked to lecture before the Royal on his meth-
ods: how most of his outdoor subjects were photographed right
in his studio or backyard, how he had made a brook out of his
darkroom drain, how he found real peasants and fisherfolk
too awkward and stupid for genre work and enlisted graceful
young ladies instead. As proof of his talents for costuming and
posing, the story is told that one day, while he was photograph-
ing some young ladies on their father's estate, the party was
interrupted by the old gardener irately ordering the wenches
to be off before the master saw them.

Nevertheless, Robinson found ultra-sharpness as awkward
in combination printing as Sir William Newton had found it
for his miniatures. He was one of the three photographers who
in 1863 petitioned the noted lens designer John Henry Dall-
meyer for a lens with a softer focus.

Two furors shook Robinson's growing "kingship" during the
1860's. One was Mrs. Cameron's powerful out-of-focus portraits
of her friends, close-ups of Sir John Herschel, Alfred, Lord
Tennyson, Thomas Carlyle, and many others. From the 1860's
to this day, these huge portraits have been overwhelmingly
praised not only by her victims—who often couldn't help mov-
ing during her long exposures, thereby adding a further blur
of motion—but by scientists, artists, writers and just plain
people to whom the meaning of these great men was never so
clear before. The professionals soon found out her faults: she
was nearly fifty when given a camera and had to explore the
collodion process all by herself; her camera was of the old slid-
ing box type; and she had either lost, mislaid, or didn't care
for the back half of her Jamin lens, which could have given
much better definition. It was a triumph of personality over
difficulties of every kind. She wrote, in her *Annals of My Glass
House*, "When I have had such men before my lens, the portrait
so made has been almost the embodiment of a prayer."

The professionals could not cope with such a phenomenon;
Robinson recognized her talent, but told her not to make
"smudges."

The other furor was what Lamartine described as "the mar-
vellous portraits caught in a burst of sunlight by Adam Salo-
mon, the emotional sculptor who has given up painting." The

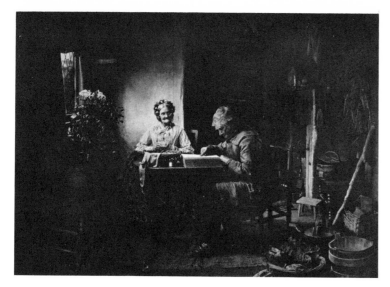

Robinson, H. P. *When the Day's Work Is Done*

"One of the best models I ever employed," writes Mr. Robinson, "was an old man of 74. He was a crossing sweeper. I should never have accomplished one of my best works if I had not seen him sitting at a table in my studio, waiting till I could talk to him. I not only saw the old man there, but, mentally, the old lady, the interior of the cottage, although, as it happened, he was sitting before an Italian landscape. The old man, by his attitude and expression, gave the germ of the idea. The old lady had to be found, and the cottage built, but they appeared to me quite visibly and solidly. This was the picture called, 'When the Day's Work Is Done.' I believe that a great many pictures originate in the same way." Those who have had the good fortune to see this masterpiece by Mr. Robinson will not question his advice as to models or, indeed, as to anything else regarding photography.

　　　　—Adams, W. I. Lincoln, *In Nature's Image* (New York, 1898)

French sculptor's "creative retouching" and "Rembrandt lighting" had everybody bowing down—including, very strangely, P. H. Emerson—and Robinson was in seventh heaven when this idol visited him at Tunbridge Wells. Salomon's tricks one could learn to copy and cope with, but not Mrs. Cameron's. She didn't have any tricks.

By 1869 the clamor for Robinson's formulae for success was so great that he responded with *Pictorial Effect in Photography: Being Hints on Composition and Chiaroscuro for Photog-*

raphers, to Which Is Added a Chapter on Combination Printing. The frontispiece was from one of his "straight photographs," two charming little girls, exquisitely dressed, reading a huge book; this was in Woodburytype, the finest reproduction process for glossy photographs ever invented. Robinson's chief ingredients were a few worn-out theories from an 1830 treatise on academic painting, illustrated by diagrams, little scribbled etchings of popular paintings, and actual albumen prints of his own work. These he garnished with quotations from Sir Joshua Reynolds, Ruskin, and so on. He advised on the proper bedside manner for getting the best out of a sitter and described his own studio methods, which are distinctly theater, movies and TV: movable platforms heaped with earth and ferns, "outdoor" lightings for indoor work, props like stumps and gates and prie-dieus and carefully painted backdrops.

"Any 'dodge, trick, and conjuration' of any kind is open to

Thomas Carlyle, 1867

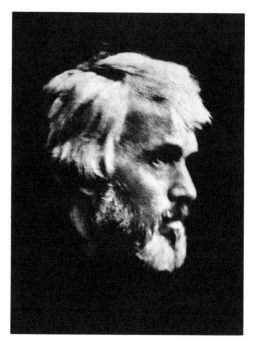

book for that vast and ubiquitous class for whom photography is a means to something else. The aim may still be, like Robinson's, to imitate whatever painting may be fashionable at the moment—Picasso, Dali, Magritte—or it may be the reverse: the painters excited by photography—a snapshot, an accidental juxtaposition, a scientific record, or simply imitating a poor thin photograph. Or it may be to advertise a personality, a liqueur, a vacation paradise, or the photographer. These days it is easier to "strip in" the models on "the scenic paradise" than to fly the whole crew on "location." Paraphrased and streamlined, Robinson's ideas and devices are overwhelmingly still with us.

And then came Emerson.

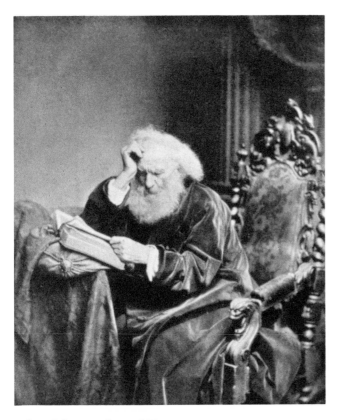

Adam Salomon, about 1867

the photographer's use . . . It is his imperative duty to avoid the mean, the bare, and the ugly, and to aim to elevate his subject, to avoid awkward forms, and to correct the unpicturesque . . . A great deal can be done and very beautiful pictures made, by the mixture of the real and the artificial in a picture." And yet Robinson was not without insight into the true potentials of his medium: ". . . this perfect truth, this absolute rendering of light and shade and form . . . which are beyond the reach of the painter and sculptor." But his glittering success stemmed from the imitation of academic painting. He went comfortably on, being elected to the Council of the Royal, receiving the gold medal of the Paris Exhibition of 1878. And *Pictorial Effect* went on, becoming through the years the source

III. PEDRO ENRIQUE

Peter Henry Emerson was born May 3, 1856, in the white-columned Casa Grande of his father's sugar plantation, La Palma, near the Encrucijada, Sagua-le-Grande, Cuba. His father, Henry Ezekiel, was only three years younger than his fourth cousin, Ralph Waldo Emerson, but the difference between them was as great as if the stepbrothers from whom they were descended had each taken half of the strong Emerson character—one the spiritual, the other the material. From Ralph Waldo's ancestor descended the men and women of thought, the philosophers and latent poets, the lovers of man and nature, the humble before God. Seven ministers were in Ralph Waldo's direct line, father coming to look after Concord and live in the old Manse, one of his sons following him, then one of *his* sons, all kindly, charitable, and much beloved, usually giving away half the parson's pittance to succor the old and ill or put a poor but gifted boy through Harvard. From Henry Ezekiel's ancestor came the fighters and builders, the men

of action and able administration. These Emersons pursued wealth and power; they married into families as brilliant and active as themselves, such as the Morses and the Tafts, eventually to list in the entangled family trees the inventor of the telegraph and first president of the American Academy of Art, and a President of the United States.

Henry Ezekiel's father, Thomas, typifies the "active" Emersons. Born in Uxbridge, Massachusetts, he married Margery Morse, daughter of a surgeon, moved to Rochester, Vermont, where they had six of their nine children, served through the War of 1812 as a lieutenant and then, in Plattsburgh, New York, made the great decision of those days: to move West, with all his family, to hack out a home and a fortune in the wilderness. Ohio was then the frontier; there he bought vast tracts of lumber and set up sawmills. When he died, Henry Ezekiel and his brother, Demarcus, went back to ancestral Massachusetts, to their Morse relatives—not, be it noted, to the Emersons. After the raw, rough, bustling frontier, how dull and peaceful, how settled, planted and pious New England seemed! How staid, even sad, seemed the story of cousin Ralph Waldo—born in Boston, son of a Unitarian minister, graduated from Harvard at nineteen, now in divinity school in Cambridge. To Henry, Ralph's future looked like the past: Concord and the Manse, the Manse and Concord, da capo, on half a preacher's salary. Young Henry had the taste of adventure already in his mouth; he lusted for wealth and power. Gray Massachusetts, though great fortunes in shipping and foreign trade were being made from there, was not for him. At twenty he sailed for Cuba, which would at least be strange and exotic as well as the legendary El Dorado of that time.

He began as a coffee planter, prospered, bought and sold plantations until he had indeed made his fortune and was sole owner of the seven-mile-square sugar plantation and refinery of La Palma. Tall, dark and distinguished, and now, at forty-nine, going a little silver at the temples, he had fitted easily into the landscape and both looked and was "Don Enrique" when in 1855, in New York, he married Jane Harris Billing, of an old Norman and Cornish family. Jane also was dark and

distinguished, her face more aquiline than Don Enrique's long-jawed Emerson face. For her too it was a late marriage, and they gave thanks to God when their first child, a son, was born within eleven months of their wedding day. At a private ceremony on St. Peter's Day, 1857, they christened him *Pedro,* after the saint, and *Enrique,* after his father.

He was fair and blue-eyed, indicating a reversion to the classic Emerson type, yet the round face and high cheekbones of his babyhood never lengthened into the Emerson face nor sharpened into the old French face of the Billings. Celt blood, Welsh, or Scots somewhere, probably on both sides, which probably added to the intensity with which the child approached all things in which he was interested and, later, to his command of language.

It was evident, too soon for his parents' peace of mind, that he had far more than the usual Emerson love of nature. Instead of "Don Pedro, look at the pretty birdie!" it was "Pedro! *Pedro!* Come back this minute! You'll fall, you'll *kill* yourself, chiquito!" The fantastic butterflies, just beyond the clutch of baby fingers, the radiant flowers, like suns, too far up, the gorgeous birds swooping above, between the magnificent trees, hopelessly out of reach, the glittering mailed fish in the aquamarine sea shallows, moving above their shadows on the white sand . . . He was a born naturalist.

On a trip to Cornwall to meet his grandmother, he eluded his nurse and started investigating a long, mysterious porthole. He was within inches of the waves when a frightened steward dragged him back by the legs. The sea could not daunt him. Once, with his mother and some servants, he was caught in a violent tropical storm in a small open boat while the Spanish sailors alternately drank and prayed. Once he was a passenger on a cholera-stricken ship. Many years later, the Cunard steamship on which he had taken passage to Italy was wrecked off the Cornish coast; coolly, Emerson and a friend replaced two panicked and mutinous crewmen, and helped rescue all the passengers. He was never happy living far inland: he loved to be within sound of surf.

When his dark and brilliant little sister, Jane, two years

younger, was able to toddle about with him, he took her to all his secret paradises. They lived, as visitors frequently observed, in the manner of *Paul et Virginie,* that romance of innocence in the tropics so beloved in the late eighteenth and early nineteenth centuries.

Their brother, Just William, was born too late to join them; he was still a baby when, in 1864, Don Enrique's failing health decided the family to move north, to the mainland—not to New England and its long winters, but to Wilmington, Delaware.

The Civil War was at its height, and Wilmington was scarcely less crowded than Washington. For two years, until peace dispersed the military concentrations and they could at last buy a house they liked, the Emersons lived in hotels and boardinghouses. So did the military; in one, General Dent, Grant's brother-in-law, was a fellow lodger. Mr. Emerson, as a sugar baron, had been no stranger to New York and Washington, and now he discovered intimate friends holding high commands: Admiral Gillis, General Thomas, of Gettysburg fame, and General French, with whose children his own became friends. Thanks to this proximity to epaulets, stars and sashes, the children were sometimes privileged to stand close by to see the gorgeous and solemn ceremonies of war. Pedro never forgot the great military funeral of General Smith: the muffled drums, the slow march, the keening music, the furled flags tied with black crepe (and in those days the caisson bearing the flag-draped coffin was no anachronism—from thousands like it cannon were that moment thundering, while bugles called charge and retreat); the led horse had borne the dead man in battle, the saddle and the boots reversed in the stirrups still bore his living impress.

After victories, the children leaned out of windows to watch the wild torchlight parades. On their way to school, shivering in the winter cold they had never known before, they would see long lines of Confederate prisoners, pale and haggard, shivering too in their tattered, bullet-riddled scraps of butternut uniform, helping along the walking wounded in their bloody, dirty bandages, being herded toward prison camp. Or Union troops, just as haggard, tattered and wounded, but marching along with laurel crowns and fancy decorations of bread given them by housewives along the way.

In the dry seasons, Mr. Emerson went back and forth to Cuba through the blockades. The children went to school, highly respected schools, but Pedro found his very dull and a very long walk morning and afternoon.

He remembered the telegram in the apothecary's window: RICHMOND HAS FALLEN. And that market day when almost everyone was weeping so hard they could barely see the vegetables or count their change: President Lincoln had been assassinated, lingered a few hours and then died, early that morning.

A month later, Jane, drinking milk given her at school recess, caught typhoid and died. With what wrath at the unnecessary and inexcusable accident and what grief they laid their brilliant and beautiful little darling in the new cemetery plot.

Pedro, with half of him torn away, plunged into voracious reading—at home—of poetry and travel, and into long hikes exploring the Brandywine River and Christina Creek, where the reedbirds nested. He did get to like the new sports, baseball and football, and, now that he exulted in frost, snow and ice, enjoyed sledding and skating.

Then Mr. Emerson, on one of his trips to Cuba, caught dysentery, which hastened his death. Leaving one tall white marble stone beside the little one, Mrs. Emerson sold the Wilmington property and took her sons back to Cuba. For Pedro, taking up the old life with his new height and strength was pure delight. Now he could really ride and throw the lasso, handle a boat, swim and fish and pursue the fleetest butterflies, while big black men cut cane on the slopes and the refinery smoked in the distance. But for Mrs. Emerson there were new troubles to face: ominous signs of revolution. Centuries of misrule and greedy exploitation lay behind the clamor for reforms, for equal rights, for emancipation of all slaves, for annexation to the United States, for independence. Incidents occurred; atrocities were committed, especially on distant plantations and particularly by the Spanish. The Rebellion of 1868-1878 was breaking out.

Mrs. Emerson took her boys back to America and they spent the rest of the year between Wilmington and Philadelphia, with excursions to Saratoga, Lake Champlain and Niagara. The war in Cuba was worsening; there seemed no chance of an early return. Pedro—or was it Henry by now?—was placed in a "military academy" on the banks of the Delaware. True, at Trinity College, the "cadets" wore uniform, drilled to "Hail, Columbia," and Henry was proud when he was chosen to be standard-bearer of the Stars and Stripes. This was perhaps the one period when he was proud to be an American, as, by American law, he could be; later, referring to the English law that declared that grandsons of English citizens were still English and that his grandfather, born in 1773, was English though born in America, he chose England as his nationality. The school curriculum, for that time, was distinctly novel: every boy had a garden and was expected to build a water mill on the river. Playing realistic "Indians" in the woods, swimming and bird's-nesting occupied more time than academic studies. Henry often received "full marks" for English and arithmetic, was praised for his drawing, but was taught, as he soon realized, only a smattering of Latin and French.

His mother undoubtedly realized this, too, and with no ties now to bind her to the Americas decided it was time to go home, to England. One of her brothers was stationed at Aldershot and, when consulted about the boys' education, expressed his violent prejudices against the English public schools—Eton, Harrow, and so on—and recommended Cranleigh School, where he had sent his own sons.

There Henry learned how desultory and superficial his previous schooling had been: at Cranleigh, in some subjects, he was in only the second form! The shock made him set his jaw and determine to achieve excellence, excellence in everything, a resolve he never abandoned. And excellence, it appeared, came easily to him. He won form prize after form prize until he stood second in school as Scholar; he wrote the "best essay on trees," gave the "best collection of wildflowers, birds' eggs and butterflies" to the school museum, adding from his Cuban and American collections, and, in spite of his original ignorance of cricket and of football as played in the English manner, became captain of both the First Cricket Eleven and the First Football Eleven. He became Prefect and then Senior Prefect and then was chosen Captain of the Games, but the Headmaster decided that this was too much power for any one man and, keeping him as Scholar, since he was good at teaching the young, and as Prefect, because he was a valuable leader, demoted him to Honorary Secretary of the Games, a move which his fellow students hotly resented.

IV. "EMERSON A.B.C.D.E.F.G."

What was he and what did he want to do? Naturalist, athlete, scholar, natural leader of men, writer: he would have made a magnificent military man. Why not Sandhurst? But that meant drill, orders to anywhere in any capacity, confinement to the military community. He wanted to be a scientific explorer—and no wonder, for that was the period of the great explorations of the world. Medicine seemed somehow expected of him; he did not think he wanted to be bound to a practice but certainly doctors were welcome on expeditions. So he passed the preliminary examinations at Apothecaries' Hall and went into chambers at King's College, London, the medical arm of Cambridge University, and began to work for his M.R.C.S. (Member of the Royal College of Surgeons, British equivalent of the American M.D.).

He later confessed that during the four years at King's the only thing he really worked for was the M.R.C.S. The rest was so easy that he was onto and into everything. The moment they saw him, his fellow students put him on the First Football Fifteen; never mind that he didn't know rugby. He was soon Captain. He went on cricketing with various teams, founded the King's College Cricket Club, became President of the Debating Society, edited the newly founded King's College magazine

and danced the Sand Dance in a minstrel show to help pay off the Cricket Club's debts.

Vacations he spent with his mother in Devon, fishing and sailing, shooting and running and driving fast horses. Back at school he reveled in the delights of London: suppers at Evans', *bals masqués* at Cremorne (whose fireworks, brilliantly featured in one of Whistler's Nocturnes, caused Ruskin to call the painting "a paint pot thrown in the face of the public" and thus set off one of the most entertaining trials in the history of art). On boat race night, Emerson filled his chambers with convivial companions, and hampers of wine and other delicacies, and, since nobody really cared if the University's gates did close at midnight, assisted his guests down the drainpipe in the small hours or, if the "wine" were in somebody else's chambers, climbed back to his own over the roof of the dissecting room. On illumination nights he joyfully participated in the classic "town and gown" fight between the students and the "toughs."

More than most undergraduates he was noted for wild jokes and pranks—and suddenly surprised everybody by winning the Leathes Theological Prize. Friend and foe alike were nonplused. Ralph Waldo Emerson might have smiled.

In 1879 he passed his final examinations for the M.R.C.S., and went on holiday to Switzerland. He always maintained that to paint the Alps was absurd. "I know Switzerland and love it well; but I would no more attempt to make a picture of a peak than I would of a donkey engine. A peak, shrouded and accentuated by aerial turbidity, and just peeping into an Alpine subject, might from its mystery and sentiment add to the artistic value of a foreground subject. But the usual photographs of peaks could be of interest only in a Baedecker." ("Photography a Pictorial Art," 1886) Nothing duller than a large photograph of a stark, cloud-naked Alp.

He decided to enter Clare College at Cambridge, since Clare's had a reputation for good athletes, and work for his Natural Science Tripos to prepare him further to be an explorer. But he kept getting interrupted through his entire University career. First a friend asked him to be his locum tenens for a few weeks, then another asked him to serve at Queen Charlotte's for a month or two. Once more at Clare's, he was of course again chosen one of the First Football Fifteen, and to row in one of the College Trial Eights. That race was a stiff one; the crew in which Emerson rowed fifth achieved a hard-fought win among ice floes. Nevertheless, he considered Clare men "a set of anaemic prigs" and was thinking of "emigrating to Jesus," another college, when the post of Assistant House Physician at King's fell suddenly vacant. Emerson was urged to enter the competitive examinations, won, and celebrated with a wild wine party involving milk punches and midnight processions, subject later of a sermon in Clare Chapel by "an ex-guttersnipe."

Back to chambers in London again, his duties often keeping him so late he found himself returning with "belated actresses, painted h———s, and prowling cats," as he put it. One free evening, he was renewing his acquaintances among the wildlife at the Aquarium when he was suddenly grabbed by the guards and frog-marched out of the building. The Aquarium Company accused him of having thrown their detective into the seal tank. He filed suit for "illegal ejection," brilliantly defended his case, and won; the real culprit proved to be a Sandhurst cadet.

During the summer, King's College closed for repairs. Emerson and a fellow student took the idemnity offered in lieu of board and went to Norway. There Emerson, characteristically, entered a walking race; of eight who started, only he and one stalwart Norwegian reached the Voringfos, where they skoaled each other in the icy spray.

He returned to be Full House Physician at King's, which meant he was the resident medical officer and on duty or on call twenty-four hours a day: a very responsible and grueling job that had almost killed other young doctors, but Emerson seemed to enjoy it. His stamina under strain, his "genius" at diagnosis, his capacity for leadership and organization were viewed with approval by his august superiors.

Then he fell in love, with Edith Amy Ainsworth, daughter of a surgeon, and a Grey Sister of the Nursing Sisterhood of

St. John's. She was not a beauty, to judge from her photographs; she was, for a wife, something much better, with her straight brows and merry eyes, her bloom, warmth and sweetness.

In November, his term at King's up at last, he returned to Clare's—to be welcomed by two clubs: the Mermaids' Reading Club elected him a member, and the Hawks', then the most exclusive social club at Cambridge, admitting only athletes of reputation, elected him a life member. And King's elected him an Associate, for "passing studies with distinction."

Fine, but he discovered that his scientific year away from the University had disqualified him for the Natural Science Tripos. Well then, he would immediately start on the A.B., the gentlemen's degree, and the M.B., much stiffer and more advanced than the M.R.C.S.

In June 1881, he and Miss Ainsworth were married in Lancaster, near her home, and spent their honeymoon at Grasmere, climbing the hills, botanizing, and boating on the lake. Inspired, he dashed off his first book, *Paul Ray at the Hospital,* in two weeks. Then his mother, who had joined them in search of health, suddenly died. He had loved her very much, and gave both a memorial window and a memorial stone in her name to Cranleigh Chapel. But, as one of her executors, he had to leave Grasmere and go to Devonshire to help settle matters there, which kept him until the beginning of the term.

In Cambridge, he set up chambers as a married undergraduate, which, he and his bride soon found, meant entry into the society of dons. To them, Cambridge society in general was dreary. Emerson described them all in very British terms: the dons, even when young, as "dull, prejudiced, fusty"; the undergraduates as "nice, overfed boys" or "priggish bounders or saps." At that time, he considered medical students "the jolliest fellows alive." He was later to change his opinion when he met the provincial medicos, often "prigs, snobs or commercial bounders," while the "nice boys" developed into "good fellows."

He worked hard on his medical degree, passed his Generals at Christmas and took his bride and two young nieces to Italy during vacation.

V. ROME AND REFORMATION

It is doubtful if Emerson had ever given a serious thought to Art before. He had written satires on the Royal Academy and on Opera as seen by an "amateur super." As for Architecture, he had more or less always lived in pleasant houses and appears to have taken them for granted, along with monuments, palaces and cathedrals; he was more interested in how the peasants' cottages seem to have grown from the ground. Undoubtedly he saw a number of famous paintings and statues, besides the average merely competent portraits and landscapes, for his references to them all are usually offhand. He seems, from these remarks, to have always been checking for "truth to Nature," as most beginners in "art appreciation" do; courses in such "frivolous" subjects were, at academies and universities, very rare until the 1920's.

A scientific drawing or photograph or research paper was entirely different: Was it accurate? Was it useful? If not, throw it out.

Nature, to him, had more than the usual interest. He had lived with it and for it—first for the impact of its beauty, then for its infinite variety. The diversity of form, for instance, within a single species: in the lands of rain, the rose; in deserts, the towering cacti. Then the miraculous interlocking life-patterns with which hundreds of different plants, birds, animals, fish, insects, worms and reptiles could live together within a single habitat, each integral to the other, from the obvious prey-predator relationship (in Emerson's time the necessity of the natural predator to the health of the prey was not recognized, though the disasters caused by man were already the subject of outcry) to relations so subtle and apparently remote that their influences at this time were barely guessed at. Then the innumerable habitats, each changing slightly as the Earth turned on its axis and geological formations, rising and falling throughout billions of years, commanded the amount of sun, water and wind.

No wonder Emerson longed to explore! Medicine occupied only one small section of this immense spectrum, yet already

it was acknowledged as crucial: on man, his hopes, fears, ideas and agonies, the ever-changing balance of life rested.

Emerson considered himself an agnostic. He considered all religions the carrot of hope dangled by emperor and pope before the donkey multitudes. The immense and glorious temples or cathedrals, the glittering, chanting processionals, the pilgrimages barefoot or on knees, the fasts in the wilderness, the rosaries and prayer wheels, the sacred images that wept or bled, the miracles and so forth, were, in his opinion, mere placebos for the enslaved.

If ever he thought of his Puritan ancestry, it was doubtless as some of that cobwebby old junk most New Englanders kept up attic. It never occurred to him that he was nevertheless of their blood and therefore the realization of corruption, the need for revolution, for reformation, and the revelation of the pure and the true might become imperative. Nor, apparently, did he realize that the Puritan is a recurring phenomenon—in every age, civilization, country, religion or sphere of thought. Perhaps to him the nearest to God was the beauty of Nature. As a naturalist, he knew how exquisite are some of the most poisonous forms of life and how obscene some of its most beneficial processes. As a doctor, he knew disease, deformity, cruelty and crime, madness, corruption and death. He knew how vast is the injustice of life and how slow the swing of the pendulum.

But Rome! All that he already knew and more, much more, often monstrous in size as well as conception, all jumbled together, layer upon layer, age upon age, ruins quarried out of still more ancient ruins, two thousand years and more—and still the magnificence of a race, of a time, or the genius of a single man could loom across centuries of rubble, and beauty still be crystal among filth.

No naïve, untraveled New Englander could have been more shocked than Emerson. For the Yankee of those times could still lay to his heart the balm that this was why Rome, like Babylon in the Old Testament, was the Great Whore, this was why the Reformation was necessary, this was why the Puritans crossed savage seas and built in a wilderness, and why, when they came to build in their own spirit, it was pure, spare, white and soaring.

In Rome, as in most very old but still living cities, the visitor is subject to two extremes: the sensuous delight of the place, the swirling life within it—or the crushing weight of the past. In Rome, that weight can bear down through the world imperialisms—Roman, Byzantine, barbarian and ecclesiastical—down through the wars, the conquests, the massacres of untold, unknown millions, the martyrs, the tortured, the killing of man by man or beast for the sport of crowds, down through the saturnalia, the sybaritic and the perverse; down even under the huge cathedrals, down through the layers of ruins on which they are built, down in the dark, the most sacred crypts, where candlelight glimmers on jewels encasing fragments of bone or rag, where you may feel, half effaced, on the walls rude symbols of another deity men came to worship when this little space stood on level ground in the sunlight or, if a cave, approached in terror, in darkness, to burn living sacrifice to the mysterious evil, to the demons older than mankind. It was these the peasants feared they were digging up when a spade struck a marble torso or, worst of all, a green bronze with eyes of night, centuries after a Christian emperor ordered all pagan gods thrown down, just as in the nineteenth century backwoods farmers in the U.S.A., digging up a thighbone taller than a man, feared they had found the bones of the fallen angels.

Emerson, courteously handing the ladies in and out of the carriage and listening as they followed the guide around, would have been much interested in the "demons," since it was possible that, in the course of his researches, he might have met some remote descendants of the huge saurians, much diminished by evolution.

No—Emerson's horror was not of the devil nor the evil depths of the past, but of what, he began to believe, produced such aberrations.

Everywhere, but especially in churches and museums, he saw lies, distortions, denials—to him, blasphemies—of Nature, and therefore of life. Even, at certain periods, the *absence* of Nature. Did these artists, these painters and sculptors, *never* look at Nature? Study her, live with her and love her? Then he began to notice that art in the early stages of a civilization sprang fresh and vernal from Nature—so close there was no

need for realistic elaboration of detail. Here, with intimate knowledge of his speed and power, was the dangerous essence of a lion; there, the whole spirit of a horse; below, the feel of a growing plant. You could sense the weight of the packs on those mules, the agony of that wounded lioness. Here were the athletes and the fierce warriors, each intense, the muscles under the skin knotted or flowing as they should with the cast of a spear or the thrust of a sword. Here were the lovely women as sensuous to the eye as to the hand, though goddesses still, and sacred. Most Greek sculptures he saw in that marble that seems to have the sun in it; he might have liked them less painted and bedizened in their original splendor.

Then, he observed, as the power of the state and the power of the religion joined in despotism, more and more the artist was divorced from Nature—told *not* to see, *not* to study. Nature is sinful and seminal of heresy, my son. Look inward, away from its false shows. Contemplate the glories of God, and pray. See, here is how you represent Christ Pantocrator—Lord of the Universe—and here, in various stages of His life, the Nativity . . . the Crucifixion . . . the Ascension. Learn the attributes of the saints, my son, so that the unlearned may recognize them. St. Peter bears the Keys to Heaven . . . St. Sebastian is pierced by arrows . . . St. Catharine is broken on the wheel . . . and here is how you draw a foot . . . and this not only in Latin and Greek but in ancient Egyptian, in the many tongues of India and China, with different gods, saviors, saints, symbols and emperors.

With Egypt, Greece, Rome and Christianity close at hand, Emerson concentrated on Christianity. And was horrified, from the catacombs, which he wished never to see again, to Ravenna, where he considered the Byzantine mosaics the nadir of the meretricious—the gold glitter surrounding the saints and emperors in all their crowns, halos and jewels attempting to dazzle into humility a belief in what was dead, corrupt and empty. As for the Romanesque and the Gothic—but you may read on a later page the anathemas he composed. He came to the conclusion that when artists ceased to study Nature, decadence set in; decay spread cancerous throughout the whole civilization. Art was not meant to preach or teach; with the eye blinded, the mind grew narrow and the spirit, wearied of this life, longed for death and heaven.

In Giotto he felt the light returning to end the medieval darkness; Giotto and Cimabue had at least begun to observe people—how they really moved, how they actually reacted to emotions. He pitied these artists inasmuch as they were still so deep in the twilight that their backgrounds were mere rocks dotted with toy trees, animals and churches. Nicola Pisano cheered him, too, though he saw that the man was merely trying to revive Roman sarcophagi.

It is strange that he never saw more of Leonardo da Vinci than the Mona Lisa, which he viewed in the Louvre and which he did not much care for, but what he read about Leonardo should have hurled him headlong into a pilgrimage to seek every note and sketch and model and painting and fragment of fresco. As for Michelangelo, hailed on all sides as one of the mightiest creators of all time, Emerson looked at him with a medical eye—and missed him completely. To him the man was an amateur anatomist and the Sistine Chapel one vast wriggle of distorted muscles.

If Art distressed him so deeply, why didn't Emerson let the ladies go with the tourist parties and the guides? Stay home and read a book or go for a walk? One reason was that the hotel was doubtless a former palace and probably baroque, encrusted with gold, cherubs, doves and garlands, with ceilings in which personages sat on clouds with instruments for music: not quite as bad as the great palaces and museums, where queens with beribboned lutes and flutes played at being shepherdesses, Dianas too delicately plump to run bathed by forest pools with little crescents in their golden hair and Actaeon, already sprouting horns, hiding in a bush, Venuses oozing nacreous flesh dallied with Mars in armor to the delight of all the little winged loves, or kings and emperors stalked the conquered world and were blessed by holy presences borne by angels. A few trees, rocks, flowers and pools were appearing, all in studio light;

now and then a sunset or a town with spires and towers above a river appeared in the distance. Sometimes an elaborate and out-of-scale bird's-eye view, or a theatrical thunderstorm or storm at sea. All lies still, all now to the glory of man, or war, triumph and the flesh—all silly, empty and oppressively monotonous.

Nor were walks any better, if you wished to avoid Art; follow the twisting alleys of some ancient slum and suddenly you face a vast plaza with an exuberant fountain with Neptune, Nerieds, Triton and porpoises all gushing with waters. Or walk by the river—but beware! You are suddenly in the most intricate and dazzling of arcades—and there is the Ponte Vecchio.

Yet Emerson *had* to see all this: he was compelled and didn't know why. After all, this Italy trip was supposed to be a pleasant continuation of the cut-short honeymoon; *why* did he have to take all this stuff so seriously?

Not until he got north again was Emerson to draw a free breath: the Van Eycks, Dürer, Holbein, Quentin Massys, Rembrandt . . . Crome, Constable, Millet, Corot. But all that was later. Let us leave him now in Florence: "When abroad, and being actually persuaded by their great littleness, we have been moved with pity for the victims we have met, victims of the pedant and the guidebook, who are led by the nose, and stand gaping before some middle-age monstrosity...Had these travellers spent their short and valuable time in the fields of Italy, they would have learned more 'art,' whatever they may mean by that term of theirs, then they ever did in the bourgeois Campo Santo or dark interiors of Santa Croce or Santa Maria Novella."

He was, nevertheless, pleased that he had made acquaintance with Art, and as trophy brought back a portrait of his wife done at the Villa Medici by a young painter who had won the Prix de Rome. It is a thin little painting, but there is an amused tenderness in her smile.

VI. THE GROUND GLASS: HIS COUNTRY, HIS THEME, HIS MEDIUM

Back in Cambridge, he plunged into medicine as if to purge himself of nightmares. Now and then he came up for air by going birding and botanizing with the ornithologist A. H. Evans. They began planning to do a book together, Evans to write about the birds and Emerson to photograph them during the next long vacation. They knew that with the old, slow, cumbersome wet-collodion process, with its dark tent and smelly chemicals, it was almost impossible to photograph a bird, unless stuffed. A hawk on a dead tree, a bird on her eggs, a duck asleep, head under wing, standing on one web—perhaps somewhere, sometime, a photographer quiet as a cat, with the wind helping him, might have managed to get his stereocamera, say, or his 5 x 7, within range of a bird.

But now there were all these "instantaneous" photographs, thanks to the new gelatin dry plates, that need not be developed until you got home. And all these new lighter cameras and faster shutters that were revolutionizing photography. These split-second snapshots of people jumping or playing tennis or diving, in ludicrous positions, appearing in all the magazines. As scientists, Evans and Emerson had doubtless seen the extraordinary silhouettes of a galloping horse, made by one Eadweard Muybridge in California, first in *The Scientific American* and later in the French and English *Nature*. They might have heard of the studies of motion being made by Marey in Paris, or of Mach in Germany photographing by the light of an electric spark a bullet in flight. Both adept at approaching wild things, they anticipated no difficulty in smuggling a light camera and its tripod in behind a blind. Nor did they anticipate that no publisher was going to risk a farthing on so unlikely a venture.

So, innocently, in 1882, the year Ralph Waldo Emerson died, P. H. Emerson bought his first camera. It was probably a small view camera with a drop shutter and a light but sturdy tripod. Given Emerson's curiosity, he must already have stuck his

head under someone's focusing cloth and beheld the miraculous image that has made people gasp since prehistoric times—when a chink in the rocks of the dark cave or a knothole in the dusky hut suddenly threw on an inside surface, upside down, a tiny, living image of the world outside. For thousands of years nobody thought of using the phenomenon to help make pictures. Leonardo noted it and shortly thereafter a lens was added, which made the image brighter. But one of these views from one *camera obscura* (dark chamber) was not enough when one wanted to see thousands. A subsequent invention was the sedan chair with a periscope on top to be carried by two stout flunkies until the image thrown by the periscope on the paper below made the artist inside cry "Stop!" But not everybody had two stout flunkies; soon two sliding boxes—one with a lens in front, the other with a hooded ground glass on top—and a portable table became an artist's common tool for solving intricate problems in perspective. Several artists are known to have painted directly from the image, among them Canaletto and, not proved until a few years ago, the painter of some wonderful small canvases, only a few of which Emerson was able to see and whose name he got as "Jan Van Neer, of Delft."

Now, as he learned to fix his camera on its tripod, throw the black cloth over his head and fumble with the knobs until the luminous blurs on the ground glass became a clear image, Emerson must have gasped again. For here, living, glowing, glittering, was Nature in all its subtlety of color and form. Here was what had been so horrifyingly lacking in Rome. Here was the answer to Rome.

In his first article for *The Amateur Photographer*, July 17, 1885, he wrote:

> In that somewhat undignified position, buried under the focussing cloth, where all is darkness save the beautiful illumination on the ground glass, one realizes how even the greatest artist fails to catch that glowing colour, that delicate tracery, that *nice* gradation of light and shade—all the incomparable beauties of the inimitable colorist, Helios. This picture gives me far more aesthetic pleasure than the final photograph itself, and it is an enjoyment which I often share in company, for many is the rustic who has stood open-mouthed at my side, and astonished has silently enjoyed, what perhaps, day after day, has passed unnoticed by him; and many too is the artist who has waxed eloquent under that same square of black velvet, and enviously wished he could transfer that picture to his canvas. Even to the untutored mind, it is evident how inadequate is photography to render Nature's picture. An excellent farmer of my acquaintance, who has a strong natural taste for art, must always "see how it looks" when I have focussed, and his invariable refrain is "Ah! if we could only get it like that." If we could, indeed! Then would mediocre art be killed, and a stimulus given to true genius.

He then quotes from Count Algarotti's *Essay on Painting*, 1744, on his delight in the image and the aid and benefits it gives the artist, and how: "The best modern painters amongst the Italians have availed themselves greatly of this contrivance; nor is it possible that they should otherwise have represented things so much to the life."

Emerson continues:

> I once happened to be present where a very able master was shown this machine for the first time. It is impossible to express the pleasure he took in examining it. The more he considered it, the more he seemed to be charmed with it. In short, after trying it a thousand different ways, and with a thousand different models, he candidly confessed that nothing could compare with the pictures of so excellent and inimitable a master. Another, no less eminent, has given it as his opinion that an Academy with no other furniture than the book of Da Vinci, a critical account of the excellencies of the capital painters, the casts of the finest Greek statues, and the pictures of the camera obscura, would alone be sufficient to revive the art of painting. Let the young painter, therefore, begin as early as possible to study these divine pictures, and study them all the days of his life, for he will never be able to sufficiently contemplate them. In short, the painters should make the same use of the camera obscura which naturalists and astronomers make of the microscope and telescope, for all these instruments equally contribute to make known and represent Nature . . . To the photographer, too, its educational value is great. The most careless observer cannot view many such pictures without cultivating, in spite of himself, some of the truths and beauties of Art . . .

And thus, though many amateurs produce but indifferent prints, they can console themselves that they have had an

aesthetic pleasure, which has at the same time elevated their natures, and educated their observant faculties. And, therefore, they have not practised photography in vain.

The process of photography, as Emerson noted, still had its drawbacks. It was still limited to black-and-white; even with the new fast gelatin plates, skies were white and red was black. So, unless the photographer wanted the white sky, which is often very effective, he made another, very brief exposure for the sky alone and printed the two negatives together. Here lay many a pitfall for the man in a hurry, or one with no feeling for what caused the quality of the light: Thin high clouds? Mist? Thunderclouds? Bright towering cumulus? And where the sun, if shining, was in relation to cast shadows? Several noted photographers, one regrets to observe, simply got one good cloud negative and printed it with everything—suitable or not.

Nevertheless, the accuracy of the drawing and the infinite gradations from pure white to pure black were incomparable; ordinary, competent etchings and engravings looked coarse and clumsy beside them. And when you printed a beautiful negative on Mr. Willis's new platinotype paper, with its delicately tactile surface and its scale from the palest silver to charcoal, you had a work of art.

Characteristically, Emerson did not go to a photographer to learn photography. At the University he was currently studying physics and chemistry with E. Griffiths, F.R.S. (Fellow of the Royal Society, then the most august scientific society in the world), so he studied with him also the application of these sciences to photography, which, after all, was one of their many children.

Soon he was photographing everything everywhere, inside or out, in all kinds of light, continually running tests and making experiments, as was his habit and discipline with every new subject. He also began microscopic photography, mounting and staining the subjects himself.

That spring, 1883, *Paul Ray*, his first book, was published, by private subscription, to the delight of his fellow medical students. And a few weeks later, in May, his first son, Leonard Ainsworth, was born.

That summer, doubtless leaving mother and child with an enchanted family, he and a fellow student went to Scotland. They were bound for Iceland, but the Danish mailboat did not call so they went hiking and sailing through Scotland and the Shetlands, Emerson becoming more and more of Dr. Johnson's opinion of that nation, collecting anecdotes of Scots' cant, brag, laziness and manners. Nevertheless, he did meet some magnificent Scots, one of whom was the first breeder of Highland cattle. More important, however, he had his camera along and, urged on by a Danish professor of geography, began photographing the Skye peasants and making notes on the land and how they tilled it, on their tools and customs.

That fall, he sent his first photographs to England's great annual photographic salon, the Pall Mall, and had one of the two platinotypes shown.

Late that year, it became imperative that he go to Cuba and settle the family business problems there. As soon as he passed his first M.B. examination, he set off on a long stormy voyage to New York during which he found a cigar magnate the most amusing fellow passenger. In Havana he presented his letters of introduction and was made a member of the Union Club, which doubtless smoothed his way through complicated business matters. He reveled in his native climate, all the more because he was escaping an English January, but photography was difficult: the extraordinary brilliance, the heat and the humidity caused him overexposure and many other heretofore unknown failures. Nevertheless he photographed, thanks to the magnate, a cigar factory and sent the results to *Pictorial World*, where, after the magazine had changed hands several times, they were at last published under the name "Dudgeon," with ludicrously wrong titles as well as remarks by "our artist." Undoubtedly a snide poke at his later eminence, it did not shore up to his already unsteady trust in journalism.

Three days after his return to England, February 1883, he was serving as locum tenens for a distinguished professor and so, for a fortnight, was a consulting physician in Cambridge—his first and last actual practice. In May, he passed his "special" in botany, alone in first class. In June, he received his B.A.

and, by way of rest and change, went visiting old friends from King's now established in Bristol and Wells, an excursion he described as "oh, so sleepy!" Provincial practice, obviously, did not appeal to him.

In August, he took his little family to Southwold, Suffolk, a small "watering place" on the coast of the North Sea. Not merely the sun rising through fogs to glitter on the sea, nor the creak of hawsers nor the gulls squawking, nor the little town gathered about its common, nor the salt marshes winding inward among sand dunes that gradually became low hills—something more happened to Emerson, something like recognition, like coming home, that sent him charging forth with his camera.

He had not been in East Anglia before, nor had he, apparently, spent much time in New England. Perhaps, except in Cuba, he had never seen a lugger or other small craft laden with fish come through the surf at full tilt, to crunch as far up on the beach as possible, often with men in high boots out in the water to push her further up; nor, in the Netherlands or Cape Cod, sheep grazing the salt marshes while windmills turned in the distance; nor an unscheduled flock of sheep baaing across the docks, driven by both irate fishermen and the cowering shepherd boy; nor inlets, where in low tide dories were left high and dry on the mud to be cleaned and reloaded and floated again when the tide rose, inlets crossed by bridges so people at any stage of tide could get to the fish houses, the ship chandler shops, the market and the butcher's. Nor seen, in the Newbury marshes, houses where a dock near the front door, with dories tied up to it and yachts bobbing at moorings nearby, were as common as, at the equally wide and hospitable back door, a stable, a cow barn, a sheepfold and certainly a hitching post. But for centuries his ancestors had lived among these sights, whether in New England or East Anglia.

At that time, he neither knew nor cared that many Puritans came from East Anglia, including his own ancestor Thomas Emerson from Essex. Essex! And the names of the other counties: Norfolk, Suffolk, Sussex. And the towns: Boston, where John Cotton was vicar at St. Bartolph's and in whose guildhall William Brewster was tried; Ipswich, after which the Emersons,

the Saltonstalls, the Nortons and other noted families called their new village behind the dunes in Massachusetts; Cambridge, Braintree, Walden, Yarmouth, Lynn, Peterborough, Andover, Berkshire, Reading, Haverhill...Every American of British descent who wanders through the British Isles comes suddenly to a place where he is at home. His family, so far as he knows, may never have lived there. It must be the same with Americans from other nations and continents. A curious, atavistic memory—a smell, a light, a fall of hills, a sense of weather, even a house so familiar that, if necessary, you would know where to find, say, a teapot or the extra blankets.

All Emerson knew at the moment was that the ground glass had never been so alive. It seemed to be leading him; he never knew what it would show him next. It seemed to throw pictures at him, and it took all his self-discipline to stop long enough to examine the image for flaws, calculate the exposure and wait for the exact instant.

When he developed these negatives, he saw that something had happened to him. These were not simply "holiday picturesque." These had character, even a salt smell, to them. Pushed further, seen and felt deeply, they could become poetry. Even so soon, he thought, the series of luggers on the open sea deserved printing in platinum.

He had found his country, his theme and his medium.

He had no idea that like Rome, and the ground glass, these photographs were a further unfolding of the revelations that were to make him a prophet crying in a strange, dry, mechanistic and mercantile wilderness.

VII. "TRUTH TO NATURE"

In October, Emerson joined the Photographic Society of Great Britain. He exhibited "instantaneous photographs" and noted again the jumbled hanging—from floor to ceiling, cheek by

jowl, several pictures to a frame. It was impossible to concentrate on any one image, unless very large and hung more or less on "the line," the average eye level. And what hideous photographs! Most of them poor imitations of bad paintings or simply topographical views, like post cards. The sentimental, the banal, the gaudy, the anecdotal—and this was the most important photographic society in Great Britain! Where, in all these pictures, was there *one*, even, which showed Nature as the ground-glass image saw it? And all these people could, if they wished, live through the ground glass. Moreover, if enough of them could be converted, they could bring about a revolution in all the arts! He, personally, vowed to clean up this mess and let people *see* how beautiful Nature, in her moments of revelation, could be.

How? These people seemed as insensitive as oysters and imitative as sheep. Most of them were clumsy with the camera and grossly incompetent at the interpretation of the negative. What could he do to wake them up?

Well, first, he must make photographs so beautiful that even the stupid could feel them. Second, since he could write, he would make out a program of articles outlining step by step the necessary indoctrination. Being in the good graces of *The Amateur Photographer* at the moment, he could probably count on their support and, if the articles drew enough interest, on the other magazines as well. Third, if he could teach Latin to the second form, urge on medical students almost dropping with fatigue and, in extreme emergency, explain to them complicated medical procedures and analyses, and if he enjoyed acting—then presumably he could lecture. Fourth, he must found a club that would wake up the Royal; he anticipated no trouble there. Finally, he must learn more about art. One trip to Italy, seen through exceedingly personal reactions, was not enough. He must assemble a good bibliography on all arts in all nations in all times, and start reading and haunting the museums and galleries.

Probably the first item on the strenuous program filled him with such desire he could hardly proceed to the others. They would not be difficult anyway. And for the last—well, he did hunger and thirst after Art, but oh, what volumes of nonsense he would have to plough through!

As for the museums and galleries, he anticipated long walks through marble halls (like the four doughboys tramping single file through the Louvre in 1920: Gee, this is a hell of a big place. We been here two hours already. How many more hours we got to walk to the exit?). But he also expected, now and then, a sudden, unexpected, probably half-hidden beauty to pierce him with that indescribable ecstasy which is half pain. When he came to write *Naturalistic Photography,* he knew where and with what companion works of art you could find such and such—and, in one instance at least, how far you should stand to get the full effect of a marble horse that seemed routine when you saw it close and a miracle of living motion from some thirty feet away. (It would be fascinating, Emerson in hand, to compare his directions and descriptions to today's installations in the British Museum, the Dulwich Gallery and the National Gallery. Most museum installation, when concerned with art, now follows very much his own theories. Tastes in painting and sculpture and theories of exhibiting have changed so much that Emerson might like them: beautiful things well-lighted, well-placed at proper distances; he might have understood artists he missed, probably because his time did not understand them—such as Piero della Francesca and El Greco.

Somehow that fall he managed a flying trip to Yarmouth, the great seaport on the East Coast and the center of the North Sea fishery. Like Dickens, he fell in love with Great Yarmouth —the old town, with narrow "rows" between its ancient buildings, seen rising behind the big harbor full of drying sails and nets and crafts of all sizes, from barks and barkentines down to wherries and gun punts.

In December, he passed the Second M.B. Then, almost simultaneously, in January 1884, his first daughter, Sibyl, was born and he was appointed to the Sambroke Medical Registrarship at King's. This was as responsible a post as the House Physicianship, but fortunately he had the weekends off, as well as, usually, the nights. It carried a £50 scholarship, and was the

next thing to being appointed to the staff. The appointment was for a year; he was to supervise the clinical clerks, coach both them and the students, and take the most serious cases himself.

Well, at least at night he could read about Art and on the weekends photograph and make prints.

At the University College Laboratory, a new field began to interest him: Hygiene, or State Medicine. Investigating London slums made him think about the "picturesque" lives of the East Anglian fisherfolk and peasants, which he longed to photograph. Now he found himself compelled to take an interest in politics, which hitherto he had managed to avoid. He joined the Liberal Club and several related organizations.

Southwold continued to haunt him. In the spring he took a cottage on the common, grandly named Wellesley House, and moved his family out of Cambridge with few regrets—except perhaps that now the train ride entailed at least two and a half hours each way, with a few miles on a narrow-gauge railway at the Southwold end. But it was worth it. He later wrote:

> For two years we revelled in the breezy, living landscapes of Suffolk—the land of Constable, the home of Gainsborough. In this country they were born and bred; here they loved to paint, in a country of extensive plains and wide horizons, of wondrous skies and wildest commons. Here . . . the trees seem to grow in fantastic shapes and cluster in weird and mysterious groups, while nothing more beautiful can be imagined than the ever-changing tints of the reeds, the silvery lines of the marsh-fringed dikes, and the sombre greens and glowing yellows of the gorses. Perhaps the great charm to be felt in this country is the ever-changing aspect of the landscape. One tide gives us the peculiar heavily clouded sky so often depicted by Gainsborough, with here and there a glint of sunlight shimmering on the high line of the full river, and on the innumerable small repetitions of the surrounding dikes...Every day, and many times a day, the picture changes. One moment the commons seem desolate and deserted by all life; the next they are beautiful, as if clothed by magic with varied tints of sunlighted gorse and spring flowers; while horses, magnificent in their freedom, career over hill and dale, exulting in their youth and strength, and scattering by their wild ungoverned paces the gentler herds of

kine. At another moment, a fierce rainstorm sweeps down and seems to wash all brightness away. Yet another day...The river is there flowing high in the middle distance; the dikes are full, but there is no silver in the landscape today; the soft gradations are all in dainty greys, and russet browns, and sober greens . . . But who shall describe what none can paint—the unsurpassed splendour of the golden gorse? We have many a time seen gorse in bloom, but never in such glory, in such masses, as here; and we sympathize with Linnaeus, of whom it is written that he fell on his knees when he first saw an English common covered with gorse in full bloom.

Already his photographs were astounding the salons with their freshness and truth; he won the first medal ever offered by *The Amateur Photographer* with "six views of the open sea, artistically printed in platinum."

At Christmas, his registrarship at King's completed, he was one of eleven, out of twenty-two who applied, to pass the second, or medical, part of the Third M. B. In January, he began to read for the final, or surgical, part—after so many delays! The two valuable years at King's, the several locum tenens, the trip to Cuba. But now the reading went fast; he actually had extra time to work with. He fitted up his house as a meteorological station of the second order, cultivated bacteria and stained them for slides, joined both the Royal Meteorological Society and the Royal Microscopical Society, and won the *Amateur Photographer*'s "Amateur Photographers at Home" competition.

He had time to photograph, too, though as yet mostly on land or from it; he knew the vital truth about this country was to be found on its waters and in the men who lived on them. But the peasants, with their windmills and dikes, the rich crops they could grow on the flat, drained fields, the fat cattle and sheep and strong horses they left to graze the salt marshes even in winter, the flocks of ducks and geese that wandered at will, as free as the wild swans—all these flocks and herds that came running when hoarse, age-old calls promised food in scant seasons: these too he photographed. And he listened to the peasants, to their tales and superstitions, their accents, their use of words hundreds of years old, long since obsolete

elsewhere, and their everyday colloquial speech full of homely metaphors that strike one as more graphic than those in common use.

During the months since he had left the University he went back to London only once, to chair the annual dinner of the King's College Football Club. This was a gesture of farewell to the many sports he had once loved so much. His friends had missed him, and said so. Why stay so buried in the country? Was he going to turn into a hermit, a recluse? Come in and have some gay times now and then. But how could he tell them what he was planning? There was so little yet to show.

In May, again—as though his creative and procreative powers tended to bear fruit at the same time—almost simultaneously with the birth of a child, their second daughter, Gladys, he passed the surgical and final part of the M.B. In celebration he toured the galleries, then went back to Southwold to concentrate on his thesis, "Washleather Skin." This he read before Professor Paget and Professor David Ferrier, F.R.S., on June 10, 1885, and was much complimented on its originality. The next day he took his M.B. degree, and went back to Southwold, thinking, At last, that's done; now I can get to work.

He had had his M.B. only a few days when he was called in consultation over a diphtheria case, a farmer's little daughter. He was so horrified by the ignorance and conceit of the local practitioner that, when the child died, he took the case as base for a diatribe on the lax regulations for qualifying medical men, urging much stiffer examinations, compulsory practical work and the implacable refusal of all incompetents. This, as far as is known, was his last act as a physician, except for what any merciful man with special knowledge and skills would do in an emergency. It was also his first polemic.

By way of rejoicing at his liberation from the academic world, he and his brother hired a little yacht and went cruising on the Norfolk Broads. The marshes and lagoons were alive with flowers and birds and shimmering with fish; it was paradise! Emerson made some of his loveliest photographs on that dreaming, drifting trip. They met other dreaming drifters—among them T. F. Goodall, a landscape painter and member of a large family of painters who lived in Dulwich. Goodall had exhibited at the Royal Academy since 1872, which certified at least his competence, if nothing more. He was a Naturalist and therefore, in the broad sense, an Impressionist. How far Emerson had come on his reading and gallery-going program is uncertain, but certainly it was natural for a naturalist to choose Naturalism! The two became friends at once; they saw eye to eye. Painter friends at Southwold had urged Emerson to take up painting, but Goodall sensed that Emerson, in his photography and writing, was aiming at something much bigger than becoming just another painter. Later, they became close colleagues and occasionally collaborators.

On his return to London after this delicious trip, Emerson found two offers of partnership, one in Yorkshire and one in Teneriffe. Having a private income, he could afford to wait for something more to his purpose. He was already vacillating between setting up as a private consultant in London and going on with writing and photography. Meanwhile, he went back to the Broads, sharing with Goodall a little yacht, with a Suffolk fisherman as factotum.

Day now began with plunging overboard into the icy, brackish water for a brisk swim around the yacht or further, then back to coffee and a sizable breakfast, then perhaps a cruise to some attractive spot where they cast anchor, took a picnic lunch and one of the small boats and went ashore, photographed, sketched, made notes and talked. Then back to the yacht at nightfall, to develop negatives and devour the fresh plaice, sole or eels fried by the fisherman, or, in season, going out to shoot their own duck, water hens or snipe. Coffee, grog, and into a comfortable berth, with the waters lapping the hull, and the jolly boat and gun punt knocking alongside. It was a good life, combining pleasant action in the open air with plenty of time for conversation and meditation.

Emerson naturally wanted to talk over his findings in the books and galleries with an actual artist. Up until that unsettling visit to Italy, his training as a scientist had suited him very well—except perhaps for that tendency toward poetry, fantasy and, though he did not yet know it, mysticism.

Science was orderly and constructive. A thing was true or false. If true, it was added to the great architecture of science and other scientists might build upon it. Miracles were taking place in the dizzy upper heights of this structure, and all because of the solid supporting masonry of fact.

But after Rome, and the ground glass, and Southwold, when, taking the art history of Woltmann and Woermann, a standard work, as his general guide, he began reading, he was horrified to find his worst suspicions confirmed. There was not a fact nor a scientific first principle in all art. There was nothing more solid than *taste*—and historical expediency. When Emperor and Pope, or Czar and Patriarch, or Maharajah and Brahmin agreed on style and message, these were dominant until the next uprising. Since the so-called Enlightenment, emperor and priest had been replaced by literary critic and art expert, who kept building new literary palaces in a quagmire. The next generation of experts, evolving a new palace and a new pantheon of saints, condemned the old to sink out of sight. The third, likewise building, enshrining and condemning, dug up the ruins of the first—and possibly those of much earlier periods, *vide* the recent Gothic Revival—and enshrined them, romantic and nostalgic ghosts, in the new holy of holies. The untutored public, who under the religious hierarchies had at least known what was represented, beheld these illusions across the bog, tried to reach them and were swallowed up. It was deplorable.

With all this, thought Emerson in his innocence, the artists had nothing to do; they simply went on working—doing as they were bid if that were necessary or, when free, doing their utmost to discover what, with the talents they were born with, they were best able to express. He had, apparently, at that time, no idea of the powerful influences artists exert on each other, or what a group compulsion, however differently expressed, can do. No, he thought, it was the critics and historians —notably, at the moment, Ruskin—who were responsible for the perversion of public taste.

And here in photography was Robinson, basking in adulation with his hand-me-down literary fallacies. No dynamite was too strong for such a mess. And he, Emerson, had already determined personally to clean up photography and establish it on scientific first principles. Doubtless he saw himself repeating the labors of the early doctors and scientists who did battle with the monsters of superstition. He became, alas, a tragic example of what happens when a man with scientific training thinks he can apply science to art.

What, then, was the scientific first principle of Art? Nature, obviously, answered the naturalist. At this point Emerson fell into the quagmire over his eyebrows, and Goodall was not able to rescue him. It is doubtful if Goodall knew as much as Emerson seemed to know, with his hasty scanning of the entire history of art. Emerson, in his search for "truth to Nature" as the only valid basis for art in a vital civilization, had come to some surprising conclusions and even more surprising omissions. From some of these Goodall undoubtedly could have saved him, but it is quite possible that it was exceedingly difficult to interrupt Emerson when in full spate, especially face to face. And, with those intense blue eyes blazing, when, basically, you were in agreement with his general thesis, quibbles about details seemed better forgotten. So Emerson continued headlong in his opinions.

Nature, then, is the scientific first principle of Art. But here enters Helmholtz, saying that the accurate rendition of nature is impossible, since the scale of pigments (or of a photographic negative) is infinitely less than the scale of light. Therefore the rendition can only be relative; it is an *impression*. This impression, said the Naturalists, must be absolutely faithful. *Nothing must be changed, added, or removed.* Every nuance of light and weather must be recorded. The painter, accordingly, becomes a kind of lens, more or less perfect, through which Nature is transferred to a plane surface. In this, thought Emerson, with reason, the painter's hand is inferior to a real lens and his canvas to the sensitive plate.

The idea of reproducing the effect of the human eye appealed particularly to Emerson's medical training. "To *look* at anything," said Helmholtz, "means to place the eye in such a position that the image of the object falls on the small area of per-

fectly clear vision." And Emerson commented, "The image which we receive by the eye is like a picture minutely and elaborately finished in the center, but only roughly sketched in at the borders." Coming across Sir William Newton's proposal, Emerson saw how this method of concentrating attention, then much in vogue among painters, could be achieved by a lens properly constructed and focused. He called it "differential focusing," and defined it: "The principal object in the picture must be fairly sharp, *just as sharp as the eye sees it and no sharper,* but everything else, and all other planes of the picture must be subdued . . . slightly out of focus, not to the extent of producing *destruction of structure,* or fuzziness, but sufficient to keep them back and in place."

He had already worked out with a Dallmeyer lens and a flexible camera his own system for differential focusing. In his hands it attained a remarkable quality peculiarly suited to the soft light and moist air of England. "Nothing in nature has a hard outline, but everything is seen against something else, often so subtly that you cannot quite tell where one ends and the other begins. In this mingled decision and indecision lies all the charm and mystery of nature."

Two aspects of differential focusing were to be most unfortunate in their effects on the history of photography as an art. One was that most amateurs confused it with out-of-focus, used rough papers and later all kinds of "art" processes such as gum bichromate and pigments which could be painted on or off at will. The other was that, in spite of the relatively recent trip to Cuba, Emerson had forgotten the diamond light and sharp edges of the Americas, where extreme sharpness and glossy surfaces have, since the days of the daguerreotype, been equally natural and logical—even today, when and where you can see through the smog.

It was not until later that T. R. Dallmeyer put his finger on the primary difficulty with differential focusing: it required a remarkable sensitivity in previsioning *and* an extraordinary manipulative skill. Emerson previsioned exactly what he wanted. In "Gathering Waterlilies," which was probably made on that first cruise on the Broads, the center of light is the water lily, the girl leaning over in light shade and the man rowing are delicately dimmer, the willows and the lily pads that frame the composition are also delicately soft, then the reflections on the water and the distant reeds all recede shimmering. So he focused on the water lily, chose what diaphragm (in those days "stops" were holes of different sizes) he wanted and racked out the back of the camera. Not every amateur has that amount of visual imagination, and still fewer have been trained as surgeons.

How much did Goodall and Emerson know of the movement, Impressionism, to which they believed they belonged? They could not have missed the extinction of the Rococo and the Classic by the French Revolution. Nor David's stark revolutionary portraits, nor his later attempts to revive the Classic by scenes from the Roman republic. Nor his overthrow, during the Napoleonic period, by the Romanticists and Realists. Yet Emerson does not mention Géricault and writes of Delacroix that he "strove to rise from the artificial influences of the time, but was not strong enough to become a master."

They knew of course that Crome and Constable had seized the French imagination; that, led by Rousseau and Daubigny, Corot and Millet, many young artists took refuge in Barbizon, to find themselves in Nature, among the trees and strange rocks of the Forest of Fontainebleau, or at Honfleur, beside the sea. The selves they found were widely disparate, but when young they were a group working and fighting together. The French critic Jules Antoine Castagnary, in *Le Salon de 1866,* called "these children of the Realists" the Naturalists, and defined them and their aim: "The naturalist school declares that art is the expression of life under all phases and on all levels, and that its sole aim is to reproduce nature by carrying it to its maximum power and intensity; it is truth balanced by science. The naturalist school re-established the broken relation between man and nature. By its twofold attempt in the life of the fields, which it is interpreting with uncouth force, and in town life, which reserves for it the most beautiful triumphs, the naturalistic school tends to embrace all the forms of the visible world . . . Far from laying down a

boundary, it suppresses all barriers. It does not bind the painter's personality but gives it wings. It says to the artist, 'Be free!'" [Quoted by John Rewald, *The History of Impressionism*, New York, The Museum of Modern Art, 1969]

Of the young artists to whom this was addressed only the writer Zola took it seriously. The others—Monet, Manet, Degas, Renoir, Pissarro and so on—took "Be free!" Each took what he wanted or needed from Nature and together they became the Impressionists. Whistler had done the same, in his harmonious symphonies and nocturnes.

In their youth, all of them had felt the force of the Realist, Courbet, and the Romantic, Delacroix, in spite of his interest in literary or historical subjects, because of his astonishing powers in color and form—and his brushwork! If Courbet freed them in subject matter, Delacroix freed them in color, form and the touch of the brush, from Seurat's pointillism to Van Gogh's squeezing the tube right on the canvas. Whistler was probably the one Impressionist in England, and of him no one there even faintly interested in art could fail to be aware.

Emerson and Goodall may not have known of Baudelaire, who held that to depict Nature was not the artist's task, but to make Art out of Nature; nor of Theophile Gautier, who believed Art should be totally independent of, and unrelated to, the public good. But with Whistler around London, they could not fail to be aware of Art for Art's Sake. Or of the "Ten O'Clock," whether or not either had attended that remarkable lecture delivered early in 1885 and later published. Emerson called it "brilliant but illogical," as did many others; in his case, the illogic was doubtless Whistler's view of Nature as a "casual" producer of "silly sunsets," useful to artists as a source but needing to be edited in the studio. And Whistler's denial that art was in any way shaped or influenced by historical events. The great artist "stands in no relation to the moment in which he occurs . . . having no part in the progress of his fellow men. Art happens . . ."

With the rest of Whistler's credo Emerson and Goodall were in hearty agreement. As Tom Prideaux summarizes it in Time-Life's *The World of Whistler:*

The total effect of the speech was to affirm the exclusivity of art and artists, to set them apart from the crowd, subject to their own laws, and responsible only to themselves. He declared that art, like a loose woman, had been on the town, cheapened by too much intimacy with the public, "chucked under the chin by the passing gallant." He lashed out, as he had before, against critics and do-gooders who demanded that art should be preachy. He stated that only other artists were qualified to criticize art, and he took an extra swipe at his old foe Ruskin by asserting that artists were a dedicated priesthood, joyous in the service of their goddess, with no need whatsoever of babbling critics.

VIII. "A REFORMER NEEDED"

Emerson was already embarked on his plans for photography. With Captain Abney, a distinguished photochemist who was later knighted and became Sir William de Wibersley Abney, and others of similar caliber, he was founding the Camera Club of London. An old hand at founding clubs, he soon had this one set up with ample funds and an enthusiastic membership.

The Royal was old and fuddy-duddy; the scientists indeed often gave brilliant and valuable papers on their researches, but there were few who could understand them; the professionals were voluble about their tricks in posing and lighting and their new developers; cheap-jacks put on shows advertising certain products. And the intelligent amateur, who brought high standards from his own profession, was bored to the point of no return. A particular point of irritation was the judging of the exhibitions. The judges, who were specialists in the commercial or scientific fields and knew nothing of art, kept reelecting each other on a self-deprecatory system—"Oh, not again this year . . . Well, if you insist . . ." and so the same old banal photographs were chosen again.

The Amateur Photographer, on October 23, 1885, ran Emerson's "An Ideal Photographic Exhibition," which contains

several startling thoughts as well as practical suggestions for improving exhibitions.

It requires no great prophetic powers to see that in a few years the art of photography will drive all competitors from the field, painting alone excepted; and should photography in colours ever be perfected, let painting look to herself for she will tremble in the balance . . . After careful consideration, there is one thing I am prepared to state and defend, and that is, that of all black and white processes, photography is the best, and will, in artistic hands, surpass them all. But there is much work to be done before we shall establish its superiority. I look to cultured amateurs to do it. At present, unfortunately, the true principles of art are a sealed book to the majority of amateurs . . . [This condition he blames on the exhibitions.] . . . what is the tendency of present exhibitions? Of course it is to hold up wrong standards of excellence to aspirants to honours, and thus to lower the art. The suggestions then, which I humbly venture to make for an ideal exhibition are as follows, and the object of this ideal exhibition is to establish fixed standards of excellence, whereby amateurs may gauge their works.

He then proposed:

First and foremost, that all the judges be artists; that there be at least three of these, five if possible: and that these painters be members of what is called the Impressionist School . . . And my reasons that the judges should be selected from this school, are as follows. They are the only artists who go directly to Nature to paint, beginning and finishing with Nature, and painting Nature as she is. For this reason alone, they would be the best judges of nature as depicted by an art. Great as Turner was in his time, yet his pictures often have the lighting of *two suns*, a dodge for effect which in inferior hands brings forth much of the meretricious work of today. Rousseau, Corot, Bastien-Lepage, these were the first painters who understood Nature; studied her, lived with her, and loved her; and there were the immortal fathers of the Impressionist School . . . Of this school, Turner, in his post Claude days, may, in a measure, be considered a member; that is his great genius saw and felt it, though he knew it not, and did not practice it in all its subtleness and tenderness, in its truthfulness and poetry. He had, however, too cramped and classic ideas, and the highfalutin nonsense of what in those days was called "high art,"—a cant phrase, thank heaven! now dead among the cognoscenti.

Secondly. That no more than one picture be allowed in one frame. The present system of framing two to six pictures in one frame is most inartistic, but is a matter of necessity, for single pictures of small size stand good chances of being unhung, or skied, or earthed, to meet the space wants of hanging carpenters.

Thirdly. That no retouching of any kind be allowed, for this is the thin edge of the wedge of introducing handwork . . .

Fourthly. That all pictures be framed uniformly, say, in gilt frames. It is unanimous among artists that paintings look best in gilt frames, and photographs never seem to look better in anything else. At all exhibitions of photographs, what is greatly deplored is the careless framing. "It looks like a shop!" "It looks like a showroom!" . . .

Fifthly. That the judges be the hanging committee. That there be no classes, but that the awards be made for the so many best pictures, irrespective of to whom they belong.

Sixthly. That each exhibitor be limited to a certain number of pictures, say three. This would, I think, encourage a man to pick out three *pictures*, and not a lot, for their general effect, and all this would improve the art value of the exhibition.

Such an exhibition would, I am sure, do more to raise our art than the most voluminous writings.

He also suggested that the winners contribute their works to the Society's permanent collection, and lived up to his own offer when the Philadelphia Society gave him a show. Whether the Society accepted his generous offer or not is not known; efforts to trace those photographs have been futile.

Later, he went still further and recommended that all pictures be hung "on the line." He argues that if it was not worth hanging on the line, then it was not worth hanging at all. He might have taken heed of what was happening to Whistler, the highly unlikely President of the Society of British Artists from 1886 to 1888. It was Whistler who designed the charming petition for a Royal charter which was sent to the Queen and obtained the title for the Society. But right there their gratitude to Whistler ended. He had novel ideas about hanging, very similar to Emerson's. (No influence has been yet discerned; they could have occurred to anyone suffering those shows.) But the results, to Society members, of Whistler's hanging what he liked best and leaving out the rest, achieving a beautiful show indeed,

with a velarium—a hanging canopy that lowered the ceiling height and softened the glare of lights—and small groups of pictures, mostly on the line, which enhanced each other in harmony or dissonance, meant that those Whistler hung sold and those painters he didn't hang didn't. Since the bad painters had depended almost solely on that annual exhibition for their sales, they found themselves facing a dilemma: starve, or kick out Whistler. They outnumbered the good painters by a large margin and Whistler was removed from office, some twenty young painters going with him. As Whistler put it, "The Artists withdrew and the British remained."

"A Reformer Needed. Apply to the Photographic Society of Great Britain." Thus began the editorial in *The Amateur Photographer* for January 15, 1886. It urged that action be taken to change "the curiously conglomerate Council" and their frequent re-election, "to avoid the repetition of the judging and other blunders that have lately grown almost to the size of a respectable scandal." Representation of the amateurs, now numbering some fifteen thousand, was proposed, and the following three amateurs nominated:

P. H. Emerson, B.A., M.B. (Cantab.)
Major George H. Verney
Richard B. Irwin

". . . and together they form a powerful 'ticket' as the Americans say. Mr. Emerson is well known as a most artistic and excellent photographer . . ." The three were elected, of course, and not only did the Society get a rush of fresh vitality—they certainly got a Reformer.

Now Emerson really opened fire. As photographer he won the *Amateur Photographer*'s "Prize Tour" competition, with pictures from that first cruise on the Broads. Altogether, he won eleven medals that year, an almost embarrassing number. But it was in his lectures and letters that the flames began to break out.

On March 11, at the Camera Club, he read "Photography: A Pictorial Art." He proclaimed that the confusions and mis-conceptions about Art were due to the laymen (not the artists, who simply went on working) who wrote about Art.

> Hence, the unthinking public have had their opinions formed for them, and as these opinions were evolved from the inner consciousness of the writers, and not based on any logical first principles, it necessarily followed that opinion on Art matters shifted like a weathercock . . . People said, "Art is a matter of taste, my taste is as good as your taste, I say this picture is better than that, and now what have you to say?" To such argument there was then no answer. Anyone who has read the history of Art, and a very interesting history it is, will be surprised at, and will look with pity on the unthinking millions who have been swayed by opinions based on no reason. The days of metaphysics are over, and with them, we hope, has died all that class of pernicious illogical literature.
>
> In our own day, the powerful effects of fine writing have had a most hurtful influence on the great British public...One of those spasmodic elegants [Ruskin] . . . has made it a point to scoff at any connexion between science and Art, and has flooded the world, in beautiful writing in which his power lies, with dogmatic assertions and illogical statements. He has treated botany, photography, political economy, and I know not what other subjects, in a style which, had it been the work of a sixth form boy at a good school, would have secured a well merited punishment. Yet these false stones, in their beautiful setting of fine writing, have procured him as many worshippers as his hero [Turner] himself. A lesser light than he [P. G. Hamerton], a poor creature, who has essayed to stride in his master's footsteps, has, with a little more truth, but with much less beauty and originality, devoted whole pages to attack and deny photography. It is a question whether this writer is worthy of a happy despatch; if so, I propose killing him on a more public stage than this; and lastly, in our own branch of Art, one writer [Robinson] has served up a senseless jargon of quotations from literary writers on Art matters, a confused bundle of lines which take all sorts of ridiculous directions and which this worthy impresses are necessary to make a picture. The bulk of the work contains the quintessence of a blend of literary fallacies and Art anachronisms, and yet in spite of all these wiseacres, many a beautiful picture has been produced which has defied their every law.

There must have been gasps from the audience, possibly boos and clapping. Battle, obviously, was joined.

Emerson then attempted—fully and apologetically realizing the impossibility of such a task—to skim through the entire history of art, from the cavemen to the present, handing around reproductions of several from each period and stressing the Greeks.

Is it to be explained why the Venus of Milo is more beautiful than the later production of Michael Angelo, the hypertrophic Moses? . . . I pass around a few photographs from the antique, and a few from the works of Michael Angelo. Comparisons are unfortunate for Michael Angelo . . . When Rome began to subjugate the Greeks, Art went into slavery . . . we find the art of the catacombs enslaved to the new mysticism which arose on the Pagan ruins. The gorgeous monstrosities of Byzantium were also made a serf to religion. At last, in the Twelfth Century, we find the Art of Italy developed into a national art, but still a slave to the church. Beautiful things were done, but alas! the great men of that period had to paint to order, to paint what are called works of the imagination, in other words, untruths; and what was the consequence? A surfeit of madonnas, annunciations, presentations, massacres, and other subjects, which are diametrically opposed to true Art. With the great Leonardo da Vinci a new departure was made, portraits and lay subjects became more frequent . . . still Art was in slavery. Pictures were judged by pre-existing standards—a most fatal error.

In a brief paper like the present it is perfectly impossible to finish even a rough sketch of the subject. Art went from one slavery to another, religion, morals, courts, kings, the literati, all in turn ruled it, until there was born in Suffolk one John Constable, the son of a miller. With a clear head, and the freshness, and the originality of genius, he sought to find beauty in nature, and not in picture galleries. A few of his pictures went to Paris, and the cultured few saw that he was right, that his was truth. Rousseau, the father of the French modern school, boldly struck aside and followed Constable. Corot, the tender, followed, but not to his full bent; then came Jean François Millet, honoured name, and later still the young Le Page, who died, alas! too young. These were the pioneers who established the naturalistic trend which is now in the van of this nineteenth century.

I have found the greatest difficulty in making my remarks brief; it is as difficult to write a little about a great subject as it is to write about nothing. We must now leave this fascinating development of Art, and show how and why photography is a fine Art . . . Now any Art is a fine Art which can, by pictures, express these beauties of Nature, and that Art is best which best expresses them. Let us begin with painting, the master art, for until we can reproduce the colours of nature, we can never equal painting; but all other branches of Pictorial Art we are able to surpass. *Painting alone is our mistress.* Now let us see how far painting can reproduce nature. Professor Helmholtz has worked this question out for us, and to him I am indebted for the following notes . . . "If an artist is to imitate exactly the impression which the object produces on our eye, he ought to be able to dispose of lightness and darkness equal to that which nature offers." He then describes two paintings, side by side in a gallery, under the same lighting: one a procession of Negroes and white-shrouded Bedouins crossing a blazing desert, the other a moonlight scene, the moon reflected in the water, and vague forms vaguely visible in the darkness. Yet the white lead in the Bedouins' clothing is the same white lead used in the moon, as the black is the same black in a desert shadow as in the night. Yet the actual sun is 800,000 times brighter than the moon; the white in a picture, seen in reflected light, is $\frac{1}{20}$ of white seen in sunlight. The painter, therefore, must, as nearly as he can, give the same *ratio* of brightness to his colours as that which actually exists. Helmholtz says that "Perfect artistic painting is only reached when we have succeeded in imitating the action of light upon the eye, and not merely the pigments."

Now let me give you an example of the fallacy of the Pre-Raphaelites. They imitated the pigments, not the light. I will illustrate my meaning with this cigar-box. [Having shown how much is impossible to Art and how much is dependent on the ratio and on aerial perspective, or turbidity, or the air, he compares.] Painters, as we do, use optical instruments, such as Claude glasses, prisms and the camera itself. The whole point, then, that the painter strives to do is to render, by any means in his power, as true an impression of any picture which he wishes to express as possible. A photographic artist strives for the same end and in two points only does he fall short of the painter—in colour, and ability to render so accurately the relative values . . . How then, is photography superior to etching, wood-cutting, charcoal? *The drawing of the lens is not to be equalled by any man;* the tones of a correctly and suitably printed photograph far surpass those of any other black and white process. . . . There is ample room for selection, judgment and posing, and in a word, a finished photograph is a work of Art. Again, it is evident that the translation of pictures by photogravure, for the same reasons given above, will be superior to that of any engraving. But we must not forget that nine-tenths

of photographs are no more works of Art than the chromos, lithos, and bad paintings which adorn the numerous shops and galleries.

Thus we see that Art has at last found a scientific basis, and can be rationally discussed, and that the modern school is the school which has adopted this rational view; and I think I am right in saying that I was the first to base the claims of photography as a fine Art on these grounds, and I venture to predict that the day will come when photographs will be admitted to hang on the walls of the Royal Academy.

He added that it is now easy to understand why the Greeks have so endured: "The secret all lies in the fact that they were done from nature, from actual living models—Phidias and Praxiteles tried their utmost to express in an artistic way, the living model, the human being before them."

Back in East Anglia, at the Priory Hall in Great Yarmouth, on March 23, he gave a related lecture—this time probably in deference to his audience, stressing the history and development of photography and its multitudinous uses to medicine, architecture, archaeology, astronomy, etc., and ending with "its noblest use," as a fine Art. Then came a showing, by limelight, of slides from his photographs of East Anglia. The audience rose to their feet in excitement; they had never seen themselves, their daily lives, the country where they lived in its many moods, expressed like this before. No wonder the ovation was thunderous.

Thinking over both lectures, back at Southwold, Emerson had another idea about judging, and the following letter appeared in *The Photographic News*, April 6: ". . . Judging at photographic exhibitions must always be a delicate and thankless task, but it seems to me that the right men would come to the top if there were an altogether new system." He then divided photography into two sections: one, as "a useful art," those

> . . . invaluable photographs—of, for instance, the heavenly bodies, of histological specimens, of coins, of architecture, should receive awards. But these must be given for technical excellence, which can only be decided by . . . professional men of each department of learning represented. For example, a photograph of a pathological specimen may seem excellent to an ordinary

photographer, while the pathologist might instantly discard it as . . . useless for his purpose. How, then, can this photograph be valuable when it has failed in the very essential of its *raison d'être?*

> In the second division of photography, it is just the same. And if we are to show the world that photography is a fine art, let us appeal through those, whom the world acknowledges to be the best judges of art—viz., the professional artist.

> Briefly, then, would it not be better to divide the exhibition into two classes? 1. Technical; 2. Fine Art. To have as judges of Class I scientists and photographers; to have as judges of Class II professional artists.

> It is to be hoped that the leading photographers will write you their opinions on the subject, and out of the ideas and suggestions so published that the council of the Photographic Society of Great Britain will see its way to drawing up a new scheme for judging at future exhibitions.

All this was fast building up, and then, in May, appeared "Gathering Waterlilies," in its luminous loveliness, in an autogravure 11 x 14¼ inches, either on India proofs mounted on plate paper 17 x 23¼ inches, in an edition of 250, or proofed directly on plate paper of the size given above, in an edition of 750. The first was 10s, 6d; the second, 7s, 6d. ". . . the first of its class from a negative from nature ever published separately as a work of art . . . In breadth and in technique it is magnificent." [W. J. Harrison, *The Naturalistic School in Photography*, 1888] It appeared to prove Emerson right in claiming that photography was a fine art when in the hand of a fine artist and that photogravure was the ideal medium of translation. Both editions sold out fast; Emerson was soon able to write that phrase that is the despair of today's collectors: *"All sold. Plates destroyed."*

Meanwhile, he was working on *Life and Landscape on the Norfolk Broads*, his first great album of 40 platinum prints, with text by Goodall and himself. Involved in overseeing the making of 8,000 platinum prints—and possibly more, because of damage in processing and mounting—for the 25 deluxe copies bound in green morocco and white vellum and the 175 bound in green cloth, it is not surprising that Emerson was deeply interested in the raw new photoengraving processes, and already working with the engravers and printers, hoping

to learn the tightly guarded secrets of the trade.

He had two portfolios in mind for the following year, *Idyls of the Norfolk Broads* (12 autogravures, with introduction by himself) and *Pictures of Life in Field and Fen* (20 autogravures, again with text by himself). In addition he wrote a "shilling shocker," to see if he could break into that gainful world, but he could not sell it and so tore it up.

He went to Paris, to see the Salon. And he was judge—his first judgeship—of the Cambridge University Photographic Exhibition. He was on the Broads at Easter, doing much writing, photographing and noting of natural history; he was back again from July to September, when, having refused several medical offers, he finally decided to give up his former profession. Sir George Johnson, F.R.S., under whom he had served during his years at King's, declared, "It is a great loss to medicine."

This year it was impossible not to make him a judge of the Pall Mall exhibition.

The two-and-a-half-hour ride each way by train to Southwold was becoming more and more an impossible waste of time. Meetings with the Council of the Royal, meetings at the Camera Club, the two or three days always involved in judging, the continual need to oversee engravers, printers, binders, etc.—no: Southwold he loved, but London he must live in, at present anyway. So that fall he moved his family to 9, Bedford Terrace, Chiswick, to a house just vacated by the playwright Sir Arthur Pinero.

Chiswick might be on the outskirts of metropolitan London, but the Royal Horticultural Gardens are there and nearby is Kew, the greatest botanical garden in the world, with its ponds, immense conservatories, arboretums, and meteorological station. Undoubtedly Emerson, when written out and suffocating for air and Nature, walked in these beautiful places. Or, for a different refreshing, took the short train ride to London and haunted the museums and galleries. His convivial companions of school and university days seldom or never saw him, nor did he seek literary London—the writers, critics, editors and publishers who might have helped him greatly. Perhaps he was too proud to go seeking; he would wait until he had done some-

Judges, Royal Photographic Society Exhibition, 1893. L. to R.: J. B. Wellington, P. H. Emerson, A. Pringle, F. Hollper, J. Gale, F. Sutcliffe, Chapman-Jones

thing so good that they would come to seek him.

Thanks to Goodall, he came to know most of the young painters in Chelsea. And, from the Emerson papers, comes this little undated handwritten note:

21, Cheyne Walk, Chelsea

Dear Mr. Emerson—I am delighted with the extraordinary photographs you sent me!
 They are full of the most charming effects—
and certainly quite unlike anything else of the kind
 I ever saw—
We are off abroad almost immediately—but I hope you will come and see us when we get back—
 Or do you think you can
come in here to tea on Sunday afternoon at about 5 or 6.

Very faithfully
J. McN. Whistler

Did Emerson make it to tea? Did those two curious geniuses recognize each other on their slightly dissimilar wavelengths? Were they amused and slightly distrustful of each other? Whistler had enough troubles without taking on photography and this intense doctor-photographer character too. There appears no evidence of any deep personal attachment on either side, but Emerson speaks more warmly and understandingly of Whistler thereafter.

Life and Landscape was finished by November, and its title page is dated 1886, yet for some reason it was not released until the new year. Its impact on critics, photographers and laymen alike was astounding, creating even more of a sensation than the large "Gathering Waterlilies" above had done (in this album it appears as a 7 x 11 platinum print). "As unanswerable refutation of those who say there is no art in photography," wrote one critic. "Epoch-making," wrote the reviewer for *The Amateur Photographer*. "Mr. Emerson has certainly been the pioneer of photographic art on these lines . . . This splendid and sumptuous book is a testimony to what photography is capable [of] in capable hands . . . a means of interpreting nature second only in value to painting itself, destined to supersede all other black and white methods in bringing an extended knowledge of, and taste for, art to the masses of the people . . . These reproductions [*sic*] by the platinotype process are magnificent; and the book will be a welcome addition to the drawing-room table."

Emerson and Goodall stated in their preface:

We venture to place before the public a series of plates taken directly from nature. These pictures were carefully studied and executed in one of the most beautiful, interesting, and unique districts of England. Our aim has been to produce a book of art for lovers of art; and the text, far from being illustrated by the plates, is illustrative of and somewhat supplementary to them; sometimes explanatory, and containing interesting incidental information or folk-lore intended to bring the scene or phase of life treated of more vividly before the reader, and depicting in words surroundings and effects which cannot be expressed by pictorial art.

All the photographs were taken by Dr. P. H. Emerson, and he alone is responsible for the Frontispiece and everything in Plates Nos. 4, 5, 6, 8, 9, 11, 15, 16, 18, 23, 24, and 35; the remainder are the result of an ideal partnership with Mr. T. F. Goodall, and all are printed from untouched negatives. These prints are absolutely permanent. Each plate is protected by copyright.

We thank most sincerely Messrs. Sampson Low, Marston, Searle, & Rivington for their generosity, for they have spared neither trouble nor expense in getting up the book. Dr. P. H. Emerson is indebted to the Editor of the "Amateur Photographer" for allowing him to republish a few of the paragraphs of his winning "Prize Tour Competition" which appeared in that paper. To Messrs. Valentine & Son of Dundee, too, our thanks are due for the care and trouble they have taken in executing the prints to our satisfaction.

P. H. Emerson.
T. F. Goodall.

October 1886.

Emerson's statement that "he alone" was responsible for 13 of the plates and that the rest were the result of "an ideal partnership" between him and Goodall led the reviewer immediately to compare them. He concluded that, while the partnership ones were more evenly artistic and with a lower horizon, those by Emerson alone were bolder and stronger, especially the "uncommon 'A Rushy Shore.'"

Often two or three plates appear between the essays, of which twelve are by Emerson, nine by Goodall. Obviously Goodall had known the country much longer and more intimately than Emerson, and gives us spirited sketches of the people and their mores and curious tools and boats, of the many ways of eel-catching, of boatyards and sailing matches, of snipe-shooting and setting the bow net for tench (fresh-water sole), of the difference between reeds (used for thatching good for fifty years or more on a roof or for walls to which the plaster clings for centuries) and marsh hay (good for cattle in winter). Emerson, the more poetic and, of course, the naturalist, deals with the natural scene; curiously, he is the more sensitive to color, perhaps because it was still denied his medium. In the middle of a learned article on *Nymphaeacea*, the white water lily, in which he goes into all the myths, symbolism and lore of water lilies and lotus, as well as their medicinal properties and habits of

growth, we come across a paragraph as flowery as its subject:

A queenly flower indeed is the white waterlily, as it floats on the surface of the lake, the numerous petals making the large blossoms appear double. We have seen it surrounded by a right beauteous court—the martial iris guarding the noble dames of the arrow-head, while the pink water-plaintain and blue forget-me-nots in their gay court dresses represent the ladies-in-waiting, and behind are gathered the strength and beauty of the nation—the fair ladies spirea, with their tall and stalwart protectors, the reed and the rush.

We learn many curious words, some not even in the Unabridged or not fully explained therein. "Quant": a twenty-four-foot fir pole, with ash at cap and shoulder to be used when wind and tide are adverse, or the mast must be lowered to pass under bridges; the wherryman puts the shoulder on the bottom, the cap to his own shoulder and walks leaning with his full force from bow to stern, while his partner on the other plank-board walks back to the bow and takes his turn pushing—a technique used by the voyageurs on the wild Missouri. "Glad-don," "gladen," "gladwin": of the iris family, and generally known as bulrush. "Rond": a floating island, usually of gladdon, sometimes mixed with other flowers, and soon to be part of the rising solid land. And "schoof" (Dutch for "sheaf of wheat"): three handspans around anything—wheat, barley, hay—but often used for mixed marsh weeds; "schoof-stuff," used for litter, "kivering beets," finally for manure.

Goodall begins his essay "Landscape" by commenting on the delicacy and breadth of five of Emerson's landscapes, including "A Rushy Shore," and remarks: "Although they are literal transcripts, it is hard to find a line in them which could be altered with advantage. The designs presented by nature, ready made, always interest us far more than the artificial compositions of painters who pick and choose, arrange and alter, the material around them in constructing their pictures . . . If the beauty of a subject in nature does not appeal to the painter with sufficient force to make him wish to paint it exactly as it is, he had better leave it alone altogether, and seek some other that does. A man must be moved too deeply by something to dream of improving it by alterations before he can possibly paint a really good picture."

He feels the same about natural color and deplores the gaudy brilliance that the English public loves. What must he have thought of his immediate successors the Post-Impressionists and then the Fauves, of Cubism, the Surrealists, the Abstractionists—and the marvelous colors of Matisse, of Van Gogh, Gauguin and the wild inventions of Picasso? Emerson at least loved Whistler and Sargent, Degas and Monet.

It is extraordinary how well *Life and Landscape* and all the large gravures, portfolios and albums sold, in spite of their high prices. All were published in both deluxe and ordinary editions: deluxe meaning, usually, bound in green morocco and white vellum with titles in gold stamp, and a finer paper for the plates; ordinary meaning bound in good cloth, titles in black or gold stamp, with plates on plate paper.

The deluxe edition of *Life and Landscape*, limited to twenty-five copies, was priced £ 5 5s; the ordinary, £ 3 3s. To estimate the true cost of these books in those days would doubtless take even the Bank of England some little time. Roughly, the pound sterling, the world standard then, was worth around five dollars gold American, and one could stay, in Europe or America, at a first-class hotel for a dollar a day. So the deluxe meant about six weeks abroad; the ordinary, a month. Yet Emerson could soon write of both, and of almost all his subsequent photographic productions: *"All sold. Plates destroyed."*

One reason, perhaps, is the cult of "the precious" in those times. The cult was at a high point then: to hold in your hands actual works of art, fresh from the artist's own hand, which very few other people would ever be able to possess. Snobbish? Perhaps. There has been much debate about "preciousness" in the twentieth century and especially in photography. A photograph, carelessly handled, can die. A photographic negative, if carefully handled and stored under "archival" conditions, is capable of possibly one million direct prints; if, while it is still in fine condition, faithful copy negatives are made, or a direct gravure or similar reproduction of fine quality, the life of the image is prolonged almost to infinity. But seldom

does the interpretation, in photograph or reproduction, equal what the artist himself produced. Some subtle quality is lost, or the interpreter has added himself, and the result carries an impact different from that of the original.

The two small portfolios, *Pictures of Life in Field and Fen* (preface dated "Bedford Park, February, 1887" and concerned with photography as a pictorial art) and *Idyls of the Norfolk Broads* (preface dated "Chiswick, April, 1887" and comprising a delightful description of the passage of the seasons in East Anglia) were obviously finished too soon for the publisher's schedule, and therefore issued months apart. One reviewer for *Field and Fen* hails Emerson as "the leader of a new school of art photography" and states that "he now has a large following." Then he puzzles over "the indefinable haze that is too prevalent in Emerson's photographs...We do not know what lens has been used, but there are certainly faults in focussing." One plate, however, "is a gem; no artist ever painted such a one, it is perfect."

With every step of Emerson's advance, the Robinson group quaked. They really would have to do something about him soon. Already his pronouncements were taking on the tone of the law and the prophets.

That spring of 1887, commissioned to photograph for the centenary edition of Izaak Walton's *The Compleat Angler*, Emerson stayed at Rye House, photographing the trout streams along the River Lea, while George Bankart photographed the Derbyshire scene. When it was too dull, foggy or dark to photograph on the river, he began *Nature Stories, Myths and Phantasies*. These he did not intend to illustrate. They were legends of ancient telling and retelling—down, perhaps, thousands of years. Alfred Stieglitz's concept of the Equivalent, though Emerson used it instinctively in other books, was not yet clear to him.

Back on the Broads in June, he saw an old hulk which had been so badly used by the cargoes she had transported—especially ice, the most damaging and scarifying of all—that many men would have passed her by and left her to rot on the beach. But Emerson saw her lovely lines, bought her from "a one-eyed winkle seller" and put her into the hands of capable shipwright with orders to transform her into a neat "pleasure wherry": berths for two forward, one aft, pleasant galley and saloon, plankboards for quanting (poling) alongside in the shallow waters when there was not enough wind for her big sail. When finished, he found her a delight; the berths were comfortable, the galley and saloon easy both to clean and to live in, and she handled like a love—so responsive she needed a knowing hand at the tiller, but with that loving hand she could accomplish miracles. He named her *The Maid of the Mist,* remembering the little steamer laboring in the mists and uproar of the Niagara gorge.

IX. ZEAL AND INDUSTRY

1. The Peasants

Much of the preliminary work for *Pictures of East Anglian Life* had been done while he still lived in Southwold, still bound to achieving his M.B. But every possible hour he could spare, every day he could wipe clean of other obligations from dawn to sunset, he spent with his camera focused on the landscape or the peasants. Driving around in his dogcart behind his mettlesome mare, with his fox terrier barking beside him, he had soon become a familiar figure. If during the harvests—wheat, barley, mangolds, marsh hay—the peasants "got up at t'ree in the morning" to be at the field when the horns blew at dawn, so did Emerson. He could take the heat of the summer harvests and also the chill of fall, winter and early spring ones—the gladdon, the reed—in the icy water. And like the peasants, he could extend the long working hours with a little fishing or fowling. He could shoot and fish and pitch his forkful with the best; he could solve problems in ways they hadn't thought of, and often bandaged a hurt hand or foot from that little black bag he always carried. He said he had been a doctor, but he wasn't a liar and pretender like most of the rest; if he said it

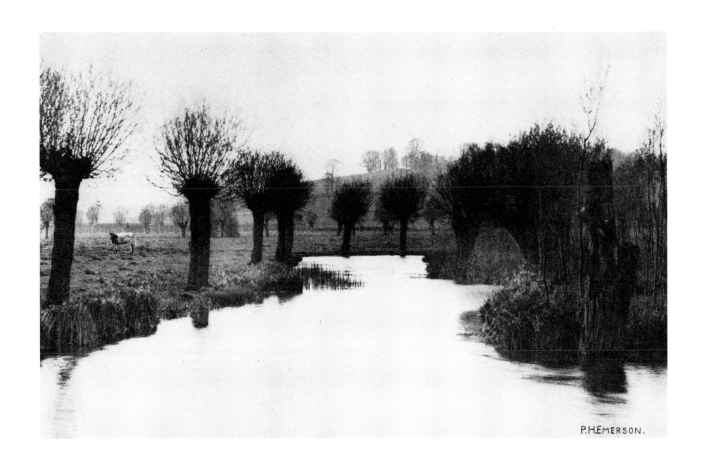

was nothing and would heal quickly, it did, and if he said it was serious you had better go do what he said immediately.

Whenever he set up his camera, everyone within reasonable distance came running to peek under the focusing cloth into the ground glass.

> They are fond of pictures, and have very good natural taste. Many is the gaudy chromograph and cheap print we have seen voluntarily ousted from its frame for a photograph, because the latter was so "lifelike." And many a time, after taking a picture and proceeding to pay our models for their trouble, they have begged us to send us a print and keep our money. Oftener than we can relate have we been begged for a picture of their Broad, their horse, their cottage, their cup-winning boat, their eel-catch, or some other object of local interest.

He was always asking questions. Some were fun and easy to answer, especially with a story, others cut so deep you had to pause to think what to say because he did not yet know things you had absorbed with your mother's milk. Questions about crafts and trades were easy—even for poachers, once they learned to trust him. He would accept ghost stories only from those who thought they had seen ghosts themselves, but when it came to witchcraft and superstitions they were cautious: you might get yourself in trouble—with the witches. He was surprised that in this country, where some six hundred poor wretches had been drowned or burned alive in the seventeenth century, people still thought there was a prevalence of witches and believed in wise men and women.

The superstitions sometimes made Emerson smile, or shake his head and ask another question. The materia medica concerned him still more, connected as it often was with the superstitions foretelling fate. Most of it, however, was harmless, like keeping a potato in your pocket to ward off the "screwmatics."

Once he had the frightful experience of having a man with an infected lip ask him what to do about it; he could not bring himself to tell the man that he was suffering the last stages of a fatal disease from which nothing yet known could save him. He told him to go to the hospital—and "shuddered as the shadow of a dead man fell between me and the sun."

For Emerson himself, this experience with the peasants often had its dark side, even its repulsive aspects, and both hurt, because they were unnecessary. Some of the old thatched cottages were three or four hundred years old; the leaded casements were set deep in the thick walls. The rooms might be small, so that one fireplace would heat them; the floors were flagged, the rafters oak. When clean and cared for, these old cottages were beautiful, freshly whitewashed and newly thatched above. Inside, bunches of drying herbs hung from the old dark rafters, the casements were open, with pots of sweet-scented flowers on the sill, and the smell of new-mown hay with sea fog coming in; the incense of a peat fire smoldering on the great hearth mingled with that of bread baking in the side ovens, and from other parts of the house came the fragrance of fresh linen and clothes, dried outside on the grass in sunlight, and now folded away with lavender. The pleas of the housewife, no matter how young, beautiful, or newly married, that her man wash, and change, at least his boots, in the shed before coming in on her shining, fresh-washed flagstones, seem to have been, by common male consent, ignored. "Don't let them women get a-holt of you, or they'll run you, and you won't have a word of your own."

So in came her man: if farmer, with boots smeared with manure, and the smell of sheep and cows about him, but with a bunch of young carrots, a plump young cockerel, freshly killed and plucked, and a pail of new milk, still warm and bubbling; if fisherman, with sand, fish scales and seaweed on his boots, but with a pail of, say, silver eels, and the fresh-faced children jumped with joy around him.

There were a few such cottages, which sheltered such idyllic lives. But in most of the old cottages the casements had been stuck fast since they were hung, perhaps in 1450; the well and the loo (outhouse to Americans) were too close together for health, and in spite of all the frantic housewives down the centuries, the cottage still stank.

And the new cottages were worse.

Emerson notes, in *Pictures of East Anglian Life:*

Once, when a student of hygiene, we viewed these cottages from the cubic-space, water-supply, village-slop point of view; but now we are able to forget these points when outside these lowly homes. But alas! with what a rush are we again driven back . . . when we enter them! The stupidly-made windows, which do not open, have much to do with it, the peasant's dislike of fresh air and cold water much more perhaps . . . The Local Board Bye-laws are admirable and necessary . . . The peasantry enjoy a given cubic space; they may not huddle in cellars; they may not live with a cesspool and a well in their best bedroom; but they may become more vulgarized . . . by the greed and ill-taste of the jerry-builder . . . Mean landlords hire these desecrators of the landscape, and tell them to run up a row of cottages, everything included for some paltry sum. Up they go like mushrooms, and twelve months after . . . the walls are cracked, their ceilings are falling, their doors and windows and fireplaces . . . have shrunk . . . lastly the cheap handles and window-catches have snapped . . ."

And this was written not yesterday but in 1887.

The blithe simplicity with which he had viewed the peasants in *Life and Landscape* darkened into pity and wrath as they came to know him better, to trust him and tell him their life stories. He was still too much an American and democrat not to be shocked at all-too-frequent practices. For instance, a poor young man, often from the pauper class or the workhouse, laboring hard from dawn to dark, was badly fed—pork and coarse bread, even offered spoiled food to eat "or starve"—and slept in the cow barn on a thin straw pallet with only the thinnest of blankets to cover him. If he complained, the farmer got out his whip and gave him a few bloody whacks. If he ran away, the farmer blacklisted him so he could not get another job in the neighborhood. If he applied for parish funds, the farmer said he could have had work at his farm had he wanted it. Or sometimes accused him of theft, and had him jailed, and again he landed in the workhouse.

The farmer did not even spare women and children from the whip; one man, finding a woman and her children picking blackberries, whipped them all and upset their baskets. Called into court, he said it was "because they would get in the way of the sportsmen."

The poor peasant girl ("mawther" means a young woman; "town mawther," an apprentice) faced a still harder lot. "She was the drudge, the nurse, the milkmaid": sometimes, if the house was ill-supplied with water, carrying two pails several times a day, even in deep snow. Often she had to work all day with the men on the harvests or among the animals, and then, at lamplighting, was given household chores lasting long into the night. Her pallet was in the attic, hot in summer, arctic in winter, again with the thinnest of blankets and no cows' breath to warm it. On ill-disciplined farms she was regarded as fair prey; the farmer and his men upped her skirts and had her whenever they found her alone. If she was of an amorous sort, these tumbles in the hay, which have always been regarded with bucolic mirth, didn't bother her, nor their possible consequences. If she was not that sort, she was in for trouble; no pleading, no remonstrance brought anything but reprisal, a whipping, a return to the workhouse, or rape. If she became pregnant, the farmer laughed and turned her loose, saying she was a whore. Norfolk in particular was noted for its high rate of illegitimacy. At fairs and festivals, Emerson observes: "Venus and Bacchus went hand in hand."

The unwanted, illegitimate children, especially those whose mothers died while they were still infants, were sent to the workhouse, to be ill-fed, poorly clothed—no nightgowns, for instance—and worse housed. Education by superannuated teachers cost a half-penny a week, and, though the natural parent often paid well, the comptroller often held back even this meager fund and the children never learned to read or write. One girl, who had resisted the supervisor's advances by throwing her supper—rice and milk—in his face, was sentenced to a cell on bread and water. Another so offended another official's amorous attempts that she was condemned to spin all day in a cold, drafty hall and sent supperless to bed, stark naked because of the no-nightgown allowance, in a freezing attic; all

that winter, a bitter one, she was denied access to a fire. Bound out at thirteen as apprentices, the children were often sent back in worse condition than they went, with diseases and tales of cruel abuse for which there was no redress.

And the pay for man or maid was miserable, sometimes no more than bed and board, such as they were, sometimes with a promise of a colt, a calf, a lamb or a measure of garden produce for good behavior.

Of course there were good families who paid their people decently, fed and housed them well, looked after them in sickness, gave dowries to their maids and feasts to celebrate their weddings, and cared for their well-being. Even the very old and senile could come to these people, be given some slight task to do, a mug of ale and a full basket to take home.

The clergy were corrupt, and few of any faith bothered to consult them or go to church at all—the fishermen still went fishing on Sunday if it was promising weather. As for the medical practitioners, they were so lax and ignorant that Emerson had long since lodged a strong protest.

All this had been going on since time out of mind, and most people simply shrugged their shoulders, expressing sympathy for individual cases but unable to act. For centuries they had had no rights, nor laws to protect them. Often their only recourse had been to the lord of the manor, himself usually the instigator of such abuses, or those of the clergy who seemed uncorrupted but whose superiors usually either persuaded or punished them.

Now, from America and France, there had come a new spirit of reform, gathering strength until it was passing new laws for the whole of England, making judges, courts and lawyers more available. A "Labourer's Union" had been set up, and a "penny press" brought the news to almost all. The dame schools had been teaching the urchins to read, write and "figger," but education beyond that was mostly absurd—incompetents trying to teach inept pupils, themselves not bright enough to perceive the gifted who should be sent to better schools.

Often it was the wife, able to have spent more time at the dame school, who bought the penny paper, and was maternally pleased when her eldest, proud of his learning at school, could read or spell out the paper to the family. During the Crimean War, those who could read were paid a shilling a day to read aloud in the public houses—unless the proprietor himself could read, in which case he had to have other helpers at the bar. Now there were a few reading rooms, with the newspapers and a few books, where the learned could come with the unlearned. Emerson wrote:

> The "Labourer's Union" and the "penny press" have taught the peasantry much, and they are no longer to be hoodwinked by the fair words and empty promises of either party. The more they learn the more their wrath and ill-feeling grow against the farmer for having ground them down so much in the past. The landlord, they say, grinds down the farmer, and the farmer in turn grinds down the labourer, who can least afford it. They maintain the farmer should have fought the landlord for fair rents, instead of robbing the labourers. The niggardly conduct and tyranny of the farmer have been, and are, constant sources of irritation to the peasantry. In Suffolk the proverbial qualities necessary for a farmer are: "A strong arm, a long purse, and a thick skull."
>
> Avarice and tyranny seem to be the curses under which the poor Suffolk peasantry have laboured.

All this was causing further troubles. Once the relations between landlord, tenant farmer and laborers had had its warm moments—in the festivals or in the elevation of a gifted peasant to important office, or the lord's care of the people in need:

> Formerly, after the haysel and harvest, the workers had a "largesse" in the shape of a harvest-home or horkey-night; but nowadays the farmer has given up all these pleasant gatherings, and he thereby loses much more in one way that he gains in another; for there is absolutely nothing now to bind the agricultural classes together. The landlords, also, have in many cases abolished the tithe-dinner, which the tenant-farmers in the old days always considered as *quid pro quo* for the tithe. Now the farmer feels he is deprived of both; so he says to the landlord when he wants the tithe, "Dew yow fetch it from my house; I shan't run arter yow with it"; and so the breach between class and class widens. The snobbery which has invaded the farmer class also increases the gap between them and the laboring class, for the labourers liked the days when the farmer's wife

superintended the dairy, when the farmer's sons were put to the plough, and his daughters to milk the cows. Then their own wives used to assist in washing and brewing, and the poor labourers could get a drink of mild or "home-brewed" at the farmhouse; but now they say it is—

"Woife silk an' saton,
Booys Greek an' Laton,
an'
Missy pi-ano,

an' tha dorg is likely tew be set on 'em if they go nigh tha housen." In former days, again, before the passing of the Ground-game Act, the farmer winked at the capture of a rabbit or a hare; but now the labourers must not look at them, for they all belong to the farmer . . .

As we have seen, Emerson blamed the tragic fate of many peasants ultimately on the rapacity of often distant landlords. He hoped his wide documentation of the whole horizons and dark depths of the peasantry and fisherfolk, all of it from living lips, even down to the fishing and farming calendars, would help in the understanding of this peculiar region and add to the rising outcry against abuses.

What he personally felt about the people can be seen in his photographs: the strong young men, the trim girls in their aprons, the old men and women almost incandescent in their courage and endurance. Most of the pictures in *East Anglian Life* are documentary—osier-peeling, basketmaking, fencing, a dame school, and so on—but here and there are some of his loveliest photographs and most lyric writing.

2. THE AMPHIBIANS

It was not until after those first cruises on the Broads that Emerson came to know the "amphibians," as he called them: the fishermen, the marshmen, the hunters and poachers—they were another matter from the peasants. He soon realized their pride in their expert skill at sailing their difficult waters, where every emergency a sailor might anticipate could and did occur, frequently in sequence. Originally half sunk beneath the tides of the North Sea, the Broads were now a series of large lagoons connected by sluggish rivers, and the reclaimed rich agricultural lands were, as in the Netherlands, crisscrossed by dikes and canals which one ascended or descended by a series of locks. But what worked well in the orderly Netherlands, where cattle clad in quilts grazed the low meadows and canal boats sailed high on the dikes above them, went awry in the fens, mostly due to British obstinacy and dislike of governmental intrusion into their private affairs; the seventeenth-century engineers had had their troubles and so had every corps of engineers since.

The result was many wild marshes, still covered at high tide, others slowly rising into ploughland. They were on the great flyway for migratory birds; they were haunts for many delicious fish and they abounded in wildflowers in their seasons. They were waters you had to *know*. How wide and how deep was a certain drain at low tide? Where could you safely moor and for how long? When and under what conditions did the tides develop swift currents, with the scour of the ebb especially dangerous? And the weather could change within seconds.

Emerson could understand the amphibians' impatience with "them cokenays" who, since the trains were built, came down from "Lunnon" on holidays, hired a boat and, for all the waters were so shallow, proceeded to drown themselves. They were tired of rescuing these idiots, spending hours in hard, wet, cold and sometimes dangerous work and then being rewarded—in return for the actual lives of the rescued—by a beggarly half-crown.

Emerson knew he would never win their confidence and friendship unless he proved he could sail as well as they. So he challenged them to a race. It was something of a compliment to him that they consented at all, but they had seen him around, handling his light little sailboat easily; he had never given them any trouble and now and then he had cleaned, bandaged or splinted somebody's wound. Nevertheless they growled as they chose the best small-boat man among them and the swiftest boat, *The Young Rover*. She was bigger than Emerson's *The Little Maid*, as he calls her in this anonymous sketch in *Marsh Leaves* in which he himself is simply "the amateur." The trials

agreed on were stiff, of course, or nothing would be proved: three races of three courses each, with the skippers changing boats in alternate races. Emerson, starting out in *The Young Rover,* found, as he had heard, that she had a tendency to turn turtle; she also leaked. Coming back up to his knees in water, in spite of bailing, he could not but complain. The amphibians agreed and sank *The Young Rover* to staunch her, then raised and rerigged her for the next set of races. All races were against time; at the end, the amphibians wore long faces as they totted up times for both skipper and boat: *The Little Maid,* with either skipper, had made the best time; Emerson in either boat had also made the best time. Emerson does not say he did, but it would be like him to stand them all a round of rums, their preferred tipple, and then suggest that he could not possibly have won if he hadn't been watching them ever since he came to the Broads. Smiles doubtless went around above the rums; that was true, and he was a gentleman to say it. He was *in.* Now they would answer his questions, take him babbing for eels, liggering for pike, shooting for birds—anything he fancied; if they found him moored for the night, they would drop in with a brace of widgeon or a huge bream or other fresh-caught delicacy, knowing they would get a measure of grog and a pipeful of good tobacco and some chat before the fire, with a man who liked to listen.

Emerson had no Tolstoyan vision of the peasants, nor did he need the devastating scalpel of Chekhov, who, remember, was also a doctor. As one of his teachers observed, "The best training for observation and description is that of a clinical clerk."

In spite of abuses, the society was not yet so corrupt and so futile as in Russia. Emerson saw these people exactly as they were—tough in mind and body, avaricious, taking courage for granted just as they took the floods and the storms, gnarled and twisted by rheumatism in their bones and in their minds by ignorance, superstition and experiences often unjust and even cruel, though they took those facing death as normal and everyday. He rather enjoyed their humor, even when a thin disguise for boasting or a downright lie, immediately punctured by their fellows to the amusement of all present—including the liar.

In the preface to *Pictures of Life in East Anglia,* he wrote:

My aim has been to produce truthful pictures of East Anglian Peasant and Fisherfolk Life, and of the landscape in which such life is lived. With this end in view, I made ample notes whilst living in East Anglia, so that all the information on shrimping, trawling, smelting, anchor-fishing, poaching, ploughing, harvesting, fencing, brick-making, eel-picking, decoy-work, and the many other operations illustrated, was gained by actual observation, and afterwards amplified and corrected by information gathered from the lips of specialists in the various subjects . . . The tales of shipwreck come from the lips of John Craigie, the coxswain of the Southwold Life-boat, and other sailors, coastguardsmen, and longshoremen . . . The workhouse experiences, ploughman's experiences, etc., come from the subjects themselves, their names also being in my possession . . . The meteorological observations were recorded by me . . . tested and corrected at Kew, and duly inspected whilst in working order by the Inspector of the Royal Meteorological Society in London . . . I have endeavored in the plates to express sympathetically various phases of peasant and fisherfolk life and landscape which appealed to me in Nature by their sentiment and poetry. In short, I trust the complete work may form a humble contribution to a *Natural History of the English Peasantry and Fisherfolk.*

A far cry from Robinson's sentimentalizing on the simplicity and charm of rustic life!

3. WILD LIFE ON A TIDAL WATER

With the manuscript of *East Anglian Life* safely in the hands of printer and engraver he went back to the Broads again, this time sharing with Goodall a rather cranky old houseboat, the *Electra,* and a beery giant of a fisherman, Joey, who served as factotum. They were moored on Breydon Water and looking across at Great Yarmouth, down the channel winding through forests of shipping and quays bordering "the sea-stained town."

Goodall scans the landscape, stroking his beard, and declares, "There's my picture . . . and what a magnificent subject it is!" Being a Naturalist, he will work on that painting for perhaps an hour on those evenings when the light and the tide are right.

Daytimes he and Emerson may go off sketching and photographing together, or Goodall, whose nickname was Dick, may stay in "the painting-room," while Emerson reads or writes in the saloon.

Most photographers and writers try to take some sort of vacation after a really monumental job like *East Anglian Life,* and very few succeed; in a day or two they are right back at it again, because they love nothing in the world so much as photographing and writing, and feel uneasy just loafing. So it was with Emerson: a deep breath or two of the fresh moist air, a few hours listening to the waters and the birds, and he was beginning *Wild Life on a Tidal Water.*

It probably started just as another of those journals he seems to have kept conscientiously for years, always beginning with sunrise, sunset, phase of the moon, the wind, the weather, the barometric pressure, and so on, and then passing on to the wildlife, the fish, and what happened to him and those around him. Leaving out the weather notes, except when important, this book is simply what happened to him and Dick on that tidal water in those weeks. And the story is more about the two-legged wildlife in and about the town and marshes than of the finny or winged varieties.

We come to know the fisherman, Harnsee (Norfolk for heron), and the hunter, Pintail, quite well. The Crab and the Cyclops, smelt fishermen, appear briefly but vividly. We join the crowds in the pubs and discuss many things of common interest to all such as cures and ghosts. We lay out the lemons and sugar and rum for toddy, while the kettle sings on the tortoise stove, set a jar of excellent tobacco alongside the huge pipes called "churchwardens," and wait for our guests. The Harnsee is already sitting bolt upright, sipping toddy and smoking, when Pintail arrives with his gift of birds. Greetings and thank you's over, conversation languishes. Pintail picks up Emerson's rifle, opens the breach, squints down the barrel, mutters "fare foul" and begins to clean it.

"You used to be a gunner on Breydon, didn't you, Harnsee?" I asked.

"Aye, twenty year ogo; but them wor times."

Little Pintail looked up scornfully. His merry eye twinkled as he interrupted maliciously—

"Ay, them wor times for them as knowed their business."

"All right, bor," rejoined the Harnsee, with his hard, rasping voice. "We bain't all born with a gun atwixt our teeth." And looking around for applause, he winked knowingly.

Both were bidding for our approbation, which placed us in a dilemma. We responded by sinking back comfortably into our corners with an air of judicious impartiality. Pintail, having finished the gun, mixed himself a stiff glass of toddy, and ducking to us, said with mirthful eyes—

"Health, sirs," and tossed it off.

The little fellow then came forward to the table and filled a huge briar pipe, winking and grinning at us like an overgrown marmoset.

"Ah, thet's good baccy," he said, lighting his pipe . . . "Hist! tha go a bunch of fowl," he broke off suddenly, sitting erect on his cartridge box, and straining every sense, pointing with his three-fingered hand up to the roof as a warning for us all to keep still. In the silence we could hear the short and trumpet like voices of some gulls as they alighted on the flat near by, and there arose a chorus of cackling like geese. This weird, mournful noise seemed to offend the little gunner, for he cried—

"Them warmin is allust at thet game of a night-time. Why can't them old uns lave us alone?" There was an awkward silence, for he had spoken of the old fishermen who had "tarned ter gulls," which is a common belief with them.

Emerson breaks that spell, and starts them off again with "Well, Harnsee, who do you reckon a good gunner?" The evening is now off to a prime start, boasts and counterboasts, Pintail often the winner, and then strange tales, quite probably true, that are like telescope views into a wild and dangerous past.

The most dramatic incident in *Wild Life* begins one morning when Dick dashes out of the painting room, yelling for the "glasses." Emerson had taken off his coat and waistcoat in order to deal with Browning—"what a terribly dull dog he was. A poet(?)—*pour s'amuser en l'enfer!* as I heard a witty Frenchwoman say of the Javanese Dancers at the Paris Exhibition."

Pintail had been in that morning, brightening like the sun as he told he had sighted a pigmy curlew, a very rare bird

much in demand among collectors, and that he knew just when and where to shoot him. Emerson says several times he had no more use for stuffed birds than stuffed men and women. He considered "collecting" a well-paying crime and the collectors criminal fools. Emerson mutters to himself, "Some wretched curlew," and returns to "the crabbed amateur psychologist's work." But Dick is back: "I say, old chap, a boat has capsized in the channel, and they're drowning! Come on!"

They throw themselves into a gun punt, Emerson taking the stroke oar and Goodall the bow oar. Now they can see clear: a swamped boat floating, sunk to her gunwales, and five people up to their waists in water, shrieking as the swift tide bears them toward an old wreck; a gunner in a punt nearby sits "motionless as the angel of death." A yacht sail shines in the sun, two miles away. Joey, bound for groceries in the jolly boat, is scarcely half a mile yet from the houseboat. They yell at him, he quickens his smacksman's stroke; his course is longer, but once he hits the tide he will go "like a rocket."

Dick swears at the gunner: beyond a doubt, the language used by all on this occasion did not resemble the acceptable Victorian curses Emerson finally commits to paper. They get stuck on the mud, Dick gets out and pushes—and falls neck-deep in a drain. They are both near exhaustion, then see a yacht bearing up—and nobody on the sinking boat except one clinging old man.

The gunner now comes to life, shoots apparently *at* the old man and rows like a madman *down* channel, *away* from the wreck. The language must have reached a new high, especially when Emerson and Goodall find themselves confronted by a mud flat they can't see over.

When finally they round this obstacle, the little gunner is still racing as for life down channel, a boat's crew from the yacht has gone to see if they can raise the sunken boat and the corpses aboard her, and here is Joey, with the old man, dripping but still alive, in the bow and a dead girl in the stern. Her blue eyes stare at the sky, her long hair trails in the water. She had suddenly risen to the surface after the yacht's crew had gone, and Joey and the old man had had a hard time lifting her aboard.

The old man looked vacant; he had recently lost his wife, and here was his last relative, this girl, his niece, apparently drowned. Joey finally responded to Emerson's shouts and rowed ashore. The doctor was sure the girl was dead, but the pitiful old man made him try to save her; his own heart pounded so hard he could not for a few moments listen to any heartbeats, and himself so exhausted he could hardly summon himself to begin artifical respiration.

She was dead, he knew, but: "I worked hard at artificial respiration till the perspiration ran down my face. I tried to save that beautiful young girl for the world, she was only eighteen and had the figure of Venus of Melos." The dead arm falls to the earth; the old man, thinking it a sign of life, is back on his knees again. Emerson is furious: "I looked down at those blue lips, the bloodless face, and those lacklustre eyes . . . Oh, the uselessness of the old man's prayers! The barbarous myths which filled his head seemed to fire me with a pitiful scorn. The sunlight, the blue sky, the gulls—Nature, what did she care for the young girl's death! I knew now that Science could not help, and yet there was that heart-broken old man praying to a God to save a life—already gone . . .

"At length I gave her up and covered her pretty lips and face with my handkerchief. Then, closing up her bodice to hide the dead, white bosom from the small crowd that had gathered around, I arose breathless with exertion." To face a dark-faced fanatic "with the face of a Tolstoi," who felt the girl's pulse with his *thumb.* "She's dead right enough," he said with a wise-looking expression.

"I cursed him for a fool and a busybody. 'You gents don't know *h'everythink,*' he replied with the grin of a street cur." Then there was actually an argument over where she was to be buried, since she didn't belong to this parish and wasn't picked up here—"in this Christian country!" comments the furious Emerson.

"Take her home, take her home, my man," I repeated.

"But will that be right?" he asked, in doubt.

"Take her home, and d—n the rights and the wrongs!" I said, and ordered Joey to row the old man and the dead girl home to Gorleston.

Behind the old ship Pintail was lolling in his punt smoking. Dick was especially enraged against him, and, rising up, Dick yelled—

"D—n you, Pintail! Why didn't you save those people?"

"What people, sir?"

"Those people that were drowned."

"I never heerd 'em, sir. Gospel truth. I never heerd 'em, sir, until that wos tew late. I wos arter that pigmy curlew (I got him, said Pintail, dragging the bird from beneath his jersey), and I was thinking of noathing elst, and then I see a boat com rowing acrost the flat. Thinks I, they be arter me for shooting out of season, so I lies quiet and lets 'em get t'other side of the hump, for I knowed I could get cotched for they had to get round the hump. Presently I fires and collars the bird, and goes rowing hard down the channel. Thinks I, they shan't hev me, and then I met Joey rowing up, and I say ter myself, What are they all rowing like this for?

"'What are you arter, Joey?' say I.

"'There's a boat capsized,' say Joey, 'didn't you see 'em?'

"'No,' say I.

"'Lor', they were close ter you,' say Joey.

"And then I came up with him, and I heard that it wos you two gentlemen as wos rowing acrost ter help 'em."

"Of course you heard them yelling," I said calmly to Pintail, looking him straight in the eyes.

He shuffled and grinned, and said, "Well, sir, them warmin don't know much 'bout small-boat sailing—sarve 'em right if they com up here and get drownded. Besides we poor men mun get a living, and they'd only hev given me a half-a-crown if I hed saved the lot on 'em, d—n 'em! I know 'em well; and I shall get tree half-crowns for this (pointing to the pigmy curlew)."

Dick and I looked at each other astonished at his impudence; we were on the balance of bursting into rage or laughter. Don't ask me how it happened; I can only tell you, after looking at each other, we both burst out laughing; then we looked at each other as if we were ashamed, and we left Pintail.

It is scarcely surprising that in his later years Emerson took to writing adventure stories, based on some locale he knew well—such as the Broads, or Wales, or Cuba.

4. STIEGLITZ

Later, that fall, having left Breydon Water, the Harnsee, Pintail and his good friend Dick nostagically behind, Emerson was wading through heaps of inferior photographs, many of them obviously attempts to imitate his own. Appointed sole judge of *The Amateur Photographer*'s "Holiday Work" competition, he was determined to find a jewel in this trash if there was one. If there were none, he would probably have declared nothing worthy of the first prize, or perhaps nothing worthy of any prize. But suddenly he found it: twelve photographs which made him start with delight. Fresh, clear without being razor-sharp, unposed, natural, simple, with an unsentimental tenderness. Most of them had been taken in and around the Veneto, in beautiful lights and shadows. Obviously they were a young man's work; equally obviously, the people knew the young man was around and liked him there. There was a young girl selling fruit, sitting at the foot of a long staircase down which the sunlight slanted, a basket of grapes at her feet. Her old mother joined her on the stairs, and her brother, a handsome boy, was photographed against an ancient, peeling wall. Emerson had no way of knowing that the photographer, finding the girl early in the morning, bought most of her basket—he loved fruit—and was immediately adopted by the family. He spent the whole day with them, and was sad when he had to refuse the mother's plea that he take the girl and the boy to America, to a relative somewhere; he would have liked to adopt them both. Meanwhile, he went where they did, haled along with delight. They went to a washing place, and some one cracked a joke that caught the whole wave of children up in laughter. Emerson knew what the little boy in a sailor suit, clapping and turning to the photographer, meant: "Oh, you must share this with us!" Emerson turned the picture over: "A Good Joke," by *Alfred Stieglitz, Berlin*. There were other pictures; there were people, mostly children, on the bridges and stairs and along the canals. And there was a ragged, scarred, scowling boy with curly hair, the only one obviously

sitting for his portrait. Through him you could see both his past and his future—and this not by any dramatic trick, just through the sudden miracle that the young photographer's profound, compassionate insight leaped through thirty years to the great work of his maturity. Perhaps Emerson saw this, perhaps he thought the picture merely pleasant. In any case, he gave the first prize, two guineas and a silver medal, to "the most spontaneous": "A Good Joke," by Alfred Stieglitz, of Berlin.

Probably the first thing Emerson knew of the young Stieglitz was that he was bilingual and a student at the Berlin Technische Hochschule (Polytechnic) under Dr. Wilhelm H. Vogel, a very great man in many fields, whom we have unwisely forgotten. To him, as photo-chemist alone, photographers owe the discovery that photographic plates can be made sensitive to all colors, including red and orange, which were formerly recorded as black, by adding dyes to the emulsion; his discovery made possible full-color photography. Vogel had already been fighting with the manufacturers some sixteen years for the recognition of this discovery, a fact which may have encouraged Stieglitz in his fifty years' fight for the recognition of photography as an art and also his fight for the creators in any field of early twentieth-

Alfred Stieglitz, *A Good Joke*

century art. Meanwhile, under Vogel, he was learning techniques and disciplines which were to lead him, undaunted, into fields till then considered impossible, such as storm and night.

Vogel admired Robinson, and some of Stieglitz's earliest photographs have a Robinsonian look. This, however, is less to be blamed on Vogel than on Edward Stieglitz, Alfred's father, who, after retiring with a modest but sufficient fortune from the wool business, and becoming the only Jewish member of the New York Jockey Club, turned to his old love, painting, and gathered about him painters of the same sort as Robinson admired. Some of young Alfred's friends in Germany were painters of that school. They envied him, his ease and naturalness in photographs.

"We know it isn't art," they said to him, "but we would like to paint as you photograph." "I don't know anything about art," said the young Stieglitz, "but I have never wanted to photograph the way you paint."

He had no need of any of Robinson's tricks. The early costume pieces were actually made at a costume party, quite unposed; the young men were really "Throwing Dice" or "Gambling." They, and many others, were successes because Stieglitz had learned to control the light, natural or artificial. The painters and photographers concluded that "things just happened right for Stieglitz."

Then he became aware of Emerson, and "truth to Nature," and the delicate beauty of a platinum print. A great light seemed to burst upon him, illuminating not only where he had been trying to go in the past but where he was truly going in the future.

And now to have *Emerson* recognize it! His first medal! (In the next decade or two he was to receive more than a hundred and fifty; like Robinson, he could have clothed himself in them.)

His first thought was for his father, who had been none too happy about Alfred's switch from engineering to photography at the Polytechnic. He had not actually said so, for he had probably found it impossible to correct this strange, mystic, perceptive son of his; the boy saw through any arguments at once. Now Alfred thought, This will please him, and show

Alfred Stieglitz, *Venetian Boy*

I've not been wasting my time. And then, How poor the other competitors must have been!

Stieglitz in later years insisted there had been no amateur photography in Germany when he was there, though he was trying to encourage a group to start. But in Vienna there was Der Club der Amateur Photographen, and Stieglitz both knew and admired its founders. Whether through him or not, in December 1887, Baron Alfred von Liebig presented the Club with ten of Emerson's gravures, and was reported as saying:

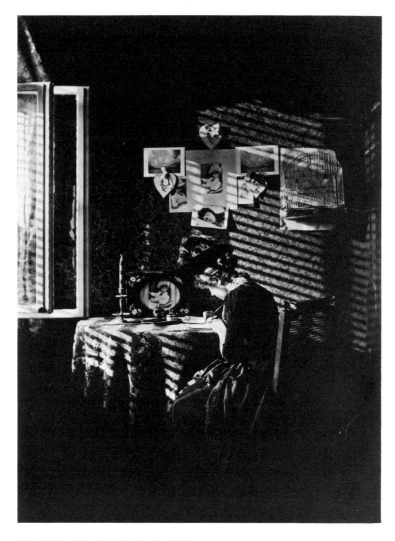

Alfred Stieglitz, *Paula, Berlin, 1889*

To the speaker's knowledge, it is the first time that art friends
have been offered a series of original photographs of interest
not for the objects they represent, but for the interpretation and
handling. The speaker warmly welcomed this endeavor. Only
by holding fast to it can photography be brought to a high
artistic level, and he recommended to all who pursue photography
from the purely artistic viewpoint the thorough study of
Emerson's pictures.

5. Publications And Reviews

In February 1888 came the huge gravure "The Haysel," 22½ x
17½ inches, in which, as W. Jerome Harrison wrote, "the old
scene of gathering the hay is depicted with wonderful softness.
The picture was taken direct with a Dallmeyer lens." In the
same months *Idyls of the Norfolk Broads* appeared, a portfolio
of twelve gravures with a lyric introduction by Emerson on the
passage of the seasons in East Anglia: there are delightful
pictures here—"The Haysel," in smaller size, the charming little
girl with a water lily in "Flowers of the Mere," and "Grey Day
Pastorale," the sheep resting with a windmill in the distance.
One cannot help wishing he had represented each month, as
his prologue suggests. But perhaps the prologue suggested
to him the year, 1890–1891, which he was actually to spend
on the Broads.

Then came *Pictures of East Anglian Life,* book size, 16 x 20,
with thirty-two gravures. It was an astounding, outspoken and
truthful monograph, and now, his foes thought, they really
had a chance at him. They roused the Tory press, which accused
him of being a radical—a dreadful thing to be in those days
of the anarchists, equal to "terrorist"—and of having slanted
his "veracious" accounts and "quotations" to show things as
being worse than they were, especially in relation to landlords.
The only landlords he showed, they said, were the *nouveaux
riches,* whose sole interest in the peasants was to wring a few
more pennies out of them. The old landed gentry, they main-
tained, were brought up to assume responsibility toward their
people and to be concerned with their welfare as individuals.

It was the only point on which they could get him. His ac-
counts *were* accurate and documented. He was a humanitarian
and therefore a liberal, with no bombs or revolutions in mind;
he did want to help make conditions better for the peasants and
fisherfolk. But—had he been unjust to the landlords? He in-
vestigated and found that, in general, what the Tories claimed
was true. With some notorious exceptions, the gentry and
aristocracy, unless devoting their lives and careers to "The
Empire," were passionate farmers, devoted to developing better

strains of animals and vegetables and better methods of cultivating them, and their wives deeply involved in charity, health, welfare projects, the drains and horticulture. They did look after the old and crippled; they did see that the promising children got to good schools, the sick ones to good medical care. Their responsibility ran generations deep, so that the peasants were families they had inherited, their peculiarities and special aptitudes as well known as those of one's cousins. It was probably at this point Emerson discovered that the "nice overfed boys" he met as undergraduates did develop into "decent fellows," and that their people often did love them.

Emerson became more Tory in his opinions and, as if in counterbalance, more agnostic, avoiding Christmas and Easter whenever possible. But the Tory attack seemed to have hit Emerson alone; photographers and the public were unaffected. The press in general hailed the book with high praise, comparing the plates with Millet and Corot (one German publication called Emerson "the English Courbet"), spoke of it as telling of the poetry and hard lives of the peasantry and fisherfolk almost through anecdotes, with a quiet humor, and recommended it to every country family's library for earnest study.

Sometime early in 1888, the historian W. Jerome Harrison, F.G.S., was summing up, for the *International Annual of Anthony's Photographic Bulletin* (New York, 1888), what he and a great many others felt about Emerson:

"The development of a man's work can only be considered by taking his productions according to the order of their production, or rather publication." He then reviewed them all, ending with *East Anglian Life*, and continued:

The six important works named above testify to the great zeal and industry with which Emerson is doing his work; but we learn that he has also executed twenty-seven plates for the magnificent centenary edition of Izaak Walton's *Compleat Angler*, which is to be issued in the autumn, the subjects being mostly taken near the River Lea. Another illustrated book—done again in conjunction with T. F. Goodall—is also well advanced.

All these works appeal forcibly to the artist; and to drive home their teachings to the photographer Emerson is preparing for publication what we believe will be an epoch-making book in photography—*Naturalistic Photography for Art Students*—in which his views on photography will be fully given and explained.

But for the student of Emerson's works, there is little need to ask what those views are. Dr. Emerson is a brilliant exponent of that rising school which has taken for its guide the teachings of "Naturalistic" French artists, Millet, Corot, and Bastien-Lepage. He writes—"Wherever the artist has been true to nature, art has been good; wherever the artist has neglected nature and followed his imagination, there has resulted bad art . . . As a means of artistic expression the camera is second only to the brush—how successful the artist is with either depends entirely upon himself. All we ask is that the results shall be fairly judged by the only true standard—NATURE, and the only knowledge required by the public for a true and thorough appreciation of pictures is a knowledge of nature, which can only be obtained by studying her."

. . . Dr. Emerson has produced what most people, even with a knowledge of the subject, would scarcely believe were "photographs." By using, as we believe (though without any authority for our belief save a study of the results), a Dallmeyer lens arranged to give "diffusion of focus," all sharpness has been avoided, and great "breadth" and "atmosphere" secured. If anyone wants to convert an artist to photography, he should present him with some of Emerson's pictures; but whether with this object or otherwise we earnestly recommend every photographer to obtain, and to study, Emerson's books.

Robinson thought it was time to start knocking the Naturalistic nonsense on the head. For the *British Journal Photographic Almanac for 1889* he wrote:

"So Natural!

"How very lucky you were to get these nice subjects!—Were they instantaneous?—they look so natural." This is one of the awkward compliments that are often paid to the photographer for which he does not feel grateful. It is difficult to persuade the general public that a successful picture produced by photographic means is not due to luck. They will give him credit for technicalities; they will allow that he uses the machine with skill; they will admit that he knows how to focus, for is not the picture sharp all over?— to develop because there are no stains visible; to print, for there are no signs of measles. But when they see that which is really the

result of the highest skill, good composition, well managed light and shade, "go" and spontaneity, they say, "So natural! how lucky!" Then again, but quite on the other hand and unintentionally, they will give you credit for high artistic skill by asking, when you show them a genre photograph, "Whose painting did you copy it from?"

It would be useless to deny that even the most skilful photographer is often indebted to luck...For instance, the sun may shine when he wants the direct aid of its light...or his model may stand in a graceful attitude...or he may meet with...an unexpected group of cattle which seems to insist on making a picture without much assistance; but all these advantages would be of little use if his artistic treatment was at fault...

"How easy and natural those portraits are! I am sure you did not use that dreadful head rest," another will say, looking at some portraits behind the sitters for which you probably built a regular scaffolding, not for the purpose of keeping them still, but to prevent them from falling into an awkward position. And so they go on, confounding nature with art.

Nature, having no inner consciousness, knows nothing about art. Nature takes life as it comes...while true art takes the best of nature and improves upon it, or, if it cannot get the best, does its best with what it can get...

Let us see, apart from art, what the scientific representation of nature is like. Let us inquire if scientific fact is like the nature that meets our view.

The detective camera takes nature as it is, yet it fixes for us what we never see. Would anybody ever exclaim "So natural!" on looking at Muybridge's horses, or even at many ordinary instantaneous photographs of the human figure?...It was considered a great feat to photograph an express train going at its fastest, the result was a representation of a train apparently standing still, with an unmeaning cloud of steam and smoke trailing behind it. The waves of the sea are sometimes photographed so quickly that they lose spirit and motion, and appear frozen... Yet this is nature as represented by science. The artist knows better and gives, or tries to give, you truth as you see it. There is a great deal of nonsense in this parrot cry for nature and fact...

To make this matter of seeing nature, or representing it "So natural!" more clear, let me take an illustration from our most familiar instrument, the camera. Take a figure a few yards away from the camera, and get it in focus; let there be another object, say a white cow, fifty yards away and nearly behind the figure, expose a plate, and what will be the result? The figure will be in

sharp focus and the cow would be a smudge, without form and void. This is a scientific fact, and would be exactly what the eye also sees if the focus of the eye, like that of the lens, remained stationary. But natural truth demands that the representation should show what the eye practically sees, which is a very different thing. Now the focus of the eye changes so instantaneously that it practically, although not actually, sees both objects in focus at the same time, yet not both equally sharp, for distance tends to obliterate detail. This absolute impossibility of representing with the lens alone what the eye sees is made easily possible by combination printing.

There is just one more nail I should like to drive into the coffin of photographic fact, which buried, I hope will leave more space in the photographic world for natural truth.

Given as a subject a heath scene, with the sun setting surrounded by clouds, a golden evening stretching forward to the setting sun. If a photograph is made of this subject, and sufficient exposure given to bring out all the visible details of the landscape, the result will be a picture of a heath with a plain sky; the excessive exposure will have obliterated the sky and clouds together. This is "the supreme power of facts." Is it truth?

The remedy. Take the same subject, photograph the sky on one plate with a short exposure, and the landscape on another with a long one; print them together skilfully, and you get something that is, at all events, much nearer nature than a representation that ignores the sky altogether. Yet I have heard a photographer say: "What art of combination printing can equal in satisfaction the straightforward, honest rendering of a phase of nature?" and there are still those left among us who insist on scientific fact, the rigid fact and nothing but fact, in photography, and persuade themselves it is "So Natural!"

X. THE CURIOUS CRYSTAL

In the late 1880's, what you thought and felt about P. H. Emerson depended very much on who you were, and how young, whom you were talking to, and what had happened lately. From a distance he seemed rather like a fierce crystal just prized from its matrix, and not yet subject to the jewel-cutters. He gleamed, he dazzled,

he gloomed ominous as a thundercloud and scarcely less baleful to the targets of his wrath. Or again he might glow like a hearth or a soft sunset with friends or a talented young unknown. Most of the time he was simply clear, bright, with an occasional prismatic sparkle.

If you were a young photographer and had been meditating over some of his luminous platinum prints, and reading some passage in one of his albums, perhaps of a change of weather, what happened to skies, clouds, winds, waters, fish, birds—all living things—in the strange storm lights, you knew he was a poet, and thought of him as extraordinary, a special lens for imagination and vision. If you were a young student studying abroad, like Alfred Stieglitz, the photographs came to you like the sun in truth, and his writings were like a great voice uttering your own half-formed thoughts. If you were poring over his fulminations in the photographic press, you knew he was an idealist, a reformer, a fanatic, and didn't believe the situation called for diplomacy.

If you happened to be in a Harley Street consulting room and mentioned the name "Emerson," your doctor would give you a flashing look, scowl, and snap, "Great loss to medicine. Damned young fool. He could have helped us a lot—Africa, India, places like that."

In a club on Piccadilly, you might encounter some crusted Tory who boomed, "Emerson? Met him the other day. Very decent feller, actually. Just didn't know enough of the right sort down there in the fens. Thought we were all like those *nouveaux-riches* grabbing everything, grinding the face of the poor and so forth. Introduced him to a few friends. He's all right."

Or, in the same club, you might run into a much younger group of members who had known Emerson from the days when they were all boys together at school or university. To them he had been a boon companion; first one and then another would recall that frolic when he had you splitting your sides or that prank he thought up which nearly landed you all in pokey. "Remember all those silver cups and trophies that were crowding off his mantelpiece and bookshelves into the closet? He earned them, all right. We voted for him as captain of the first football eleven *and* captain of the first cricket eleven simultaneously. We certainly followed him and it seemed victory did, too. We *minded* him, even.

"When he was Senior Prefect and called you aside to comment on some misdeed or eccentricity of yours, you were damned careful not to offend again. Prig?—Nonsense. Haven't we been telling you? Ever see him as Fox in the paper chases?—Oh, no, of course, you weren't there. Fastest runner you ever saw, knew all about covert and leaving confusing trails. Said he learned how playing Indians in the States. Never got caught and was always Home first as Fox. Swam a canal once, with that huge paper sack!—Well, yes it *was* a bit of a shock—confusing, you know—that he was such a scholar. Prize after prize, honor after honor, and then, you know, in stiff competition, the most coveted posts. And not by pull or family connections—no, sir! Just plain brilliance and hard spade work, and where did he ever find the time? Of course, nobody worried about energy in those days, but still—As Scholar at school he had to teach some of the little boys' forms, Latin, French, Geography and so on. And how he loved to act!—We were all rather young then, but I thought then there never was a Hamlet or Macbeth who rolled the lines out better. Edited the School Mag. too—that was at King's. Remember his satires on the Royal Academy and the Opera?— Funny thing—he never seemed to have enough to do—felt vaguely underexercized. No, he never told us much about himself. Reticent and offhand as a prince. Born in Cuba, father an American sugar planter, mother from Cornwall, then living in Devon. Once admitted, rather under pressure, that he was a distant cousin of Ralph Waldo Emerson. As if it were nothing to be proud of. Curious.

"Wonder where the old boy is now. Like to see him again—Oh, *I* did, couple of months ago. Had a wonderful few days cruising with him on the Norfolk Broads. Has charming wife, three fine young, but is all wrapped up in this photography business. Goes off in houseboat to think, I gather. Little heavier, less hair, constant pipe, modest moustache—and a chef as good as Prunier's or La Tour d'Argent, if you please! Best fish, right out of the water, you ever ate. And sometimes we went shooting our own

birds for dinner. Remember those collections of butterflies and birds' eggs and things? That's still on, more than ever. He's doing the first volume for that spectacular centennial edition of Izaak Walton's *Compleat Angler*. Pretty lucky fellow, I'd say."

After which it is perhaps unnecessary to describe how naturalists looked when you mentioned the name "Emerson." Glowing eyes, somewhere between falcon and bird dog. "Going to do the *Angler!* Oh, good! Chap I know—bird man—was going to do a book on birds with Emerson—he to do the writing and Emerson the photographs; never got a publisher to risk tuppence on it. Nor for a fine zoo book they planned. Now they're coming around —now publishers can see public likes wildlife. God! How I'd like to do a book with Emerson! Give him my most distinguished, will you, and tell him he has a notetaker and camera-carrier anytime. I can quant and scull too."

When it came to his enemies, however, it was distinctly a different tale. If you met H. P. Robinson, he was probably delightful over the teacups, and when you mentioned Emerson, merely twinkled and quoted, "'Even the young are not infallible.'" His own career had begun before Emerson was born.

It was nothing so amiable if you met up with really bad photographers—the sticky and inept imitators of Robinson, or the professional portraitists who heavily retouched faces and accentuated every gorgeous detail of jewelry and embroidery, or were so poor at composition that they relied on not only retouching but veils and scarves or plain vignetting to conceal their inability to cope with fat arms or scrawny hands. Even the earnest but dull "topographists" were no friends to Emerson; he had dismissed them as unimportant except to Baedeker too often. And bad painters and engravers who hid the fact that they relied on photographs for their drawing and shading didn't like their sins exposed.

Nor did the manufacturers of shoddy goods, such as Emerson had dubbed "Mr. Slowplate," "Mr. Chromatic Wide-Angle," "the Cracked Camera Co.," and so on, appreciate having the competitions for which they offered prizes shown up as the gulls for the gullible they really were—offering cheap prizes for photographs made with very expensive and very fallible merchandise.

Sales of such merchandise were seriously falling off; fewer people came to the inept portrait studios; even the "topographists" who usually had a steady trade and even "artists" like Robinson who had enjoyed a generous income from his huge combination prints were selling less and less. "The Ammonia Society," as Emerson called the Royal, possibly including also the Camera Club, had been berated for their dull and inane speakers. And amateurs, who could usually depend on a medal or two, found the medals going to younger photographers with a more direct approach.

He must be stopped, or at this rate they would all go bankrupt. But how? But how?

P. H. Emerson, A.B., M.B. (Cantab.) and member of several learned societies—one irate writer called him "Emerson A.B.C. D.E.F.G."—doctor, naturalist, writer, and most unfortunately a great photographer, he seemed unassailable. (Puzzling over this continued use of basic degrees by one whose friends, colleagues and teachers held far more important degrees, often omitting all the rest when they could simply add F.R.S. to their names, one comes to the conclusion that Emerson considered most photographers such lunkheads that they would be impressed by this rather minor string of letters. He was right; they were.)

To his enemies, he was the most infuriating man in the world. He was not only a heretic, he was taking the food from their mouths. They longed to break through his maddening pigheadedness and hurt him where it would do the most good. But, again, where?

Since he believed nothing he had not proved to his own satisfaction, his mind was an impervious blank wall to any opinions varying from his own. He feared nobody. His energy was limitless. He used invective like a sledgehammer. Or, if the case seemed not altogether hopeless, he used the cat-o'-nine tails, flicking off a little skin here and there.

And what he could do with plain, printable Victorian prose must have made some old bones glow, and preacher mutter to preacher through the moldering coffins, "That's our boy!" And if, in a rage, he did pull all the stops and use all the words, then the steamboat mates of whose use of language Mark Twain stood in awe and envy would have risen from the muddy bottoms of the Mississippi to find their mates from the clipperships, the merchantmen, the man

o'wars and the whalers, who had kicked Melville, both with foot and rhetoric, and made Dana jump, risen from the abyssal deeps of all the seas, to listen agape to a master of their art. The British called it "Billingsgate" after London's fishmarket, where the idioms of the sea are in daily use.

Why wasn't Emerson continually embroiled in suits for libel? As the facts stand, there were only two suits, both brought by Emerson (one was the Aquarium Company and one he threatened against Robinson); Emerson won both. The answer, of course, is that they were all afraid of him.

They couldn't just starve him; he had some sort of private income, probably from the Americas and apparently enough to live on comfortably, if not lavishly. His big gravures and expensive albums sold remarkably well. And he had a considerable audience overseas. Even before he erupted, in 1885, onto the English photographic scene, the gorges of many sensitive people had been rising against the Robinsonian gloss and glamour and the sickly sentimentality and downright falsity to which his followers had sunk. By the time his enemies realized the danger Emerson presented, his admirers and adherents numbered in the hundreds, and possibly, through his trumpet calls overseas, to America and the Continent, in the thousands.

Now, with the press announcements and preliminary blurbs appearing about his new book, *Naturalistic Photography,* his enemies thought they saw at last the opportunity they had been yearning for: the chance to knock both the book and its author on the head. They gained control of *The Amateur Photographer,* ousted the editor who had been Emerson's staunch supporter, and put in a man they could trust as chief. They arranged—Emerson later thought by cash—for Robinson to write the first review. (In view of his later attacks on Emerson, it seems more likely that he was the leader and nothing could have kept him from writing it.) They approached other publications, occasionally with success. After these first damnations, there would be anonymous letters; after that, everything would take care of itself.

Emerson, of course, was unconscious of this cabal, and probably would not have cared tuppence anyway, except that the venom of the attack surprised him and later prevented the translation of the book into German. He himself, to be certain he understood sculp-

ture, had been working long and daily, for three months, in the studio of a sculptor friend, J. Havard Thomas. Surprised at his grasp of principles and ability to achieve form, Thomas urged him to go on with sculpture, but received the same answer as had the painters.

Back at his book again, and wondering how he could get its message into other languages, he suddenly thought of that young photographer in Berlin, who was, apparently, bilingual. He looked up the address, but did not get the spelling right; consistently, through more than thirty years' intermittent correspondence, he misspelled it *Steiglitz.*

Private

<div style="text-align:right">

June 20th 1888
10, Marlboro' Crescent
Bedford Park
Chiswick

</div>

Dear Sir,

Although we are unknown to each other in the flesh we are I trust friends in the spirit. I am now taking the liberty of writing to you on this "spiritual basis" on a thing which recently came to my mind.

As perhaps you have seen in that periodical the "Amateur Photographer," I am writing a book on "Naturalistic Photography." The MS is now nearly finished and I hope to have it in the printers' hands by the end of this month and on the market by Xmas or before. Now the matter I have to propose to you is this. Would you care to undertake the translation of it into German, a task for which you are undoubtedly highly qualified? If so, we can arrange terms. You could no doubt get a German publisher to take it up—the same who publishes Burton's and Robinson's books* and we could demand a royalty on every copy sold and share it between us if that would meet your view in the matter. The expense of production would be . . . little as there are no illustrations. I may say it treats everything photographic from a new point of view and especially goes into the artistic side of the question. In short the book is intended for a student who wishes to produce pictures and it contains all technical directions. It also contains the most advanced ideas on

* The publishing house was Ed. Liesegang's Verlag in Düsseldorf. The books were: Burton, W. K., *Das A-B-C der modernen Photographie,* 1883; Robinson, H. P., *Das Glashaus und Was darin geschiet,* 1886.

art, ideas which I have been able to gather and learn from my large circle of artist friends and from my training in art.

It is perhaps late for me to express my admiration of the work you sent in to the "Holiday Competition." It was the only *spontaneous* work in the whole collection and I was delighted with most of it.

With kind regards
Yrs faithfully
P. H. Emerson
B.A., M.B. (cantab.)

We do not have, as yet, Stieglitz's half of the correspondence, but he must have responded with enthusiasm, for Emerson writes back on June 27 how delighted he is, proposes doing a new preface for the German edition, and again getting the best possible terms. and sharing the profits.

Emerson thought then that the book was done, and would go to the printers in a fortnight; actually, as usual, the comments of valued friends, of his publisher or editor—if Sampson Low had such an officer in those days—and his own afterthoughts delayed the book another two months. On August 28, he could write Stieglitz that at last it had gone to the printers, and that he had just learned that the German publisher must get the consent of the English publisher and pay them a fee, as well as the author and translator.

The Maid of the Mist was now resplendent once more, with her new cabins and galley and saloon; Emerson and Thomas took a recuperative and refreshing cruise in her, exulting in how easily she handled. Then, his family apparently still on holiday, he went back to London alone and began *English Idyls* (Tennyson had certainly made the word *idyls* all but inevitable), which was not to be illustrated. When it was published, he received a congratulatory note from Walter Pater, that master of deathless prose during the *fin de siècle*.

At Christmas time the *Compleat Angler* appeared, and was showered with praise—at least Volume I, for which Emerson had done the photographs. Then, by way of escaping the holly and mistletoe, he went on a short trip to Holland with Thomas and W. L. Colls, whom he considered the finest of the photo-etchers. There they feasted on the great Dutch, Flemish and German masters: the Van Eycks, Dürer, Holbein, Quentin Massys, Rembrandt—the artists Emerson loved best.

XI. "A BOMBSHELL DROPPED AT A TEA PARTY"

On March 16, 1889, Emerson could write Stieglitz: "At last I am able to send you a copy of the book. It was published *yesterday*." He further discussed terms with the German publishers, proposed adding translations of the many favorable comments on his other works, and suggested Stieglitz write a Translator's Preface. "I shall look forward to hear from you and have your opinion on the book."

And so *Naturalistic Photography for Students of the Art* went forth, an exquisite little white book with delicate rubrics and Keats's "Beauty is truth, truth beauty" on its title page—looking innocent as a lamb and packed with explosives. Ruthlessly, it attacked the art world with its "Truth to Nature" criterion, no matter how illustrious the artists on the other side. Most important, it defined straight—or "pure"—photography for all time, no matter what improvements in sensitive materials, techniques and equipment may be invented or discovered in the future.

No book in the history of photography—or perhaps in the history of art—has ever caused such vitriolic abuse or such ecstatic praise. R. Child Bayley's "bombshell" metaphor was apt indeed.

We do not have Stieglitz's immediate reaction to Emerson, but we can guess at it. Stieglitz was no art historian, but he loved pictures and haunted the great galleries of Europe. Whenever he

was in Vienna, he went back again and again to Rubens's portrait "Hélène Fourment in a Fur Coat" at the Kunsthistorische Museum. To the end of his days, he considered it the finest interpretation of a woman ever made. So he can scarcely have agreed with Emerson's brief dismissal of Rubens as showing "more regard for 'getting on' than for art; it is lacking in feeling and truth."

Whatever else Stieglitz may have had reservations about, he was overwhelmed by reading this first great statement of pure photography:

(1) That photography is an independent medium, with its own inherent characteristics, and potentially a great art form.

(2) That the controls offered are sufficient to express vision:

Nature does not jump into the camera, focus itself, expose itself, develop itself, and print itself Where an artist uses photography to interpret nature, his work will always have individuality, and the strength of the individuality will, of course, vary in proportion to his capacity . . . The point is, *what you have to say and how to say it.* . . .

(3) That the emotional and psychological effect of a photograph lies in the untouched image of the lens as recorded by the sensitive material, and therefore,

(4) that this effect should never be spoiled by handwork or combination printing:

Retouching is the process by which a good, bad, or indifferent photograph is converted into a bad drawing or painting. . . . The technique of photography is perfect, no such botchy aids are necessary, they take the place of the putty of the bad carpenter. . . . Avoid retouching in all its forms; it destroys texture and tone, and therefore the truth of the picture. . . . With all the care in the world, the very best artist living could not do this [combination printing] satisfactorily. Nature is so subtle that it is impossible to do this sort of patchwork and represent her. . . . Although such "work" may produce sensational effects in photographic galleries, it is but the art of the opera bouffe.

(5) That composition has nothing to do with rules or formulas:

Composition is really selection, and is one of the most—if not the most—vital matters in all art, certainly the most vital in the art of photography. But the writer maintains there are no laws for selection. Each picture requires a special composition, and every artist treats each picture originally, his method of treatment, however, often becomes a law for lesser lights.

He also states the tenets of classic photography—its simplicity of means and its straightforward approach:

In all apparatus, the student should choose the simplest and the strongest, for lightness *per se* is no object, nay, it may even be harmful, as leading to over-production. In fact, nothing should stand in the way of getting the best results, and though many of the cameras on the market are light and fitted with numerous devices which are said to simplify operations and help the worker, yet such is not really the case, and the thousand-and-one aids to work are apt to become deranged and finally to embarrass the worker at some critical moment.

For portraiture, he condemns Robinson's scenery as "incongruous lumber" and recommends the use of a plain background slightly out of focus:

It is a false idea and an inartistic one to endeavor to represent outdoor effects in a studio. Studio lighting and outdoor lighting are radically different, and in a studio you have only to try and give an *indoor effect*. . . . None but an amateur could fail to notice the falsity of lighting as seen in outdoor subjects taken in the studio. . . . The true photographer . . . must have the camera ready, focussed, and arranged, and when he sees his model in an unconscious and beautiful pose, he must snap his shutter.

Such statements and the philosophy behind them became Gospel to the young Stieglitz, and, apart from a few manipulative experiments, he adhered to them personally all his life. For the present, he rushed the little white book off to the great German publisher, Wilhelm Knapp, at Halle an der Saale.

Now the reviews came pouring in. The first three, all unsigned, appeared on March 29: *The British Journal of Photography,* by its editor, J. Traill Taylor; *The Amateur Photographer,* by H. P. Robinson; and *The Photographic Journal,* by its editor Thomas Bolas.

Let us consider all three, beginning with J. Traill Taylor in *The British Journal of Photography:*

The author seems to have slipped off the rails even before he made a start with his book. . . . In the introduction, [he] takes objection to the terms "amateur" and "professional" as usually understood, believing it to be folly to apply the former to one who does not practise photography for his living, or the latter to one who gains his living thereby. He gives it as his dicta that "professional photographers are those who have studied one branch of photography thoroughly and are masters of all its resources." An amateur, on the contrary, according to this authority, "is a dabbler without aim, without knowledge, and often without capacity, no matter how many of his productions he may sell." Under which designation does Mr. Emerson consider that he himself is entitled to rank? Photographers, accepting the universally received definition of the term, relegate him, perhaps too unceremoniously, to the professionals, because he—very wisely, as we think—practises the art for money, although not necessarily for that alone.

Passing over all that Mr. Emerson writes concerning ancient Greek and Italian art, Egyptian art, Greek and Graeco-Roman art, and art of a great many other nationalities and periods—passing over likewise many pages devoted to the phenomena of light—we come eventually to the technique and practice of photography. Here we find much to astonish and amuse, with a limited amount of solid instruction for the young photographic aspirant. In the course of this department of his book the author says, "In our student days it was considered bad form to give a testimonial to a tradesman for publication. This is still bad form." Seeing that there is a good deal of testimonial-giving in the form of recommendation of certain manufactures, and which is not far from a mild form of touting to be met with more than once in his pages, we might ask if our author would not have occupied higher ground had he adopted the considerations of his student days in this respect. And in the face of this, Mr. Emerson allows his publishers to utilize and publish such testimonials as he himself has received in the form of favorable notices of his productions.

An air redolent of the personal superiority of the writer to the vulgar herd of photographers pervades the book, and much that they do is offensive to him. . . .

The reviewer agrees to some extent with Emerson about the abuses prevalent in current exhibitions, the medal system, the incompetent judges, etc., until Emerson says:

No one can judge a work of art unless he be an artist. *

According to this, no one is competent to judge the quality of a

*Italics mine. N.N.

beefsteak unless he be a butcher; of a glass of beer unless he be a brewer; or, to come nearer home, of a gelatine dry plate unless he be a plate manufacturer. . . . But to continue: "The combined assurance and ignorance of those who accept what should be considered a serious office is laughable and lamentable. Is our exhibiting student, then, going to submit his work to men untrained in art? If he does, he will find it either unhung, skied, or passed over in the awards to make room for the pretty nothingness and false renderings of the craftsmen's ideal."

Mr. Emerson is a fluent and forcible writer, who shows considerable familiarity with the writings of artists; and we think it a pity he has not adopted in his book a tone that savored somewhat less of grievance against his fellow "craftsmen," who are to be excused if they have failed to discover in his published pictorial works aught that would warrant the indulgence of any superiority over the mass of Photographers.

Robinson, in *The Amateur Photographer,* also March 29, 1889, has more of the airs and graces of the gentleman, but he comes down severely on what were to be the main sources of debate: composition and focus.

. . . The book commences with an admirable introduction, in which are detailed the various applications of photography and its effects on the sister arts, and with which we agree with but few exceptions, the chief of which is the dogmatic manner in which the author lays down the law that everybody is wrong except himself; all writers on art from Ruskin downwards are stigmatised as incompetent, and we should really like to know why those who use the compound word "art-science" should be contemptuously called hack writers, and that those who laid down canons of art—these men being really the greatest artists of all time—should be "men of narrow intellect."

The first chapter is devoted to a definition of terms, the second is headed "Naturalism in Pictorial and Glyptic Art," in which the author endeavours to trace "the influence of the study of nature on all the best art up to the present day." In his criticism of the great works of art produced during more than 2,000 years, Dr. Emerson judges them all by his one standard, naturalism. It does not matter what other great qualities they may possess; if they do not fit the new naturalistic creed they are condemned. . . . In other words, all the world is wrong and Dr. Emerson is right. A humourist once said that "even the young are not infallible," and we cannot get this line out of our head as we read through the book. He has a habit of referring to the "uneducated" in art, the uneducated being those who have not subscribed to his particular doxy. There is an air of

infallibility and assurance running through the volume which sounds young, and is not convincing, the keynote of which is struck in the dedication to the memory of Adam Salomon as "the first artist of acknowledged ability who was original enough to practice photography for its own sake," and only ending with its last page. Sad havoc is made of great names. Michael Angelo was "rather an anatomist, and often a lover of pathological specimens than an artist," Raphael "a religious youth with no great power of thought," with his "sickly sentimentality, his puerile composition, his poor technique, and his lack of observation of nature." Turner is contemptuously referred to as "a great man gone wrong." And you are told if you are pleased with many of the "much-vaunted watercolours of the present day," you have "the taste of a frugivorous ape." Well may Darwin say, in his "Descent of Man," "Ignorance more frequently begets confidence than does knowledge."

. . . Dr. Emerson's principles of art as applied to photography are derived from the practice of the School of Naturalistic Painting, and labour under all the difficulties inherent in imitating the methods of one art with the materials of another. This little clique of painters has been long struggling to gain recognition, but the results they show have not been inviting, and their self-assertion has been almost as hard to bear as their ugly pictures. It ought not to be necessary to tell amateurs that the imitation of one art by another is essentially bad art, and that it is no wiser to judge the results of photography by the principles of naturalistic painting, than it was to judge them by the teachings and experience of the past. . . .

The naturalistic principles are scattered throughout the book, but are nowhere definitely stated. . . . Visitors to London picture galleries will, perhaps, understand the position if we quote the author's surprising assertion that "Whistler's name rises far above any artist living in England." We will try to give some idea of the system in the author's own words, as far as we can in our limited space.

Impressionism and Naturalism mean the same thing.

"To us Impressionism means the same as Naturalism, but since the word allows no such latitude to the artist, even to the verging on absurdity, we prefer the word Naturalism, because in the latter the word can always be referred to a standard—Nature—whereas if Impressionism is used the painter can always claim that he sees so much, and only so much, of nature, and each individual painter thus becomes a standard for himself, and others, and there is no natural standard for all."

There is the fallacy here of supposing that nature is the standard to the naturalistic school; it is their method of *seeing* nature they always refer to.

One of the great principles of the school is that there shall be one unchanging centre of vision. This is insisted on in Bate's "Naturalistic School of Painting," which is the source of much that is written on the subject, and the principle is illustrated by example by Dr. Emerson.

"Let us imagine an example. A decaying wooden landing-stage stands beneath some weeping willows at the edge of a lake. From the landing-stage a path leads through a garden to a thatched cottage, one hundred yards distant; behind the cottage is an avenue of tall poplars. On the landing stands a beautiful sun-bronzed girl in a plain print dress: she is leaning against the willow, and is looking dreamily at the water. We row by on the lake, and are struck by the picture, but, above all, by the dazzling native beauty of the peasant girl; our eyes are fixed on the ruddy face, and we can look at nothing else. If we are cool enough to analyse the picture, what is it we see directly and sharply? The girl's beautiful head, and nothing else. We are conscious of the willow tree, conscious of the light dress and the decaying timbers of the landing-stage, conscious of the cottage, away in the middle distance, and conscious of the poplars shining blue and misty over the cottage roof; conscious, too, are we of the water lapping round the landing-stage; we feel all these, but we see clearly and definitely only the charming face. Thus it is always in nature, and thus it should be in a picture. Let us, however, still keep to our scene, and imagine now that the whole shifts, as does scenery on a stage; gradually the girl's dress, and the bark and leaves of the willow grow sharp, the cottage moves up and is quite sharp, so that the girl's form looks cut out upon it, the poplars in the distance are sharp, and the water closes up, and the ripples on its surface and the lilies are all sharp. And where is the picture? Gone! The girl is there, but she is a mere patch in all the sharp detail. Our eyes keep roving from the bark to the willow leaves, and on from the cottage thatch to the ripple on the water; *there is no rest*, all the picture has been jammed into one plane, and all the interest equally divided. Now this is exactly what happens when a deep focussing lens and small stops are used, and the operator (for no artist would do this) tries to make everything sharp from corner to corner. Let the student choose a subject such as we have suggested, and put what we have imagined into practice, and he will see the result. Yet this 'sharp' ideal is the childish view taken of nature by the uneducated in art matters, and they call their productions true, whereas they are just about as false as can be made."

In this extract lies the point on which most photographers and a great majority of good painters differ from "the school." It is the stronghold of their creed, upon which their existence depends, that the picture should represent the first impression on the eye of the artist; "a true *impression* of the scene, not a realistic wealth of detail." It may be worked up, but the effect of this first impression

must be preserved. The eye must be fixed on the principal object, the rest of the picture must be "felt" but not defined. They wilfully ignore the fact that the eye changes its focus so automatically and instantaneously to adapt itself to vision, that we are not conscious of it. Does a naturalistic painter, as a matter of fact, keep his eye on the face of the girl while he is painting the cottage and the lake, and paint only what he "feels" of these accessories? We defy him to see these subsidiary objects sufficiently to paint them, however mistily, without moving his eye. He pretends to follow nature willingly, he would have to *obey* nature and move his eyes. When he had done so the object to which the eye was newly directed would no longer be out of focus. We sorrowfully admit that sharpness and definition have been a great deal too much insisted on. What we want to see in a photograph is the amount of definition our eyes, as we use them, *practically* see in nature. We don't want to resort to any such device as keeping the eye fixed, so as carefully not to see much of the subject. Art can give prominence to parts without any of these dodges, and keep the rest in proper subordination without putting any part out of focus.

. . . It is only fair to state, however, that the author disclaims fuzziness, although how he escapes it when he says depth of focus is to be carefully avoided, puzzles at least one of those "untrained persons" Dr. Emerson is so fond of referring to.

It teaches nothing to say—in reply to the question, how can composition be learned?—

"Our answer to this is that composition, that is selection, cannot be learned save by experience and study—there is no royal road to it, no shilling guide. This subtle and vital power must be acquired, if we are to do any good work, for we are dumb until we do acquire it. We can no more express ourselves in art without having mastered composition, than a child can express himself in prose until he has learnt the art of writing."

It is very satisfactory to learn this, but rough on the poor student who has to go out and grope blindly in the dark, and afterwards finds, as Dr. Emerson quotes Constable with approval in another place, that "the self-taught artist has a very ignorant master."

Mention is frequently made with commendation of the works of Mrs. Cameron. The present writer knew that talented lady, and admired her exuberant enthusiasm for photography. Would Dr. Emerson be surprised to learn that the effects, or defects, in her works he so greatly admires, were greatly due to the misuse of a very inferior lens? The rapid rectilinear, which he mentions, was obtained rather late in the gifted artist's career, and we can remember her delight when she found she could get sharper and clearer negatives. . . .

The book is written with great ability, marred only by those hard words which break no bones and are more damaging to those who use them than to their intended victims. We have been more severe than usual, not without pain to ourselves, in our notice of this volume, because we hold it to be our duty to protect the young photographer from false doctrine that may be prejudicial to him in the exercise of his art. In face of this imminent danger we can no longer hesitate about expressing our opinion. *Amicus Plato, amicus Socrates, sed magis amica veritas.* While giving Dr. Emerson all credit for sincerity, we cannot help feeling that his system is pernicious, and tending to lead the amateur into slovenly ways, and into a habit of excusing bad photography by calling it good art. This is epidemical. It is not a new disease, for it has broken out many times, and we feel it to be the imperative duty of a journal like our own to produce a disinfectant, and stop the disorder. . . .

Again on March 29, the leading editorial in *The Photographic Journal* takes both a more sane and more excited view of the book:

The duty, or it should be said, the custom of a majority of the reviewers of a scientific work is to look at the table of contents, read the preface, and write a review from the information picked up in this way, damning and praising the book according to his own sweet fancy, and according to the highness of the name of the author. *Naturalistic Photography,* however, cannot be treated in this way, for as it is a book thoroughly unique, and, as some would think, unorthodox in matters of art, it has to be read through before an opinion of its value can be expressed. . . . In the first division, on naturalism in pictorial and glyptic art, we have an instructive, historical and critical notice of ancient art, commencing with the Egyptian and ending with Modern Art. This has been carefully thought out, and conveys to the reader a synopsis of the subject in fewer pages than we could have conceived possible. . . . It will not do to linger over each chapter, but we are glad to find . . . that the author takes the same view we do regarding the truth of instantaneous pictures. They may be true scientifically, showing us positions at the moment when the image was impressed, but they are false artistically as conveying the impression which the eye sees. The remarks on . . . retouching are also what we heartily agree on, and which we should have expected from the pen of such a master of the art as Dr. Emerson. They should be read by all, and digested by those who carry out retouching beyond its legitimate functions.

The practical part of the work is just what it should be in one sense, and the dryness of formulae is conspicuously absent. . . . We are also glad to see that the author thinks there is but one proc-

ess for printing, and that is platino-type, and perhaps he had done more to show that artistic photographs can be produced by its means than anyone else. Like him, "We have no hesitation in saying the discovery and subsequent practice of this process has had an incalculable amount of influence in raising the standard of photography." . . . Suffice it to say that the book is distinctive from any other book on photography, and there is reading worth study on every page.

We have been so fascinated by the freshness of language, and the forcible way in which the author endeavors to bowl over old ideas and institute new ones, that we have had a difficulty at times in laying aside the admirably printed and got up volume. We can only say that we heartily commend it to all who are interested in artistic photography, and who are not above learning from a master in the subject, though a decidedly heretical one, on which he writes.

Emerson wrote Stieglitz on April 11, 1889:

I enclose a review which may help you. The review in the British Journal you must take no notice of — that paper belongs to Ross and Co. Opticians and I recommended Dallmeyer's lenses — voilà tout. The review in A.P. was written by H. P. Robinson whose antiquated notions and book I sneer at in Nat. Phot.

Somewhere in the press in those days of rising fury, *Justice* snarls: "Naturalistic focus, then, according to Emerson, means no focus at all, a blur, a smudge, a fog, a daub, a thing for the gods to weep over and photographers to shun."

On May 3, a leading editorial by the editor T. Bolas appeared in *The Photographic News*:

Dr. Emerson is a photographer who knows how to follow his own judgment with confidence and steadfastness. He has the spirit of the craftsman of the period before the great industrial revolution of the second half of the Eighteenth Century — a spirit which prompts him rather to look upon his work itself and its relations to nature, than to look at it through the distorting glass of convention. To understand Dr. Emerson's work aright one must know this. We may, however, point out that although Dr. Emerson is, so far, true to his own instinct and feelings, not to be dragged aside by any convention of taste, he in no sense does what is often the case when an impulsive person rebels against a convention — whether artistic, social, or political: he does not so rush to the other side as to mar his work by straining himself to avoid that which has been approved by any convention merely because it has the stamp of such approval.

Indeed, we find Dr. Emerson honestly and candidly acknowledges the considerable aid he has received by a careful study of the works and writings of those who have gone before him, in the direction of efforts towards the production of pictorial results by photography; indeed, he has paid striking tribute to one of the best known of these gentlemen [Robinson] in recognizing the fact that his works and writings have served as a warning what to avoid. . . .

Truth in photography has two very distinct meanings, each being after a fashion reasonable and correct; but the confusion rises when both meanings are used indiscriminately. The man who, like Mr. Muybridge, brings to light, by photography, things hidden from the unaided senses, is an exponent of one phase of truth; while he who represents a scene as the eye perceives it, with atmosphere, light, and shadow, expounds the other phase of truth; and the latter phase is the sort of truth the artist seeks to realise.

In the work just issued . . . the reader soon finds he is not in contact with an author who is either an echo of others, or wishes to make his readers mere echoes of himself; indeed, the reader soon finds that his teacher is not one who expects and strives to mould his readers to his own image, but one who hopes to rather lead them to think and act for themselves. If our author's spirit were more current among the technical teachers of our day, we would probably be in a more hopeful condition as regards future progress in the arts and crafts.

The literary style of the work is excellent, and it contains a fund of useful information conveyed in a pleasant manner — a manner which contrasts agreeably with the overbearing dictatorialness of the teachers whose aim is to force all students into the same mould. . . .

It may be worth while at this point to quote what our author has to say about the use of the word photographic, and we fancy he is partly driving at the PHOTOGRAPHIC NEWS, but Mr. Emerson never drives wantonly, or for the mere desire to take up arms. He writes on p. 24: —

"Some of the best writers and journalists of the day have adopted the use of the word 'photographic,' as applied to written descriptions of scenes which are absolutely correct in detail and bald fact, though they are lacking in sentiment and poetry. What a trap these literary men have fallen into will be seen in this work, for what they think so true often is utterly false. And, on the other hand, photography is capable of producing pictures full of sentiment of poetry. The word 'photographic' should not be applied to anything except photography. No handwriting can be 'photographic.' The use of the word, when applied to writing, leads to a confusion of different

phenomena, and therefore to deceptive inferences. This cannot be too strongly insisted upon, as some cultured writers have been guilty of the wrong use of the word 'photographic,' and therefore of writing bad English."

The mass of the book is composed of valuable and thoughtful essays on the various branches of photographic work—both from the technical and the artistic aspects—embodying the author's own experience. Altogether "Naturalistic Photography" is a work which should be possessed and read by everyone interested in the practice of photography.

The Amateur Photographer, May 17, contains one "Anon." and an interesting review by Houston Stewart Chamberlain. "Anon.," "In Search of the Naturalists," begins with:

I have a confession to make which I can only impart to you under the densest veil of anonymity. I am an amateur in search of Genius; I want it for myself! A friend tells me that what I really want is only the appearance of genius, and that I want it cheap; that there was a time when a velvet coat, long hair, and a slouched hat would do the trick, but that this device was too *thin* now; that what I wanted was what the author of "Robert Elsmere" calls a "marketable eccentricity," not for money making (for I am an amateur, and it would not be dignified to sell my photographs singly or in sets), but to enable me to pose before the world. I mean to be candid, and confess he is right. That's so. This is the age of posing, and I want to go with the age. Then he gave me what he called the correct tip. He said that if I would consult Dr. Emerson's book on "Naturalistic Photography," I should probably find the newest fashion in what I wanted, and he didn't think it could be done cheaper. I got the book and read it with the greatest delight, for it abuses everybody, and what can be more gratifying than to learn that nobody but the author knows anything? You don't feel so powerful mean yourself when you find that the princes of painting were duffers. There was one exception, as there always is to prove a rule scientifically, a Mr. T. F. Goodall is the only one who comes under the censure of the author's unmitigated praise. As I heard a man say at the Club, "Michael Angelo and Raphael are not *in it* with Goodall, according to Dr. Emerson." This was a fruitful hint to me. Having learnt all I could of the naturalistic school from the book, I could hunt up the pictures of this perfect painter, and should, doubtless, find the principles of this epoch-making school fully illustrated.

He starts with the Grosvenor Gallery, only to find Goodall's

pictures so skied as to be "where the worldly, lacking a ladder, could not follow." Then, at the Academy, he finds "A Dream of Paradise," with "a blue-eyed Eve," in which he delights until a friend points out it is by another Goodall, an R.A. Finally he locates three genuine Goodalls, one skied, the others tolerably well-placed, and likes the skied one best, until he is told that

. . . it was the jealousy of the Hanging Committee that placed the others too near the line, as it was found that the further off the better they looked.

What I particularly wanted to see was how the principal object was placed in focus, and the rest of the picture only "felt," as described in the book. What was my surprise to find that there was no principal object in any of Mr. Goodall's pictures, and they seem to be finished, or unfinished, alike to a certain degree of fuzziness—but perhaps this was where the art came in. *Ars est celare artem.* If so, these pictures were most subtle, for I could not detect any art in them, and they certainly do not carry out the law on which Dr. Emerson insists, that the chief object only should be in focus. They seemed to me like those "stretches of scenery of equal value" which Dr. Emerson describes as "no works of art, and not worthy of discussion."

After one or two other adventures: "*I came away quite convinced that I had made a mistake in wanting to be a Genius, if it must be one of this kind, which does not seem suited to the peculiar idiosyncrasy of—Yours truly, Anon.*"

Houston Stewart Chamberlain was the son-in-law of Richard Wagner and, when he speaks of Genius, has some acquaintance with the subject. He begs the impartiality of the magazine to let him state an opinion contrary to many of its readers. He believes that Dr. Emerson on treating "the possibility of creating real works of art by photography" has written *"an epoch-making book, which does honour to himself and to England."**

To recognise this, it is by no means necessary to agree on every point with Mr. Emerson.

As for his arrogance and petulance, these are qualities which the author of "Naturalistic Photography" has in common with all real reformers and originators. To carp at them simply betrays ignorance of human nature. And what can be more exasperating to an

*Italics mine. N.N.

author than to see a work in which he has embodied the best of himself referred to in a disparaging manner by one who has either not read it at all, or who is so blinded by prejudice of self-sufficiency that he misconstrues and misunderstands every word and meaning?

It is on the purely artistic ground that one would feel disposed to break a lance—in all friendliness—with Dr. Emerson. His historical review of art is very clever and suggestive, but the argumentation is somewhat specious. I am convinced that by following Woltmann and Woermann, as he does, one could easily establish a proposition diametrically opposed to that at which he arrives (p. 95) and show that every time "imagination" flagged, art declined. . . . all doctrinarianism is fatal to art, the vital essence of which is the individual liberty of the real artist and, in a wider sense, the liberty for each time and people to have the art which is appropriate to their special genius. Not only the degree, but also the nature of naturalism will be found to differ everywhere. Many friends of Dr. Emerson's book will also certainly reject the summary judgment the author passes on some men whom they admire as great artists. But then we are so very grateful to him for the courageous manner in which he attacks the whole system of official and "comme il faut" admiration that we feel lenient. And straightforward, open expression of opinion never does any harm. A much weaker point in Emerson's judgments on art seems to me his want of organic feeling. Picture and sculpture galleries are necessary but most miserable make-shifts, and I maintain that it is both illogical and unjust to pass judgment on a work of art which is snatched out of its surroundings and stripped of every indication concerning its aim and scope. . . .

This drew in *The Amateur Photographer,* May 31, the following riposte:

Sir—I am sorry that none of your readers found sufficient interest in "Naturalistic Photography" to take up your hint and discuss the subject. I can only surmise that they think it has already been sufficiently knocked on the head, for it seems to have no friends, except, perhaps, the editor of the *Photographic News,* a force that does not count, for he seems to beggar ingenuity in finding out unpopular causes to support, and in depreciating those which the great body of photographers approved and admire. Dr. Emerson has surely received no greater blow than the laughable support he has received from this quarter, in opposition to the general opinion of the more discerning and impartial members of the photographic press.

Dr. Emerson must have considered Mr. Chamberlain's letter a

case of "save me from my friends," for it consists almost entirely of excuses for the author's "arrogance and petulance," and suggestions for the improvement of the book; and I can only account for the letter by supposing that Mr. Chamberlain has a turn for irony more delicate than that of your other correspondent in the same number, who wrote under the signature "Anon."

It would be very interesting, if anyone has anything to say in favour of Dr. Emerson's views, if he would say it in your columns, for it is not likely that your readers would seek it in the pages of your dull contemporary, in which we never expect to find anything livelier than patent cases and high and dry scientific papers.

NEMO

Emerson by this time had completely lost his temper. He wrote Stieglitz on June 1: "May I ask you not to send any communication to me c/o 'The Amateur Photographer.' Ever since Mr. Stone gave that paper up I have had no interest in it, for it is *retrogressive.* You will have seen the 'low' letters on my book that have been appearing recently. I am going to show their tactics up soon, and I think you will be astonished and disgusted. I will send you a copy of the paper with the Exposé."

"The Exposé" came out in *The Photographic News* on June 7, and was addressed directly to the editor, who, after all, had himself been attacked. If any man ever needed a sympathetic colleague strong enough to hold him down until he cooled off, that man was Emerson. But Goodall was not that strong, nor his wife—nor, apparently, even Abney. But Emerson, when furious, could damage both himself and his cause.

Dear Sir—In the last issue of the *Amateur Photographer* there is a letter from one who may be taken at his own valuation—i.e., a "nobody." It is, perhaps, hardly surprising to see such a letter in that paper, though we cannot help thinking any reputable editor would have consigned such a communication to the waste paper basket. Now, since that letter mainly consists in attacks upon yourself and upon me, it is seemly, perhaps, that I should contradict a few of the lies (there is no other word to characterise the statements made) in that letter. Having watched the policy of the *Amateur Photographer* ever since it passed out of the hands of Mr. J. Harris Stone, M.A., an educated and highly-cultured gentleman, whose only fault was outspokenness, I may, perhaps, be allowed to record here some of the tactics of a paper which sets itself the responsible

task of elevating (save the mark!) photography, and instructing young photographers. Probably all right-minded gentlemen will accept that paper at its true value after reading his letter, and will also accept at their true values the writers "Nemo" and "Anon," its supporters.

The first curious fact I noticed in connection with the *Amateur Photographer* was a communication to one of its correspondents, in which it was frankly announced that it was run to pay, or words to that effect. That day I mentally determined to cease subscribing; but the weekly art criticism (?) in the answers to correspondents so amused me that I continued to read it, though not to subscribe. Any disinterested person may take up these numbers, and he will find the refrain, "They are not sharp," "They are not sharp."

My book "Naturalistic Photography" appeared, and the erudite (!) and polished (!) editor gave it to Mr. H. P. Robinson to review—at least, so I am informed on good authority, though one would not like to believe it for Mr. Robinson's sake, for one fondly hopes that there still lingers amongst us that nice sense of honour which prevents a *gentleman* from *anonymously* reviewing the work of an opponent. But "chivalry is an ingredient sadly lacking in our land!" This review appeared. It showed ignorance unbelievable, and was wilfully and stupidly malicious. Extracts were quoted from passages in which I condemn certain popular artists, and my reasons for condemning them were suppressed. A "little clique" of painters is sneered at and libelled as having "been long struggling to gain recognition, but the results they show have not been inviting, and their self-assertion has been almost as hard to bear as their ugly pictures." There is a critic for you.

. . . This delightfully ignorant critic then goes on to give my system in two or three paragraphs. This truthful gentleman proceeds to say that the naturalists "wilfully ignore the fact that the eye changes its focus so automatically and instantaneously to adapt itself to vision that we are not conscious of it." Indeed! And when did the critic become an authority in physiology? But the fact remains that I do not wilfully ignore the fact; *vide* "Naturalistic Photography," pages 119, 120, which proves either that the reviewer did not read the book, in which case he was dishonest in his capacity of reviewer; or that he read and wilfully suppressed my remarks, in which case he was doubly dishonest as a critic and as a man. From this false premise, a creation of the reviewer's own brain, follow several specious deductions, which are, of course, of no account. . . .

. . . The editor of this paper talks of photography imitating Claude Monet. Either he has not read my book, or not understood it, or else wilfully stated a misleading fact, for I have never advo-

cated that photography should resemble the so-called "Impressionists'" work, and I clearly stated this opinion on page 22 of my book. In the same number there is a scurrilous letter by a lying coward who is unknown, and signs himself "Anon." This letter is headed, "In Search of the Naturalistics." The first part is a deliberate, coarse, brutal, and impertinent insult—such an insult as no gentleman would have admitted into his paper. But the letter has its ludicrous side, and says, "A Mr. T. F. Goodall is the only one who comes under the censure of the author's unmitigated praise." What the meaning of this illiterate sentence is, I must leave to your readers to guess. If it is intended as a joke, I suppose Mr. Robinson and the editor have done the laughing required; if seriously meant, it is a deliberate falsehood. Anyone interested in the matter can find a good dozen modern men mentioned in "Naturalistic Photography" with "unmitigated praise." This wonderful letter further says, "Michael Angelo and Raphael are not *in it* with Goodall, according to Dr. Emerson." Does this stupid fool think Galileo is *in it* with last year's senior wrangler? Yet Galileo is the greater. This ignoramus says there are no naturalistic works at the Grosvenor! He then, out of pure malice, says he found three of Mr. Goodall's paintings, "one of them skied, the other *tolerably well placed*" (italics are mine). This is deliberate misrepresentation, as anyone can prove by going to the Academy, for the two "tolerably well-placed" pictures could not be better placed. They are *on* the line, not *near* the line, as this unscrupulous, nameless one says. The anonymous one could detect no art in these pictures—all educated observers can well understand that. . . .

Still, even Sargent, Shannon, Degas, Whistler, Bate, and many others *are* considered artists by some people, and I am one of them. The only true part of the letter comes at the end—he "came away quite convinced that he had made a mistake in wanting to be a genius". . . .

Last week appeared "Nemo's" letter. This choice nobody begins by what is proved to be a false assumption, and invites a discussion on my work in *The Amateur Photographer,* an "independent field," which I hope none of my friends will enter, and so help the sale of that disinfectant paper. They are amusingly eager for a controversy —"all for the truth," we presume. "Nemo" goes on with this envenomed and malicious lie: "I can only surmise that they think it has been already sufficiently knocked on the head, for it seems to have no friends; except, perhaps, the editor of *The Photographic News,* a force that does not count."

These mendacious statements make us laugh most heartily. The PHOTOGRAPHIC NEWS, a force that does not count! and a book, the second edition of which is in the press, "being sufficiently

knocked on the head!" They say laughter is the best of medicines; if so, we owe many thanks to "Nemo," of the *Amateur Photographer*. The statement that "Naturalistic Photography" has no friends is only another sweeping lie, which sounds suspiciously like the hiss of the green-eyed monster. As a matter of fact, amongst reviewers it has met with only three enemies—the *Amateur Photographer*, and what that is worth people can judge by "Nemo" and Company's letters; the *British Journal of Photography*, a trade journal, the property, I am told, of Messrs. Ross and Co., opticians. . . . Now to enumerate the friends that "Nemo" denies me: the *Photographic News, Photographic Journal, Photography, Camera Club Journal, Journal de l'Industrie Photographique, Deutsche Photographische Zeitung, Scientific American, Photographic Art Journal, American Journal of Photography, Anthony's Bulletin, Photographischer Correspondenz*, and *Photographisches Mittheilungen*. Many of these reviews could not have been better had my best friends written them, and amongst the writers are many of the greatest living photographic authorities in art and science. Besides this, I have numbers of letters from leading photographers and artists which you, Mr. Editor, or any one else rationally interested, can see at any time with their permission. . . .

Robinson replied on June 14:

. . . In his letter Dr. Emerson follows the stale device he pursues in his book of calling everybody he does not agree with, or who does not agree with him, "imperfectly educated," "ignorant fool," and other such amenities; and he does not scruple to accuse them of "deliberate, coarse, brutal, and impertinent insult," and "envenomed and malicious lies." It would require an amount of Billingsgate I do not posses, and a different nature to my own, to reply in the same spirit, and my many friends in the photographic world will understand my reticence. I am afraid it would be ineffective to try to soothe him as the Irish scholar silenced the fish-wife, by calling him a quadratic equation, or an isosceles triangle.

. . . It is in this light that I look on Dr. Emerson's ungentlemanly epithets. At present I think him amusing, and should not like that feeling to degenerate into anything more serious. Dr. Emerson is young and impetuous, but a little wanting in ballast. Much may be forgiven under the circumstances. He will learn as he grows older that neither sound, fury, nor bluster is force, and that he will never bring the world to his feet by calling names. The hysterical scream has ceased to be successful.

Meanwhile Knapp, having read assorted reviews, had turned down the German translation of *Naturalistic Photography*. And thanks to all the controversy, the first edition had sold out so quickly that Sampson and Low were rushing out—three months after its appearance—a second edition. Emerson had had plans to make some changes, but there was too little time for more than one or two. To Stieglitz, June 22:

I will send you some press cuttings and in a month or two a copy of 2nd edition and perhaps then Knapp will reconsider his position.

The "Amateur" fell into the hands of a clerk of the former editor's who knows 0 and has already been prosecuted for an ignorant libel in the "Gas & Water" review on Forbes one of the best engravers here. It was a good paper but now it is worthless and unscrupulous. "Photography"—onepence—beats it all to pieces. . . . Couldn't you find out from Knapp what review he saw that determined him not to publish it.

This first campaign of the war ended on a gentle note; *The Photographic News*, on June 28, reports:

Mr. W. Jerome Harrison, of the Ickneild Street Science Laboratory at Birmingham, writing in the *Summer Annual*, of which he is English editor, says of Dr. Emerson's *Naturalistic Photography:* "If his work only succeeds in making the average photographer understand that he must study art principles and go to painters and paintings for information, he will not have written in vain."

Nothing much appears in the press during July. Emerson was back on the Broads; he realized that much of the controversy was due to the fact that not enough photographers understood differential focusing, and so, before he destroyed all the negatives and plates for *East Anglian Life*, he was preparing a portfolio of ten gravures with a preface "To the Student" criticizing the focusing in each plate; one negative had already been broken, and the plate badly worn, so he had himself etched and printed another. To every photographic society in England who already had a copy of *East Anglian Life*, he sent a copy of the statement to be pasted inside the cover.

Robinson seems no more capable of being idle than Emerson. He had rehashed *Pictorial Effect* into *Picture-Making by Photography*, and a few articles besides. In "Definition," *The Photographic Times*, August 9, he attempts to prove how *un*natural

naturalistic photography actually is:

There is a great deal of misconception at present afloat on the subject of definition and detail as it is used in art. This has been caused in a great measure by the publication of Dr. Emerson's book entitled "Naturalistic Photography," in which he endeavours to prove that all photographers, with the exception of one or two, of which he himself is one, have never understood the right use of lenses, or where to introduce definition; and, at the same time, his object seems to be to show that photographers know nothing of their art, and are uneducated, ignorant, and untrained, and he says this notwithstanding his own dictum that "it cannot be too often repeated that artistic criticism is not authoritative unless made by masters of the several arts."

. . . Every photographer knows that softness is quite compatible with the utmost sharpness, and that for many years the best photographers have known, and worked on the knowledge, that the utmost degree of sharpness was not desirable, and that when undesirable sharpness was apparent, it was caused by stopping down the lens, not for the purpose of obtaining sharpness, but in order to get depth of focus, so as to get rid of that fuzziness and distortion which is the defect of the optical lens, and in which it differs so much from the lens of the eye, with its instantaneous adjustment which enables it to have true depth of focus, and optically to render all planes alike; not sharp in one plane, and fuzziness in all others, as Dr. Emerson would recommend, but in tolerably even, well-defined focus throughout.

By his definition of "depth of focus" it is evident that Dr. Emerson does not know the meaning of the term. He says:—"By 'depth of focus' is roughly meant the *sharp* rendering of the different planes of a landscape or any object with more than one plane in one plane. Needless to say, this quality greatly sought for in lenses by photographers, is a thing to be carefully avoided in artistic work." Depth of focus does not necessarily mean the *sharp* rendering of the different planes; it simply means that the different planes shall be in moderate focus without fuzziness or distortion. In practice, this is usually produced by the construction of lenses which distribute the focus, and which those photographers whom Dr. Emerson accuses of such inordinate affection for sharp pictures, forced opticians to produce against their own optical judgment; lenses in which the sharp plane of focus is broken up and spread over different planes as far as their means would allow. Perhaps, however, I have misunderstood Dr. Emerson in the sentence I have quoted, for, I confess, I have not been able to understand the words, "or any object with more than one plane in one plane." There may be an occult

meaning in this beyond my comprehension. . . .

The whole of this part of the subject may be summarised as follows:

Artistic photographers endeavour to make their lenses represent nature as seen by the eyes. Naturalistic photographers degrade nature to the level of what the lens sees. . . .

Next came, in the *British Journal*, August 16, a laudatory review of Robinson's new *Picture-Making by Photography*. A single passage will suffice to illustrate the main message of the book: Robinson, inspired by a drawing-room incident, decides to dress the young ladies up in peasant costume and make "A Merry Tale." So on a wild, windy Welsh day, they go on location, and here are his stage directions:

A few last words—at the special request of the models I use fictitious names—"Now girls, let this be our best picture. Mabel, scream; Edith, a steady interest in it only for you; Flo, your happiest laugh; Mary, be sure you don't move your hand, or all the good expressions will go for nothing; Bee, I will say nothing to you, but leave you to fate. Steady! Done!" and two seconds' exposure settled the matter.

Then the reviewer praises the addition of a new chapter:

We are pleased to see that a chapter has been devoted to *Naturalistic Photography*, the "new heresy," if heresy it be worthy of being called. He naturally alludes to the writings of Dr. Emerson, with which he is not in accord. He says:—

In imitating the impressionists, Dr. Emerson has to give up the quality for which photography is distinct from all other means of art—its great facility for giving definition. It is recognized by all artists that each art should take advantage of those features which are peculiarly distinctive in its practice; oil painting has richness, transparency, and depth; water colours, luminosity and clearness; photography has something of all these qualities, but its most prominent feature is that of definition; yet Dr. Emerson would have us give up this great feature, so that we may imitate the effects of a totally different method of artistic expression. Dr. Emerson has thought fit to write of Mr. Ruskin as a "spasmodic elegant of literature," and a "splendidly false critic," therefore I cannot expect him to treat any word of the author of *Modern Painters* with respect; but the rest of the world still recognise in Mr. Ruskin the greatest writer on art that ever lived, and in *The Two Paths* he lays it down

as one of the main principles of all work "that whatever the material you choose to work with, your art is base if it does not bring out the distinctive qualities of that material." And he says further that ". . . it can be only affectation and desire to display your skill that lead you to employ a refractory substance, and therefore your art will be all base." Now definition is the distinctive quality of photography, and it follows that according to the dictum of our greatest writer on art, naturalistic photography which omits definition is base art. No wonder that Dr. Emerson should denounce Mr. Ruskin as a splendidly false critic!

Naturalists pretend to represent what they see, but healthy human eyes never saw any part of a scene out of focus. . . .

This inspired a lively warfare in *The British Journal of Photography.* Graham Balfour, cousin and biographer of Robert Louis Stevenson, objected to the "new heresy" chapter quoting Robinson in the review. Robinson replied with a new challenge on August 30:

If I had not said all I have to say at present on naturalistic photography several times over, I should have been glad to discuss the subject with Mr. Graham Balfour—whose letter on your favourable notice of my book appears in your last—feeling sure that I should meet with fairness and good temper, for in this respect Mr. Balfour differs widely from his leader.

To my mind the subject has been thoroughly threshed out in *words;* it is now time for *works.* The Exhibition of the Photographic Society of Great Britain is now within measurable distance. Let Mr. Graham Balfour, Dr. Emerson, and other naturalistics, show us examples of what they mean; let them justify the faith that is in them. It would be only fair, not only to myself, but to photographers generally, that after so much excited theory the naturalistics should show us a little of the results when reduced to practice. I believe I shall be on the hanging committee, and I will take care that as far as my influence will go they shall have fair play, which, however, they would have had anyway.

. . . In October there will be an exhibition of my works at the Camera Club; I have no time to consult the authorities before writing this letter, but I have little doubt they would admit a collection of naturalistic productions for comparison. If it should be said that there will be no room, I would gladly give up some of mine.

I thus offer two opportunities of converting photographers to their peculiar doctrines, which the naturalistics should not allow to slip.

Balfour responds, in the next issue, September 6:

I fully agree with Mr. H. P. Robinson that no advantage is likely to be gained at present by any verbal argument on Naturalistic Photography. But when it was assumed that all who differed from him had been swallowed up, a word of protest became necessary.

But Mr. Robinson's challenge still remains. He wants to see some photographs executed in accordance with naturalistic principles. Sir, in this *blasé*, withered age such ingenuous inexperience is pleasant to contemplate. Is it Rip van Winkle who speaks, fresh from a ten years' slumber, or is it the voice of the wily controversialist skilled in every move? I will offer him a dilemma in answer: Either Mr. Robinson is asking to see Dr. Emerson's pictures, which he has seen himself any time for the last six years at the Pall Mall Exhibitions and in illustrated volumes, or he has been criticising and condemning the work of a photographer without taking the trouble to qualify himself for his self-imposed task by examining the work in question. Dr. Emerson has, as I think, hidden his light away too much in *éditions de luxe*, but nobody is in a position to condemn his theories without having seen his later productions, especially *East Anglia.*

. . . To whom does Mr. Robinson so confidently look for suffrages in his favour? Is every visitor to the show qualified, by payment of a shilling at the doors, to have a vote, as for the "Rejected" at Olympia? . . .

But, after all, I shrewdly suspect that Mr. Robinson wants to argue with Dr. Emerson and to exhibit against me. . . . But the issue cannot be decided on one narrow vote. Permanence of success, and adoption by the best artists among photographers, can alone settle differences. Is it to be equal focus, dressed-up models, combination printing, and silver printing reluctantly abandoned, or long, patient study out in the country, subordinate detail kept under by every means, study of tone and photogravure, that will win the day? . . .

In the same issue there is a long letter from George Davison, which contains one unforgettable sentence:

. . . Mr. Robinson appears to hold that Naturalism is defined by the word *fuzziness,* and by going somewhat unfairly for this evil of his own invention, he succeeds easily, with his characteristic mixture of smile and sneer, in exciting the ridicule of the *un*naturalistics. . . .

Mr. Robinson has tried to make Naturalism a bugbear to photographers, but the impartial student will find there is nothing very terrible in it, and that as far as mere focus goes, even Mr.

Robinson himself (presumably under compulsion of his lenses) might be included within the sacred pale. Unfortunately, all hope of Mr. Robinson's regeneration is denied his naturalistic friends by his attitude on other points, in which he is diametrically opposed to naturalistic principles. On these points Mr. Robinson is judiciously silent. . . . *It is not in man, even in f-64* man, to overlook the unnaturalness of joinings in photographic pictures, and the too visible drawing-room drapery air about attractive ladies playing at haymakers and fishwives.* [Italics mine. N.N.] Naturalism does not stand or fall upon a question of how much or how little softness of focus is admissible, but it certainly is diametrically opposed . . . to all *un*naturalism in figures and their attire. Its creed is *Truth, and the best of everything.*

Robinson defined the chief characteristic of Naturalism as "an utter lack of imagination," and discovered with glee that Naturalists compose their pictures with "the precision and formality of Dutchmen," even hinting that perhaps, after all, they owed something to himself. This drew fire from Emerson: "I *never* ignored or lost sight of the fundamental and vital importance of composition, and challenge anyone to show that I have done so. But I did, and still do, condemn all arbitrary 'rules and laws'. . . ."

And then the "fishy" Traill Taylor, who had greeted *Naturalistic Photography* with "The author seems to have slipped off the rails even before he made a start," must have astonished a great many people by stating, in *The British Journal Photographic Almanac for 1890* (yearbooks are always prepared the year before):

> Without any doubt, *the* book of the year—that which made its presence best known in photographic circles—is Dr. Emerson's *Naturalistic Photography.* Despite certain features which excite disapprobation, but which, their causes being ephemeral, might in future editions be eliminated with lasting advantage, *Naturalistic Photography* ought to, and will, take its place in the standard literature of the art.

*Ironic that a term of opprobrium hurled by one of Emerson's colleagues should become the sign and title in the next generation for his direct descendants, *Group f.64,* fighters for pure photography—no fakes allowed, combination printing and soft focus utterly condemned, and the sharpest possible focus on realities insisted upon.

Palms were being awarded to the victor though the war was not yet over and was to take some highly unexpected turns.

XII. "ICONOCLASTIC PEN"

To Emerson, things must have been going well, on the whole. The portfolio of gravures from *East Anglian Life,* "To the Student," was nearly completed. The second edition was ready, but would not be released until the "dull, dead season" was over; when it was, the reviewers followed Traill Taylor almost unanimously. F. C. Beach, editor of the *American Amateur Photographer,* is an example:

> Probably no book on photography has been more severely criticised than this of Dr. Emerson. Its appearance less than a year ago, speedily divided English amateurs into two camps, and aroused a bitter controversy whose echoes are still heard. Unlimited abuse has been showered upon the book and its principles have been ridiculed and scoffed at.
>
> It may be said at the outset that "Naturalistic Photography" has the merit of decided originality, and that its author has the courage of his convictions, and that he has given us a book which is well worth reading. The technical treatment is, in the main, admirable and almost above criticism. It is on the artistic side that the book has been most fiercely attacked by the Robinsonian school of photographers. The editor of the influential American photographic journal has recently stated that there are no followers of the naturalistic school in America, and that none are wanted. He may be right in his statement, but before condemning naturalism in photography, it might be well to understand the meaning and applications of the term. Dr. Emerson uses it as a synonym for impressionism, and defines it as an attempt to give a true and natural expression of an impression of nature by an art. Naturalistic photography is, therefore, photography used to translate impressions of nature into visible forms. This being so, we see no reason for attacking those who prefer naturalism to realism. It is purely a matter of individual taste and preference. Photography is an art of expression, and the visible expression of individual impressions of nature have a value

and a place in photography as in literature. There is ample room in photography for the realist and the naturalist. The former is more scientific than artistic, to be sure, but he is not to be ruled out of court any more than is his naturalistic brother who prefers to render nature according to his impression of her. Abuse is not argument, and it is greatly to be regretted that so many hard words have been freely used in the controversy anent "Naturalistic Photography." Those of one bent of mind will rank themselves under one banner, and those whose mental bias is in the other direction will fall into the ranks of the other party. Impressionism will always have its followers in photography as in art, and we need not wish it otherwise. The thoughtful mind will find much in "Nat. Phot." to reward its reading, even though its principles and teachings may not be accepted.

Beach had already asked Emerson to be his correspondent in London, and Emerson had already begun a series called "Our English Letter" for *The American Amateur Photographer.*

The first, dated Chiswick, August 10, 1889, dealt with the changes, mostly for the better, in English photographic magazines. T. Bolas, for years editor of *The Photographic News,* and a friend of *Naturalistic Photography,* had been fired from the *News* because he "has always, unflinchingly exposed frauds," even those of the advertisers in the *News.*

Especial offence arose because he very uncompromisingly denounced the conduct of dealers who had supplied mounting boards of a material so impure as to cause the photographs to rapidly fade or become spotted, thus injuring the reputation of photographers of previous high standing, and tending to bring struggling photographers to ruin.

Now Bolas had founded a new magazine, *The Photographic Review,* the first number having been issued in July: "...rather a comprehensive review than a news sheet of undigested items, and in this respect . . . a departure from the beaten track."

The *Photographic Art Journal* . . . cultivates especially the artistic side of photography, and is most ably edited by Mr. Hinton, a gentleman who possesses sound knowledge of his subject as well as literary ability. . . . The new and ably conducted journal, *Photography* . . . gives each week leading articles of great value, its staff of

leader-writers being Captain Abney, Professor Burton, Mr. Davison, Mr. Chapman Jones, Mr. Pringle, and Mr. F. H. Sutcliffe, all well known *workers and writers* in different departments of photography, and all sound teachers in the subjects which they write upon. [Remember these names; some were to become Emerson's bitterest enemies.]

A prospectus has been issued by a private association, in which is set forth the terms of a series of photo-etchings, from negatives from nature, the publication being clumsily called "Sun-Artists." The plates of prominent photographers are to be published quarterly in a portfolio, with descriptive letter-press. . . .

Emerson has his doubts of this effort as being too youthful, with the title open to misinterpretation.

He takes notes of the desire of amateurs to get their works published, and warns that "the world is wiser than they think. If an amateur works hard and produces really good work, he will find no difficulty in getting a publisher. . . ."

Platinotype printing is greatly on the increase in this country. I have seen platinotypes exhibited in all sorts of small out-of-the-way photographers' windows, where albumenized prints formerly held entire sway. . . .

The *Magazine of Art,* our most advanced artistic periodical, in a recent issue has a highly favorable review of the late Mrs. Cameron's naturalistic portraits. This magazine has always generously praised really artistic photography, and I was delighted to see it boldly announce that it had now been proved that photography in the hands of an artist can produce works of art. . . .

All the talk just now is of the conference [of the Photographic Society of Great Britain], of which I shall write you in my next. Under Mr. Pringle's presidency it is sure to be a success.

Meanwhile in Berlin the great Jubilee show, celebrating photography's fifty years, had opened, and Stieglitz was one of the judges in the technical department. Emerson won a medal for his work, as did Stieglitz, and also a prize, and Emerson writes him:

Sept. 18, 1889

Thank you for your kind remarks on the awards. From what I know of many of the English Exhibitors who attained 1st class medals I am curious to know what sort of *painters* the judges were—for no

real artist could medal Robinson's work in any class. I shall like any details you could tell me—for *private* satisfaction only. Had my remarks on German art in Nat. Photoy. any *influence?* Do you think Germany holds its own in Photogravure?

I am English correspondent to the American Amateur Photographer and will you write me a short resume of the Berlin Jubilee Exhibition to forward in my letter? I will of course attach your name to it.

Has the award been made in Class VI (I think it has) Book or Photo Lit depart. I sent in Nat Photoy in comp.

Photographic judging is I regret to say as far as my experience goes pretty "filthy work." We must try to clean up the Augean stables. We are attempting it here and it will tell in time. The "British Journal of Photography" is the biggest rascal over here.

P.S. Aren't you an American?

Stieglitz proudly replied in the affirmative. In Germany his father had been a maker of mathematical instruments and his mother the daughter of a rabbi. In America his father had served as a lieutenant of cavalry in the Civil War and he himself had been born on the first anniversary of the Emancipation Proclamation. Yes, he was an American, and he would fight for America till the day he died. Of course he accepted the invitation to review the Jubilee Exhibition.

Emerson answered:

Sept. 29, 1889

Shake—I am an American too—my father was a Massachusetts man one of the Emerson family—but we had better not say much about our nationalities this side of the water—especially in photo-circles, that is a tip. It is very noble and magnanimous of you to go on with translation in spite of such opposition and I do hope you will get a publisher. I don't believe what Knapp says about Eder. What German art worth twopence is there can Knapp or Eder tell me. There [are] a few promising young men at Munich but none have yet "arrived." Will you yourself oblige me by referring to an early schedule of the Berlin photo exhibit. I am sure there was a class for Photo Literature—Class VI—and I entered. I am seriously thinking of returning the Berlin Soc medal *with thanks,* but don't know if it is [the] cure. I will take six of those plates out of East Anglian Life and back them against any six *collected photos* for £100 purchase. L'Hermite, Dagnan, Bouveret, Carolus-Duran, Jules Breton. Monet, Pelouse were judges and they are generally allowed to be the 1st six panel artists.

I am not exhibiting personally at Pall Mall, though four of my things go in by reproducers.

Traill Taylor and co too fishy for me. [*The British Journal Photographic Almanac* had not appeared.] Do you receive "Photography" it's the best paper over here now. "Photo Art Journal" very fine indeed too. You should get those two.

I have made Robinson apologize for libelling me. You will see the letter in some of the photo-papers. He is trying to trim and make out he is a *"Naturalist."* Why don't you write Beach [editor of *The American Amateur Photographer*] and offer to be Berlin correspondent for American A.P.

Shall look forward to your notes on Berlin exhib—*please send at once,* so I can catch mail.

If Robinson's apology to Emerson did appear in the English press, I have not yet found it; Emerson, however, makes strong reference to it in one of his next "English Letters." Meanwhile Robinson and Davison continue to exchange polite insults. Robinson, in the *British Journal,* October 4:

My friend the enemy is still not satisfied, and, I am beginning to fear, will never arrive at that happy state. . . .

Mr. Davison says that imagination to him means absolutely nothing. I was quite sure of this, but it is not our point at present. What I and many others want is a clear and sensible definition of what naturalistic photography really is. We don't want Mr. Davison's airy "gibe" of a former letter, that it is "the best of everything"; we don't want to know what it is not; we don't want merely destructive criticism; we don't want to hunt for it through the tedious pages of a voluminous treatise; all we want from Mr. Davison is a clear and concise definition of what naturalistic photography really is. It surely must be within the resources of a clever writer to gratify us in the compass of a column or two of THE BRITISH JOURNAL OF PHOTOGRAPHY.

It cannot be what we have all thought it to be if Mr. Davison practises what he preaches. In the present Exhibition, near the door, is a group of pictures—real pictures—by this admirable artist which will command the admiration of all who see them. Mr. Davison condemns combination printing in the most unmitigated manner, sometimes with a frenzy which almost carries one away and makes one determined to sin no more; yet—it is almost incredible—many of these pictures owe their beauty to combination printing. So skilful a combination printer is Mr. Davison, that I should never have found him out if I had not detected the use of one sky negative

in two different pictures. *I* have always condemned this practice as against nature; can Mr. Davison justify it? Then, again, my friend scoffs at pictorial composition as it has been understood and practised for many years, yet many of these pictures are composed admirably according to the strict rules and laws made and provided. Who can fail to see the subtle use of the balancing point? The chiaroscuro is sound throughout, and the definition as sharp as his lens could make it. When a disciple denies his master to this extent, he must not be surprised to hear the cock crow! In theory Mr. Davison may be a naturalistic photographer; in practice I claim him as an artist. . . .

The next novelty, I hear, is to be the Tuning-fork School of Photography; the fork being used during exposure to make the camera "didder," and thus produce the blurriness of nature as seen by the naturalistic eye.

Davison, *ibid.*, October 11:

Mr. Robinson calls for a clear and sensible definition of naturalistic photography as if it were a specification of a patent that was wanted. Would Mr. Robinson like to give a clear and concise definition of art? . . . Naturalism is a revolt from the domination of conventionalism in composition and in colour, and has resulted in a school of thinkers and workers who gain their inspiration from nature, and charm us by giving us truth, beauty, and poetry expressed in the translation of their impressions. . . .

Mr. Robinson is consumed by a fear that his opponents will never be satisfied. The question naturally arises, satisfied with what? With his defence of outrageous combination landscape painting? There has been no defence. With his justification of the use of lady models as rustics? . . . With his claim as to imagination? He declines to say what he means by it. With his wonderful contention that the distinctive quality of photography is definition? He wisely allowed the refutation to pass without comment. With his vaunted challenge to competition? We are content to leave the decision as between naturalism and unnaturalism even to the public in the present or any other Exhibition.

It is one of Mr. Robinson's pleasantries to persistently write the word naturalistic as opposed to artistic. Perhaps it ought to be pointed out that the opposite of naturalism is artificialism, a point worth thinking upon by my friend.

Another personal matter. I am charged with combination printing in the several photographs near the door in the present Exhibition. No wonder Mr. Robinson was deceived by my skilful combination. *In only one* of the seven is there any cloud printed from a

separate negative, and that is not improved thereby. . . . There are degrees of severity in naturalism. The printing in of clouds is sometimes a necessary evil.

Mr. Robinson condemns very justly the use of the same cloud negative in more than one picture. He boasts that he has always held this practice to be against nature, and asks, "Can Mr. Davison justify it?" Certainly not, but he has some excuse in youth and inexperience, which Mr. Robinson cannot find refuge in. If using the same cloud more than once is contrary to nature in Mr. Robinson's opinion what, in the name of inconsistency, is the use of the same model over, and over, and over again in varying character, now a fisher-maiden, now a haymaker? . . .

Then W. K. Burton, from Japan, gets into the fray with his "Sharp All Over" in *The Year-Book of Photography and Photographic News Almanac* for 1890:

Should photographs be "sharp all over," or should they not be? We have recently had the question answered with great vehemence in the negative by Dr. Emerson. There are in reality two questions: one is, "Should a photograph—considered as a picture—be sharp all over?" The other is, "Should it be as sharp in any plane as it is possible by optical means to get it?" As to the first question: there is so nearly unanimity amongst those whose productions we must admire, and whose dictum we must therefore respect, in pronouncing that, in most cases at least, a photograph should not be sharp all over, that one has scarcely anything left but to submit to them, and this, whilst knowing perfectly well that they are, as a rule, quite wrong in their optical arguments, by the aid of which they attempt to support their contentions.

In fact, if the "artists" would only content themselves by saying simply that they know a thing should be so because their intuitive feeling tells them that it should, and would not attempt any scientific proof of their assertion, they would generally find their opinions treated with more respect than they are, for the artist has the most unfortunate way of getting hopelessly out of his depth whenever he tackles any scientific subject, and especially, it would appear, when he gets meddling with optics. . . .

The fact is, that there is no *conclusive* scientific argument in favour of having less than the greatest sharpness that we can get in all planes of a photograph, and there is no shred of an argument in favour of anything less than the best definition obtainable in the case at least of the principal object. If we are to be guided by artists in this matter, and be persuaded to sacrifice such sharp definition, it must be merely because from their work we recognise them as

artists not likely to be wrong, and because they have said it, not because they can prove it.

These little exchanges faded into mere squibs, however, as a new series of explosions began to shake the photographic world. These were Emerson's "English Letters" to *The American Amateur Photographer.* Emerson seems to have felt it more necessary to use what one critic had called "his iconoclastic pen" to reveal the truth to the distant and somewhat provincial Americans than to the British public itself.

In October, Emerson reviewed the convention:

The chief English photographic event in August has been the convention held in St. James Hall, London. Altogether the meeting may be considered as but a partial success. To begin with the papers: The President's [Mr. Pringle] address was extremely disappointing and truth to tell, inaccurate as well as rather inclined to log-rolling in character. Instead of an unbiased and critical *resumé* of the scientific and artistic progress in Photography during the last fifty years, we have a loose and incomplete historical sketch, wherein Mr. Burton, Mr. Traill Taylor and Mr. Robinson are glorified, whilst Poitevin, Hunt, Blanquart Evrart, Adam Salomon, Rejlander and Mrs. Cameron are not mentioned at all. Further comment is needless. *The British Journal of Photography,* a trade journal, is held up as classic, and described as the first journal issued, neither of which is correct. . . . It is hard, too, to find whom Mr. Robinson has educated artistically for the last twenty-five years. . . . It is a matter for great regret that such an able and independent gentleman as Mr. Pringle should have allowed his address to degenerate into special pleading on such an occasion.

Then he dismissed most of the papers read as not having "original matter," except for three. The first was Mr. W. Bothamley's "Orthochromatic photography with gelatine plates." Here the argument was whether the old standard Edwards plates or the new Obernetter-Vogel plates (Vogel was finally winning out) rendered water reflecting sun and the nuances of distances the better. Emerson favored the Vogel, but would have preferred a still better plate with "the same rapidity as the latest Pagets."

Mr. Bolas, in the second paper, gave "an interesting review of photo-mechanical processes. There are, however, a few errors in his paper, but as it does not profess to be for specialists, they are unimportant. . . . A perfect typographic block to stand the wear and tear of the printing press is still a desideratum. Finally I consider that photo-gravure printing is yet a virgin field for experiment, and I have set to work to learn what is already known, which is the first step to experiment."

His real argument, however, was with the reader of the third paper, a new friend, T. H. Dallmeyer, like his father a great lens designer, when he says "spherical aberration . . . is the only legitimate way to soften images." Emerson comments: "I emphatically maintain that the softness as given by these special lenses *does not* in all, nay in most cases, meet artistic needs, but these needs can only be met by throwing different planes, as required, out of focus by focussing and the judicious use of the diaphragm. . . ."

Turning from the papers to the exhibits, we find the exhibition by no means representative; no exhibition can be that without Mr. Sutcliffe's truly artistic work, to say nothing of others. In wandering round the hall and gallery, I found a few gems, but they were few and far between. Mr. Davison has several frames, including his splendid "Part o' Day," a picture full of poetry and charm. . . . May Mr. Davison go on producing work of that quality. It was *facile princips* in that exhibition. Mr. Horsley Hinton has a beautiful landscape "A Winter's Morning," true in sentiment and full of poetic suggestion. There might, perhaps, have been a little finer analysis, there is, perhaps, just a little too much detail and equal massing of light and shade, still the picture is a gem. Mr. Cox shows some well-studied mediaeval subjects with monks and fools and caps and bells and all that goes to make a romance. Though I have no sympathy with such work, we cannot help feeling how immeasurably superior, artistically, Mr. Cox's pictures are to the work of the self-conscious nursery patch-worker school. Mr. Gate's work shows a steady advance to truthful impression, but it is still pretty and small. . . . Messrs. Pringle and Cembrano's Alhambra pictures are marvellous topographical works and invaluable. Mr. Friese Green's portraits show a feeling above the herd. . . .

Of the lantern-slide exhibits, Mr. Muybridge's seance was a great treat and lucky were those who got seats.

Finally there was snap-shooting, and blank firing, and outings, and council meetings and dinners and mutual buttered toasts and all that goes to make a convention, and excellent Mr. Briginshaw, the secretary—is still alive.

After all *Katzenjammers* had vanished, there was time to consider the *raison d'être* of these conventions and conferences. Are they of any real use? We fear not. Did the societies do their work properly, they would not live two years. However, they give prominence to pushing tradesmen, pushing charlatans, and a few good papers are born, a few good pictures exhibited but through it all, there comes the wrangle of the market-place and often the eloquence and superficiality of the hustings. *Mais que voulez-vous?* They *dine* and the daily press shout "Photography" and they, the *bourgeois*, dote on the printed list of patrons.

An amateur has given £10 to the Photographic Society of Great Britain as the nucleus of a fund for building a museum. Not twice the amount has yet been subscribed, which shows astonishing indifference or stinginess on the part of photographers who are many of them making thousands yearly. The donor's idea is to form a "National Gallery of Photography," and a splendid idea it is, and may some energetic committee work out the idea and carry it out. Such a collection of photographs from all parts of the world would be invaluable to the scientific and artistic world.

The November letter began with Alfred Stieglitz's review of the German Jubilee. Emerson introduces him:

> Thinking that perhaps your readers would be interested in an account of the late Jubilee Exhibition in Berlin organized by the Gesellschaft der Freunden der Photographie, I have got Mr. Alfred Stieglitz, who was a judge in one of the sections and the recipient of a silver medal and the special Steinheil prize, to write a few notes, which I give herewith. Mr. Stieglitz has left out any mention of his own beautiful work which is duly appreciated here and doubtless well known to your readers. . . .

Stieglitz, of course, conscientiously reviews each section of that vast show—the new lenses, apparatus, techniques, scientific photographs, etc., but his comments on photographers interest us most. Under professional photographers:

> Frank M. Sutcliffe, England, was represented by his well known studies, including his prize picture, "Water Rats." His work is too well known to say anything about it. . . . Jackson, Denver, carried off the highest honors with his immense landscape pictures of the Colorado region. Germans are not accustomed to work on such size and naturally gazed at it with wonder. . . . H. P. Robinson, England, exhibited his latest: "Merry Fisher Maidens." It is a pity that this picture was hung so poorly; it seemed to be good,

> but of no exceptional value. I have seen better work from this gentleman, if I am not mistaken. . . .

And under amateurs:

> The crack exhibit . . . was undoubtedly some of P. H. Emerson's (England) landscape work. Here is a man with great individuality and great originality, and one who has had the pluck to introduce naturalistic principles into the art of photography notwithstanding tremendous opposition. His influence is bound to be felt sooner or later, and the sooner art photographers see into this, the better it will be for the general standard of art photography. Artists greatly admired Mr. Emerson's work, although some of the old so-called "smooth school" preferred to pass it over. *Photographers* didn't like it. Naturally!

How young and very American Stieglitz appears! He was twenty-five, but he still sounds like a schoolboy.

Then comes the real blockbuster, Emerson's own review of the annual exhibition of the Photographic Society of Great Britain, at Pall Mall:

> The winter season may be said to open with the Pall Mall Exhibition, and as this exhibition is all the talk just now, it will be well to study the tendencies of our art as shown by the exhibits.
>
> For the first time the judges were elected by a ballot of the Society and the judges were also the hanging committee, both steps in the right direction. But if the members of the Photographic Society of Great Britain really wish to elevate the art side of photography they must in many cases return different judges. The best artists were not elected and the judge was about as fit to pass an opinion on *pictures* as he is fit to lead a *cotillon* at a court ball. But such anomalies always exist in the infancy of all things. . . .
>
> On entering the exhibition the first impression is one of joyful surprise. Purple and black gloss have given way to black and white and brown, in short the general appearance of the exhibition is more like an exhibition of etchings or engravings than any photographic exhibition we have ever seen. That at any rate is satisfactory and it is especially satisfactory to me, for seven years ago I was one of the trio of men who exhibited platinotypes and, though I met with much opposition and scoffing, I persisted by writing and exhibiting to advocate the great superiority of this process over any other, and I have in that seven years lived to see Davison, Gale, Sutcliffe, Robinson, L. Sawyer, Byrne, one by one drop silver printing and take to the more artistic printing method. . . . The battle is com-

pletely won now. . . . But there is the great outside public to educate, that will be a slower and more difficult task, but the battle will be won in time.

Now, proceed we to discuss the more important exhibits, and this we shall do in an impartial spirit, as we have ever done, keeping simply one end in view—the true advancement of photography. The first exhibit that calls for mention is Mr. George Davison's Nos. 7-13. These are printed in platinotype of various colors—brown and black. We regret that Mr. Davison should have exhibited this series, and after the "Part o' Day," which I was glad to call to your attention in my last letter, these are bathetic indeed. Technically they are of the ordinary photographic type, and artistically they won't hold at all.

In the majority too much landscape is included and in all the figures look posed and artificial and the sentiment is spurious. . . . This gentleman's work is very uneven and no one who has seen the masterly "Part o' Day" can understand these photographs as coming from the same hand. We hope sincerely such a promising worker as Mr. Davison will not think he "has arrived" and be spoiled by the ignorant and vapid praise of interested and designing persons.

The Rev. J. C. Allen, in a series of Epping Forest pictures, shows sympathy with Nature, but a perfect lack of artistic knowledge. . . .

Decidedly one of the best figure subjects in the exhibition is Mr. I. M. Brownrigg's "Patience Trumbert in her 90th year." The artistic focus is perfect, and though there is just the faintest show of artificiality, it is altogether capital and far more deserving of a medal than Tolley's, Green's, Schmidt's, and much other work. . . .

The next series we come to is Mr. Lydell Sawyer's. We heartily congratulate this gentleman on his series, and though he has written against naturalism and perpetrated some fearful travesties like "Tam O'Shanter," and obviously lacks art training, as shown this year, he displays genuine artistic ability. His works are all naturalistic, and he has paid especial attention to just focussing, having, with artistic knowledge, subdued his middle distance and distance by throwing them out of focus. His work, like the work of all untrained persons, is very uneven. One lights on a masterpiece here and suddenly a really childish composition follows. This always fills one with doubt as to whether the photographer really knows which is the better, and certainly the judges did not know the best, for they medalled a stupidly sentimental picture when such masterpieces as "Waiting for the Boats" and "On Their Own Hooks" hang nearby. Yet even in the two last pictures there are many and serious faults. The clouding is false, part of them have been sunned [dodged] and so rendered false in tone, and the figures are too black. All this produces a striking effect in an exhibition and kills quieter

and truer work. But it does not live. We have gone to this length over Mr. Sawyer's exhibits because we see the "makings" of a great artist in him, and years hence he will perhaps feel grateful for timely criticism, though he may not like it at present. We heartily congratulate him upon his medal—none was better deserved, but it should have been awarded to "On Their Own Hooks" or "Waiting for the Boats."

The next photograph we come to is Mr. H. P. Robinson's "Merry Fisher Maidens." This is an inane, flat, vapid piece of work, bigger and more worthless than ever. Its composition is childish and its sentiment puerile, and yet the sage Germans awarded this "Picture?" a first class medal. . . .

Mr. Horsley Hinton sends some promising work, but the topographic blends too much with the artistic. "A Study in Betchworth Park" is fine. "Ere Winter Yields Its Brown Defiance" is a fine poetical landscape, but the focus is not so perfect as it might be.

A huge cathedral (Cologne) by G. A. Schmitz, takes an undeserved medal, the award being a satire on the judges, Won't artists laugh!

Mr. F. M. Sutcliffe sends a fine collection of naturalistic pictures as usual. Here the artistic focussing is done with judgment and knowledge, the sentiment is true, and the artistic qualities perfect. We are glad to see that Mr. Sutcliffe has adopted platinotype printing. Mr. Frank Hopps sends a really marvelous study of a bunch of grapes. A Mr. E. A. Perkins sends a stupid lot of rustic scenes in plush and gold. Messrs. Green brothers take a medal for a series of topographical views of the English lake district. For this kind of work the medal is well bestowed. . . . Col. Nuerre [Noverre], a new name, sends three striking photographs with false and meretricious clouding, but they show promise. Col. Nuerre has strong artistic instincts, but he wants culture. They are true in focus. J. P. Gibson sends a series of his well-known topographical views. The student can study the poorness of the old "sharp school" as compared with naturalistic methods by comparing these and H. Tolley's scenes with Davison's, Sutcliffe's, and Sawyer's works. Mr. H. B. Berkely, a well-known worker of the old school of landscape, has an interesting series. These are all good topographical studies of Venice, "Lobster Pots" being the most picturesque.

Mr. Davison sends a series of landscapes taken with a pinhole camera. Mr. Davison has earned the thanks of all students for experimenting in this direction, and we hope he will continue his researches and show us the full possibilities of the pinhole. This is a field that requires thorough study. Judging from these examples, good effect can at times be obtained, but we feel that the planes cannot be sufficiently manipulated at will. . . . Captain Abney's

snow and frost scenes are very good and interesting. . . .

Mr. Blackmore is a new name to us, but his work proves that he is a very promising young artist, and we hope to see more of him in the future. "Eventide" and "The Silver Lining" are delightful little pictures full of the true sentiment and far more worthy of a medal than many of those who obtained them. Go onward and aim high, Mr. Blackmore, and be more careful of the focus—not too sharp.

Mr. Cembrano's interiors (the Alhambra) are splendid and deserved a medal. . . . We are glad to see another convert to naturalism in Mr. Lyonel Clarke. His portraits are capital, most artistically treated even down to the framing. These three portraits thoroughly deserved a medal and it speaks ill of the judgment of the hanging committee when we say they are skied and ignored (medally). We hope Mr. Lyonel Clarke will go on in this direction and receive his reward another year. Mr. R. H. Lord sends a vapid composition à la Robinson. . . .

Mr. MacFarlane's "Midnight Sun" should have been hung lower; it looks interesting. Finally, Mr. Alfred Stieglitz sends a charming little landscape, that has all the quality of a fine etching.

The exhibition, as a whole, is markedly interesting as showing the great strides made in artistic photography during the last five or six years, and after a careful survey of all the pictures the one lesson that it teaches is the *complete triumph of naturalism*. Photographs that a few years ago would have been rejected, now take the places of honor, and the old school suffers terribly by being hung next to these modern works. Nearly all the best workers have discarded silver printing, sharp focussing, artificial compositions, made-up interiors, combination printing, brilliant views of nature to the exclusion of others, and still all through there is evidence of a want of training. An *artist* should not and never does send out anything but a picture—some better, some worse. But nearly without exception, specimens can be found in each exhibitor's series, which no artist would father.

The great exposition in France has proved triumphantly the victory of naturalistic or impressionistic art in Europe and America and this exhibition proves its triumph in photography.

We start, then, on our second fifty years of history with a healthy basis and sound first principles. . . . This revolution in photography has been accomplished in the last six years, and no sane or unprejudiced person who really knows the subject will deny that it has led to a great and distinct advance. An epoch of a most lasting character has been marked, and though there still live a few survivals of "other days," like the ornithorhynchus, they are doomed to speedy extinction.

England holds the first place in artistic photography today and the naturalistic school holds the first place in this country, as this exhibition conclusively proves, and has proved to all persons of sane understanding. There are many promising young men with sound principles and determination, and things look bright for the future. May they continue steadfast, produce less, and never send out any but good works.

This caused such an uproar that a more edited version than the one given here was republished by the English *Amateur Photographer* to show what a warped and venomous view of English photography Emerson was presenting to the Americans.

The most amusing attack on Emerson's review of the Pall Mall show came from D. Harbord, of London:

Dr. Emerson's letter on the exhibition of photographs at Pall Mall is unlikely to disturb or interest American readers. It is equally certain that the exhibitors themselves can afford to be amused or indifferent, as the worthy Doctor is well known to be absurdly extreme in his ideas of art, and very unscrupulous in his criticisms as formed through his remarkably solitary pair of spectacles. . . .

What particularly amuses me is the way in which certain amateurs are propping each other up, who, in my hearing, have in times past smiled in pity upon one another. I particularly remember one of those scathing, scalpel-like criticisms in which the Doctor excells, of one of his own great (?) "naturalistic" pictures which people were afraid of not believing in, for the Doctor was *the* man then. I allude to an awful abortion representing a man plowing uphill with a pair of horses. The man's foot was as long as the horse's head and the whole picture so gloriously "naturalistic," i.e., "fuzzy" or "focussed with judgment" that it was denounced as an imposture. Another nondescript represented two women in a fog, apparently looking for something they had lost; not an iota of detail; all let to the fervid imagination of the naturalist."

And yet "focussing with judgment" found a very reverse effect in a decapitated "Head of an old salt." Every wrinkle, line and spot was depicted as sharp as lens could make it. [Plate 23]

Occasionally the Doctor has won the hearts of admirers over some lovely photographs such as "Gathering Waterlilies," but he is never free from adverse criticism; his boasted "subjects" are often inappropriate, as witness the woman "gathering" who suggests the washtub.

The name of an advanced student of the anti-focus or "fuzzy" school is descanted upon, but I have a lively recollection of that turncoat showing me work the sharp focussing of which was his

pride and delight. One thing is very patent in the Doctor's letter; he is more bent on vituperation—*vide* his rage at Robinson's masterly work—than on reformatory criticism, and his airs of superior judgment, to which he is his solitary witness, deprive him of any hope of being valued at his own estimate.

Anything more silly than his laudation of Mr. Davison's pinhole pictures could hardly be conceived. They simply show what can be done with nothing, and how very undesirable the attempt is. The Doctor's pedantic desire to "educate the great outside public" to his views of what photographs should be will never be realized by such asperity as he indulged in by his denunciations of "spurious effects," "meretricious clouds," etc., etc. His only chance lays in a practical demonstration of what art is, and I, for one of the many, fail to appreciate it in nine out of ten of his pictures, nor to realize it from his writings.

For both the photograph, "A Stiff Pull," and the favorable reviews of other critics quoted by Emerson in reply, see Plate 40. Emerson's letter was accompanied by a long one from George Davison, who says D. Harbord's one distinction lies in "watering your Mr. Beach's developers."

The December "English Letter" opens with a tale to tell:

I thought I should be unable to send you a December letter, but the Fates decreed otherwise, and instead of being at the present moment tossing on the Bay of Biscay, I am comfortably seated at home, having been shipwrecked last Tuesday night on the Cornish coast. We escaped with our lives, but all our luggage went to the bottom, including my new Beck hand camera and a fine supply of Edwards plates. In the middle of the confusion, after the steamer struck upon a rock, an old clergyman came to me and begged me in a faint voice to get him a life-belt and fasten it on him. This I did, noticing that the trembling old man clutched tightly to his side a neat leather case. Gold suggested itself to me as the probable contents of the bag, and leaving the old man, to help bear a hand in getting the ladies into the boats, I forgot all about the matter until the following morning, when we were waiting in the smoking room of the village inn to see if any of our baggage would come ashore. Then the old parson recognized me and thanked me for my help, and on the mantlepiece I noticed the bag. The poor old fellow, now grown brave that all danger was over, began to talk of how he had stuck to his bag and carried it safely up the perilous cliff paths in the dark. "Was it valuable, then?" I suggested. "No, not intrinsically," said the old man, "but I value it, as it was a parting gift from my lady

friends upon giving up my incumbency. I will show you," said he, and he opened the bag and to my surprise pulled out a quarter-plate Lancaster camera and lens. That was all he had saved. My friend, J. Havard Thomas, the sculptor, was on board with me, and he, too, had lost his photographic kit and a large supply of plates and chemicals. Had there been less work for us to do I should have tried an exposure or two as the blue lights were being burnt; but we had to do the crew's work, for they were a "scratch lot" and panic stricken, one deserting and one becoming mutinous. . . .

The winter session opened at the Camera Club with an interesting discussion upon hand cameras, in which, however, no definite conclusions were arrived at, as is, alas! too often the case in these meetings. One thing is certain, for artistic work every hand camera should have a long-focus lens, seven inches being a good length. . . . The majority of cameras are far too cumbersome. The perfect hand camera has yet to be made, and I do not think it would be a difficult job, if manufacturers really understood what is wanted.

There follows an exchange of letters between Emerson and Dallmeyer on the false rendering of photographic images, which are of interest, probably, only to the historians of lens making. Emerson says no lens yet made will give the effect he wants without racking out the camera; Dallmeyer says Emerson proves his point by his "works of art," but points out that few amateurs are capable of following the Doctor and promises there will shortly be such a lens as the Doctor requires. He did construct such a lens, and Emerson rejected it, but the rejection did nothing to mar the close friendship that grew up between them.

Emerson concludes his letter:

Mr. H. P. Robinson has issued a second edition of his "Picture-Making by Photography," to which he has added two chapters on "Naturalistic Photography" and "Instantaneous Photography." I take leave here to warn your readers against his teachings. Everything worth considering that he has written about will be found elsewhere, especially in Burnet and Harding [treatises on academic painting], and I have looked in vain for a single original idea in his books. . . . The book is not worth criticizing in a serious spirit, and the chapter on "Naturalistic Photography" is an unscrupulous or ignorant attack upon a subject the author is perfectly incapable of understanding. So unscrupulous are some of its statements that I had to threaten him with an action for libel, which extorted a full apology for the greatest untruth in the chapter and stopped the

circulation of the book until this passage was erased. . . . The writer knows no science, and to take a person whose ability (artistic and otherwise) I honestly consider beneath contempt *au sérieux* here, would be ridiculous.

There is a great desire here to learn photo-etching. I have advocated this from the beginning, and have lately learned the process thoroughly myself and shall in future etch my own plates. This, as I pointed out years ago, is the *only* satisfactory way of publishing photographs. For if the plates be given to a reproducer, the etcher (or photo-engraver, as some call him) will be either an artist or a mechanician. If he be an artist he will have certain *nuances* of preference for certain tones, and so his personality enters into the reproduced work. If he be a mechanician, the probability will be that all his efforts will be directed to obtaining what is falsely called technical excellence, but what is really topographical accuracy, and so the original photograph may be ruined.

Undoubtedly Emerson had been working on his *Wild Life on a Tidal Water* ever since he left Dick, the Harnsee and Pintail on Breydon Water, but opportunities had been few—too much else happening. Now at last he was correcting proofs, working with his engravers, Colls and Dawson, and the book would soon be out. It was, especially at the time, regarded as one of his best, possibly because of its informal atmosphere. Ornithologists, sailors and hunters must have been grateful for the Appendix by Fielding Hunter (a pen name? If not, how fortuitous) for his listing of birds shot on Breydon Water by himself during the last forty-five years and his tracing of Breydon at low water, of drains still navigable and flats that were dry. All Emerson's books have interesting appendices. Yet here, though it is long, I commend his Preface, to those interested in the early history of photoengraving and in Emerson's methods of work:

> This simple record of my impressions and experiences, whilst living with my friend, T. F. Goodall, on his house-boat on Breydon Water in Norfolk, may prove interesting to the public who have so kindly welcomed my previous productions.
>
> The plates illustrating this book were taken during this sojourn on that great tidal water in the summer of 1887. They form a series of separate chapters which will help to give the reader an idea of the wild life on Breydon and in Great Yarmouth, the old fishing town on its shore. The photo-etchings must speak for themselves; I have

thought it unnecessary to write anything concerning them. The photo-etching, *The Last of the Ebb,* is from Mr. Goodall's large painting of Great Yarmouth from Breydon: his *opus magnum* during our sojourn there. It was exhibited in the Royal Academy of 1888, and will be known to some of my readers. The remaining plates are photo-etchings from photographic plates, all taken by me.

Technically I am responsible for all the work, whilst in selection of subject the majority are the result of a pleasant partnership with my friend, T. F. Goodall—a partnership in which each gave his best, and where there was none but friendly rivalry. The plates have been photo-etched by Messrs. A. Dawson and W. L. Colls. . . . I ought to say here that some years ago I was the first to advocate that all artists expressing themselves in photography should etch their own plates, in order to get the best results; but there was and is great difficulty in getting taught these processes, since, for commercial reasons, they are kept secret. I have, however, since learnt the etching process from my friend, Mr. W. L. Colls (who, in my humble opinion, is the best exponent of photo-etching and photogravure), so that in future I shall reproduce my own work. As I have said before, the artist who works in photography must not rest until he has mastered photo-etching: then he is completely equipped, and ranks with the etcher—for, as an artist has lately pointed out, such an one, even if he be reproducing work done by others, is nothing more nor less than an etcher.

. . . Hitherto the reproducers of these plates have been content to print them hurriedly on ordinary plate-papers; no study having been given to the subject of printing photo-etchings, which require very different treatment from ordinary etching. When I first asked Mr. Colls to submit proofs on various papers, he replied that "photo-etchings were best on plate paper, and would not print on the harder papers." Mr. Alfred Dawson, too, has written: "A paper with a coarse fibre, however excellent otherwise, will never do for photogravures. So too size must not be allowed. Then the paper admired for etchings is quite unable to print photogravures; it is harder in texture and rough, so that it cannot enter into the tiny pits in the process plate." I hired Mr. Colls' printer for some days, and he obtained for me specimens of every possible printing paper, and I set to work to experiment—Mr. Colls having to acknowledge finally that he was wrong. I shall carry my experiment in this matter much further, now that I have set up a printing press of my own. I have in addition examined every print issued. The necessity of this was brought home to me by the ruinous manner in which some of my plates were printed in a previous publication. The proofs were splendid, and I approved of them, but the prints were done with differently mixed inks and in a few cases the plates practically ruined,

for in etchings of all kinds the choice of papers and inks is most vital. I hope in future to print my own plates, which I see is the only satisfactory method. . . .

A word on the artistic focus of a few of the plates is necessary. In the frontispiece [Plate 58] the middle distance and distance are a trifle too sharply rendered, but subtle focussing is well-nigh impossible when working with a quick exposure shutter on a swift tideway. This fault may therefore be considered excusable in similar cases, whereas with portraits and landscapes any want of focal subtlety is inexcusable.

All the provincial words used *I have heard spoken;* they are in use therefore to-day. They are spelt phonetically. Philologists will find too the local names for the various birds, as given in the Appendix, worthy their consideration. A kindly critic once objected to my use of the word "opalescent," suggesting that every scribbler used it. That gentleman little knows how carefully I work: all my descriptions are *written on the spot,* and with as much care and thought as a good landscape painter bestows on his work. It is in such a place as Breydon that the water becomes opalescent under certain effects, this being due to the minute particles of mud held in suspension, causing an interference of light, the shorter waves being reflected more copiously than the longer, these being, however, more abundantly transmitted. "Opalescence" is a phenomenon which could never exist under the conditions described by some writers. To my mind all descriptions and characters not drawn truthfully from nature are mere playthings. My critics may rely that whatever I write is the result of careful study and observation; other methods are too easy, and the results, to my thinking, unsatisfactory.

For the February "Our English Letter," Emerson reviews the vast memorial show of O. G. Rejlander, some four hundred prints at the London Camera Club. In this he attempts a fair and just art historical critique:

I do not pretend to write a biographical critique of the man, because most of the materials are not at hand. For one thing we should require for the purpose a complete collection of his paintings, and if none now exist *tant pis* for Rejlander, for that would be conclusive proof that he had not much artistic ability. We should have to trace the reasons why he gave up oil-painting for a less perfect technique; for this exchange must always arouse a suspicion of failure in the first method in the mind of the inquiring critic. Was it incapacity that led him to the adoption of photography? This is at any rate the reason that some lesser lights have entered photography, and, cap-

tious as it may sound, I can never regard such renegades with the same feelings as those who felt from the first that photography was their natural technique. The very best work has been done by the latter class of men and such will always be the case, for failures in one branch of art are commonly failures in other brances. Mrs. Cameron towers head and shoulders above Rejlander, and she was no failure at painting. The reasons for Rejlander's exchange would be largely shown by the quality of the paintings, etc., that he left behind him. We should, too, have to arrive at a just estimate of the state of art at the time of his appearance on the stage; to an estimate of the influence he had on our art and upon his contemporaries and they upon him; and lastly we should have to get a true knowledge of his personal character, of his dealings with opponents, of his aims, and above all his self-sacrifice. It would be an interesting study, but personally I do not think the subject worthy of this study, for I may as well say at once that I was greatly disappointed with the show.

One of the first things that strikes the critic after wading through the dull wastes of the four hundred prints, is that Rejlander was a great *imitator,* perhaps an avowed imitator like some disciples and lesser lights. He has actually dared to dress and pose figures after certain well-known pictures, and he has done it so well that one involuntarily exclaims "Ah! A Carlo Dolci," "a Raphael," "A Gerard Dow," "a Fra Angelico" (with a background actually painted in with illuminating gold). Such is really the case. There are unblushing plagiarisms of Dow's "Woman at the Window," of a Fra Angelico figure, of Raphael's "Madonna with the Plate," of a Carlo Dolci head, and probably of lesser lights. Now why did he imitate these pictures? Two theories may be enunciated. 1. It was either plagiarism, or 2. It was *experimental.* He may have endeavoured to show how closely a photographer could render such subjects as a painter had already expressed. Whatever the origin of such work it does not rank as a fine art at all, and if they are plagiarisms they are beneath contempt. The acute critic of the future must decide which they are. Now whatever their motive they either implanted or fostered a natural *sentimentalism* in Rejlander. It is most suggestive to the thinking critic that Rejlander picked upon such men as Dow, Dolci, Fra Angelico, and Raphael to imitate, for it conclusively shows his natural bent, and to my mind goes too far to prove that he had but little artistic insight. Whatever the origin of this spurious sentimentality, it shows itself in nearly every one of his works, excepting the scientific studies that I am coming to. The most flagrant examples are the two youths in the "Two Ways of Life"; "Fresh from the Cow"; "The Disciple"; a portrait of a child and another of a young woman caressing her heart; "The Message"—affected: a girl trying

to catch hayfever from pots of roses, yclept, "Girl Smelling Roses"; "The Glass that Cheers"—artificial, and various gross and inelegant nudes. *Sentimentalism, affectation* and *artificiality* are the three cardinal sins of this photographer, and they are three of the most deadly artistic sins. Rejlander seems to me to have possessed a most *theatrical* mind; his puppets seem to be acting in *poses plastiques* of a better kind, and this impression is strengthened by the careful but spurious amateur theatrical drop-scene in the notorious "Two Ways of Life." It is an improvised front-door-step scene, and is not very allegorical; rather suburban. We next come to another phase of this curious mind, i.e., combination printing. We cannot even give Rejlander the credit of originality on this score, for he was anticipated by Messrs. Berwick and Annan of Glasgow, who exhibited a combination picture—a figure in a landscape—in 1855, two years before the appearance of the "Two Ways of Life," in 1857. But to Rejlander is due the credit of developing this wrong-headed method to its highest possibilities: to a height never attained by his followers. For such jugglery the result is a marvel of manipulative skill, fifty-seven negatives [actually thirty] being employed in making this combination. Such work necessarily crumbles before severe criticism, even in the fundamental facts of perspective tone and atmosphere, and the "Two Ways of Life" can no more bear this criticism than any other production of the same kind. The allegory, too, is not well worked out, the story is not well told throughout, but the artistic grouping of some parts is very clever and artistic. Its special artistic demerits are the sentimentality of the two youths starting on life—they look as if they were posing at a penny-gaff instead of starting on life, the youth choosing the path that leads to the straight and narrow way looks positively as though he could not help it, and I don't think he could. There was evidently not much choice in the matter. The two gamblers look as if they had dropped in from the stock exchange to while away an hour. Rejlander was a *poseur,* he delighted in dressing up as Garibaldi, whom he in no way resembled. Witness his parading before his friend, H.P.R., as a heroic volunteer—a real burlesque. The theatrical element seems to crop up everywhere. But turn we to the good parts of this notorious picture. The sirens, who would dally with the not unwilling youth, are capital. The arts and crafts as represented by a schoolmaster and globe, and especially the blacksmiths, are cleverly and artistically posed. Still "Two Ways of Life" is a magnificent failure, and Rejlander had the sense to see it, for later on he denounced the practice of combination printing. . . .

We now come to another phase of his experimental work, his studies to help illustrate the late Mr. Darwin's "Expressions of the Emotions." I do not know the history of these photographs, which are of a quasi-scientific nature. It is probable that Mr. Darwin asked him to illustrate certain emotions, stating specifically what he wanted. Mr. Darwin may even have supervised the work. Whatever their origin, when we consider the processes and tools of the period, they are most clever in overcoming manipulative difficulties, but even here Mr. Rejlander can lay no claim to originality, for Mr. Darwin says in his introduction: "Finally, I must have the pleasure of expressing my obligations to Mr. Rejlander for the trouble which he has taken in photographing for me the various expressions and gestures. I am also indebted to Herr Kindermann, of Hamburg, for the loan of some excellent negatives of crying infants; and to Doctor Wallich for a charming one of a smiling girl. I have already expressed my obligation to Doctor Duchenne for generously permitting me to have some of his large photographs copied and reduced."

From an examination of the plates in Mr. Darwin's book I find that Rejlander *acted* some of the expressions, and again I say the theatrical instincts were stronger than the artistic, and, since his portrait appears so often in these plates and he was so fond of acting Garibaldi, I am afraid that he often expressed the emotion of vanity. These results, then, show clever manipulative skill, good histrionic powers, enthusiasm, the last being one of his finest qualities. . . .

I find then, that Rejlander was decidedly no genius, no artist, as I understand the word. I find him vain, sentimental, artificial, theatrical, but at the same time tremendously enthusiastic, energetically experimental, and best of all self-sacrificing. I do not find him turning out bad work for money all the year and taking one picture per annum to go a-medaling with, and then posing in retired villa-affluence as an artist. No, Rejlander *sacrificed* everything for his art and the pity of it is that he did so little good by his self-sacrifices. I find, too, he did not write illiterate drivel on art, which showed his great good sense. The life of O. J. [*sic*] Rejlander is to me a most pathetic story, the story of a decidedly commonplace, uncultured, and unrefined mind struggling against its fate with a cheerful, fiery enthusiasm and self-sacrifice worthy of a better cause. The poor moth and the candle-flame are to me symbolical of his life. The man in some ways I admire and respect; he was a worthy pioneer. The "artist" I feel was but an artist of the green room.

With all he was doing Emerson was nevertheless feeling underexercised. He dreamed about getting out the greatest magazine yet, to be entitled *Nature and Art.* But the dummy he submitted was composed of such fine materials and demanded such high criteria that no publisher thought it could possibly be a success.

And this seems to prove that he did not have enough private income to back such an undertaking, nor enough capacity to raise money. He did not foresee this when, announced in May, he submitted his resignation to *The American Amateur Photographer*.

Now there was a lull. Occasionally some letter-writer would gleefully regret the passing of Naturalistic photography, and Robinson would preach over its supposed grave: "Naturalistic photography may now be taken as a negligible quantity. The good of it will be absorbed into serious art and the sound and fury, which signifies nothing, not finding a congenial home here, has crossed the Atlantic and blown itself out in America.... It was a case, if not of temper, then certainly of temperament." Robinson proved but a partial prophet, for this same year, 1890, Alfred Stieglitz also crossed the Atlantic, and it would be seen, in due time, that he was no fitful gust, but a mighty storm which, raging for fifty years, produced over half the world a dramatic change in the climate of art.

Meanwhile, Emerson was working on a remarkable essay. The first issue of the deluxe *Sun Arts* had been devoted to Robinson, with a eulogistic piece by Pringle. This caused Emerson to decline having his own work appear in the series, but he did consent to write an essay on Julia Margaret Cameron. This is probably the first true aesthetic criticism written about a photographer by a photographer. He begins:

> In undertaking this task—a labour of love—I feel obliged, as a duty to myself and the subject of my memoir, to state my critical attitude. There is some necessity of doing this in the aesthetic criticism of photographers and photographs, for it could be easily shown that the appreciations of this branch of Art have sinned against proportion; that pitfall to the amateur; that mystery to the herd. I know of no *critique* on photographs that shows a just sense of relative value, an impersonal seeking after the virtue, the very marrow of the work. Nor is this surprising, for artistic photography is a new thing: the matter is but just beginning to be apprehended. Hitherto the medium has been used to imitate the conventions of painters, but for seeing the thing as "it really is," for recording the very gist and marrow of life, its possibilities have only lately been demonstrated and appreciated by artists of ability imbued with the new spirit. Hitherto, in all that is elemental, conventions have been followed,

and according to the innate taste and capacity of the individual, so have been the results. There have been conventionalists who, looking with brutal eyes upon Art, have degraded everything that is dainty, that is fresh, that charms, stamping photography with the blatant sentimentality of the province, the cult of the suburb, or the red tape of the warehouse. All such works are the hall-marks of vulgarity. On the other hand, there have been amongst this toiling, moiling crowd of aspirants one or two with native good taste, true artistic perception, and possessed of great sympathy, have followed good conventions and achieved success; in the case of Mrs. Cameron, brilliant glimpses of truth and beauty, instinct with aesthetic qualities recalling the great artists she took as her models. Of the crowd of dark-box bearers now with the shades, the most successful was Mrs. Cameron, whose pictures alone are worth preserving.

Before giving my appreciation of this noble-minded lady, allow me to remind the reader that in estimating her works I make the comparison with all the fairer forms of Art that were produced before her star arose. I recognize no petty world sanctified to photographers and their works, but I look upon the photograph criticised in its relative value to all great art. I am inclined to think that my predecessors have gauged the subjects of their memoirs according to the values in which they are held by photographers—an uncritical democracy at best. It is thus their sense of proportion has been at fault. Great art knows no boundaries, no distinctions, the medium used by the artist often being determined by chance or some organic idiosyncrasy. The results must be valued only in proportion as they possess the fundamental qualities found in the beautiful visions snatched from nature and hewn in marble by Phideas and Donatello, preserved in paint by Titian, Rembrandt, Velasquez, Corot, Maris and Whistler, etched on metal by Rembrandt, or struck from trembling cords by Paganini. Mindful then of my aim, I shall attempt to find the "virtue" of Mrs. Cameron's work, and express its influence on me; that is all a critic is able to do. And in truth, to persons who like myself are makers, not critics, by profession, any appreciation seems ever to be dogged by the spectre of futility. All I can plead in excuse is, that pious worship has prompted the mind and a jealous regard for my own art the pen.

He then gives us a brief sketch of her life and personality. Born in Calcutta, in 1815, she was the daughter of an Indian civil servant. All her six sisters were beauties and famous for their wit; she alone was ugly, but with double all their other qualities. They all married well, two to titles. She herself married, in 1837, Charles Hay Cameron, fourth Member of Council of Calcutta, succeeding

Lord Macaulay. Tremendous energy, sympathy, enthusiasm, impulsiveness, a generosity so lavish it almost rivaled that of the Rajahs and came close to impoverishing the Camerons, and a great intellectual curiosity.

Sir Henry Taylor tells us that after the Governor-General's death, Mrs. Cameron was at the head of European Society in India, yet amid the bustle of such a life she was assimilating ideas that were destined later on to yield a thousand-fold.

Sir John Herschel, one of the few really great names on the roll of Photography, was corresponding with her. She has written "My illustrious and revered, as well as beloved friend, Sir John Herschel. He was to me as a teacher and high priest. From my earliest girlhood I honoured him." Referring to the correspondence of this friend—in the days of Talbotype—Mrs. Cameron writes: "I was then residing in Calcutta, and scientific discoveries sent to the benighted land were water to the parched lips of the starving, to say nothing of the blessing of friendship so faithfully evinced."

... From these notes it will have been gathered that Mrs. Cameron was sympathetic to all intellectual achievements, the wizardry of photography seeming to possess some special fascination, whether owing to the influence of Sir John Herschel's enthusiastic letters or the possibilities offered of possessing a gallery of dear friends' counterfeit presentments can only be surmised. That this passion was strong is well known in the family circle, for long before that memorable day in 1864, on which little Miss Philpot was conjured as with a magician's wand upon a glass plate covered with chemical film, and in her new and beauteous form re-named "My First Success," Mrs. Cameron had spent hundreds of pounds in paying the degraders of the art to fix the faces of her friends. Her generous nature did not consider money, photographers were ordered with lavishness to work for her, often under her immediate supervision. The best of this vicarious photography was Rejlander's portrait of Tennyson, taken at Freshwater, but truth to tell it is a sorry product: what were the feelings of that operator when he saw his patroness produce the masterly Tennyson, it were better to leave to the imagination.

Upon returning to England they settled at Putney Heath for a few years. Emerson quotes a friend of Mrs. Cameron's:

... This period of their lives was full of intellectual activity, a complete and welcome change from the barbaric life of the East. Mrs. Cameron's most intimate London friends were Sir John

Herschel, Lord Hardinge, Sir E. Ryan, and Sir Henry Taylor, who has written of her at this period: "She appeared to us to be a simple, ardent, and honest enthusiast. Her genial, ardent, and generous nature makes her love others and forgetful of herself." Miss Fenwick describes her as a fine generous creature and writes, "We all love her, Alice, I, Aubrey de Vere, Lady Monteagle and even Lord Monteagle, who likes eccentricity in no other form like hers." During this happy time, she was a regular visitor at Little Holland House, where her sister, Mrs. Prinsep, used to entertain, on Sunday afternoons, the best artistic and literary society of London. There she met her old friend Mr. G. F. Watts, who had painted her portrait in 1850, Mr. Woolner, Mr. Holman Hunt, Mr. Burne-Jones, the late D. G. Rossetti, and Frederick Walker. Instinct with a natural love of the beautiful and of pictures she was, doubtless, influenced by these artists, although she was neither an amateur of painting, a collector, nor a creator—she could not draw.

In 1860 they moved to Freshwater Bay, where Tennyson was a neighbor and soon, whether he would or no, a frequent target for Mrs. Cameron's camera. It was, apparently, impossible to resist Mrs. Cameron when she wanted to make a picture. Tales are told, though not by Emerson, of her chasing Tennyson up into his tower crying "Coward! Coward!" Another tells of the time he left his guest, the American poet Longfellow, in her hands, saying, "You'll have to do what she tells you. I'll come back in an hour and see what is left of you."

Emerson asks us:

Now think of the circumstances in which she began photography. She was nearly fifty years of age, she knew absolutely nothing of practical photography, and there was no one at hand to give her instruction; she had to hammer it out for herself—and that in the days of wet collodion. Think then of the masterly work she went on producing for the next ten years, and confess the artist is born, not made.

It was by merest chance that she began at all. Sir Charles Norman married one of her daughters, and together they presented their mother with a lens and dark-box. "It may amuse you, Mother, to try to photograph during your solitude at Freshwater." No artist ever began under kinder auspices—love smoothed all difficulties and opened all locks. . . . The donors were innocent of the marvels that lens would transmit, and all unconscious of the genuine artistic temperament possessed by their mother. But Mrs. Cameron was no

dilettante, she immediately set to work, and for nearly a year chased the dainty one, sometimes being favoured with a smile of encouragement, oftener being eluded. What a lesson her life should be to the blatant coxcombry of to-day, where conceited ignorance begins to preach before it has mastered the elements of its art. . . . A short description of her tools may prove interesting to the craft. Her lens was by a French maker, Jamin by name. I am indebted to my friend Mr. T. R. Dallmeyer, who has recently examined the lens for me. He reports the following general notes. "The 'Jamin' has a focal length of 12 inches and is 3 inches in diameter. It has a fixed stop of 1-7/8 inch diameter—in other words, works at about F/6-F/7. It is a 'Petzval' construction and there is no outstanding spherical aberration—but there is positive chromatic aberration." Her camera was of the simplest type, consisting of two wooden boxes, one sliding within the other. It is still in the possession of her son, Mr. H. H. Cameron, whom I take this opportunity of thanking for courteous co-operation in gathering material for this memoir. The chemicals and apparatus were also of the simplest description, the barest necessities for the wet collodion process and silver printing. Nearly all her work was done in a studio of the simplest kind. She writes: "I turned my coal-house into my dark-room, and a glazed fowlhouse I had given to my children became my glass-house. The hens were liberated, I hope and I believe not eaten, and all hands and hearts sympathized in my new labour, and the society of hens and chickens were soon changed for that of poets, prophets, painters and lovely maidens, who all in turn have immortalized the humble little farm erection." The glass-house was fitted with simple white roller-blinds; no head-rests or other abominations finding place there.

Quoting frequently from her *Annals of My Glass-House,* then privately printed and unavailable to the public, Emerson goes on:

It is interesting to read Mrs. Cameron's remarks upon her focussing. "I believe that what my youngest boy, Henry Herschel, who is now himself a very remarkable photographer, told me is quite true, that my first successes, viz., my out-of-focus pictures, were a 'fluke,' that is to say, that when focussing and coming to something which to my eye was very beautiful, I stopped then instead of screwing on the lens to the more definite focus, which all other photographers insist upon." I am sure, after examining her lens and looking over her prints, that she did get her results by accident, but that her explanation, given ten years afterwards, is the wrong one. The "Jamin" working at F/6 had no small diaphragms, abominations introduced later on by a scientist and invaluable to such an one, but utterly *useless* to the artist—nay fatal, as I have proved

scientifically. In addition, though the image appeared sharp on the screen, owing to the positive chromatic aberration, the picture would be out of focus when taken. It was therefore *impossible* for Mrs. Cameron to get what is technically known as the "sharpest focus." Still, having learnt from this experience, in after years she did not work with the sharpest focus obtainable with the Rapid Rectilinear Lens. Having produced out-of-focus results at first by accident, she was artist enough, and so well advised, that she determined to imitate that effect; a determination fulfilled later on when she became possessed of an 18 x 22 Dallmeyer Rapid Rectilinear Lens—one of the triumphs of Photographic Optics. She used this lens at large aperture, so that her son, an experienced photographer, says it is almost impossible to distinguish the pictures taken with the two instruments as regards the quality of focus—but this I think an error. All her work was taken direct, indeed she claimed that as a merit, and she was right. . . . Mrs. Cameron gave very long exposures, ranging in duration from one to five minutes. This method was brought up against her as a matter for raillery by jealous craftsmen. Unable, with all their appliances, to produce work comparable to hers, the photographers of commerce sought every pretext to belittle her pictures, but all in vain, for many of them possessed those undying qualities of art which artists immediately recognized, and after all it is in their hands that the final judgment in such matters rests. All that can be said against her is that she used too short a focus lens for her 15 x 12 plates.

In 1865, she sent two of her portraits to the Edinburgh exhibition. She writes:

They did not receive the prize: the picture that did receive the prize, called "Brenda" clearly proved to me that detail of table-cover, chair and crinoline skirt were essentials to the judges of the art which was then in its infancy.

The prizewinner—Robinson, of course—wrote that many of her works were "failures from every point of view. . . . It is not the mission of photography to make smudges." Robinson was only one of the howlers; even the council of the Photographic Society of Great Britain (the Royal) called a meeting to condemn her work. At the same time, Watts was calling her work "divine," Dr. Vogel was praising her, as was Herschel, and as artists, scientists, writers and all sensitive people have done ever since.

Emerson is not blind to her faults. The grandchildren in swans'

wings, the allegorical subjects, the illustrations to *Idylls of the King* showed her limitations, and to him her blindness to nature was inexcusable.

Mrs. Cameron, then, was not an impressionist nor naturalist, but what is known to some as an "idealist," she saw her models through the old masters' spectacles, fondly, lovingly, joyfully, as a child. She was in no way original, but the follower of good conventions. She endeavoured, it is true, to sound the stops of her models' characters, but the sentiment of the old Florentines would always obtrude itself. She was above all things a humanitarian, she loved her kind and preferred them well-favoured. A great artist she was not, though possessed of talent at times rising almost to genius.

He gives a list of her principal works, not without adverse comments: "there is a theatrical air . . . they are noisy, and lack the simple dignity and repose of her best work. . . . This is a popular picture, I believe, but personally I do not care for it. It possesses a sentimentality and lack of decorative feeling that distresses me."

Of the four plates, the magazine's limit, which he had photo-etched by W. L. Colls, he writes:

Portrait of Mr. Alfred Tennyson. (Photo-etching by my friend W. L. Colls given herewith is reduced from 10½ x 14 size.) A masterly work, with all the breadth of effect and vigorous simplicity that belongs to great art. Reminds me of Velasquez. Taken in 1869 at Freshwater, Isle of Wight.
 Portrait of the late Sir John Herschel. A wonderful portrait of old age, and according to Sir Henry Taylor, of the man. (Photo-etching by W. L. Colls given herewith is a reduction from 10¾ to 14½ size.)
 The Kiss of Peace. (Photo-etching by Mr. W. L. Colls given herewith is reduced from 10½ to 13½ size.) A picture instinct with delicate observation, sweetness and refinement. One of the noblest works ever produced by photography.
 The Day Dream. Ranks with the *Tennyson,* or perhaps surpasses it. It is full of the profoundest expression, together with the simplicity, dignity, and impersonal greatness of style that belongs to the masterpieces of the world. (The photo-etching by W. L. Colls given herewith is reduced from the original, which measures 9¾ x 13¾ inches.)

He concludes:

Every portrait photographer in the world will do well to hang in his studio such classical works as the "Tennyson," the "Mrs. Jackson," the "Joachim," the "Kiss of Peace," "Sunrise," "Mrs. Ewan Cameron," "Christabel," "Florence," "The Day Dream," "Mr. Norman," and "Oenone"—a dozen pictures that would teach him almost as much as reproductions of the great masters of portraiture—Titian, Velasquez, Holbein, Rembrandt, Gainsborough, and Whistler.

The essay is dated Chiswick, August, 1890.

XIII. "THE DEATH OF NATURALISTIC PHOTOGRAPHY"

On May 31, 1890, there appeared in *The Journal of the Society of Chemical Industry,* "Photochemical Investigations and a New Method of Determination of the Sensitiveness of Photographic Plates" by two chemists, Ferdinand Hurter and Vero C. Driffield. Both amateur photographers, they had found the trial-and-error, rule-of-thumb methods of exposure used by most amateurs much too inexact for their own use. In the old days, when you had to develop your wet collodion plate within fifteen minutes after sensitization, it didn't matter; you simply scraped a failure off the glass, resensitized it and went at the subject again. With the new, fast gelatin plates, which you developed at home hours or days later, it was entirely a different matter. Often it was impossible to return to the subject, and, as all photographers know, nothing ever happens exactly the same way.

So Hurter and Driffield, up in an attic, using a candle as standard illumination and an old sewing machine to work the shutter, had discovered the immutable relation of exposure, density and development known as "the characteristic curve." Emulsions differ: some are slow at the "toe"—overcoming the basic resistance of the emulsion; some rise steeply, some slowly, as exposure and development increase; some can contain more values in the

highlights, while others go suddenly "over the shoulder" into curious results such as solarization, a reversal of tone.

Manufacturers of plates and films immediately recognized the importance of "H&D," as their principles were soon known. Of course, by judicious exposure and related development, the relation between the tones could be expanded or contracted; in printing, overexposed areas could be "shaded" while underexposed areas could be "burned in." Few people in those days had electricity in their homes, so print frames were set out in the sun. A piece of cardboard might be so positioned as to shade the overexposed area, but the photographer had to be alert in moving this shield around to avoid obvious edges, and those who let their prints get too dark were known—at least by Emerson, who abhorred dodging in any form—as "sun-downers."

But Hurter and Driffield had proved that by no chemical or printing sleight-of-hand could you change the relation of one tone to another: a dark tone remained inevitably darker than a light one. Emerson had thought you could change the relation at will; it was one of the cornerstones of his argument that photography could be an art. If Hurter and Driffield were right, and he feared that, being scientists, they were, then his whole structure tottered and threatened to crash down around him.

It is strange to us, today, to comprehend why Emerson, himself scientific in training, did not realize that H&D offered photographers a superb creative control through which they could achieve effects otherwise only accidentally possible. But the fact remains that only one or two photographers realized its importance until Ansel Adams, in 1941, brilliantly translated it into his famous Zone System and stuck to it, though cries of misery at the mathematics involved rose from his students, scientists condemned him for his terminology and asked testily, "What in hell does a photographer know about photography?" and fellow artists like Edward Weston, who had always "felt the light," held their heads and groaned. Adams himself insisted that the Zone System was nothing but applied sensitometry, an aesthetic use of H&D. Emerson could have anticipated him by fifty years and saved millions of photographers untold hours of useless labor and massive cash losses in negatives, chemicals, and paper.

But he did not. He wrote: "Some of my friends to whom I have recently privately communicated my renunciation, have wished to know how it came about. Misgivings seized me after conversations with a great artist [Whistler?] after the Paris Exhibition; these were strengthened by the appearance of certain researches in psychology, and Hurter and Driffield's papers; and finally the exhibition of Hokusai's work and a study of the National Gallery pictures after three and a half months' solitary study of Nature in my house-boat did for me."

He had always wanted to spend a whole year in his "pleasure wherry" on the Broads, and, after the explosions of the past year, even a man of his extraordinary energy doubtless needed the rest and seclusion. What his wife thought about it is not known. Daughter of a surgeon and a Grey Sister, she doubtless understood doctors and scientists, but certainly she had caught a strange specimen. Was she one of those saints, those patient Griseldas, that explorers, scientists, seafaring men—and now, astronauts—seem gifted to woo and win? She doesn't look like the ideal Victorian wife to whom her husband was next to God. And photographers are notoriously difficult to live with, demanding breakfast before dawn—Emerson, an excellent cook, may have fried his own eggs and bacon and concocted his noontime snack himself—and coming back after sunset hungry as lions. Next day they are shut into their darkrooms—Do not disturb!—emerging at odd hours with cries for sustenance. Writers are difficult too; they can't think if the children are making too much noise, or the plumbers are tinkering, and they don't like being interrupted in the middle of a paragraph. Both are serious disrupters of an orderly family regime, and may also be gone for months on various projects, leaving their wives to cope alone with whatever happens. Perhaps Mrs. Emerson and her children and servants, after getting Emerson off with all his necessities, simply fell exhausted into the nearest chairs and laughed, glad he was gone on his beloved project, looking forward to peace, freedom and quiet—and yet finding the house strangely silent and empty.

That Emerson had an eye for the ladies no one who has read his books can doubt. He admires the country girls, who, after climbing a stile, shout back at the boatload of "Cockenays" who have

been teasing them, "Well, did you see what you wanted to see?" But he obviously preferred real ladies of real elegance, and such affairs are not easily hidden. Whatever he did or didn't do, Mrs. Emerson—was she called Edith or Amy?—bore him two more children: Zoë Orchis, third daughter, 1893, and Ralf Billing, 1897, second son and last child.

That Emerson did love and understand his children is proved by the sketch of Gladys, his second daughter, in *Marsh Leaves*, 1895. He understood why she was a fairy princess, commanding each day a different domain, and why the young gardener, his assistant, brought her every day the loveliest flowers in the garden. But after her sister Zoë was born, Gladys suddenly pulled up all the cabbages in the garden—red, savoy, the lot. Both Emerson and the young gardener were furious and demanded an explanation; the more they scolded, the more silent she became, until Emerson, really angry, sent her to bed.

"But nurse went and soothed her, and asked her why she had been so naughty.

"With brimming eyes she kissed the kind woman and said— 'Why, nurse, I was looking to find a baby under one of the cabbages: you said that was where they came from.'

"And the nurse hid her smiles by hugging the child to her ample bosom."

But Ralf, his last child, came too late to see his father as anything but a grumbling, vindictive old man, and hated him.

Meanwhile, let us read Emerson's charming invitation to the reader to join him on that almost yearlong cruise in the *Maid of the Mist:*

Sept. 15, 1890

Floated with a rakish and unmaidenly air upon the clear shallows of Hickling Broad, the wherry's low bulwarks and tall mast, stepped far forward, giving her a devil-me-care appearance from the willow-embowered staithe [dock] towards which my messmate Jim was rowing with jerky sea-strokes to ship the pile of cases and packages upon which I sat contemplating the sand-martins alighting with twitterings upon the yielding gladen leaves bordering the broad, for the September moon was waxing full—that moon that inaugurated the meteorological *Annus Mirabilis* 1890-1891. . . .

Reader, will you pack up your *impedimenta* and join us? Ah, you will—good! Jim is coming too, and here's a hand upon it. I am skipper, therefore must write the log, so forgive any omissions or commissions which are not quite to your taste, for what is called life is merely what we make of it. . . .

But here we are alongside our future home. She looks clumsy as you step aboard, but is very handy and sails very close to the wind, is comfortable and well found, and Jim there is obliging and musical —what would you? Go below, kind reader, and be careful not to slip on the narrow plank-ways. Now, please judge what comfort you can get on a twelve-ton wherry. Down the steps there before you is a pantry. On the right, you see, is the kitchen; hasn't Jim made the pots and pans shine? On the left, through that sliding door, is the saloon—if you are six feet high you can just stand there, if you are over a fathom long then you can lie on the seat along one side, or you can sit on the other lockers by the tortoise stove—how that will roar in midwinter, and boil our grog, when the Great Bear sparkles with a new beauty in the frosty skies. . . .

Yes; open the door. There is the cabin—two good berths and shelves for our library and guns—cosy, isn't it? Never mind the rooms looking small now; they will grow bigger to you as the days shorten. . . . Yes; the polished matchboard is cleaner than paint, and wears better. . . . Jim? He sleeps outside in his cabin, and is quite comfortable with a stove of his own.

Come now, messmate, make yourself at home, and arrange your household gods for a year's cruise, whilst I cook an omelette and curry you some shrimps freshly snared from the cold North Sea.

He then relates the history of *The Maid* when she was called the *Little Spark*—carrying marl, ice, ash-pit siftings, once sunk and fished up again. Now her "attendants were a jolly-boat with a balance lug sail, and a gun punt with outriggers—a most handy craft, for it is easy to scull and very stable—one can safely stand and quant [pole] it along if you know how. . . . "

But come now, the omelette, *aux fines herbes,* is on the table, and the Beaune cork has been drawn—the curry smells savoury—and how cheery the dinner looks spread under the topmast light swinging from the beams overhead. We have music too—the waterfays are playing upon our timbers—do you not hear them?—clapotemen, clap-clap, curious music but their own.

And yet he had boarded the *Maid of the Mist* with H&D in hand. In the immaculate log he kept during this cruise, in the superb text

he developed from it, and in the handsome plates he engraved and printed himself, there is not one suggestion of the agony he was going through. He does mention some experiments by moonlight, not even specifying that they were photographic. During one, he and his factotum, Jim, waited for two hours with the temperature at 32° before they finally took down the camera and tripod and rowed, half-frozen, back to the *Maid.* Emerson says merely, "The experiment was a failure." But the second plate in *On English Lagoons,* "The Moonlit River," is unmistakably "by actual moonlight." Bright as it is, it has that strange luminosity never found in so-called "moonlight" scenes which are merely underexposures by daylight printed dark.

Most of the time he was alone with Jim, a factotum much superior to the beery, shifty, boastful Joey of *Wild Life on a Tidal Water.* Jim learned to field expertly, with imperturbable wit, such questions from the waterside as "Is that the *Great Eastern?*" or "What on earth are you two doing out here in this weather?" He was quick and competent, and his foreknowledge of the weather clearly so ancestral as to be almost instinctive. But why were his master and the *Maid* herself so well-known and so heralded on even remote waterways? He liked Emerson and they worked well together, yet he suffered nightmares in which his skipper was suddenly arrested as a contraband runner or a criminal fleeing justice.

Now and then friends came to join Emerson for a few days' shooting or fishing. Once he and Jim came back half frozen to find the current friend had built up the fire in the tortoise stove till he was stupefied by the heat, and the temperature in the cabin was 100°. Another friend was an "African traveler" who had acquired such a horror of crocodiles that the slap of a fish's tail sent him running, pale as death, for high ground.

But Emerson's real companions, most real, most close, were the wind, the light, the sky, and the waters. When did he sleep? Aboard the *Maid,* he must have developed his experiments proving H&D right or wrong by night, and set the print frames against the *Maid*'s deckhouse when there was sunlight. Yet he does not seem to have missed, night or day, a single tattletale cry of anguish from the marsh nor a significant flighting of birds nor a shoaling of fish; nor the moment when, in the succession of seasons, the marsh turned gold or blue or russet; nor, when, in winter the willows at first sun wept tears of ice, or rime, transforming the weeds into miracles of diamond jewelry far beyond the hand of man, soon melted, leaving the weeds dark as sorrow.

Music to Emerson is the many sounds of water, of storm, of ice, of wind and wildlife crying in the marshes. Each to him is a different instrument in the quiet sonatas of evening or in the all-encompassing symphonies of storm. With such ears, no wonder he could catch the exact turn of speech, the exact idiom, the exact sound of the speech of the peasants and fisherfolk.

No less extraordinary is his sense of color. It is alive to the most subtle differences—he sees how color changes with texture, light, brightness, sharpness, softness, how each can intensify or absorb the basic colors. He writes of a sunset, "Nature *yelled* in color." How he would be hounding—and helping—the manufacturers of color film today! What a painter he might have become—far beyond his dear friend Goodall.

Then, from his log:

Dec. 19—Mooring—Oulton Broad; Min. temp., 23°. Wind S.W., then N.W., and freshened; ice cracking loudly; snowed hard; wind changed to E., and heavy snow at night. Several gulls flying over ice; a wren alights on wherry; flock of mallard; Lake Lothing covered with gulls sitting on the water; starlings and rooks digging by water's edge; kittiwakes, blackbirds, mavises, and starlings on ploughed ground; find half-frozen wren in wall. Steam wherry tried in vain to force the passage.

Dec. 20—Mooring—Oulton Broad. Broad frozen hard all over. Channel frozen; navigation closed until February; skating; walked across broad with luggage; left for London.

With him must have gone the MS. of all or most of "The Death of Naturalistic Photography," for he refers to a letter from George Davison, who had lately gotten out of hand, as dated "16 December, 1889, ONLY A YEAR AGO." Then, perhaps, in confirmation of his renunciation, he studied the exhibition of the prints of Hokusai and the National Gallery pictures.

In January, 1891, the editors of all photographic magazines received a letter from Emerson, begging them to give publicity to

the enclosed, addressed "TO ALL PHOTOGRAPHERS." Asking forgiveness of those who had followed him and those whom he had mistakenly attacked, he proceeded to renounce in toto the claims of photography to be an art.

> To you, then, who ask an explanation for my conduct, art — as Whistler said — *is not* nature, it is not necessarily the reproduction or translation of it; much, so very much, some of the very best, is not nature at all, nor even based upon it. . . . If there can be no scientific basis for art, as some have asserted, Meissonier can claim to be as artistic as Monet and Monet as Meissonier. The sharp photographer can assert his artistic rights alongside the veriest "blottist." So all opinions and writings upon art are as the crackling of thorns beneath the pot.

This he reprinted in a black-bordered pamphlet entitled "The Death of Naturalistic Photography," which appeared probably in February. It is a cry from the heart, an anguish so great that by turns it is rhetorical, sentimental, vehement, vindictive, and even inconsistent. If he has cast all his ideas and theories on the dust-heap, why castigate George Davison for lecturing on these before the Society of Arts without giving him credit? Why protest that the Society's magazine had given *Naturalistic Photography* a bad notice, and that a friend, who had presented the true facts before the Society, was untruthfully reported? Here again he needed a strong and sympathetic editor, who would have let him publish as reasons for his renunciation only such understandable statements as:

> The limitations of photography are so great that, though the results may, and sometimes do give a certain esthetic pleasure, the medium must rank the lowest of all arts, *lower than* any graphic art, for the individuality of the artist is cramped, in short, it can hardly show itself. Control of the picture is possible to a slight degree. . . . But the all-vital powers of selection and rejection are fatally limited. . . . I thought once (Hurter and Driffield have taught me differently) that true values could be obtained and that values could be *altered at will* by *development*. They cannot; therefore to talk of getting values in any subject whatever as you wish and of getting them true to nature is to talk nonsense.
>
> In short, I throw my lot in with those who say that photography is a very limited art. I regret deeply that I have come to this conclusion.

EPITAPH.

In Memory of

NATURALISTIC PHOTOGRAPHY,

WHICH RAN A SHORT BUT ACTIVE LIFE,

UPSET MANY CONVENTIONS

HELPED TO FURTHER MONOCHROME PHOTOGRAPHY TO THE

UTMOST OF ITS LIMITED ART BOUNDARIES,

STIRRED MEN TO THINK AND ACT FOR THEMSELVES,

PRODUCED MANY PRIGS AND BUBBLE REPUTATIONS,

EXPOSED THE IGNORANCE OF THE MULTITUDE,

BROUGHT OUT THE LOW MORALITY OF CERTAIN PERSONS IN THE

PHOTOGRAPHIC WORLD,

BROKE DOWN THE PREJUDICE OF THE OUTSIDE PUBLIC AGAINST

PHOTOGRAPHY'S VERY SLENDER ART CLAIMS,

ENCOURAGED MANY AMATEURS TO BABBLE AND MAKE THE WORDS

"ART," "TRUTH" AND "NATURE," STINK IN THE

NOSTRILS OF SERIOUS ARTISTS,

ENDING BY GIVING A FEW A BRUTAL SORT OF APPREHENSION

OF ART, AND DYING WHEN ITS

ALLOTTED TASK WAS DONE WITH A GIBE ON ITS LIPS,

FOR THE "AMATEUR," THE "PLAGIARIST,"

THE "PRATING TRUE-TO-NATURE MAN,"

THE "IMPRESSIONIST," THE "NATURALIST," THE "IDEALIST,"

AND THE HUMBUG.

The editor would doubtless have approved that Emerson amiably settled a dispute between his friends and enemies: "Suggestions have been made that I get some of my ideas from a book, called 'Naturalistic Painting.'" (Serialization of Francis Bate's *The Naturalistic School of Painting* began in the March 1, 1889, number of *The Artist*. It starts off with a quote from Ralph Waldo Emerson: "When we speak of Nature in this manner, we have a distinct, but most poetical, sense in the mind. We mean the integrity of impression made by manifold natural objects." Bate does indeed share many of P. H. Emerson's ideas and opinions. Emerson had already published some rousing articles, and on March 11, 1886, less than two weeks after Bate began his serialization, gave his resounding annunciation, "Photography a Pictorial Art," to the Camera Club.) Emerson continues: "I have a letter in my possession from an artist, wherein is stated clearly and exactly that Mr. Bate had read a paper of mine on *Naturalistic Photography before* his first article appeared in the 'Artist.'" Emerson clarifies the above in a footnote: "This does not imply that Mr. Bate took any ideas from my paper; on the contrary, I feel sure his ideas were his own, as were mine."

The editor might have toned down the sting in the tail of: "Some amateurs following Colonel Noverre's REVIVAL of rough printing-papers LAST YEAR [1889], have thought that salvation lay in rough surfaces. Colonel Noverre's dustheap was ransacked, and we have heard of a new departure—a newer school, and all the bleat of the over-weeningly vain 'amateur.'" Yet it was nearly two decades, during which worse things were said, and not only by Emerson, before the amateurs came to their senses again.

If the hypothetical editor had been also an historian, he would have crossed out the P.S. in italics: "— *Will every Secretary of every Photographic Society take four wafers and a sheet of black paper, and hide forever the words 'To the Student' in Pictures of East Anglian Life.*"

But that was Emerson leaping to save others from the quagmire into which he himself had fallen. Whatever he thought, Emerson was a deeply religious man, with a strong sense of duty, integrity and purity. After all, he need not have written "The Death" at all; he could have comfortably rolled along in his fame, with-

drawing, perhaps more and more. One must acknowledge, however, that he did love drama and rhetoric, but that does not make him any the less sincere.

It had taken enormous courage to make his renunciation, in face of the certain triumph of his enemies. But courage, moral or physical, was something he had never lacked. He had no idea how much he had meant, even to his enemies, no dream that he was in for great honors or that, though he would die forgotten, resurrection was at hand.

He arranged for the publication and distribution of the mourning-bordered "Death," resigned from the Camera Club ("that home of the amateur. . . . I was and am no amateur") and, if he had not done so already, from the Society of Arts, and recalled all remaining copies of the second edition of *Naturalistic Photography*.

Then he took the train back to the still-frozen Broad and walked across the ice to the wherry. (See Plate 74.) He was happy to be back, awaiting the thaw, noting the swans, mavises, linnets.

What he probably was thinking about, with a sense of relief, was how, with that off his chest, he could get on with *East Coast Yarns* —a collection of stories such as the Harnsee, Pintail, the fishermen and the peasants had told him, each teller probably adding a bit of his own, and with *Birds, Beasts, and Fishes of the Norfolk Broadland*, which he did not intend to illustrate either; he could not abide stuffed birds, beasts, fishes, etc., and left that chore to T. A. Cotton; the photography of wildlife, alive in habitat, was still beyond photography. Certainly he photographed during the rest of that cruise, as two more albums testify. And there was the delightful daily chore of keeping the log and, working as carefully as he says he does, describing vividly what was happening almost while it was happening. *On English Lagoons* contains the finest writing of any of his albums as well as some of his best photographs, photo-etched by himself and printed in sepia.

The response to "The Death" in England was almost immediate. In *The Amateur Photographer*, January 31, 1891, there appears "Exit Emerson"—indubitably by Robinson, that inveterate quoter, or we should not have "the Giant Despair," "the mountain

of optimism" and "the pit of depression," and "much ado about nothing."

It has always been the opinion of many thoughtful workers that the doctrine of "fuzziness," particularly in the heyday of its influence, operated as a kind of *ignis fatuus* to the earnest student of pure photography. That an art which is especially and peculiarly adapted to the portrayal of nature with minute precision and brilliant definition should seek as its highest manifestation the representation of vague suggestions, was felt to be a glaring anachronism; it was so violently out of keeping with the obvious genius of the art. Yet many have, possibly in the main through the persistent teachings of Dr. Emerson, adopted the above heresy; not the least offender being, in our opinion, the Photographic Society of Great Britain, which, at the last Pall Mall Exhibition, stamped with its approval a number of works characterised by blur and mist.

The photographic world now learns with considerable surprise that Dr. Emerson has, to use his own words, made a dust-heap of his well known volume entitled "Naturalistic Photography," and has renounced all his previous peculiar views. Much as he has, in our opinion, hindered the progress of photography by his now recanted teachings, he has still more injured it by the bitter and desponding words which he has included in his renunciation.

In the past he compared "photographs to great works of art and photographers to great artists." Now, overcome by the Giant Despair, he can hardly think too little of art photography.

After this *bouleversement* we are not surprised to read that he derides the rules of composition, nor that he considers "the eternal principles of art . . . mere catchwords." These opinions should convince Ruskin and his like that they lag superfluous upon the stage of life. Dr. Emerson proceeds as follows:—"It may be asked, then, what theories on art I have? I answer, at present *none*. . . . What do I think of writings on art and art criticisms? Mistakes."

We are greatly inclined to agree with him in this last: that is, as far as he is personally concerned, if he really has no theory on art left to him. Such being, according to his own words, the case, why should he so ruthlessly endeavour to smother the hopes of other students by a hailstorm of assertion which, if undissipated, would relegate photography to the perdition of a sham art?

Is there a fly in the ointment, or has Dr. Emerson nothing to interpret his thoughts with but acids and bitters? Whichever may be the case, he has tired of searching for Dame Nature in an artificial fog, and now writes this petulant jeremiad. What he in so many words says is this, "I, even I, have failed; therefore, ye little fishes, there is no hope for you; how can a tadpole succeed where a mighty leviathan has suffered inglorious defeat?". . .

Let us not all forget that art-photography is still in its teens; let us remember that within the past few years it has made great strides; let us hope and believe that it is destined to advance in the near future as much as it has in the past. How far this advance will be maintained it is hard to prophesy, but anyhow we may all confidently expect that art-photography will travel along the road which leads to the temple of art, a long, long distance beyond the spot where Dr. Emerson has lost heart and fallen by the way.

The news was slow in reaching America. Thomas Bloas, Emerson's successor, in order to catch the mail in time for the February issue of *The American Amateur Photographer,* had written:

*Dr. Emerson and His Teachings:—*Dr. Emerson in his various writings, and notably in his "Naturalistic Photography," has emphasized the need of rather studying nature than the works and methods of other photographers, and to his teachings we have doubtless to attribute the almost entire disappearance of the worst form of old style of landscape, in which trees and buildings stood boldly out against a white sky—and in the production of which two canons were so faithfully observed by the producer: 1st. Never to photograph unless on a day so clear and bright that the extreme distance is sharp. 2nd. Always to so set the camera that the sun shines from behind it. One result of Emerson's work is a notable irruption of papers and discussions on impressionism and naturalism in photography—but many of those who are credited by the mass with being exponents of Emerson's impressionism, so far miss the mark as to put forth some incidents, appliances, specifics, or methods as being essentially concerned in the production of "naturalistic" photographs. This was very notably the case when Mr. Davison read a paper on "Impressionism in Photography" before the Society of Arts; neither reader nor discutants appearing to have any notion beyond the use of certain specifics for producing naturalistic results, such for example as working out of focus or the use of rough paper. This sort of thing in which the tool or method which may incidentally assist an intelligent worker in realizing nature, is exalted into an essential means, is calculated to lead a convention more destructive to the production of desirable work than were the old conventions in photography. To expect to imitate nature by the mere use of certain manipulations is as unreasonable as to expect to produce work like that of a distinguished painter by going into his studio and using his tools. The climax is reached now that "Naturalistic Paper" is advertised in the photographic publications! Dr. Emerson's latest illustrated work, "Wild Life on a Tidal Water,"

represents, in my opinion, a distinct advance on his previous efforts, both from the photographic and the photo-etching standpoint. The first plate, "Great Yarmouth Harbor," is, perhaps, the most striking as a picture, and will perhaps be regarded as the best thing Dr. Emerson has done; but if looked at by the light of those who, like Mr. Davison, seem to think that such artifices as rough paper and working out-of-focus are of the nature of essentials in realizing nature, this and the best of the plates are poor indeed. There are twenty-nine photo-etchings from Dr. Emerson's negatives and one from Mr. Goodall's painting, "The Last of the Ebb."

This reinforces Emerson on the subject of Davison, and also his protest in "The Death" of the revival of Colonel Noverre's rough papers, combined with inept handwork, to give the effects pure photography does not give.

In the next issue, F. C. Beach noted:

Naturalistic Photography. — As we go to press we have received a pamphlet by Mr. P. H. Emerson, entitled "The Death of Naturalistic Photography." The front page has a border of mourning. Somewhat sarcastically Mr. Emerson renounces all he has maintained in his book on "Naturalistic Photography," and attacks some others leaning in his direction because they do not give him credit for proposing the principles he has put forward. He claims that it is impossible by printed books to thoroughly explain his views on naturalistic photography, and for that reason wishes to throw overboard what he has theretofore described. Doubtless he has set many to thinking on the subject, so that his change of front may not have as bad an effect as it would soon after the book was published.

As for Emerson, he went on living on the wherry, except for a few days in June when it was necessary to go to London.* But it was an evil season; gales and high tides flooded the harvests and rotted them on the ground. In spite of a few fine days, and sailing matches with Dick and Jim, and a cruise to the dunes and surf of the North Sea, when they returned to their old mooring, Emerson thought it was time to leave. He had struck up almost a friendship

* Perhaps to arrange for publication of "Perspective Drawing and Vision," on which he had collaborated with Goodall, and in which they pointed out the differences between what camera and lens see and what the eye sees, maintaining that photography was often in error, no matter how mechanical, and therefore useless to the scientist, architect or artist. Goodall had a house on the Broads and perhaps it was there they worked on this pamphlet.

with a little sedge warbler who had nested close to the mooring. When the first batch of eggs was destroyed by a weasel, Emerson dug out and killed the weasel.

So, fifteen days before the full year he had promised himself:

Aug. 31

. . . as I stepped out of my ship on the last day of August in the drizzling rain, my little sedge warbler jumped upon a reed and began to sing joyfully. I stopped, took off my hat, saluting the plucky little bird—wished himself and family a safe voyage across the seas.

As I walked up the wall, masses of thistledown were blowing across the marshes, an unfailing sign of autumn, and the last marsh-note that I heard as I rode off was the farewell song of the brave little warbler.

XIV. AFTERLIFE: 1. ACCLAIM

As if to show he still loved them, Emerson took his family off to Southport for a few weeks, and then, as if to sever all ties with his recent past, rented for six months Chancery House, Beaumaris, on the Isle of Angesby, near Colwyn Bay, North Wales. Chancery House was supposed to be haunted, but no intelligent ghost would ever have dared appear to Emerson; he would have been after it instantly.

He had been twice before to Wales, and the Welsh fascinated him almost as much as the East Anglians, besides being a different race still speaking its own strange language and still, centuries after its conquest, so belligerently unassimilated with the English that it had been deemed politic to call the heir apparent to the Crown of England the Prince of Wales.

While working on *A Son of the Fens* and finishing *On English Lagoons*, Emerson dashed with his usual vigor over the wild countryside, settling down with anyone Welsh to talk. The Welsh, of course, have to learn English, but it is not improbable

that Emerson, a bit of a linguist already, with his acute ear, learned enough Welsh to make himself welcome. Only four Welsh fairy tales had been unearthed so far; he heard dozens. In the short time he was there, he gathered the material for *Welsh Fairy Tales* and *Tales from Welsh Wales.*

But Wales, with its mists, rains and waterfalls, was too damp for him and he suffered a mild attack of rheumatic fever.

So he moved to the southeast corner of England, Ramsgate, which he found too dull and too ugly. While there, he gave evidence in a trial concerning Hickling Broad. If the waters were tidal, the public could fish and shoot there; if not, the waters were private. Evidence that they were distinctly tidal and, moreover, that in places like the Broads the tides follow no mathematical theorems, was strongly given by Emerson, and he was furious when the judge ruled the waters were not tidal, thus denying the public a rich source of food while still allowing them to sail over it.

Then Emerson discovered, a little up the coast, a charming house, Claringbold, at Broadstairs—so called because the opening in the cliffs that led down to the sea was unusually large, and long ago a flint gate had been erected across the stairs of Harbour Street to protect the little town from attack.

The grounds at Claringbold so inspired Emerson that he became an ardent gardener, with such intelligence and so gifted a green thumb that in 1893, he won the Royal Horticultural Society's Bankerian medal for growing foreign vegetables in the open; the year after that, he received the Relway medal for gaillardias.

But if Emerson thought he had severed himself from photography and photographers he was mistaken. What he had started not even he could stop. He did not like a good deal of what the so-called Naturalists were doing: the rough papers, the extreme out-of-focus, the inept handwork, and even, here and there, the emergence of what was to be a craze—the use of gum bichromate, which permitted not only black or sepia but colors to be painted on or washed off at will. These, of course, were attempts to overcome the inevitable relation of tones of which he had himself complained. Yet they led to claims of being artists even louder than before.

Back in Beaumaris, he had written "Photography Not Art" for

The Photographic Quarterly, January, 1892.

Let us, lest we be misunderstood, preface our article by acknowledging without stint the great and invaluable uses of *scientific* photography—that is, photography taken with the best corrected optical instruments that give mathematical reproductions of objects before them—reproductions scientifically true in *some* respects, but not in all; *e.g.,* false in colour translation. No doubt science will remedy these defects, and then we shall have an invaluable *machine* by which *impersonal* drawings can be made. The uses of such drawings it were superfluous to consider; they are already widely known to many, and their increased usefulness can be trusted to gain ground without any advocacy. But it must never be forgotten that such mathematical plottings of persons and things are not true in the sense that they reproduce objects as we see them. I first called attention to the fact as regards form and perspective drawing, and subsequently, in conjunction with Mr. T. F. Goodall, published a paper on the subject. Our observations have, in many cases, been corroborated by one of the greatest living psychologists; and one or two of the results, we have since found, were previously discovered by another psychologist. In addition, a well-known teacher, the author of a work on simplified "perspective," has accepted our pamphlet, and intends to withdraw his work. Our investigations easily explain why photographs so often do not resemble the people they are meant to represent, why landscapes are nearly always so disappointing and petty, and why architectural photographs are useless to the seeing draughtsman, as Mr. J. Pennell so ably pointed out.

. . . In most transient landscape effects photographs are absurd. Look at the full moon just rising, and take a photograph of it, then compare the proportion of the moon to the rest of the landscape; the photograph will give an absurdly "small" impression of the scene.

This brings us to the subject of photography and art. It has often been asked, "Is photography an art?" We answer, *"No,"* and with Mr. Pennell agree that "it can never be an art."

. . . But there are some who really are puzzled to know why photography is not an art.

We will endeavour to enlighten them. Let us assume we are going to prove to the world photography is an art; that the most fastidious and critical judges of the period (artists of all schools), have assembled for us to demonstrate to them that photography is an art.

. . . *Up to the taking off the cap, then, nothing is required but artistic knowledge* (saving a trifle of mechanical knowledge learnt in a *few minutes* by any intelligent person). . . . All done so far has

nothing to do with photography, but with art; as for example, any great painter might come and do all this, and then any operator could take the picture. Whatever artistic value it had, would of course belong to the artist who selected, arranged and focussed the view. For "taking" the picture is pure science, as for ever proved by Messrs. Hurter & Driffield.

...*The photographer does not make his picture*—A MACHINE DOES IT ALL FOR HIM....The fact that the photographer does not do the work is nearly always overlooked; he gets to talk of his works so much that he forgets that after all he has *only set the machine to work*, and he has no more done the work than the engineer who starts the locomotive pulls the train. . . . But to proceed. We have now got the negative—*and by pure photography nothing more can be done.*

Next comes the "printing" from the negative. An *artist* has the power of choosing the process, and paper that will best suit his subject. *That is purely a matter of art-knowledge* if the object be artistic; but, if scientific, the paper will be chosen for scientific considerations. The choice here is very limited. After the paper is chosen, again comes the mechanical photographer and starts the engine, and *light does the printing*, he merely stopping the engine when the printing is done. . . . If the photographer dodge in printing by masking, that is merely a crude form of art, and not photography.

Et voilà! He presents his print to the judges whom he imagines assembled. They discuss it, and the spokesman sums up as follows: "You selected the view: that was art (we allow you have an eye for the picturesque). You arranged it well; focussed it well (we think): that was art. But you were so limited by the machine that your individuality could but barely assert itself in this respect. Then you started a machine, and *that machine drew* the picutre for you; you merely fixed its work by chemicals, which is photography, not art. You selected some ready-prepared paper, and the *sun printed your picture*, and you fixed it again. That is photography, with an iota of art in the selection of the paper. We find you have not proved to us you are an artist, for *you* can execute nothing. You cannot even draw a cube fairly; and moreover, we find your machine does not give us any idea of the magnificent scene you selected. One of us—an accomplished landscape painter—has been drawing the scene in black and white (we omit to refer to your colour impotency), and his *proportions* and tonality are altogether different from those of your photograph. His picture is altogether grander and bigger, yours being merely a *mechanical perspective drawing false in many respects.* We find that, if you think photography to be an art, you must decide who is the artist in the case of an automatic machine—

the penny, the person who drops the penny in the slot, or the automatic machine". . . .

There was excuse until quite recently for men who contended that photography was art. For men are justified in fighting for a cause, provided they base their fight on knowledge *up to date;* and until quite recently it was justifiable to contend that photography might be a fine art in the hands of an artist. That position, in the light of recent investigations, is untenable and foolish; but, like all old "truths," it will be for a time perpetuated as a superstition amongst the vain and uncultured. Photography is an easily acquired *science,* and never can be anything else.

Art is personal; photographs are machine-made goods, useful, as is machine-made furniture, machine-made fabrics, and perhaps—for the slums—machine-made music.

But the Royal asked for more, so he wrote a philosophic treatise on "Naturalistic Photography." This essentially consisted of a number of Propositions—to be thought over, not fought over. But when it came time to deliver the paper, in March, 1893, his brother had just died in Florida, and he asked Dallmeyer to present it for him in his absence. Doubtless Dallmeyer's delivery was less effective than Emerson's might have been. The article was published in *The Photographic Journal,* March 28, 1893.

Two years ago I withdrew my book *Naturalistic Photography,* and I owe you some explanation for so doing. My researches into the subject of vision and perspective drawing were mainly responsible for that act, and if you will bear with me for a little I will endeavour to explain my position.

When I first took up photography I was told by the whole photographic world (including optical experts); told by all, without exception, that if the photographic observer closed one eye at the focal distance of the lens used in taking the photograph under observation, he would see the picture "true to nature."

I felt all along that such was *not* the case, and maintained the "sharp" or any other photograph when viewed under such conditions was not true to Nature—to Nature as *two eyes* see it, and hence arose a long and inky warfare.

Gentlemen, it was in this as in many other disputes—we were both right and we were both wrong.

The opticians were right from the mathematical standpoint, and

* Also in the third edition of *Naturalistic Photography*, I, 1899, pp. 170–90.

I was right from the physiological and psychological standpoints, and so it was evident there were two truths to Nature—the perspective or mathematical truth and the psychological or visual truth. After many practical experiments I found the closest truth to Nature IN PHOTOGRAPHY *(from the physiological point of view)* was to be obtained by throwing the background of the picture out of focus to an extent which did not produce *destruction* of structure— that was my limit; the principal object of the picture being either sharp or just out of the "sharp." This convention I termed the naturalistic method of focussing, and pointed out it had no connection with a general *soft sharpness* such as that produced by Mrs. Cameron's badly corrected "Jamin," or by pinholes, or by throwing the *whole* of the picture out of focus—practices all inferior from the naturalistic standpoint, in my opinion, to my method—which is a deliberate and conscious act to be modified according to circumstances, and no haphazard "dodge" like the "soft sharpness" or "bastard naturalism," as my friend Mr. Balfour calls the more mechanical "soft-sharp" method.

This naturalistic method I practised and advocated and found later on by further research that it was justified by physiology. Well, gentlemen, all this led to a great storm in a tea-cup, and disputes arose as to how we did see with two eyes and what was really *truth to Nature* from a visual standpoint. In the course of this argument I was pleased to find a broad-minded optician taking an interest in these matters. I refer to my friend, Mr. Dallmeyer, whose acquaintance I did not make till after the publication of my book and whose knowledge in practical optics has enabled him to make a lens of my conception (*i.e.,* the tele-photo lens), a lens which to my mind is the most powerful tool yet put into the hands of the decorative photographer, but still a lens that I hope is only a step to a better.

Well, gentlemen, all this argument—though warm at times— did good, and set many thinking, and at last I was lucky enough to drop upon the key to the solution, which key I published in April, 1890, in a number of *Photography*. It was a short Paper entitled "A Note on Naturalistic Focussing." My friend Mr. Goodall, who has always been interested in the practice of photography, was told by me of this little research, and immediately he took it up enthusiastically and suggested some new proofs and experiments, and together we published the results in a pamphlet entitled "Perspective Drawing and Vision," a pamphlet that created another storm in the tea-cup, but a pamphlet whose propositions, I venture to say, still remain unshaken. . . .

So, gentlemen, what I advocate is truth to the point of illusion (for I am not considering to-night scientific photographs but decorative or pictorial photographs. And I may now say the methods of practice I advised in *Naturalistic Photography* I still advise, and the artists I held up for admiration in that work I still hold up as the best exemplars of their various crafts, but my art philosophy is different as I shall show you to-night, and lastly, I do not consider photography an *art*, but regard it as a mechanical (I say *"mechanical"* advisedly) process, whose results are sometimes more beautiful than art, but are never art, just as Nature is often more beautiful than art—just as the beautiful Japanese *lilium auratum* surpasses the painted lily—yet is the real lily not art but Nature. So the photograph is not art but a mechanically recorded reflection of Nature. To state this matter more clearly I have adopted a genealogical form of presentation.

NATURE
(The fountain-head of sensuous impressions,
but not necessarily of *ideas*.)

One | branch.

PHOTOGRAPHY
(A cross between *Nature* and a *machine*.)

Two | branches.

Realism.
(The sharp photograph— wherein sentiment, illusion, and decoration are disregarded; merely a register of bald facts mathematically true.)

Naturalism.
(The more or less correct reflection of Nature, wherein truth of sentiment, illusion of truth [so far as possible] and decoration are of first importance.)

From which it is self-evident that I believe there is no true realism nor naturalism in the arts proper but only in *photography;* for TRUE realism and naturalism are *impersonal*—the results of a mechanical process which photography logically is, because under the same *physical* conditions the same *results* will always follow. Place the camera under certain physical conditions and the same results will always follow, which is *not* the case with art, which is *personal;* indeed the personal element in real art is paramount and all-pervading. Thus art is a cross between *Man* and Nature, or—

ART
(Cross between Man and Nature—no machine intervening.)

Two | branches.

Impressionism.
(Which is a purely *personal* vision of Nature as thus an impressionist may paint *sharply* or may paint colours wrongly from defect of vision: as does Monet.)

Idealism.
(Cases in which the imagination is used; that is the combining of several ideas into one harmonious whole. The idealist may transcend known Nature and so the vase is produced.)

In brief what I submit is that all *artists* (who do not use photography, and such are bastards) are either impressionists or idealists, and that logically they *cannot* be either realists or naturalists, for they can never be truly *impersonal.* M. Zola *calls* himself a "naturalist," but he is not, as Mr. Thomas Hardy has pointed out: were I to classify him it would be as a morbid impressionist....

And now we will return to the main subject, which I shall lay before you in a series of *propositions only,* for psychology has not yet become a science in *the true sense;* psychological work is merely in the working hypothesis stage, though by no means at the worked out hypothesis end.

PROPOSITION I.

That the material universe may be regarded by us as eternal (though varying in aspects), and the fountain-head of all our *sensuous* impressions.

PROPOSITION II.

That accepting the doctrine of evolution the mind has evolved from the merest crude sensations of the amoeba to the complex and subtle sensations of the master artists of today.

PROPOSITION III.

That in the course of this evolution there arose the sensation and perception of the beautiful* and this emotion was followed by acts intended for ornamentation of their persons or homes.

*According to Darwin this is a fact first noticeable in birds. (Emerson)

PROPOSITION IV.

That from this germ developed the sense of the beautiful until in civilised man this appreciation of the beautiful may be divided into three steps:—
1. That of sensation.
2. That of perception (intellectual).
3. That of emotion.

That these three be three distinct processes, yet are they one—indissoluble. . . .

PROPOSITION XVI.

That though photographs are sometimes more beautiful than art, they never equal Nature when she sings in tune. Indeed, I submit that when Nature "sings in harmony" she is more beautiful than photography or art, unrivalled in her delicacy, fineness, and distinction.

PROPOSITION XVII.

As for these propositions, gentlemen, I do not intend to fight over them, for they are *propositions,* and therefore no fighting matter, but provisional until psychology shall either prove or disprove them.

I offer them to you frankly and trust you will deem them worthy for your consideration, after which I leave you to accept or reject them, as your honest judgment dictates. At any rate, they may prove interesting to some of you, at least I hope so, for they are an attempt on my part to solve what has long been a vexed question, a problem to which no satisfactory or *rational* solution has hitherto been offered.

Considerable discussion followed:

MR. T. BOLAS said the meeting was under considerable difficulty in having read to it—necessarily somewhat hastily—a paper involving a great deal of thought, and it was no reproach to Dr. Emerson to say that, in some respects, his phraseology was not easy of apprehension. Any man who thought a great deal, and thought earnestly about a subject not commonly discussed, almost necessarily expressed himself in phraseology difficult to others. Although it was impossible adequately to discuss the paper at the present time, it enabled those who had studied Dr. Emerson's previous remarks to understand the full bearing of his recantation. He ap-

peared to have changed his fundamental views, but not what might be considered his practical views as to methods of working. . . . The writer of the paper had dealt with the difficult question as to whether the beautiful was objective or subjective. Most constructors of paintings and frequenters of art schools would say, quite confidently, that beauty was objective and not subjective; but among careful thinkers the subjective view is more common. . . . The tendency of thought was gradually verging very much towards subjectivism, and the idea of subjectivism ran all through Dr. Emerson's paper, and from that point of view it was very interesting as corresponding with the tendency of philosophical thought at the present time. . . . It would be hardly possible to fully understand the paper until it was printed and could be examined at leisure; in the meantime, there were a great many ideas in it which he thought were quite new in the field of art criticism.

Mr. W. E. Debenham said that in the early part of the paper—in which, presumably, Dr. Emerson recanted his recantation—the author had referred to photographs out of focus "to the extent that structure must not be destroyed." He [Mr. Debenham] thought that insofar as a photograph was out of focus structure was destroyed, it would be necessary to provide a definition as to how far sharpness was to be wanting before structure was destroyed. A gentleman had once shown him one of Dr. Emerson's photographs and, covering a portion of it, had asked, "Now, what is *that?*" referring to a particular part. Judging from the background and the rest of the picture, the portion in question was a tree, but it would have passed just as well for an old broom—the structure was so completely gone. . . . Then it was said that a truthful representation of Nature was absolutely impossible on a plane surface, and the instance was given of seeing round the reeds. Of course, that condemned pictures of all kinds, paintings and photographs together. But were they to be condemned because with two eyes the reeds could be seen without obliterating the background? If so, they were brought to this; that photography was the only means of representing Nature truly, because a stereoscopic photograph removed the objection; but he had never heard it claimed that stereoscopic photography was particularly true to Nature. Finally, Dr. Emerson said these were not fighting matters. Why not? Because they were propositions? Why should they not be "fighting matters"? It was absolutely unreasonable.

The Rev. F. C. Lambert said he was unable to tackle at once a paper covering so wide a field, and calling for previous and very careful study. . . . The subject matter at first glance seemed to resolve itself mainly into this, that because the photographer placed between his brain and what he saw something which Dr. Emerson

was pleased to term a "machine," therefore the product had no stamp of individuality upon it. Did not this argument hold good just as much with respect to the painter, who used a brush, if it was to be chiefly a question of the invention of tools?

Mr. Birtacres remarked that Dr. Emerson had said that given a certain view, half a dozen photographers would produce exactly the same result from it; he was at issue with Dr. Emerson as to that statement. Half a dozen photographers would have half a dozen ideas as to the way in which the view struck them as a picture, as to what conditions of light would be most suitable, what would be the best exposure to give, and so on, . . . the consequence would be that the representations of two photographers would differ as widely as those of two painters. . . .

Mr. T. R. Dallmeyer said the question of differential focussing laid down by Dr. Emerson was a reasonable matter, because if one looked at any particular point concentrating the eye on it, that point was emphasised and everything else was duplicated, and this was in accordance with physiological law. . . .

Mr. Pringle . . . called attention to the fact that in Dr. Emerson's former vocabulary "decorative" was a term of opprobrium. . . . In spite of all the changes of position that Dr. Emerson had displayed, the fact remained that the photographic world owed a great debt to him. Few would deny and none could deny with truth, that Dr. Emerson did a very great deal not many years ago towards turning the attention of photographers to the attainment of improved artistic results. It was quite true that many who were more or less his pupils and disciples had thrown him overboard and did not admit allegiance to him; but the fact remained that he did undoubtedly inaugurate a great improvement not only specifically but generally in photographic work.

Colonel Gale said it was very pleasant to find Dr. Emerson coming out of his seclusion, but he was afraid that while there he had learned some hard terms and phrases. He was disappointed to find Dr. Emerson still comparing or contrasting the painter and the photographer, of which he could not see the necessity or the desirability. Photography had its own independent course to pursue, and could be carried on and stand on its own merits without reference to the painter's view of things. . . .

The President confessed himself only a maker of photographic maps, of the country or the face as the case might be, and he left the rest to those who had time and brains for it. Whatever might be the outcome of the discussion as to naturalistic photography, Dr. Emerson himself was the outcome of it; he had come out of his shell, and they hailed him as entering once more into the photographic ranks. They all knew the beautiful things he had produced, and the

marked effect he had had on photographic art from the time when he first gave vent to his views and showed his pictures. Whether the school he had influenced was going to last was for the public to determine. For himself [Captain Abney] he was quite content to take sharp photographs and leave the "fuzzy" ones to take care of themselves; perhaps the "fuzzy" school would some day go to the wall, and then he would be in the fashion again. . . .

A vote of thanks was accorded to Dr. Emerson for his communication, together with an expression of regret at the cause which prevented his attendance, and also to Mr. Dallmeyer for reading the paper.

By Easter, 1893, Emerson was back from Florida and—though out of training, having been in the house all winter writing—accepted a challenge from a world he thought he had put forever behind him; he rowed in a four-oared galley from Dover to Broadstairs. A few weeks later he rowed in a fixed-seat four from Herne Bay to Broadstairs. Naturally he was one of the founders of the Broadstairs Rowing Club, was soon elected Captain, and got together enough money for two racing galleys; then he began whipping his crews into shape.

Meanwhile he wrote some short stories and went into training for the Broadstairs Regatta. There he rowed a pair oar in one of the wherries lent out by the fishermen, he and his partner easily winning first prize. Afterwards he went back to the Broads for a last cruise in *The Maid of the Mist,* which he later sold.

That autumn of 1893, he began *Caóba, the Guerrilla Chief,* sometimes subtitled *A True Romance* and sometimes *A Tale of the Cuban Rebellion;* this of course was based on his own Cuban experiences. *On English Lagoons,* his fifth album, plates etched and printed by himself, appeared and was greeted with the applause it deserved. During the next year, 1894, *Welsh Fairy Tales* and *Tales from Welsh Wales* were published.

In the spring he readied his crews for the south coast regattas. The first boat, in which he himself rowed third, captured five prizes, and the second boat, the Novice Challenge Cup at Brighton Regatta. They were much stiffer races than those of the Inter-University Race—over the ocean, on courses of four to six miles, half of each against the tide.

Emerson, as Secretary of the Broadsides Regatta, organized a very spirited and successful regatta. He and a friend, also an old Cambridge man, started out in a pair-oared galley in seas so rough that many small yachts dared not sail. His partner had never rowed in such seas before and his stroke was timid.

They fell far behind. Emerson took a moment or two to curse out his partner, ending with, "What the h— does it matter if you *are* drowned?" It worked as it had for the steamboat and clippership mates; his friend, challenged to the bottom of his courage and probably now more afraid of Emerson than of the seas, put his full power into his stroke: one by one they passed the other boats and won, a minute and fifteen seconds ahead of the next boat. It was Emerson's last feat in competitive sports.

Then Broadstairs, perceiving what a remarkable man was living amongst them, scenting the reformer and believing his energy inexhaustible, asked him to stand for the district. No, said Emerson, because he was leaving the district. Why? Obviously he loved Claringbold, loveliest of all his homes, and Broadstairs itself and the sea below. Because he felt he was already wasting too much thought and energy on uncreative matters, and that politics would be all-consuming? In any case, in January, 1895, he moved to Lowestoft, occupying the corner house of a row of tall stone townhouses; already a member of the Royal Corinthian Yacht Club, he joined the Norfolk and Suffolk Yacht Club, doubtless continuing to sail.

Both Robinson and Emerson wrote for *The American Annual of Photography* for 1895. Robinson is talking from the point of view of the Linked Ring, a society formed in 1892 by himself, H. Hay Cameron (Mrs. Cameron's son), A. Horsley Hinton, and ten others, whose names today are less remembered. Its aim was international: to bring together photographers who were fine artists from every country. Alfred Stieglitz was elected in 1894 and resigned about 1908. The society held annual Photographic Salons. Even if they had wanted him, they would not have dared ask Emerson to be a founder. His answer might too easily have been a lightning blast.

Robinson, however, in his article for the *American Annual,* pays a curious tribute to Emerson:

. . . now-a-days, it requires something more than earnest individual effort to call effective attention to any matter whatsoever. If an angel came down from heaven it would be necessary to advertise him. In the case of art photography something less ethereal and more in the nature of a revolution, or an earthquake, came to the rescue. This happened five or six years ago, when Dr. P. H. Emerson published his "Naturalistic Photography." This remarkable book—not only the teaching but the robust language, the excess of energy of which was induced possibly by extreme sincerity—was strongly opposed, by no one, perhaps, more vehemently than by myself. The author's hard words broke no bones, and he shortly withdrew the book from publication; for Dr. Emerson is one of those very rare brave men who have the courage to be honest, and not ashamed to frankly withdraw as altered opinions dictate.

But the upheaval was of infinite value to the progress of the art, if not exactly in the way the author intended. During the controversy I wrote as follows, according to opinions I have always held: "Good fruit sometimes comes from the rankest soil; out of everything good may be extracted; and out of 'naturalistic photography' may come a reaction against that excessive sharpness of focus, which is still dear to the amateur and professional alike; and against which photographers who practice art have always protested."

This has happened, and more has followed. The animated discussion is to a great extent answerable for the much greater attention that is now paid to photography as an art all over the world; the art is placed on a firmer, broader and more catholic basis; and the "New Movement" in the art promoted by the organizers of *The Photographic Salon* is perhaps a far-off effect of the artistic disruption of a few years ago. And I think I may truly add that out of the preaching of many dogmas has come universal freedom. The sharpest photograph, so that it shows artistic feeling, is as welcome as any other variety of the fruit of the camera.

Emerson's contribution to the same *Annual* was "What is a Naturalistic Photograph?"

1. A PHOTOGRAPH true to the sentiment of Nature.
2. A photograph giving the visual *appearance* of things as truly as possible.
3. A photograph in which the *foci* of different planes is so arranged as to help give this truthful appearance.
4. A photograph that is decorative, in addition to the above qualities.

A NATURALISTIC PHOTOGRAPH

is not merely a photograph with one plane sharp and the rest fuzzy, as asserted by the muddle-headed idiot.

Is not merely a blurred view, as suggested by the incompetent operator.

Is not every photograph printed on mat surfaces, as suggested by the unintelligent.

Is not a "fuzzy" thing, as hinted by the back-biter.

A naturalistic photograph requires a man of strong artistic sense to produce, and a refined artist to appreciate, but it is doomed to the sneers and contumely of the Chicago and purely British section of the photographic press Philistines who have sneered in their day at Whistler.

This was accompanied by the first portrait made, November, 1893, with Dallmeyer's new long-focus lens, "Portrait of a Lady": the head and shoulders of a very young, round-faced lady, exquisitely dressed in white, with a little smile as if about to speak, and the wind in her short curls that gray day.

Early in 1895 the Royal Photographic Society awarded Emerson its highest honor, the Progress Medal, the first ever given for artistic achievement. Photographers were not going to let him go.

Birds, Beasts and Fishes appeared this year, and so, later, did *Marsh Leaves,* the most exquisite and the last of his albums. In this he returned to the silver-gray of the platinum prints in *Life and Landscapes,* and the plates show an uncanny ability to attain the mood and feel of mists, smoke and fogs, of the brilliance of the sun on the water and in the melting frosts of early morning. It does not seem possible that these images were made in 1890-91; he seems to have entered a whole new period of the perception of form, detail, composition. He belongs with Monet and the Post-Impressionists and even anticipates much later periods in art—the early Abstractionists, for example.

The text, being a collection of short stories of varying power, does not equal those of *Wild Life* or *English Lagoons;* he does not make the stories build into a strong climax. But, oh, if he had only gone on with the photographs! He was on the verge of creating a

new movement at least as important as his "Gathering Water-lilies," nearly a decade earlier.

Perhaps his oldest daughter, Sybil, was right when, in answer to my question Who was the great artist who dissuaded him, she wrote her brother, Colonel Sir Ralf, producing the Whistler note and adding, "I think that when PH had got to the bottom of anything his interests went to something else."

Did Emerson feel he had conquered photogravure and had said all he had to say in photography? All he says he has done since 1891 was to test new lenses, such as Dallmeyer's admirable new long-focus; Colonel Sir Ralf says he spent much time making stereos—avoiding the blocking effect of the reeds?—and writing adventure stories. His letters to Stieglitz, however, prove he never lost his interest in photography, its trends, techniques, instruments or personalities.

While at Lowestoft, he made the acquaintance of a Colonel of the Royal Engineers, who was keenly interested in genealogy. Emerson had lately received a letter from an American cousin inquiring into the English antecedents of the Emersons, and the Colonel persuaded Emerson into doing the research necessary for a book on *The English Emersons*. This was to occupy Emerson for three years, and he called it "penal servitude." Genealogy was a fad at that time, and led to the founding of many ancestral or "patriotic" societies, especially in America.

But Emerson had to have physical outlets to endure such an uncreative literary life. He tried the popular pastimes, bicycling and golf, and disliked them both. Bicycling, he said, meant merely "dust, horse manure, and ragged hedgerows," and golf "an excuse for a walk." Repeatedly asked why, being an excellent botanist, he did not write more about wild flowers, another current craze, he answered that they excited him only when in masses of color—that he like flowers as works of art, and that "this weed admiration is mere hysteria."

But he couldn't stand Lowestoft any longer, and in April, 1896, moved to The Nook, Oulton Broad, close to where George Borrows' Hall had stood. Here again he could watch and listen to the Broads in all seasons, and the boathouse was reached by narrow channels through the reeds.

He commissioned a Daimler launch, which he christened the *Wagtail* after his favorite bird, but being used to the *Maid* he found her build awkward for the Broads and her motors uncertain (he was probably no mechanic) and soon sold her.

Caóba, the Guerrilla Chief came out in 1897 and was quickly in second printing. The next year, 1898, came *The English Emersons*, privately printed. In its Foreword, Emerson apologizes for the amount of time and space he has spent on "the Massachusetts Emersons."

The writer hopes he will be forgiven the importance he has given to the Ipswich, Massachusetts, Emersons, but he feels that that family has done perhaps more for humanity than any other branch, in that they have the proud distinction of being amongst the original English conquerors of America (for this English conquest was a far nobler and greater conquest than the Norman conquest, and its influence on civilization incalculable . . .) Besides, many of the members of this family have fought for their country, whilst a great many others have, from the earliest times, done much to shape the intellectual thought of the keen-witted citizens of the United States of America; and, above all, there has never yet been a *single* member who has dishonored the name. Sacrificing everything for freedom to worship God in their own way, they have ever maintained that independence of mind, chivalrous honor and courage which first started them in a small vessel across the great, stormy and comparatively unknown Atlantic Ocean in 1638, to settle in the wilds amongst blood-thirsty, cunning and brave savages.

Then, for the biography of himself:

The writer offers his apologies for including the biographical sketch of himself with its multitudinous photographs. But as he has often been asked for "biographical notes," he took advantage of A.A.'s kind offer to get together some *facts* to which in future he could in future refer the curious, and some of the numerous photographs he possessed, for, being connected a great deal with the photographic world, he has been, as most other photographers have been, an endless target for the "snap-shooter," and hence these pictures, which may interest his posterity.

He does not identify "A.A." Why not? Possibly because she was his wife, using "Amy Ainsworth," two of her names? That would have been against the code of the times; only when a man was dead could his wife appear as his biographer. The academic

and athletic acheivements, which suggest someone of the old school tie, could well have amused and delighted her during their courtship. A certain vagueness about photography could mean that, finding herself with child soon after their marriage, she did not go along with her strenuous husband and learn the craft. And if, as I later suggest, she was his amanuensis from the start of his writing career, the beginning of a new work would be to her an event, a milestone, even while bearing and raising five children, running a household and performing her social duties. Like the sensible woman with a sense of humor she looks, "A.A.," if she is his wife, both appreciates and disagrees with her subject:

> It is not our purpose to write an appreciation of Emerson, but we venture to say that some books and many photographs have never been surpassed in their line, and few equalled, and that some of his books will live as literature and become better known in years to come. He would have been more popular already had he not had the honest knack of calling a spade a spade. We should like to see a popular edi tion of his books with all such "spade a spade" portions cut out, and think it would pay any publisher to print such an edition in cheap form, could he obtain the author's sanction, for plagiarists and imitators of his work are already cropping up in journalism.

And who would be more intimately concerned with the daily details, unknown to the public, which lie behind this just and true summary:

> When one reviews his past life one cannot but be struck by the strength and versatility of the man's character and physique. Truly nothing short of a Prime Minister's work would have satisfied his craving for doing.

"A.A." feels it only just to report the following, which must have been radical heresy at the turn of the century:

> Dr. Emerson's views on some matters may be of interest. In art teaching he thinks we should revert to the old apprentice system, and that none should adopt the profession unless he gives early promise of success. Literature he considers is being ruined by journalism and magazines, which bring into notoriety and hold up for admiration false gods. He feels that England will become a second-rate power, unless the present "greed for gold" is stamped out, and men learn that *noblesse oblige* has some meaning, and that wealth is the last

thing to be regarded in the estimate of a person. All weak and diseased should be forbidden marriage by law, and that for the sane and healthy polygamy is advisable. He believes in the "strong hand" in politics, and that we should hold integrity and honour beyond all other virtues, for he finds that clever and brave men are common enough, genial men abound, but the really chivalrously honourable men are the rarest and the most valuable gold of the State. Cant he looks upon as the prevailing sin of to-day, cant and petticoat government and the allowing "the fool to have his say." His disgust at the eulogies on Mr. Gladstone knew no bounds, for he regards "Professor Gladstone" exactly as did Bismarck, and says he was of the barren type that are a curse to this country—the *learned bourgeoisie*. He thinks the populace is being "over-educated," and that for the bulk of them the three R's should be taught, the clever ones alone being pushed on, and he says in rural districts about 12 per cent. of the children belong to this class. Socialism he considers a dream fit for the angels. And, finally, he believes the United States of America will be masters of the world before the year 2000, for, he says, people in this country are forgetting how to work, and traces much of our degeneracy, in this respect, to the public schools and other educational systems.

These "views" have given some critics, otherwise sympathetic, the impression that Emerson was a reactionary, a truly horrid old country gentleman, a Victorian remainder.

Now let us translate each item into twentieth-century theory and experience, and see how they look.

Apprenticeship: Do you personally know of a gifted young person, no matter of what background or possessed of how many academic degrees, who doesn't jump at the chance to work—and I mean *work*—under a master he admires? He is not by any means pursuing imitation; what he wants is control of skills, enlargement of horizons, and knowledge of that particular field.

Literature: Isn't this still true? And not only of journalism, to which we often owe our first news of some hitherto secret horror, but also of even the avant-garde quarterlies, too devoted to a single cause or person?

England: Great Britain was then the mightiest and most extensive empire in world history.

> *...Beneath whose awful hand we hold*
> *Dominion over palm and pine.*

So wrote Rudyard Kipling, once an ardent Imperialist, in his great prayer for England, "Recessional," in 1897, the year of Queen Victoria's Diamond Jubilee.

> Lord God of Hosts, be with us yet
> Lest we forget, lest we forget.

Emerson saw still further than the corruption by the "greed for gold." Who, after Watergate, will not *agree* with him that

> we should hold integrity and honour beyond all other virtues, for he finds that clever and brave men are common enough, genial men abound, but the really chivalrously honourable men are the rarest and the most valuable gold of the State.

Cant, of course, we have always with us; *petticoat government* doubtless refers to the aged Queen, and the revolt against "domestic virtues" then resulting in the moral degeneracy of the *fin de siècle.*

Education: The *learned bourgeoisie* are still with us—the loud-mouthed who took a few courses in something without gaining either breadth or depth, and now consider their opinions as the Law and the Prophets. To be found in every field and stratum of society. Most are merely bores and utterly sincere. Some are charlatans. More than the R's are necessary in the complexities of present civilization; education, from kindergarten up, is in process of revolution. The college diplomas parents once considered essential have resulted not only in dropouts but in the discovery that a good plumber makes more money than a college professor. Hence the growth of junior colleges and instructional schools in various special skills, from which the graduate goes on to work under, say, a master electrician or electronics expert.

Socialism: Probably no country in the world remains untouched by its ideals; much good has been accomplished. But the perfect Socialist nation is still "a dream fit for the angels."

America: Long before the year 2000 the U.S.A. became a world power. But Emerson did not foresee that we too would forget to work and that corruption would deeply undermine us.

Genetics: Increasingly, sterilization is recommended for the diseased, but the comfort of marriage, if they desire it, is not refused. Polygamy, whether through a series of divorces and new marriages, or a simple distaste for the bonds of marriage, is certainly with us. Emerson himself would doubtless have enjoyed polygamy old-style, as with sultans and rajahs, but the daily increasing threat of overpopulation to the mere existence of man on this planet would doubtless have changed his scientific mind on this subject.

But if Emerson, or his distant cousin, Ralph Waldo, were still with us, what spokesmen they would be for future changes as yet but dimly foreseen!

To return to the actual man:

The only photographic thing he acknowledged doing during those three years of genealogy, besides testing lenses for Dallmeyer, was, in 1897, to lead a steamerful of photographers through Oulton Broad.

Then Dallmeyer, realizing how reticent Emerson had always been about himself, and how few photographers, if any, would ever look at *The English Emersons,* condensed "A.A."'s biographical essay into a short sketch for *The Photogram,* 1899, and added his own estimate of the man and his achievements:

> Probably no man living, who has played anything like an equally important part in photography, is so little known in the rank and file of photographers as Dr. P. H. Emerson: on the other hand, there is probably no man in the photographic world of whom so much that is interesting and inspiriting might be told.
>
> Dr. Emerson, who is now forty-three years of age, has lived a life of ceaseless activity and brilliant attainment. His share in the advancement of photography is only one of the many things he has set himself to do, and his most intimate friends would hesitate to predict to what he will next turn his energies. . . .
>
> Too few such men as Dr. Emerson can photography number in her ranks. A man of the world, who has seen many people and countries, who has taken the good gifts which Nature heaps on some, and has enjoyed them to the full; one who, to use Leigh Hunt's metaphor, "has warmed both hands at the fire of life" without, however, yet betraying any apprehension that it is sinking—Dr. Emerson brought the culture of the scholar, the acumen of the scientific man, the boundless energy of the Englishman, and besides these, his own intense personality to the study of photography, and by precept and practice led it into lines from which it has latterly manifested, in some quarters, some intention of straying back to the

photo-faking of an earlier period, though its chances of recognition assuredly lie along Mr. Emerson's lines.

Of Dr. Emerson's work in the field of pure literature it is not within my present province to speak. I will only say that he has found a large circle of readers of the somewhat rare class, who can appreciate the exquisite word-painting of nature scenes and characterisation of rustic life. In an age given over to sensational or decadent literature Dr. Emerson's pen-paintings have nevertheless obtained a measure of the success they deserve, and while some may sometimes smile at his emphatic—and at times, lurid—epithets, none will lay down his books because they are dull.

During the past few years Dr. Emerson has withdrawn himself from the photographic world, and the exhibitions have seen none of his work. His determination to issue a third edition of "Naturalistic Photography," and his acceptance of nomination as a judge of the Royal Photographic Society's Exhibition indicates that his interest is not entirely dead. We may, therefore, hope that he is returning to his old love, and that sincere well-wishers of pictorial photography may again have the opportunity of gathering inspiration from his work with camera and pen.

Then, presumably in 1899, the Royal asked him for a one-man retrospective, for presentation in 1900, and also to address the Photographic Convention of the United Kingdom. If, as every author should, he had kept one of each of his huge photogravures and his exquisite albums, he probably could not bring himself to tear the albums apart nor risk the photogravures and portfolios to public show. Apparently he never kept two copies of these things, for he says he was compelled to beg, borrow or buy his own work back for the one hundred and forty prints or photogravures he finally showed at the Royal. His brief introductory speech, thanking those who had helped him and especially the Royal itself, was followed by a catalogue listing each work under its publication title, in *The Photographic Journal.*

In the *British Journal,* October 13, 1899, we read of a

DINNER TO DR. P. H. EMERSON

On Thursday evening, October 5, Dr. P. H. Emerson was entertained to a complimentary dinner by a few friends, on the occasion of his visit to London during the present month. The scene of the festivity was the Restaurant Frascati, Oxford street, and the chair was occupied by Mr. Thomas H. Dallmeyer, Vice-president of the Royal Photographic Society.

After other remarks, in the course of which the Chairman assured the guest of the evening of the very high esteem in which his name and work were held in the photographic world, Dr. Emerson's health was drunk with full musical honours.

In reply, Dr. Emerson thanked those present for their kind reception. It was some years since he had been in London, and he had taken the opportunity of visiting the two photographic exhibitions now open. He was very much disappointed with what he had seen. He could detect no advance at either exhibition, save in the framing. The R.P.S. show was certainly the better of the two. With regard to the Salon, in his opinion Demachy's work was simply imitation of that of French painters, and his fan and similar subjects were copied from the bon-bon boxes. There was no sincerity in Mr. Horsley Hinton's work, which was frequently a travesty of nature and vulgar. Dr. Emerson strongly deprecated the imitation of painters' work by means of photography. The latter, he pointed out, had a power of rendering delicacy of gradation not possessed by painters, and, if photographers only availed themselves of that power, photography would certainly hold its own.

After other toasts, a pleasant evening was brought a close in the usual loyal manner.

The reason, probably, that Emerson had come up to London after so long an absence was to arrange for the British distribution of the third edition of *Naturalistic Photography.* Brought out in New York as part of the Scovill Photographic Series, by Scovill and Adams, it had none of the elegance of the first and second editions produced in England. A coarse drawing of a man in a darkroom with the red light on filled at least a third of the beige cover.

Inside, the chief change is that all passages which claim photography is an art have been emphatically rewritten in the negative. To these he has added his lectures "Photography Not Art," "Naturalistic Photography and Art" and "Science and Art." Here and there he records a change of opinion, as that Bastien Le Page seems to him now to present only "a cockney's view of the country," and that he "has seen nearly every Corot, Le Page, Millet, Daubigny, Troyon, Courbet, Manet, Monet, and the works of other epoch makers." And that "Millet was a poet,

though he seems to me to feel colour as a house-decorator would."*

The reviewer for the *British Journal*—Traill Taylor?—regrets the exquisite format of the first editions, but hails the return of Emerson:

> . . . It is eight or nine years since the last edition of *Naturalistic Photography* was published, and no doubt, there are to-day large numbers of photographers who will make the acquaintance of the book for the first time in its third edition. Of the new readers who will turn over its pages it may be safely conjectured that a very large percentage will be ignorant of what Dr. Emerson has done for photography. Neither the man nor his work is sufficiently known to the general photographic public, and for this state of things the person most responsible is Dr. Emerson himself. In an age when any charlatan can catch the ears of the mob by persistent shouting, Dr. Emerson is content to lead the life of a silent country gentleman in Norfolk, and eschew vulgar self-advertisement. He does not go lecturing on pictorial photography on the smallest provocation or reproduce his own pictures in a newspaper, or publish never-ending lengths of penny-a-lining diffuseness upon that topic, with the most unblushing and wearisome reiteration year after year. In other words, Dr. Emerson disdains to force himself down the throats of the photographic public, and, if he thus misses notoriety, at least exchanges it for respect.
>
> But Emerson's place in the history of the development of pictorial photography in Great Britain—and, for that matter, the world—is assured. When the photo-faker and all his works have been swept into the dustbin of time, three personalities will stand forth with the greater clearness to the gaze of the student of the future. We mean those of D. O. Hill, Mrs. Julia Margaret Cameron, and P. H. Emerson. The first two in portraiture, and the last in landscape and figure work, have, in the phrase of the time, "got more out of" photography than anybody else in the interpretation of human character and the sentiment of nature. In these days of illustrated photographic periodicals, nobody interested can fail to acquaint himself with the Hill and Cameron broadly-treated portraits to the extent which the half-tone process, despite its imperfections, allows, but it is a thousand pities that Dr. Emerson's work is so inaccessible. In some of his books, notably *Life and Landscape on the Norfolk Broads, Pictures from Life in Field and Fen, Idyls of the Norfolk Broads,* and, above all, the magnificent *Pictures of East Anglian Life,* as well as in several separate plates, amongst which the dainty *Gathering Water Lilies* was more imitated than almost any other photograph we know—in these books produced with a painstaking carefulness and labour which stamp the author as a thorough genius, there are a great number of photogravure reproductions from his negatives (direct, untouched, unfaked negatives, let it be marked), which, in our deliberate opinion, form a collection of the most wonderful and faithful nature photographs that have ever been produced. Of their kind nothing today excels or even equals them, and we repeat that it is a thousand pities they are not accessible to all modern photographers. But there must be many who can recall individual pictures, and as we write we pause and think, What arresting charm and conviction there was in the always delightful *Poacher!*
>
> *Naturalistic Photography* should be considered as merely a part of the fine and conscientious work which Dr. Emerson, still fortunately a young man, and with his best working years in front of him, has contributed to art and literature. It cannot be adequately appreciated without a knowledge of the man. To his unfaltering thoroughness there is no limit. He is sincere in all that he undertakes. In a *Son of the Fens,* for example, he gives a minute study of a Norfolk peasant from youth to man's estate, derived from actual and close observation. His pictures of East Anglian life were, so to speak, sketched and finished on the spot, for the author lived and worked amongst the very people he was closely observing. So, again, in *On English Lagoons,* the record of a year's wherry cruise on the Broads, not a line found its way into that fascinating record of a natural history tour which was not the outcome of keen observation and accurate knowledge. . . .
>
> Of *Naturalistic Photography* we have before expressed the opinion that it is one of the most notable books that have ever been produced in connexion with the subject, and the new edition before us finds us of the same opinion still; but thorough justice will never be done to the author until a fourth edition is published which substitutes for some of the not very necessary chapters on technique a number of reproductions from his photographs, so that Emerson's theory and practice may stand side by side for all to profit by.
>
> In conclusion, it will be well to remind our readers that the author

*It was this edition that Beaumont Newhall, on December 14, 1935, found in a secondhand bookseller's outside stall on Union Square while waiting for one of the great early Russian movies to begin. He paid twenty-five cents for it and saw no reason not to mark it up; for instance, Chapter II, "Impressionism in Pictorial and Glyptic Art," is headed in indignant pencil, "Ridiculously ignorant and irrelevant." Robinson he knew, but he had never heard of Emerson. The great statement on pure photography hit him hard; it sounded like Stieglitz, Adams, Weston . . . Thereafter, when his duties at the Museum of Modern Art would let him, he was down in the New York Public Library finding out all he could on this extraordinary man. And so began the rediscovery of Emerson, though he never knew it and Newhall had no idea that, at nearly eighty, he was still alive.

withdrew his second edition, because he was convinced by his own researches and those of his painter friend, that no photographs give reproductions of nature as the eyes see it, and because of the impossibility of strengthening or making selected tones by development as proved by the researches of Dr. Hurter and Mr. Driffield. That is the true reason of the withdrawal of the second edition in a nutshell, and the third edition views photography from this standpoint.

Emerson's speech, "'Bubbles,' A Paper read before the Photographic Convention of the United Kingdom," was printed in full in *Photograms of the Year,* 1900. He began:

> Some of you may remember *A Study in Gum,* by an American, published in *Photograms of the Year for* 1899. It was a rather awkwardly posed girl showing a "sticky back" . . . a back that looks as though it had suffered from a bad attack of eczema, and yet we are told this is what we are to live up to, that this is an advance, that this is Art.
>
> Now, before we accept these mentors we want a reason (artistic) for changing our opinions. These gummists may shrug their shoulders and squeak and gibber for "perfect freedom," and shrilly ejaculate "Art!" but we will not accept such shifty arguments. It is useless crying liberty when there is no liberty.

By now the audience was doubtless sitting up on the edge of their chairs. They had missed him—the geyser of his idealism, thundering up in its dazzling purity, scattering its scalding satire upon the worthless and pretentious. Who else was there who told the absolute truth and nothing but the truth—granted, as he saw it? Or caused that anticipatory shiver at being possibly the next victim and that titter of amusement or gasp of outrage as the unnamed target of a diatribe was recognized in the man sitting next to you? Who else made you want to punch him in the nose one moment and clap him on the shoulder the next? Who else made you, even if still in a towering rage and feverishly concocting the most viperish riposte you could think of, feel that nevertheless some issues were clearer than before and admit to a reluctant admiration for the courage and stature of the man?

> We are hard bound by the mechanical conditions of our craft, and if these workers require that "perfect freedom" which they are always crying for, let them become artists and adopt media where there *is* perfect freedom and leave us poor photographers alone. . . .

Now, in looking at the example of fine carpentry or cabinet-making, shall we say, in which these precious daubs are enclosed and afterwards photographed, one is constrained to think that the ideal these amateurs set before themselves is to produce something like a *photograph of a painting,* and they imagine this is progress, this is art. . . .

Now, it seems to me this "gum" printing is one of the greatest bubbles floated upon the limpid stream of pure photography, or pictorial photography, or whatever name you may be pleased to call it.

Those who would have us sell our birthright for a mess of gum will, I am confident, never succeed in their object; and, when they talk to us of art, I, for one, will burst into mocking laughter at their solemn pretentiousness; and I regret to see amongst their number some who used to talk of "subtle tonality," "values," etc.—evidently gum-paint cant on their part, and I should like to know what the young woman with the sticky, diseased back thinks of the outrage. I'll warrant her back is far more lovely than such a sickly representation of it.

France has given us much in true art to be thankful for; but these *bourgeois* French photographers make us begin to wonder if the seeds of Philistinism are there, as the seeds of political and social decay are there, and strongly sprouting. . . . I, for one, hope fervently that those ridiculous travesties are perpetrated by the uneducated Philistines of that country, and a French Philistine is hard to beat. One of these scribbles a deal and causes us much amusement, and thus adds to the gaiety of nations, and gives such artists as Mr. J. Pennell a fine subject for satire.

To sum up this point: the gum process destroys tone, texture, and with it values and atmosphere; it makes the result coarse and false, and to look like the photograph of a painting—*à pis aller* . . . which no real artist is satisfied with or cares a toss about, except merely as a rough and crude memorandum to keep when he has sold his picture. . . . And, lastly, it is hand-work, and not photography.

Another bubble of less pretentious size and less objection is the "dodged printing fake," for sometimes that might come true, but it rarely does. I have been greatly amused to read, in a shilling guide to pictorial photography, that the greatest care must be taken in selection of the view, and in exposure, etc., so that the values may be true; and straightway he gives a ponderous apparatus for "faked printing". . . . His advice continues in the same vein, to "sun down" the print, and in his work he does not hesitate, by scraping the film or some other dodge, to make garish highlights. In short, his chapter on printing is a pocket encyclopaedia of how to ruin values and often textures! . . .

. . . The same issue of *Photograms* contains a print produced by

this "sun-downer," and I ask you frankly, "Is it art?" . . . I showed some of these prints to a great landscape painter, and he simply asked, "Why the fellow did them; what was he after?"

I ask the same question: If pure photography is not good enough or "high" enough for such as he [Davison], by all means let him become an artist, and leave us alone, and not try to foist "fakes" upon us.

I suppose these fakers appear in all arts—"il faut être dans le mouvement,"dear boy; "must conspire with 'notions,'" like the cheap jack: "when one stock of rubbishy goods fail, must bring out another, old friend," I suppose is the explanation. It's commerce, but is it art? It isn't photography. . . .

I do not suppose you, I, or any sane man cares one brass farthing or the proverbial "two penn 'orth of gin" what our fakers do in the faking line if they only don't pretend to us it is something new, something we are to follow—"Art, dear boy!" The British public will have the fake of retouching, and the photographer must live; but we should think him an ass did he begin to shout and yahoo that he had found the recipe—the new recipe, mind you!—the solution of the pictorial photograph—in faking.

The appreciator of the gum plaster and photo-faking is, doubtless, the type of scribbler who is responsible for foisting the sickly monstrosities of Aubrey Beardsley upon the unwary public, and for driving Mr. Whistler abroad. . . .

Returning now to the two principal Exhibitions of last year and to Photograms of 1899, one meets with the gum landscape of an American [Keiley]. A meaningless smear is said to represent Mountains in North Carolina. Now, if this means anything to anyone, I ask to be instructed. Now, it is said that Americans do things on a big scale; but, to judge by that plaster, the mountains of North Carolina look very much like a photograph of a scrubby British hedge. . . . Mr. Stieglitz and Mr. Day are the best exponents of American photography and I rejoice I've seen no gum-plasters or fakes by either, and I hope I never shall. Then we have the French school . . . another worker's theatrical and ill-posed women. [Demachy] They recall the sweepings of the worst type of Paris atelier. The chief interest is that this amateur has an island where he retires with his models, an idyllic picture that makes one long Mrs. Grundy were dead and her soul gone to Paris . . . and all along with this jumble of inanities we have the most solemn, inane and pretentious letter press by the great and original gum-splodger himself. . . .

But to continue. Of what avail is such a picture as that hung in last year's Royal, In June—woolly trees, degraded lights, impossible grass—and all to represent June, the glorious month of light and leaf. The photo looks like a miserable December evening, with the leaves as though suffering greatly from cell congestion. Another

equally bad Salon companion picture was a Gleam of Sunshine. "Subtle tonality," again, I presume—only gone wrong. As dismal a sun as one could expect in Hades.

I appeal to you, is this photography? I am sure it will not last—cannot last; and we will welcome the new parlor biographs [an early manifestation of the movies], if only as a sure and certain kill-all for all these pretentious bubbles.

A painter and I sat down one night to select, from the publication referred to, what we considered the two best photographs in it pictorially, and what think you they were? Mr. Tingley's Light Beyond and Mr. Cambell's Messengers of Death. And, lo! we found the latter was included in the Technical Section. On the other hand, the very worst in the book—to which, too, we adjudged the wooden spoon—was A Pond at Weston Green [Davison] which seemed to us to possess every ill that photography is heir to; and this to me was all the more regrettable since the producer of that abominable daub has done some beautiful things in pure photography and platino-type, and may he renounce false gods and return to the style of his saner days.

There was a time when the great bubble of sharpness enveloped the photographic world, but that has burst and the explosion thereof seems to have upset the sanity of some, who have been carried away in the explosion, and lost all reason and sense, all tone and texture, those vital and great qualities of photography.

Photograms comments in that same issue:

Dr. P. H. Emerson's paper, read at the Photographic Convention of the United Kingdom, is bound to be useful by making people think, and criticize on the basis of the faith that is in them. It is a pity that the slang of Billingsgate was introduced into such a paper; it is unwise to refer to Robert Demachy as "the great and original gum-splodger," or to Horsley Hinton as "the sundowner"; and such championship injures the cause which Dr. Emerson honestly wishes to help; but in spite of these blemishes the paper is sure to be useful. The issue of a third edition of "Naturalistic Photography" and the one-man show at the Royal Photographic Society's rooms, both indicate Dr. Emerson's returning interest in photography; and though his methods may be cyclonic, even cyclones have their values as clearers of the air.

It is perhaps a pity that the show of "The New American School" did not open before "Bubbles." This vast exhibition had been organized by F. Holland Day, of Boston, and his helpers were his young cousin, Alvin Langdon Coburn, and Eduard (not yet Edward) Steichen. All three hung a lot of each other's work. Most

of the photographers around Stieglitz had submitted their work, but not Stieglitz himself. He disliked Day, and thought him vain and pretentious, especially in the series in which he photographed himself as Christ, acting out in close-up portraits on the Cross "The Seven Last Words," for example. To England, the show was a shock, a revelation, and a success.

In retrospect, the Progress Medal, his one-man show at the Royal, and "Bubbles" appear to be the climax of Emerson's career. But the message in "Bubbles" seemed to his audience of the moment a little out of date. Though he never quite gave up photography or his connection with the Royal, he seems never again to have addressed so large a photographic audience.

AFTERLIFE
2. OBLIVION AND THE STRUMPET

But the "bubbles" Emerson had derided did not vanish into thin air. Instead, the air itself became full of "splodges," "gumplasters" and every fake the would-be imitators of painters and etchers could think up. And the bubbles proved merely the first ripples of a tidal wave of "gum" and "oil" that lasted nearly a decade. Even Stieglitz was temporarily submerged, while his protégé, Steichen, who was also a painter, became the greatest "gummist" of them all.

After the Progress Medal and the honors of 1900, Emerson's name for more than twenty years rarely appears in the photographic press. Stieglitz may mention him as a pioneer in, say, photoengraving, or Child Bayley ask why is so great a man forgotten.

He himself became more and more furious with the gauds and daubs on the beautiful face of his "pure photography," more and more bitter against the villains responsible. He went on with his beloved muse, though he never allowed a print to be exhibited or reproduced after 1900. As late as 1924, when he was sixty-eight, he could write Stieglitz: "I am a productive photographer. I develop all my own plates, including the 24 x 22's, before photography is made fool-proof." What has happened to all those negatives? And the prints he could not have resisted making? What happened too to the sermons and diatribes he must have written? Would no magazine print them? Or, as with his photographs, had he clamped him formidable will down tight against releasing them to an inimicable world? Nearly all his letters to Stieglitz are marked *"Private and Confidential,"* as though only to his closest friends — and possibly only to Stieglitz — could he let out his pent-up wrath and ever blacker contempt.

What has happened to his own albums and prints, his books and papers? To the MS. and illustrations of his history of artistic photography? Recent attempts to reach his descendants have so far proved futile. Therefore, at present, all we in America have for documentation of the years 1900–1924 is the sparse press notices and the letters Emerson now and then wrote to Stieglitz, in the Stieglitz Archive in the Beinecke Library at Yale University.

There are thirty-seven of these letters, dated from 1888 to 1933. They come in gusts, often ten years apart, and every gust is from a different address, as though Emerson were incapable of taking root, no matter how charming the place. Some of these moves may have been due to fluctuations of health or income; more often he seems to have exhausted the potentials of a place for him and sought fresh woods and pastures new.

The letters themselves must rank high among the hardest-to-transcribe letters in English. Emerson uses not only abbreviations but hieroglyphics: for instance, two squiggles which only time will help the transcriber distinguish as "I," "you" or "yours." There is a right angle with a wiggle-tail that usually means "in" but can also mean "the" and a number of other things. One saving grace is that the first paragraph is fairly clear, so the subject at least is known. But then, as his mind begins to race, so does his pen, until he hardly bothers to articulate even the first letters of a word and then trails off in an insufficient number of wriggles to stand for the letters intended. Many transcribers have given up in despair, and so, in hopeless cases, has this one. But sometimes, going at these mysteries again and again, a kind of ESP descends or possibly an angel from heaven takes pity, and suddenly the disconnected words, names, and phrases make sense. Or so one

5 Lascelles Mansions
Eastbourne
Sussex.

Dear Stieglitz
May 30: 1924

The weeks roll on — I am receiving parcels of prints from all parts of the world + yet I do not even get a reply to my question. Are you or are you not going to send me some prints — "Portraits — Sky Songs + landscape lately that barn with melting snow. If not please tell me + then I shall know where I am —

I had a parcel from Davison yesterday —

Faithfully & P. H. Emerson

Be a sportsman + give us a chance! — hallowed virtues have no merit

hopes; it will surprise no one who has attempted these transcriptions to find a later, clearer reading—or that it was certainly no angel who inspired that "translation." *Traduire c'est trahir:* "To translate is to betray"—an axiom among those seldom appreciated, highly dedicated people called translators.

This brings up the question of who was his amanuensis in those days of no dictating machines and few typewriters? Who made readable that great spate of articles and books? Someone, certainly, who knew him and his handwriting well and was close enough to ask questions. His wife? She must have coped with her father's hand, and, as a Grey Sister, with those of other doctors.

Did she begin with his first book, written during their honeymoon, *Paul Ray at the Hospital?* Lacking her or whoever it may have been, future transcribers might do well to consult a pharmacist or druggist—or, in British, a chemist or apothecary.

The letters tell us little about what Emerson was doing; they tell us how he felt. And, as noted before, we do not yet have Stieglitz's replies in his own calligraphy, one of the most beautiful and powerful in the history of handwriting. The one letter in the Beinecke from Stieglitz to Emerson was typewritten, and therefore we have still a carbon.

To understand these letters, of which we have only Emerson's

side, we must attempt to understand the curious relation between the two. Emerson had discovered and acclaimed the young Stieglitz, true. (By the way, he was only eight years older than Stieglitz.) Stieglitz was to go far beyond him into seeing life through photography and art, yet still Emerson had gone before him, calling for "truth to Nature," for the unconscious, natural pose, for the moment when light, landscape and the activities of men fused together, or when a cloud, a tree, a house, a face was suddenly revealed as a symbol of human experience. In exhibitions, again, Emerson went before him, insisting on beautiful prints on fine paper, simply framed — and if the prints were not worthy of hanging on "the line," why hang them at all? Publications the same: fine platinum prints carefully printed, mounted on good paper and protected by delicate tissue, or gravures made under the photographer's eye, equal to original prints in the opinion of both, and many others. Emerson learned to photoengrave, set up his own press and printed his last books himself. Stieglitz became a professional photoengraver, specializing in three colors. Both insisted on beautiful books, bindings and typography — necessarily expensive, though neither was in business for money. Emerson founded the Camera Club in London, the first important amateur club in England; Stieglitz welded together two desultory amateur societies into what became the mighty Camera Club of New York. At this point, these two great masters begin to part. Emerson's prepared *Nature and Art* never materialized; Stieglitz, having been an editor on the staff of *The American Amateur Photographer,* went on to edit four more magazines: *Camera Notes, Camera Work, "291"* and *MSS.* Emerson never ran a gallery; Stieglitz ran The Little Galleries of the Photo-Secession, which became the astounding "291," and later The Intimate Gallery and An American Place. At the galleries, during the winter seasons, he was there, ill or well, from 10:00 to 5:00. When he could, he photographed New York City, the harbor, the streets, the rising skyscrapers, often in storm or night, often from his windows. During the summers, up at Lake George, he photographed the house, the lake, the barns, the trees — people in the water, on the porch, in a rowboat — until he was too weak and ill, at seventy-three, to set up camera any more.

In spite of the long silences, Emerson seems to have had a proprietary, even familiar feeling about Stieglitz, as if he were, photographically speaking, his son, or perhaps an erring nephew in need of a strong dose of the truth at certain times. It is doubtful if he ever realized how far his "son" had outrun his every dream.

The differences in temper and temperament between them widened as they grew older. Emerson, after his unnecessary self-crucifixion on the cross of art — a man of high integrity and courage, he *had* to do it — could not, thereafter, ever chop and change; the Calvinists behind him forbade any backsliding. After his discovery of a new world and its beauties, his battles for it, his endurance of all the verbal sticks and stones which can do worse than break bones — a broken spirit and heart may never heal, but the breaking had been his own act — from then forward he pursued a steady course, no matter how ominous the sky, how dire the storms.

Not so Stieglitz. Impossible to defeat this man. Stieglitz too fed thousands on the loaves and fishes of his spirit; he too was hailed in triumph; he too had his crucifixions — which turned into transfigurations. He believed in life and art as its greatest and purest expression, and whether the expression was photography, or African sculpture, or children's drawings or Picasso, or Brancusi, or Gertrude Stein, or Ernst Bloch in music, or the faithful service of Andrew, his matter and framer, it was no less life and art.

Stieglitz in his old age commented that his life had been a series of secessions. By that he did not mean the Civil War, the War of the Secession; he meant something much closer to a revolution of the spirit of the times. A brief, occasional sketch of these secessions may be helpful to those who do not know the life of Stieglitz, since they illumine the unknown later life of Emerson.

The first was not of his making. In 1890 Stieglitz was studying in Vienna with Josef Maria Eder, the photo-scientist, when his mother, heartbroken over the death of a daughter, begged his father to call Alfred, their first-born, home. Stieglitz did not want to go; he loved his life in Europe, he had just won a scholarship and the future in photography looked bright. He went, in August, 1890.

Emerson, preparing for his year on the Broads, wrote him:

I congratulate you on the scholarship — Bravo! We are all winning around here and soon everybody will be a Naturalist. I hope to see

you working with Beach on the American A P when you get back. . . .

I hope you will get a publisher in Germany. I am preparing the *3rd ed* which will be published in the spring. I would rather you published a German translation from that as there are important alterations, not of principles but of matters which further confirm my teachings. . . .

And after that note, silence for twelve years. Why?

When Stieglitz got home, he found his parents insisting that he go into business, marry, and settle down. There was nothing he wanted to do less; he wanted to be free—free to wander and to photograph, experiment, perhaps run a magazine and assemble exhibitions of the most exciting and beautiful photographs. Nor, as he maintained all his life, did he feel man enough to assume the responsibility of a wife and family.

Then his father bought an interest in a company which was to be the first in America to develop three-color gravure. What better business for Alfred, with his fame as a photographer and his training under Vogel and Eder?

Was it at this point that he wrote Emerson that, being no longer in Germany, he could not easily find a German publisher, and that, with his present schedule, he could no longer take the time to do a translation? The truth was, of course, that he had lost interest in the idea. And Emerson, probably off on the Broads and wrestling with the problems that led to "The Death," undoubtedly felt this and was a little hurt.

This is pure conjecture; Stieglitz may never have written at all. But he said he felt differently about Emerson after "The Death," as if he had been false to his own ideals, in which Stieglitz still passionately believed. He himself, after Vogel and Eder, took H&D in stride and went on to push the medium beyond its then accepted limits—into night, rain, and storm.

Meanwhile, he became a professional photoengraver, making and printing the first three color gravures in the country—an invaluable experience.

In July, 1893, Emerson's wish for him was fulfilled: his name appeared on the masthead of *The American Amateur Photog-*

rapher. All went quite well until Stieglitz devised a rejection slip worthy of Emerson: "Technically perfect; pictorially rotten!" This worried Beach a good deal; he felt he was losing subscribers. Stieglitz felt it was a good way to get rid of the dabblers and the fuddy-duddies who cluttered the American pictorial scene.

In 1895 he seceded voluntarily for the first time: he said he was "tired of doing business with a lawyer on one side and a policeman on the other," and left the gravure company to his partners. The next secession was from *The American Amateur Photographer.* Beach published a copyrighted photograph without permission, was sued and forced to disclose his true circulation, which was a good deal smaller than he claimed for advertising purposes. Stieglitz resigned in disgust.

All this time he had been making photographs, winning medals (some one hundred and fifty in about a decade), writing articles and reviews. In 1894 he had been elected to the Linked Ring, then regarded as a great honor. Since, like Emerson, he never had to work for a living nor accept a job for pay, and now that he was free, he decided to do something about the desultory state of American amateur photography.

He welded together two clubs, one of which was thinking of becoming a bicycle club, into the Camera Club of New York. He refused the presidency but accepted the vice-presidency, saying he thought he could make the post more than a mere figurehead. Still, nothing seemed to happen creatively, so he asked the Club to let him take over the monthly bulletin they sent out free to each member; he had in mind a quarterly to be called *Camera Notes.* Each issue would comprise a thousand copies, and outsiders could subscribe for a dollar a year.

Camera Notes speedily became the most exquisite and exciting periodical of its time. Europeans began talking about it and subscribing; soon its first numbers at auction soared in value. It made the Club famous. And Stieglitz, traveling around on his frequent judgeships, began bringing back gifted unknowns who in turn brought others; he, for instance, found Clarence H. White, of Ohio, and White found Edward J. Steichen, of Milwaukee.

Soon, it seemed to the original New York members, more of the Club's exhibition space and more of the pages of *Camera Notes* were being given to these outsiders than to themselves.

Their protests mounted until, in 1900, Stieglitz resigned as vice-president; in 1902 they fired him as editor of *Camera Notes,* which speedily collapsed.

Having recently been asked by the National Arts Club of New York to organize an exhibition of photographs, Stieglitz chose his favorites with no club to hold him back. He felt strongly that both the contents and the title of the show should constitute a declaration. Thinking of his friends, the painters in Munich and Vienna, who called themselves the Secession, he suddenly had title and theme—The Photo-Secession! Asked who belonged, he said, "Yours truly, for the moment. But there will be others."

The show was an immense success. And *Century* magazine asked him to do some articles on photography.

How much of this did Emerson know? The main events, probably. If he did not personally subscribe to *The American Amateur Photographer* and *Camera Notes,* he could peruse them, whenever he went to London, at the RPS. But it was in the October 1902 number of the *Century* that he got a shock.

In his second article, "Modern Pictorial Photography," Stieglitz began:

> For some years there has been a distinct movement toward art in the photographic world. In England, the birthplace of pictorial photography, this movement took definite shape over nine years ago with the formation of the "Linked Ring," an international body composed of some of the most advanced pictorial photographic workers of the period, and organized mainly for the purpose of holding an annual exhibition devoted exclusively to the encouragement and artistic advancement of photography. This exhibition, which was fashioned on the lines of the most advanced art salons of France, was an immediate success, and has now been repeated annually for nine years, exercising a marked influence on the pictorial photographic world. These exhibitions mark the beginning of modern pictorial photography. Exhibitions similar to those instituted by the Linked Ring were held in all the largest art centers of Europe, and eventually also in this country. America, until recently not even a factor in pictorial photographic matters, has during the last few years played a leading part in shaping and ad-

vancing the pictorial movement, shattering many photographic idols, and revolutionizing photographic ideas as far as its art ambitions were concerned. It battled vigorously for the establishment of newer and higher standards, and is at present doing everything possible still further to free the art from the trammels of conventionality, and to encourage greater individuality. . . .

He continues by telling of the acceptance of photography in various art salons, ending with the ridiculous tale of the Champ-de-Mars in Paris accepting ten of Steinchen's photographs along with his drawings and paintings, and then, on learning they were photographs, refusing in horror to hang them. Stieglitz goes on to praise the expressive qualities of the manipulative processes, and lists the leading photographers of Austria, Germany, France. Then:

> Great Britain, too, has her photographic celebrities, who have done their share in furthering the movement in pictorial photography by the individuality displayed in their work; the foremost are J. Craig Annan of Glasgow; A. Horsley Hinton, George Davison, Eustace Calland, and P. H. Emerson, of London.

Imagine Emerson by this time! Stieglitz must have been in great haste and at crisis in his own affairs to be so careless and thoughtless. And he did, at this time, disagree with Emerson, as the last paragraph proves:

> It has been argued that the productions of the modern photographer are in the main not photography. While, strictly speaking, this may be true from the scientist's point of view, it is a matter with which the artist does not concern himself, his aim being to produce with the means at hand that which seems to him beautiful. If the results obtained fulfil this requirement, he is satisfied, and it is to him of small consequence by what name those interested may see fit to label them. The Photo-Secessionists call them pictorial photographs.

Emerson's expostulation is more than usually illegible; someone has interpolated between the lines a kind of translation. Stieglitz, knowing what an indomitable fighter he had roused against him, undoubtedly wanted to know what next.

Ailsa Lodge
W. Christchurch, Hants.
1/10/02

Dear Mr. Steiglitz

I see an article of yours in this month's Century in which you are
good enough to remember my name. Knowing you or rather your
career as I do I feel sure you are the last man to falsify history.
You have been imposed upon as have a good many others by push-
ing and unprincipled charlatans. Of all the names you mention as
having made modern photography the only one besides my own
which has any claim is that of Mr. Davison, who was a follower
of mine in company with Mr. Graham Balfour, Mr. Colls and others
but who wandered afar [?] the battle and.... [Davison became an
anarchist] and found his congenial home of art in commerce in the
Kodak Co. As for the counter-jumper Hinton . . . he is a charlatan
who has openly confessed to several of us that he made . . . so-called
art-photographs for the £.s.d. he could get out of them.

Nearly everybody . . . long since has found him out and if I may be
permitted to say so you are misrepresenting history and misleading
people when you write as you do of these people. When I come to
write the whole inner history of the whole business you will I am
sure regret that you have allowed youself to be humbugged by
charlatans.

I must ask you to consider this letter as private and only send it
to you out of your young honesty of purpose and enthusiasm, which
I for one consider wasted on a dead cause.

Faithfully yours

P. H. Emerson

A. Steiglitz Esq.

Stieglitz, when this had finally been deciphered, must have been
aghast at his own thoughtlessness. How could he get so caught
up in the whirlwind of his own recent affairs as to forget what
Emerson had done for photography and, for that matter, him-
self? He must have rushed to get off a letter on the next boat.
But in those days mail took two weeks to cross the Atlantic,
so that a reply, even posthaste, could not be received by the
sender under a month.

Emerson's next letter, again from Christchurch, is dated
26/11/02.

Thanks for your letter. I felt sure you wished to give *facts*, but you
see you have been away from the center of the storm.*

Davison up to a certain period (when he had learned my methods,
which I have letters of his acknowledging) did help on the cause—
then he was too vain and too ignorant to pursue the very legitimate
means of experiment in pictorial—and he joined the charlatans and
did more harm than good. Hinton came into the business a good
deal later than Davison—had nothing to do with the development
of Naturalistic Photography and struck [?] a meretricious, usually
faked landscape which for a period here surely amazed the ignorant
press man Gleason White—a little bookseller who came to his new
home (at Christchurch) and who is a dabbler and scribbler intro-
duced to the press of an artistic friend of mine who always smiled
at his reputation when he set it.—But no serious artist ever con-
sidered being any maybe . . . than the 1000 and 1 scribblers who
lie and throw pens. Eustance Calland never did anything to merit
his name being remembered and I say this to you although he came
before Davison and who has always been honest—among the true
aesthetes [?] of those who gave it up in disgust. He was Louis
Stevenson's cousin and a high classical scholar . . . and if I say so
my pupil before Davison took up with Nat. Photoy. If you will
permit [me] to say so I have always considered you as man and
honest and you must of course follow your own impulses. I perhaps
have been able to plumb the depths—or rather shallows—of
Pictorial Photography sooner than others through having a lot of
real big artists as friends and I assure you it is a dead cause. I can-
not go into full details in a letter—but my *last* edition of Natural-
istic Photography which I have *not discarded* ought to explain all
to you if you are not impatient of carefully weighing the other side
of the question.

The chief people are included in every [?] Pictorial Photography
by the editor of the A P and as he confessed to us he did it for money
you can see what his communications [?] are worth and Snowden
Ward also as anyone can tell you does it for some trading pur-
poses. . . . I remain honest and unprejudiced ever. . . . The only
use I can see in anything is many proofs [?] to guide the young
professional so that he will not produce the frightful things of years

*Obviously Emerson had so lost touch with America that he was unaware
that the "storm" had moved from London to New York, and that Alfred
Stieglitz was its "center."

ago—how few a man of brains like yourself—You will I feel one day agree with me that you have banked [?] your talents on a *Strumpet*!—i.e. pictorial photography.

I would not take the trouble to tell anyone to escape that I know I personally have influenced it is a dead cause (a lie a few now have found out for themselves) but when I feel I have influenced anybody I feel a sense of responsibility. I wasted some of the best years of my life and for me a lot of money on the Strumpet. . . . Had I been able to produce a book like my own Nat. Photoy. (last ed.) I should have. . . . in for it and been in a very different position than to-day. . . .

Kindly regard my letter as private and wishing you a speedy enlightenment so that no more years may be wasted.

Believe me—yours faithfully

P. H. Emerson

If you honor me with any more letters yourself, kindly address as above and not c/o the Royal Phot Soc—

Finally, the first number of *Camera Work*, dated January, 1903, but delayed by Stieglitz's insistence on perfection, was ready. Crews of Photo-Secessionists had worked days and nights around the Stieglitz dining table, tipping in the superb gravures of Gertrude Käsebier's portraits and Stieglitz's "The Hand of Man" and the branch of baby birds, each subtly toned to be as close as possible to the original. The response to the announcements had been gratifying.

Stieglitz had sent a copy off to Emerson, together with a letter which may well have summarized what all photographers and photoengravers owe to him and how much *Camera Work* itself was due to his pioneering efforts. Beyond doubt, it also contained a plea for more legible handwriting.

Emerson's reaction is curious. He does not note the Käsebiers nor "The Hand of Man," he does not comment on the quarterly's exquisite qualities—the soft gray cover, with Steichen's design for the title in a paler gray, the delicate tissues protecting each gravure, the rich paper and distinctive typography. None of these could he have missed, after the books and portfolios he had himself designed and produced.

Dear Mr. Steiglitz

Thank you very much for your kind letter and No. 1 copy of your new venture. I must apologize to you for my infirmities—calligraphic—a friend of mine gets in a blacksmith to help him. *Verb: sap.*

But if I may be so bold what do *you* in the company of Hinton, Child Bayley, Demachy & Co. [He is pouncing on the Foreword, which lists their names among its supporters.] I always placed you higher far than these, and if the Strumpet is still a Circe toward [?] you why not publish some of your own beautiful work in a good style and leave these penny-a-liners and splodgers to their own devices. It is I hope not ungracious to look a gift-horse in its mouth—but how *you* give business *to these pictorial photographers.*

Davison as I tell you gets his living out of it and is a good business man. Hinton was a shop-walker, is what I call illiterate and uneducated (for the science of the A.P. is the work of *T. Bolas*) and the editorship of the A.P. *is his living.* If pictorial photography dies as it will—he will have to turn professional or go back to shop walking or such. Of late hear sounds of Journalism. Snowden Ward is a publisher and a pushing *business* man. . . .

[This is a letter of such illegibility that I am reduced to the following scattered phrases which may, however, give the general drift. N.N.]

. . . shallow people of no account with a handful of amateurs who take photos in their spare moments. I know of nobody except myself who can give up his trade or profession for it. . . . You have Mrs. Cameron's work—it is simply unshakeable. . . . Photography as an Art is a Strumpet and as a science it must . . . *careful watching* . . . one of the greatest German geologists . . . has had to give up its use in the science of geology, and take engravings. . . .

For certain trial purposes it is of course useful illustrations for catalogues etc., records . . . and I think you will before you die agree with these.

The rest of this letter seems to be lost. The next two letters, from 1904, appear to cast light on a mystery: Why did Stieglitz never publish Emerson's prints and/or words in *Camera Work*?

Curmudgeons were nothing to Stieglitz, except possibly as entertainment. And as for the difficulty of making a new gravure from an old one, from an earlier stage of the process, especially

if one's standard is as close as possible to perfection—even that might not have stopped the skilled professional he was. It is possible that he did not know of *Life and Landscape on the Norfolk Broads* and its forty actual platinum prints, which he could easily have reproduced in all their luminous loveliness. And what an introduction six or eight of these might have been to a number of *Camera Work!* Each issue was numbered, I to XLIX-L, some double, some special, to make up for appearing very late (frequently the case with avant-garde publications). Each number was dedicated to a portfolio by one artist, one photograph to a spread, no words except the titles on the introductory page. A few others appeared further on, among the articles, by other photographers. Thus each was usually referred to as the Käsebier Number, or the Steichen Double Number, and so forth.

The first letter implies that Stieglitz had asked Alvin Langdon Coburn, a very young Bostonian with a private income who was already an inveterate globe-trotter, to find out what Emersons were available.

<div align="right">

Foxwold
Southborne-on-Sea
W. Christchurch
21/1[?]/04

</div>

Dear Mr. Steiglitz

I trust you are ok as of this.

I write to tell you that I replied to Mr. Cockburn's card at the Carlton very much in haste. I misread his name for *Cohen* and so addressed it to Mr. *Cohen* with his initial—but will find it in the letter office. I just want to man the rifles to show him I was not impolite enough to take no notice of his card.

I also note in your letter Al Cockburn brought to the new gallery you ask if I can put you in the way of getting one of my portfolios. I regret I *cannot.*

I have only one and have no idea where one could be bought, for they cost money. The only illustrated books of mine which are not quite sold out are:

Life and Landscape on the Norfolk Broads S. Low & Co. publisher. £ 6.6.0. A few left.

Wild Life on a Tidal Water. Edition de Luxe. D. Nutt—publisher. £ 3.3.0 A few left.

On English Lagoons Edition de Luxe. D. Nutt—publisher. £1.1.0—and the rest are pictures [?] etc.

Excuse this hurried note—but I have a pile of correspondence on my schedule.

<div align="right">

Yours ever
P. H. Emerson

</div>

The next is a fragment, the front page or pages having apparently been lost. It cannot, however, have been written much before the middle of 1904, since it reviews the first six numbers of *Camera Work*.

. . . wandered from the true and narrow way that you can think anything in the publication worth issuing . . . in the eyes of cognoscenti to *raise* photography.

No. 1 [Portraits by Gertrude Käsebier; "The Hand of Man," the great locomotive puffing on its shining tracks, by Stieglitz]

Too low in tone with a meretricious trickle [?] of light.

No. 2 [Portraits by Steichen]

Flat, banal, and terribly crude and amateurish in composition.

No. 3 [Clarence White]

Commonplace, false in values and childish in composition.

No. 4 [Cathedrals by Frederick Evans, who confessed his "pet heresy" was pure photography; "The Flatiron Building" by Stieglitz]

Head too big, hands ditto. [Name undecipherable] is being damn bad—a rotter.*

No. 5 [Robert Demachy]

Cui bono?

No. 6 [Alvin Langdon Coburn]

Best destroyed at once.

* This is incomprehensible. Who *can* Emerson have mixed Evans with? Steichen? But the undecipherable name looks more like "Young Annan," who doesn't appear for a year or two and of whom it would not be even acceptably true anyway; most of his work is landscape.

The "art" seems to lie in the paper used and reminds me of weak art students who cannot draw well in chalk on white paper and use white chalk on dark paper and so get a meretricious and facile "artisticness" which the learned advise the real student to avoid. I cannot truly accept your very kind offer to appear in that crowd in any capacity for as far as I can see excepting yourself they are a lot of incompetent poseurs and as for raising the Strumpet—why it is merely adding more rouge and powder to an aging and decaying Strumpet. Hence these tears.

<div align="right">

Yours as ever
P. H. Emerson

</div>

This was enough for a perpetual silence, but in 1904 the periodic trip the Stieglitzes made to Europe included, for the first and only time, England. In a very amusing series of sketches called *Time Exposures* by Searchlight (New York, 1926), Stieglitz, listed as "The Prophet," is reported as going to England especially to tell George Bernard Shaw what he thought of him. On the Channel, he gets so sore a throat he loses his voice. Since he can not possibly cope with Shaw without a voice, when he gets to London he cancels his luncheon date with Shaw by telegram and leaves England immediately.

What Stieglitz told me does not necessarily invalidate this tale. He had written Emerson he wanted to see him, specifying hotel and date. He said he wanted to talk *to* Emerson, not *with* him. But Stieglitz, like many whose intense energy is spiritual and emotional rather than physical, was actually frail and often ill. He said that when he arrived in London he had so high a fever he was forbidden to talk. Through the fever he dimly perceived a man come in, look down at him for a moment, then leave without a word. They told him afterwards the man was Emerson.

Many years later Stieglitz asked Emerson if Coburn brought him, and Emerson answered: "No. You asked me to come see you and I did. Coburn was already there." Which seems proof enough. "So," said Stieglitz to me, many years later, "you see we *almost* met!"

It is as fascinating as it is futile to speculate what might have happened if Stieglitz had had his voice. Shaw, I think, would have been immensely amused and written so brilliant a comment that Stieglitz could not have resisted putting it into

Camera Work. With Emerson, my bet is that it would have been a draw, with Emerson composing a magnificent epithet—printable?—and stalking stiffly out. With the Stieglitz of, say, 1914 or 1924, it is doubtful if even Shaw would have had a chance, barring a witty riposte in a note. As for Emerson, would it have been too late for him to understand what Stieglitz was about? Probably he was too hard-set in his thought—but if the two had really ever met, in the true communion of brain and heart, the history of art, including photography, might be different.

In 1905, Steichen, who had come back to New York for a while, suggested that the apartment across the landing from his own on lower Fifth Avenue, near Madison Square, might make a nice little gallery for the Photo-Secession. After all, only a few things could be shown in *Camera Work* in one issue; the Secession did need walls, and a place to meet and have visitors. Whether it occurred to either of them that this would also be a forum for Stieglitz is unknown. Stieglitz signed the modest lease, and Steichen designed the simple, subtle, but for those days startling decor of the two little rooms, found the huge brass bowl, often filled by autumn leaves or spring branches, for the center table, limited hanging to the eye level and protected prints and books under a bookcase with pleated skirts below. And so began The Little Galleries of the Photo-Secession. Steichen, the painter, specified from the first that media other than photography should be shown on its walls.

Stieglitz himself did not begin to glimpse the Strumpet until a year or two later. His colleagues were twitting him for being so pure and old-fashioned; Steichen, world-famous now for his huge two-color gums, advised him not to send to shows any more unless he did a little revolutionizing. Stieglitz merely laughed. He knew what they all thought. He still believed in each realizing his own mode of expression. He had sometimes yielded to a delicate soft focus, often the perfect expression of a subject, such as his little daughter touching a blossom, or a lovely passing lady, or a spring shower on a young tree in half leaf, with a street sweeper below and the dim towers of Manhattan behind. Or the prizewinning "The Street, Winter"—the soft snow falling on the hansom cabs, the brownstones, the man walking in a long

cape. Some twenty years later, a critic who doubted there was a hansom cab to be found in New York City remarked that the picture did not look dated.

But around 1906 Stieglitz began to be bored and oppressed by all the preening little personalities, with their jealousies and squabbles. Who was seeking truth or new beauty? Or life? Or anything but his or her own praise?

In January, 1907, he suddenly surprised everybody by devoting the Little Galleries to an exhibition of watercolors by Pamela Coleman Smith, an American illustrator living in England. Expressionistic, wild in color and image, her work must have been a shock to the photographers. Steichen, who was back in France, cabled: WANT RODIN DRAWINGS? Stieglitz cabled back: YES.

1907 was a portentous year. On the steamer to Europe, Stieglitz found he could no longer stand the overbearing people and strident voices of first class—which his wife insisted on—and walked forward. There, down below, were the people in steerage: the people, returning to Europe, for whom the present America had not been Paradise. Stieglitz rushed back for his Graflex, breathless. (He has often told this story.) Yes, nobody crucial to the composition had moved—the man in the straw hat, the man in suspenders. He developed this single negative with prayer in Paris. He was laughed at—all that complexity of figures split by huge diagonals. But Picasso, who that same year did his strange split-vision "Demoiselles d'Avignon," said when he saw it, "This man is working in the same direction I am."

Then, in 1909, Stieglitz and Steichen were wandering through a large photograph exhibition in Dresden. Steichen, who had been the greatest show-off of them all, but who had both power and perception, said to Stieglitz, "Yours and Hill's are the only ones that stand up." Then he himself seceded from photography—the Strumpet anyway—and went back to painting and plant-breeding. And began sending to Stieglitz small shows by friends of his whose names were then unknown in America and even sometimes in Paris: Picasso, Braque, Matisse; some, like Cézanne, who were dead but recently recognized as geniuses; a couple of young American students named John Marin and Marsden Hartley. Fewer and fewer photographers were shown, and some years, none at all.

In 1910 the Photo-Secession organized a huge international exhibition of pictorial photography at The Albright Art Gallery in Buffalo. It was actually a series of one-man shows grouped by nationality. Velariums were hung, where needed, from the high ceilings to bring down their height and diffuse the skylights. Blue gauze was laid over the burlap walls to give them delicacy and a softer color. A team of four—Stieglitz, Paul Haviland, Clarence White and a new member, Max Weber—organized and hung this show. Installation, already become a fine and subtle art under Stieglitz and Steichen, rose to a new height with the help of the young painter Max Weber.

The Strumpet in her Pictorial guise had a splendid funeral. Everyone knew this was the death of the Photo-Secession, and many sincerely mourned its fighting spirit; it had been heroic, a magnificent gesture.

But the fighting spirit of art was flaming higher and more brilliantly than ever. And the Little Galleries became the famous "291," after its address on Fifth Avenue.

Stieglitz did little photography if any in these years; he had to save his energy for converting visitors to seeing the vitality and beauty of early twentieth-century art and for presenting it with equal force in *Camera Work*.

In 1913 came the great, shocking International Exhibition of Modern Art, the "Amory show"; Stieglitz and "291" had sparked it. As honorary vice-chairman, he was exultant, vigorous and vociferous. At "291" he showed, for the first and only time, a one-man retrospective of his own work: critics found the counterfoil fascinating. And he must have been amused to open the New York *Evening Sun* and find the most controversial painting in the show, Marcel Duchamp's "Nude Descending the Stairs," inspired by photographic studies of motion, caricatured as a subway rush: "The Rude Descending the Stairs."

Emerson did write Stieglitz one letter in 1914—just before World War I:

120

Foxwold [?]
Southbourne
Bournemouth
31/V/14

Dear Mr. Steiglitz

Bedding gave me your address and I wonder if you can tell me anything about the *Verito* lens of the Wollensak Optical Co. Is it a semi-achromatic of the *Smith* type or one with primitive [?] spherical aberration or what. The Smith lens I do not regard with favor—Dallmeyer made me a lens like that 20 years ago and I rejected it—it gives a pin-holy effect and pin-hole effect is not the texture one requires at all.

How is Pictorial Photography in the States—it is practically dead over here except for some misguided and superficial people like Demachy and Co—they are doing bungling *Photo-oleographs* that are false in tonality and crude enough to delight a child.

I saw Coburn some time back—he is a sort of photo-journalist and is issuing topographical books on high [?] New York* etc.—he seems very enthusiastic.

I hear you do no more photography.

With kind regards
Faithfully yrs
P. H. Emerson

If Stieglitz bothered to answer this note, he probably told Emerson that yes, the Verito was not unlike the Smith; that many people liked it, though he himself neither liked the results nor had personal experience with it. And yes, Pictorial Photography in the States was dead if not worse.

Also that he hadn't dusted off his camera lately.

Silence for another ten years.

Perhaps this is the place to sum up what happened to the lesser Pictorialists in the States. The strong, who had never really needed the favors of the Strumpet anyway, eventually gathered force and momentum to become the Purists, of whom more soon.

The weak, lacking their great leaders, forlornly huddled together and formed the Pictorial Photographers of America. They

New York, 1910. Introduction by H. G. Wells.

elected Clarence White their president, and when he died, in Mexico City in 1925, the last of their former standards died with him. They sank into unbelievable quagmires—trash worse than the Robinson period: babies, kittens and puppies of insufferable cuteness; bosoms brimming over gypsy costumes; the gray bearded old man with Bible or pipe, the old lady knitting. The greasy nude, often with Clarence White's celebrated bubble, not without pornographic overtones. The absolute nadir was reached by one William Mortensen; one title and description will suffice: "Preparation for the Sabbat"—an already gleaming nude ramping on her broomstick in the firelight, while a shadowy old crone applies the last grease and gives the last unholy instructions.

That August of 1914, the Great War began crashing over the world. Emerson's elder son, Leonard, was probably among the first to enlist, and probably at once commissioned an officer. The younger son, Ralf, was only sixteen but may have edged in later toward the end; perhaps this was the beginning of his military career in the Royal Engineers. During World War Two he was promoted to colonel and knighted for his services and his courage. How proud Emerson would have been! He must have fumed that, in 1914, at fifty-eight, he was himself too old to fight for England.

Stieglitz, on the other hand, could never quite believe that the good and gentle Germans he had loved and lived with in the '80s were capable of the atrocities reported of them—the massacre march through Belgium, the burning of Louvain, the shooting of hostages. Most of it must be propaganda, mere hysteria. In the first years of the war, this didn't matter; America was determined to let Europe fight her own wars.

The shows at "291" had never been better: African Art, Children's Art, Brancusi, Nadelman, and in photography Paul Strand ("the man who has done something from within . . . the work is brutally direct—the expression of today"). And the reaction to Stieglitz's question "What is '291'? *I know it is not I*" evoked so wide and multi-toned a response that he devoted to these letters the single issue of *Camera Work* that contains no illustrations.

If Emerson, as he later states, was appalled by the delicately

colored reproductions of the strong, free Rodin drawings (what ugly women in what awkward motions!), the Picasso charcoal all split into curves and angles, and the repetitious writing of Gertrude Stein, what must he have thought of any of the twelve issues of the magazine *"291"* which may have survived the wolf packs of submarines to reach London? Satire, caricature, experimental typography. The first issue contained an "Ideogramme," a poem by Apollinaire in picture form. The first important proto-Dada eruption. Picabia's cover, with a lens pointed toward the word "ideal" detached from its Kodak, and beside it "Ici, c'est ici Stieglitz foi et amour." The bold caricatures of Marius De Zayas; Picabia's amusing and satiric machine drawings. Almost the whole roster of avant-garde artists and poets in both Europe and America. Emerson must have torn at what was left of his hair: was Stieglitz crazy or had he just gotten in with "a rotten crowd?" Shades of his good friends Goodall and Thomas!

But then the attitudes of Americans began to change. The doctrine of *Schrecklichkeit* ("frightfulness") came home to them with the sinking of the *Lusitania*. Only the intelligence officers on both sides knew that, apart from passengers, her cargo was ammunition for the Allies. Britain, "perfidious Albion," calculating that drowning a hundred or more Americans, among the horrendous list of victims, would bring the United States into the war, where its tremendous forces were badly needed, merely withdrew an expected protective warship and the German commander on the submarine was able to carry out his orders.

"The war to end wars" was on.

Friends began dropping away; "291" was dying, and so was *Camera Work*. The defection that hurt the worst was undubitably Steichen's. After all, he had been born in Luxembourg, one of the first little countries annihilated. A lieutenant, he soon became chief of aerial photography for the U.S.A. He was desperately in need of film and other necessities, and glad he knew his way about European photography. But when Stieglitz offered to get the desultory Eastman Kodak Company going on its promised deliveries, Steichen ignored him.

"291" and *Camera Work* both died in 1917. As Stieglitz said, they began clean and they died clean. Photography died with Paul Strand, in the last double number of *Camera Work*; painting, with Georgia O'Keeffe—that last show on the walls of what she says was the most beautiful place she ever saw.

In 1915, Anita Politzer, a girl Stieglitz had seen "100 percent alive" in front of the Picassos, brought him a roll of charcoal drawings, telling him she had been enjoined to show them to nobody but felt she must show them to Stieglitz. He was amazed—"At last, a woman on paper!"—and insisted on keeping them, saying he would look at them several times a day for possibly months. They were not signed; all he knew was that a woman of genius had made them.

He hung them, completely convinced. Suddenly a thin girl in plain black with a white collar confronted him. "Who gave you permission to hang these drawings?" "Nobody. Myself. They asked to be hung." "Well, I made them. I am Georgia O'Keeffe. Take them down." Stieglitz persuaded her she had no more right to keep these things from the world than a child had she borne it.

Did he see then in this spare, plainly dressed spinster, a Texas schoolteacher, her extraordinary beauty?

At last the senseless war was over. The stench of the millions too blown apart to be buried was dying from the battlefields; towns and monuments were being rebuilt.

Free now of gallery and magazines, alone since he and his wife had separated, Stieglitz could at last devote his full energies once more to photography. He had picked up his cameras occasionally during the last few years, photographing the clear, exquisite installations and also making a series from the windows of "291"—a little tree covered with fresh snow, dim lighted windows on a misty night. He had also begun to photograph O'Keeffe when she came to New York; in 1918 she came determined to make her living as a painter somehow. The little money she had saved soon ran out; she would have to go back to teaching. Stieglitz's own income had dwindled seriously, but he offered her enough to live on for a year and just paint.

They shared a studio together. Suddenly, without intent on either side, as Stieglitz said, "It happened." Exalted, deeply in love, both transcended any work they had done before. Stieglitz made a hundred or more photographs of O'Keeffe—everything

about her: feet, hands, breasts, torso, ears, clothes, and most of all moods and emotions. He called this series "The Portrait of a Relationship." He began to photograph a number of his friends with the same series idea of conveying a whole personality—not just one face, one mood, one setting, but as living beings, moving, sensing, changing.

Young photographers, coming back from the nightmare battlefields, their roots torn out, or equally uprooted by the stupidities behind the lines, found "the old man" (he was in his fifties) had performed miracles. There had never been photographs like these—so simple, so penetrating, so profound. No tricks, no personal theater, not even a signature. Clear and yet abstract in plane and form.

Various photographers reacted in astounded ways. Steichen, now in a colonel's uniform, found the amazing experience of both O'Keeffe's paintings and Stieglitz's photography so overwhelming that he was nearly in tears and then, deciding he was tired of being poor, went into fashion, portraits of the famous, and advertising—in all of which fields he raised both the standards and the prices considerably. Edward Weston was already making the painful change from prizewinner of the salons to the great artist he became; he decided to go to Mexico and found his own new formal approach, both realistic and abstract, an inspiration to the artists there—Rivera, Orozco, Siqueiros.

Paul Strand, so close he felt like a son, was perhaps the hardest hit. During the war he had been an x-ray technician and then made medical movies. But back in the early '20s he could not at first see past Stieglitz and could only imitate him. The imitation extended even to photographs, Paul trying to photograph his wife Rebecca as if she were Georgia. Stieglitz tried to prove to Paul that in Becky, daughter of vaudevillians, he had a much more pliant and vital model than the then rather fragile O'Keeffe. He made a series of nudes of Becky in the cold, sparkling water of Lake George; O'Keeffe could not at that time have endured such a trial. And why not find his own subject matter instead of the old barns and trees Stieglitz had been working with lately? Strand took his advice and began working with machines, such as his beautiful Akeley movie camera and lathes, and what was happening to the New York farm country as suburbia destroyed it.

In 1921 Mitchell Kennerly, who headed the Anderson Galleries, persuaded Stieglitz to give a one-man retrospective in two huge rooms. One hundred forty-five prints in platinum and palladium, less than a score from his early familiar work, 128 never shown publicly before. Sensation. "People came again and again. At times hundreds crowded the rooms. All seemed deeply moved. There was the silence of a church."

Emerson began to hear about this from travelers recently in New York. Perhaps he also read in the *Photo Miniature*, July, 1921, what the editor, John Tennant, thought of that show; after summarizing Stieglitz's career and his "impenetrable silence and obscurity" since "291," and the question Where is Stieglitz?:

> At once his answer and the challenge; the apocalypse of a personality unique in photographic annals this exhibition at the Anderson Galleries aroused more comment than any similar event since photography began, and deservedly, in that it was an exhibition of photography such as the world had never seen before. . . . A revelation of the ultimate achievement of photography, controlled by the eye and hand of genius and utterly devoid of trick, device, or subterfuge! . . . Never was there such a hubbub about a one-man show.
>
> What sort of photographs were these prints, which caused so much commotion? Just plain, straightforward photographs. But such photographs! Different from the photographs usually seen at the exhibitions? Yes. How different? There's the rub. If you could see them for yourself, you would at once appreciate their difference. . . . In the Stieglitz prints you have the subject itself, in its own substance or personality, as revealed by the natural play of light and shade about it, without disguise or attempt at interpretation, simply set forth with perfect technique. . . . They offered no hint of the photographer or his mannerisms, showed no effort at interpretation or artificiality of effect; there were no tricks of lens or lighting. I cannot describe them better or more completely than as plain, straight forward photographs . . . plus the nature, substance or personality of the subject, the vital interest, truth and life of the subject, resulting from an absolute mastery of the mechanics and technique of the photographic process. . . .
>
> . . . They made me want to forget all the photographs I had seen before, and I have been impatient in the face of all the photographs I have seen since, so perfect were these prints in their technique, so satisfying in those subtle qualities which constitute what we commonly call "works of art."

Accused of hypnotizing his remarkable sitters, Stieglitz turned his Graflex to the skies. "Clouds . . . I always watched clouds. Studied them. . . . I wanted to photograph clouds to find out what I had learned in forty years about photography. Through clouds to put down my philosophy of life. . . . Clouds were there for every-one—no tax on them yet—free."

He also discovered that poignant images evoking intense response from others—*equivalents,* as he called them, the clouds—ecstatic, emotional, meditative—and also simple, profound details, such as the rain-dripping apples before the gable at Lake George, photographed while his mother was dying, a rainbow plunging into the woods, the dying chestnuts crying in protest, the poplars accepting with grace their usual silver death, the old gelding in harness, which he called "Spiritual America" (work-horses in Europe were not gelded), the old dark barns at Lake George with melting snow on them—they were images of sorrow, mostly, but though few bore titles, people found in them some-thing they felt which had never been expressed before.

As for reproducing his recent photographs, Stieglitz said NO to all comers. There had been such enormous changes in the photo-engraving world that he felt he would have to get back into the works himself to find out how these things should be reproduced. Nothing quite like them had ever been done before, much less reproduced. They were contact prints from the 8 x 10 or the 4 x 5 Graflex, moderately sharp; they were at one and the same time real, abstract and mystic. Stieglitz had grown tired, during the Photo-Secession, of sending out beautiful things and getting them back, however be-medaled, damaged—frames nicked, glass broken, prints scarred, mats dirty—and no longer sent things on tour. Rarely could even nearby museums persuade him to lend anything in his care or collection—painting, watercolor, sculpture—and still more rarely, his own photographs. He had arrived, as early as 1903, at the conclusion that, no matter how many prints you made from a great negative, or how you toned them or ac-cented one center of interest or another, there was always one finest print, and that was worth a thousand dollars. But not every-one who offered a thousand dollars—always as a donation to An Intimate Gallery or An American Place, never to Alfred Stieglitz

—was allowed to have one. The same was true of Marin water-colors, O'Keeffe paintings, Lachaise sculptures and Dove metal paintings. "How much are you willing to give the artist?" was his invariable question to would-be collectors. But money could not buy art, nor could prestige. He would not let just anyone with money have these beautiful things; he had to be assured the possessor would love and understand them. And Stieglitz was by no means alone in his conviction that where photographs were concerned, museum people simply stepped on them or kicked them aside during installation. As for the postal services, we were all convinced the mail sorters played football with anything marked PHOTOGRAPHS—DO NOT BEND.

Praise for Stieglitz, for his photographs, his galleries and magazines, was coming from all sides, though no one who had not been in New York recently had seen the photographs.

In 1924 The Royal Photographic Society presented the Progress Medal to Stieglitz "for services rendered in the founding and fostering of pictorial photography in America, and particu-larly for his initiation and publishing of 'Camera Work,' the most artistic record of photography ever attempted."

This undoubtedly spurred Emerson to undertake his long-promised "inner-history" of artistic photography; if he didn't do it, no one, he felt, would ever know the truth.

5 Lascelles Mansions
Eastbourne
Feb 14 1924

Dear Mr. Steiglitz

Owing to the stupid and mendacious statements of the ill-in-formed I am writing a true history of the development of artistic photography.

I wrote to you some weeks ago to your address as given in the RPS list of members—i.e. Madison Avenue—and the letter was returned—marked "Return" [?] which I take is equivalent to "Un-known." Then I wrote to Mr. Child Bayley who is a great admirer of yours and sent him the returned envelope and asked him if he could give me your current address, and he has given me the one on the cover which I hope will reach you.

What I needed to ask you is to let me see a half-dozen of your best

prints of your photos done during the last five years. I know they are something especial but would be very much obliged if you could let me see them. I will return the stuff [?] and send them to Mr. Child Bayley. If you care to pen me a few *brief* biographical notes of your photographic work then I shall be obliged. I am most anxious to be fair to everyone whilst I agree that . . . but I took it you were led away by "gum" and "oil" for no one with real artistic feeling could be [taken] in by "pseudo-artists" like Demachy, Puyo, Coburn and co who could be led away by the rubbish. [?]

I am glad you got the progress medal though the ruling body of the RPS is so . . . to the progress medal that it is a dubious honour these days — but your genuine enthusiasm and work in the *Camera* publications deserved some mark — and perhaps your recent photographs which I am anxious to see.

Yours very truly
P. H. Emerson

Stieglitz hesitated over this letter quite a while. The history of photography as an art (note difference in terms) did need to be written, but — by the opinionated bulldog Emerson? He was not going to send him any of his new work — What? Trust those prints to a steamboat handling? — though a crossing now took only one week. And he was certain Emerson, who had not even understood *Camera Work* nor kept in contact with twentieth-century art, would never understand them. Finally he wrote a letter explaining his present viewpoint, which obviously asked if Emerson thought he could really write such a history. Apparently he also included some comments by Herbert J. Seligmann, a friend and frequent visitor.

March 25 1924

I'm glad to get a reply from you at last. I don't anticipate any difficulty in writing a real history. I have served my apprentice days in writing history for three solid years. I am writing history based on documentary evidence — and I flatter myself I know what art is and have had my opinions confirmed by the . . . artists with whom I have been brought in contact — to name two Whistler and J. Havard Thomas the sculptor an . . . old friend of mine, and the finest bas-relief sculptor England has ever had. Then I have studied psychology — *scientifically* — I am a productive photographer. . . . "and we

are the new men." I develop all my own plates including the 24 x 22 before photography becomes fool-proof. . . .

I am not doing the scientific end — *Eder* did that and if he had not done it I should not be competent to do it.

I had a nice letter from Mr. Seligmann. I replied. . . . [This is a long and difficult letter of which I can decipher only an occasional phrase or sentence. N.N.]

The box of prints [?] and your letter has not arrived. I hope it will reach me by the next mail.

I of course can say nothing about your letter and photos until I see them — but somehow I think you are wandering far from the track in your thoughts. Why be so sensitive about not having any "ism" and objecting to Pictorial Photography. . . .

I think you are messing things up in the letters you sent about your photos. . . .

I object [to] your words straight photography . . . competent photographers can now be "straight" photographers. . . .

As for the museums buying your pictures . . . I attach no importance to that. . . . many years ago some museums here and bigger ones [than the Metropolitan Museum of Art in New York and the Museum of Fine Arts in Boston?] have shown examples of my work. Museum people are mere collectors. . . .

. . . puny literacy now in art photography. Coburn too. . . . empty and puff about his mediocre work . . . because Shaw and Wells wrote introductions to his books of prints. . . .

A painting is the result of the work of the brain and the hand — a photograph is the result of the brain and a mechanical apparatus — you can't get away from that — no one can. . . .

Coburn . . . has not an original idea in his head and is no artist at all — he has no art. . . . I spent an afternoon with him here. He couldn't see a picture in Nature! . . .

I have been very frank and hope you will understand. But I need to see your work. I hope you will be courteous enough to let me see it. . . .

How much of this letter Stieglitz could decipher is unknown. In any case, he sent Emerson a number of gravures, Paul Strand's portrait of himself — in which he looks incredibly hoary, older than God — and quite a batch of clippings about his latest work.

April 6, 1924

Just a line to acknowledge your courtesy and kindness in sending me the New York Harbour and other publications which arrived safely. I am very interested in your portrait[s?] — but have been too

busy to study any of the literature. I guess this is called literature and it fills me with *amazement!* Some of the writers cannot write clearly and there is a horrible pretension and affectation which is really laughable. America must be in a bad way to tolerate such piffle. I am no longer surprised at Pennell's condemnation. . . .

In my humble opinion there is too much scribbling on "Art" and Photography. . . .

I hope to receive reproductions or copies of some of your "cloud songs"—

In great haste

Yours faithfully
P. H. Emerson

Is Mr. Seligman your brother-in-law?

One can hardly fail to sympathize with Emerson. He does not say he has seen the gravures before (in *Camera Work*) and that the New York Harbor scenes are not too different from his own East Anglian; it is of course possible that he did not sense the much greater emotional impact and symbolism. But all those clippings! And yet, with them, none of those reputedly wonderful works which had elicited so much almost inarticulate praise.

Perhaps the most amusing of all these letters was written on April 30, 1924. And it may interest and entertain readers that Stieglitz's own opinion of a few of those mentioned was not too dissimilar to Emerson's.

Private

5 Lascelles Mansions
Eastbourne
Sussex
April 30, 1924

Dear Steiglitz

Yes I heard you were top-notch at billiards—well you won't allow it I know but our skill in billiards proved we had to my mind much more "art" than art photography because we could not show *what was in us* with the machine we could cry [*sic*] show up for a limit.

Paul Strand is an ignorant and pretentious duffer—he can neither write nor take a fine photograph judging from his portrait of you which is all wrong and proves he does not know the elements. It is dishonest in him to write as he does.

I think your friends would help your work along much more if they did not make comparisons and say it is far ahead of anything done—on which point I am agnostic until the spirit moves you to let me see 12 of your best things.

Mr. Seligmann has told me is no relation—you will allow a relative is bound to be inclined to favor his relatives—it is in human nature but now I know is his own spontaneous opinion. Bedding Chuff ran my work *historically* which he was competent to do—he said and many other papers . . . that I was founder of modern Pictorial Photography and this can be legally proved and I am providing the historical data to prove it. Then I showed Beddy letters artists had written me and he often met F. Sandys who is a great admirer of my work and one of the best English artists. Beddy is very modest and knows he does not know art—but when a new so-called artist cropped up in photography he always consulted artists—so in his opinion you really get a sort of composite of several artists. . . . Hence his condemnation of gum and oil.

I hope when you do decipher the rest of my letter you will find my sketch is not so far off.

Yes Coburn is a superficial, designing, unscrupulous little "bounder." I don't believe he could write that Ruskin *cum* Watts article on Beauty himself. He is as vain as a peacock with two tails—both which he has probably stolen.

Just a rotten little opportunist—he guns at what he has a poor hand.

The fuzzytypes the Naturalistic work which he could never do for he could not see a picture in nature. He got the better scrawlers to write introductions to his books, and neither Shaw nor Wells know anything about art that I know from the artists who know them.

You see the present nincompoops who run the RPS want to make out I did as little as possible because I am an American and that's all—but there are honest Englishmen who won't allow it—Why shouldn't anyone do photographs according to some art theory—in fact anyone does who does any artistic work, whether conscious or unconscious. I pay no attention to Rosenfeld—I could cut him to bone and ribbons—he does not understand at all and his style makes my head ache—he can't write clear English—Seligmann can. . . .

Well send us along the dozen or baker's dozen if you will and let me a fair look at your best work. If the work be as it will while here [it will be] no matter what anyone says. If it be not here [it will not] no matter how highly boosted. I think you will agree with this.

Look how photographers recorded Mrs. Cameron's work but it came into its own all O.K. One photo society solemnly sat down and passed a resolution condemning it and it is entered *in the minutes* (!)

H. P. Robinson [intriguing?] and poking [her? them?] in the back and a lot of this—see Mrs. Cameron's *Annals of My Glasshouse.*

With kindest regards
Yrs faithfully
P. H. Emerson

Then futilely:

May 7, 1924

I have had many very beautiful sets of photos sent to me and so kind are people that I am going to give *three* medals (2 silver and one bronze) for the three best prints sent in. The medals were those of me done by the late J. Havard Thomas, the best bas-relief sculptor England has ever had. . . . It is a work of art by a great artist and will someday be worth money.

I hope this may be an added inducement for you to send me twelve of your best photos—portraits and songs and nudes but especially I want to see . . . songs and the city and nudes and landscapes.

I will select three for the competition . . . and return you the rest in a week. . . the three I show to all my committee of artists for their opinions before I make the award.

You did show Strand didn't you—and you might tell him of this letter . . . to have sent me a dozen prints of his I shall be glad.

Why worry so about "aim" and "theory" . . . these neither are of any importance—all that counts is the photographs—by them alone will the future judge you. . .

I shall not print the names of [unaccepted?] competitors for the medals. . . . There will be no *comparative* criticism—either a man has art or has not.

I don't see that it matters a halfpenny of gin whether you sign photos or not—some artists do. . . . I happen to do it.

Dangling a medal (of himself) before Stieglitz, who, after winning 150 or so of the things, waged a campaign against awarding them—Emerson, of all people, who, after winning what he considered an inordinate number himself, withdrew his prints from competition! What psychology Emerson may have studied certainly didn't include a key to Stieglitz; in nearly a year of letters he tried every tactic he knew, including insult, and got nowhere.

And yet it could have been so simple, if he had the cash and health, to go to New York, see the wonderful things and talk to Stieglitz. They could have worked out together the means of reproduction—and many other tangled matters.

Plaintively:

5 Lascelles Mansion
Eastbourne Sussex
May 30, 1924

Dear Steiglitz

The weeks roll on and I am receiving parcels of prints from all parts of the world and [from?] you I do not even get a reply to my questions. Are you or are you not going to send me some prints—(portraits, Sky songs, and landscapes including the old barn with melting snow.) If not please tell me and then I shall know where I am.

I had a parcel from Davison yesterday.

Faithfully
P. H. Emerson

Be a sport and give us a chance!
Sheltered virtues have no merit.

Then he heard Stieglitz was ill and wrote, on June 6, 1924:

I am so sorry you have been ill. I think you will find Lake George much better for your health than New York.

Please re-assure yourself that I have no feeling at all about not being included in Camera Work. You did ask me to write—this is quite true—and I gave you the real reasons why I did not want to. Hinton and Demachy did more harm to artistic photography than any two names I could give. Hinton confessed to me he took to it because he could *never see a picture in nature.* He began a Naturalistic and produced a lot of fresh stuff for that very reason. He thought [?] of possibly 15 of them and sent them to me for my opinion and I told him they were not worth keeping let alone publishing. He reproduced one the paper *Photographic Art Journal*—which see —a "frothy" thing—then he took to that terrible. . . . a drunkard in ten days and died of *delirium tremens.* I guess Demachy is the same as far as inability to see pictures in nature and no one can be an artist without that. You will I think agree with that. . . . There is far too much rotten stuff written about it. That you should take

Shaw's opinion on photography amazes me—I would as soon take the man in the street—any man. . . . Shaw is a Irishman and like many of them hates England. Wells is an upstart and easily over-sold [?] in every way.

"Gum" and "oil" are neither photography. They are bastard processes using photography and no photographer with artistic feeling would ever have touched either. Coburn tried gum and his "gums" are as feeble as anything else. I spotted his *deceit* at the very start—he . . . down to me on the pretext of taking my portrait and writing an article on my work for *Platinotype*—of course the article never appeared. I find him a wishywashy conceited vain and mediocre person—no delight in probing the *characters* of near-ly. . . An insufferable little bounder. . . .

I was surprised to see you mention Robinson in your last—Surely you do not regret having not included him in Camera Work?

I have not seen Camera Work yet [Emerson is under the delusion that it was resuming publication, confusing it with *MSS*, the avant-garde little magazine Stieglitz ran in 1922-23.]—but from what I hear from competent critics—it is most incomplete as a recovery and you haven't. . . . pushing a lot of feeble stuff of Caffin, Shaw and others.

I just have to combat that view of you alone—words being inter-related. I hold this to be a policy. A single work of art stands or falls upon its own intrinsic merit. A photograph proves whether the producer "has art" or whether he has not. That is why I wanted to see 12 prints. Photographers here and there have "fluked" a single "masterpiece." That is the curse of photography. No one could do that in any of the graphic arts—he must be a master craftsman to produce a masterpiece.

Now pull up your britches and take in your belt and send me a dozen or 20 prints that is a good feller. There is to be no compara-tive criticism in my "history"—this is odious—I will not even give an opinion on them—all I need to see is enough to put you on my list of artists. You need not compete for my medals—they . . . will be marked *hors concours* if you do not wish to compete. . . . No one but you has refused yet and I have all the artistic photographers on my roll—many from abroad. But I have not finished yet not by a long chalk.

I have tried to write legibly and hope I may have succeeded. Wishing you a quick return to health and with kind regards—

Faithfully yours
P. H. Emerson

I don't worry whether you work for money or not—all that concerns me is the *art in the photographs.*

Then he received from Paul Rosenfeld his *Port of New York,* which is a collection of character sketches and especially laudatory of Stieglitz and his works. In a rage he wrote Stieglitz:

5 Lascelles Mansions
Eastbourne
Sussex
June 21st, 1924

Dear Steiglitz

You I think mistook my letter and probably Paul Rosenfeld has written to you he sent me his book and in that book he made the absolutely misleading statement that in *Camera Work* is a full record of all the most artistic photographers. I wrote to him and pointed out that this is a terrible mistake for him to make for many of the best photographers are not in it at all. . . . Six of the very best are not included in it from the index published in *Manuscripts.* I said nothing about you or your work or it except that. A terrible mistake for any responsible critic to make—a mistake which damns ruin on a critic at once—mistake which you admit and which I am sure you would not have liked to be printed. All this scribbling on ART Photography does much harm and there comparisons are odious and futile. I don't care whether you have an art theory or not—nearly all great painters have had theories—even Whistler and the great painter Hogarth spent much time in words at a theory—in the *Analysis of Beauty.* Painters work out their theories as they go along where they are going, whether they realize it or not. For example you have one principle "pure photography"—But all that does not matter—*all that matters is the merit of the photographs.*

[He then announces he has 12 b&w prints from nearly all the men worth considering, and that most of them have had difficulty in finding 12 really fine prints, for every 12 had a few weak ones that had to be replaced. Most of the best men are, he finds, very modest]—except for that vain and conceited little puppy—Coburn—who is not a great photographer and never will be (This is all private.)

I still get no photos from you nor any definite statements or whether you will not send me some. I would see some of your land-scapes, and "songs"—if you will oblige I shall be glad and grateful. I hope you are better,

Yours faithfully—
P. H. Emerson

Then, apparently having received a note from Stieglitz which pleased him and soothed his anger:

June 26, 1924

Dear Steiglitz

I feel sure your health is returning for I see a glint of humour in your letter—sorry I can't send you some words of wisdom how to get more and more health from *your* side.

I shall trouble you no more about prints. I say nothing of your recent landscapes for I have not seen even reproductions of them. Now I have the opinions of three competent persons (two artists and one photographer) upon them which is the next best thing to seeing them myself—for I can trust the opinions of the artists.

I hope the country life has completely restored you to health and if you change your mind send the prints along—or send a parcel to the RPS as a gift—so that if they be what is claimed by some of your friends they may be a prime [?] influence—so please don't say *I* am *wrong,* or may be, about the *landscapes.* I have not given any opinion on them.

Cheerio. Yours faithfully.

P. H. Emerson

Silence for some months—or perhaps Stieglitz did not save the letters. Then:

Oct 1st 1924

Dear Steiglitz

That terrible production the 'Playboy' reached me and I thank you for sending it to me. I don't wonder at lunacy being in the increase in the states when these terrible things are done in the name of Art. I see a reference to your cloud pictures—it is the photos I want to see and not 'puffs.' A chap called Hoppé has been puffing you over here and calling you the 'arch-pioneer' and as I am writing history I should like some legal evidence in what direction you have been a pioneer—bar the 'fuzzytype' I know of no pioneering of yours. Perhaps you will enlighten me. He who drives cattle should himself be fat and Hoppé's production is that second-rate and where it's appeared prove my theme that he has no art. If you get in with that crowd of German-Russian aliens you will go mad. 'Playboy' has given me a headache and as Pennell said of another publication it is the work of 'incapables.'

How are you—I hope your health is better. Send along those photos and don't be shy. Clarence White sent me a batch of his work. In fact now I have had photos from all but two or three who are really artists and they have promised.

Pure art photography is very very difficult to do—that I have learned and that is why all those chaps run off to gum and oil and jazz photos and fuzzytypes etc. I have been wading through acres of drivel on art and sacks [?] of photos and there is very little gold when the washing is done.

And following up:

October 3rd 1924

I wrote you yesterday on receipt of the terrible production the Playboy was it—it went into the waste-paper basket. The little part about your "Clouds" does not interest me at all—a man who edits a monstrosity like that does not count and the very fact that he puts his name as editor to it proves that his opinion is worthless.—You seem to fail to see this. As I said before if you get a favorable opinion on those cloud prints by an artist like Colike or Whistler let me see it.

I have had an opinion on them and others of your recent work by two competent artists and the verdict is that there is no special merit in them at all and they see dozens of better things.

I do not want to *sit in judgment* on your work or anyone else's but I am writing a history of art photography and after assembling [a jury of?] real artists we decided to select [?] the man and work who should appear in the way I have arranged and my judgment only goes as far as this: Is X's work good enough to appear in the book or is it not? If it is then the question arises [?] is X deserving of a medal for very high class work? We have given six silver medals and have 22 names on the roll of artist photographers at present and this last month will bring in more but there are not many more like Craig Annan who can come. I have the majority of all real artistic photographers as it is. The art photographer has been the most modest and the most sporting.

Now you know very well if you were really keen for me to see your prints you would send a few unmounted in an envelope and they would be returned to you by the next post.

It's no use, Stieglitz, trying to humbug me.—I know too much about human nature. There is no one I should like to see do really first class art than yourself but your methods of playing the *precieux* don't appeal to me at all—it is Un-English, Un-American, and

un-sportsmanlike. You got in with the rotten ideas and a rotten crowd of pretentious so-called artists in "291" and have played "old heavy" with your brain. It will be your loss if you don't appear in my book but you may be so "in the clouds" that you think you are above it. Well I have made many inquiries in New York and have heard all sorts of information. You are doing no good to pure photography by your attitude and your friends are making a laughing stock of you and your work.

Photographs which are art *are rare* and always have been and always will be. When I thought I had something new and important to show photographers I exhibited my work and sent a portfolio of prints to every photographic society in the world. That was in 1889. It cost me a pretty penny but I did it because I had the cause of art photography at heart.

Now in my book [?] I shall thank you for your propaganda in behalf of Art Photography in the United States after 1890 when you returned to the USA up to the time you adopted the fuzzytype and became a decadent. If you send me a dozen prints before it is too late. They will be returned within a week and can't go wrong and as a friend and . . . check all that rotten crowd of incapables and come back to photography without any airs and graces and take your chance with the rest.

I had a letter from Kühn. . . . he mentioned his work in your Camera Work and did a lot of what we call "pumping." Now I will be *very frank at the risk of offending you—but you are in an unhealthy* state of mind—and if you have the cause of pure photography really at heart you should be battling for it by exhibiting and showing your works *everywhere*—it is your duty—Often you seem only to be thinking of your own works and please yourself. You minded my attitude—I am sitting in judgment on no one *except* in the and there will be no comparative criticism. I shall not say A's prints are more artistic than B's—all we say is A and B have done pure art photography and this suffices for the present. I do not cite in "straight" and write as you did in Child Bayley's Complete Photographer that America is ahead of any other without giving examples. Anyone in a . . . can make a statement like that and in my opinion . . . does photography any good; *au contraire.*

With kind regards Faithfully
P. H. Emerson

It is not surprising that Stieglitz lost his temper over this one and wrote Emerson that he never sent his fine prints anywhere, since often there was only one print and why make an exception? His letter would be worth seeing.

13 Oct 1912*

Dear Steiglitz

It will serve no good purpose to continue this correspondence. If you had told me *frankly,* when I asked you to let me see some of your best prints, that you did not intend to, it would have saved me and yourself much trouble. You had no hesitation for many years in submitting your prints to all sorts of juries—often incompetent— why this sudden *volte face* with those "masterpieces"—

Kind regards. Cheerio
Faithfully
P. H. Emerson

Please accept my apologies for bad writing—I don't know Hoppé— have heard much about him as the most unpopular man in the Photographic World—a Levantine Jew—*on dit*—and as for that "Art" magazine—seems it won't go down in London they tell me— After that "Play-boy" and Broom [?]! I am not surprised that Augustus John said recently that there is no art in USA—the best brains of USA are in "affairs"—very nice of them.

But Emerson could not let the matter alone. This man, Stieglitz, was the key to his book, and he'd be damned if he would let Stieglitz defeat him.

Nov 13th 1924

Dear Steiglitz—

You have not yet grasped why I have been after you. I am writing a history of art photography (which you are already biassed against by saying you will find much erroneous matter in it. Maybe! but you have no right to say that *before* you see the book and on consideration you will see that you are biassed already.

I asked you to let me see a dozen prints. . . . including say "Wet Day on the Boulevards" "Snowstorm—Fifth Avenue"—"Canal Venice" as I told you there would be no question of your not being up to the roll standard *but as a matter of form* we have decided at the start to put no one on the roll until we *see their prints.* When all these claims were made for your more recent prints I naturally

* Emerson's error for "1924."

hoped to see them—that is my natural human curiosity—but I don't ask you to send any of them in the dozen.

It is no question of *comparative criticism* which is odious and by which your mistaken friends are doing you so much harm. Either a man is good enough for the roll or he is not. In the case of several on the roll it was only a *question of form* to see their prints. Why even Davison sent prints and Craig Annan and probably every photographer with a name in very pure photography. For the soundest [?] the 12 prints must be well-nigh perfect—but a man who isn't sportsman enough to face the music can mark his prints *hors concours* for the medals. Craig Annan whom I do not know at all put himself out a great deal to help me.

But you will return to the personal always—the scientific historian *has no personality*. He acts, if he be worth his salt, like an accurate machine. (I had three years at writing history before)—I tried to show you I did not care what your ideas on art were or anything else—*that is none of my business*. As an art historian all that concerns me are your *prints*.

And I shall be obliged to you if you will tell me what soft focus lens you used at the period when you and others were doing soft focus photos for *Camera Work*. I can judge for myself when I see it.

Now I will say no more except to enclose you my list of awards to Nov. 1, and to tell you that the offer is open till April 1—so if you change your mind send along 12 prints. Some admiring friend may lend these to you. My object is to make my history correct and I shall spare no pains to do so.

From what I can see and according to the mutters [?] I hear the Photo-Secession had for the great an opinion of the worst [?] and I hear they just like the Linked Ring here . . . all or nearly all chucked that idea of theirs and the Linked Ring is dead.

A history is badly needed to correct such blatant ignorance as Dudley Johnstone [*sic*] has been pouring forth at the RPS—he is a business man—a very mediocre photographer and no critic at all. And I know he . . . egregious farce and folly in it wrote an article for the *Camera* praising that old imbecile H. P. Robinson!

Now please don't let us discuss it any more—but I shall be pleased to receive 12 of your prints—early work or recent work or musical [?] work and they will be returned within a week. Let's leave it at that. I am independent now—I have 30 names on my roll which includes probably every art photographer worth having except yourself and two or three others and two of them have promised to send.

Kind regards
Faithfully
P. H. Emerson

I asked Seligmann's advice on this—he seems a sensible fellow—and he writes clear English which is a treat after Rosenfelt and P. Strand—now please don't repeat that you can't send—either send or say nothing—I am up to my neck in work and my trouble [?] is much bother over you because you have done a good deal for pure art photography—that none can deny.

Finally Emerson gives up, but warns Stieglitz he had better show or be discredited and recommends the exhibition at Leipzig. He asks a few more questions, of which the most interesting is:

Dec 30th 1925*

. . . Are there any art photographers in the U.S.A.? I can't find them. The U.S.A. seems in a bog of gum, oil, bromoil, soft lenses and every damnable fake possible. This is true, isn't it?**

"Creative Photography"—I have heard of this poor ideal. H. P. Robinson claimed to do this sort of stuff and others have claimed the same for every "fake" under the sun.

Terrible weather here this summer and autumn—rains and sunless days and heavy . . . and every ill the flesh is heir to.

Good luck for 1925:

The final letter in this series is dated Jan. 22, 1925:

Dear Steiglitz

H. P. Robinson claimed years ago that he was a "creative artist" in photography others have done the same—the claim is nothing new.

I shall be obliged if you will tell me how long you used the soft focus lens—you did use it and in one of the prints wisely gave it up. I have seen better Hills or Cameron—but not from USA.

Also will you tell me when you re-commenced photography after

*Emerson's error for "1924."

**Yes, the photographers were there, though some were scarcely visible even to Stieglitz. Paul Strand was beginning to come to his maturity, though he had not yet reached the somber and poetic majesty of his greatest work. Edward Weston was at the start of one of his most creative periods. Ansel Adams was still studying to be a concert pianist in the winters and photographing the Sierra Nevada in the summers. Dorothea Lange was still a portrait photographer. Imogen Cunningham was doing huge close-ups of flowers, not unlike the painting of O'Keeffe. Brett Weston, at thirteen, had just taken up photography. And so forth. Whether Emerson discovered any of them during the next nine years is unknown. If he wrote any of them, they don't seem to remember it.

you dropped out in 1908—1916-17, or 1919 what? I heard Steichen had returned to f/64 work. I now view *one* find—Käsebier.

For your reputation it is urgent that you make no more claims until you publish something all the world can see so as to make good your claims—think Leipzig is indicated. At once as you have to offer

No time for dialectics [?]
Faithfully
P. H. Emerson

Meanwhile Emerson and his committee continued to award medals:

In making his famous decision, this eminent authority showed no partiality whatever, recognising only absolute merit. His verdict was accompanied by the following explanatory note: "We examined the work of most deceased photographers of note—some sent by relatives, others lent to us. We went carefully over the work kindly contributed by living photographers from ten countries and notified those good enough for the roll at the time. Their names and those of the medalists will appear in my history. Those who failed to reach the roll-standard will never be known. It is noteworthy that the best artists were the most modest and the best sportsmen. I thank all for their courtesy."

And of his history:

P. H. EMERSON, B.A., M.B. (Cantab.), whose work on "Naturalistic Photography" created such a stir in the 80's and caused the revival of true pictorialism in vogue today, is writing a history of artistic photography. In this work will be included a roll of eminent pictorialists, past and present, who have attained a high rank. To complete this roll, he desires American workers to send twelve unmounted prints, for examination by a committee who will pass on their merits and decide if the contributor is worthy of inclusion in the honor roll. If postage is sent, in postal money order (not stamps) the prints will be returned. Entries close in England, April 1, 1925. Address Dr. P. H. Emerson, 5 Lascelles Mansions, Eastbourne, Sussex, England.

The same issue of *Photo Era* contains an article on Emerson and Nicola Perscheid of Berlin, one of the medalists.

Dr. P. H. Emerson, B.A., M.B., the eminent English writer and authority on photography, has seemingly concluded his self-imposed and laudable task of investigating the merits of successful workers in various branches of photography, past and present, with a view to determine the most worthy one in each class. In his efforts to reach a definite conclusion, Dr. Emerson spared neither pains nor expense, and displayed a comprehension, sincerity and breadth worthy of admiration. In publishing the names of those whom he considered the most meritorious, Dr. Emerson emphasised the bestowal of the honor by giving a silver medal. Their names are also to appear in his forthcoming history of photography. The list of the medalists is published elsewhere in this issue. In dealing with the problem, Dr. Emerson exercised absolute freedom of prejudice or personal feeling. This he manifested when he awarded the only silver medal for portraits and figure-subjects in the open, to Nicola Perscheid, of Berlin, Germany, to the disappointment of other nationalities.

The full list is interesting, for many medals go to the dead or the unknown. If the dead had families, the descendants may have been pleased. What did Emerson do for the unknowns? Medals and photographs to the RPS?

Of the silver medals, only Hippolyte Bayard, one of the inventors of photography who never got due recognition for his work, is at present known. Of the bronze medals, the following are known:

Hill and Adamson (Scots), 1842, for calotype portraits only.
Gaspard Felix Tournachon, Nadar (French). . . .
Julia M. Cameron (English), 1864–70, for portraits only.
J. Craig Annan (Scots) for the excellence of his photo-aquatints.
T. Bolas. F.E.C., F.C.S. (English) for his accurate learning and honest contributions to photographic journalism and for his invention of the hand camera.*
Colonel Noverre (English) for pictorial "pinholes."
W. L. Colls (English) for the excellence of his photo-aquatint prints.

Later, Emerson added to the list:

*A much debated subject. Like photography itself the hand camera in various forms was invented by many people. George Eastman bought out a number of these inventors to ensure his world-wide patent on the Kodak.

Silver: Nicéphore Nièpce (French) for the invention of photography. Rev. J. B. Reade, M.A., F.R.S. (English) for having invented the calotype process and hypo fixer. * Charles Victor Hugo (French) for the photograph of Vacquerie's cat, taken at Jersey when in exile. . . . *Bronze:* Sabatier Blot (French) for portraits, 1842. . . . R. Fenton (English) for the Russian battery at Sevastopol after its capture by the British. William Willis for inventing the platinotype process. . . . Dr. C. E. K. Mees, S. H. Wratten and J. Cadett (all English) for the advancement of the process of panchromatic photography. T. R. Dallmeyer (English) for the telephoto lens. R. Eickmeyer (United States) for having founded pictorial photography in the U.S.A. (at Yonkers) and for his artistic photo, "On the shoal at Barnegat (N.J.)" Brassai, Paris, for night photography, *Paris de Nuit. This closes the awards under the old regulations.* But, as many have asked me to keep up viewing photos and giving awards, I decided to go through all the prints published in the annuals (978) in 1932-33, and give a medal to any deserving print. This will be my method for the future. . . .

The last medalist was a very surprised young Hungarian artist living in Paris, Gyula Hálàsz, who had adopted the name Brassaï from his native town Brasso, had published in the spring of 1933 his Balzac-like *Paris de Nuit* which was later republished in England. Suddenly he received a letter from England, headed with a family crest:

Sep 27 1933

Dear Sir

We are much pleased with your photographs in *Paris de Nuit* and have awarded you a bronze medal. If you will tell me your private address I will forward the medal. All I ask in return is a very *small snap* (2½ x 1½) of yourself to be reproduced in my *History of Pictorial Photography*—just finished.

Faithfully
P. H. Emerson
B.A., M.B. (Cantab)

*Emerson is in error: William Henry Fox Talbot invented the calotype process, and Sir John F. W. Hershel was the first to suggest the use of sodium thiosulfate (then called the hyposulphite of soda) as a fixing bath.

M. Brassai

Are you Italian or French or what?

Brassaï confesses he thought this Englishman awarding medals must be some kind of nut and ignored the note. But ten days later he received another, in which Emerson explained a little more: "The medal is by the great sculptor, the late J. Havard Thomas, Professor of Sculpture at the Slade School of Fine Arts, London. . . . May I congratulate you again on your excellent photographs."

This time Brassaï responded, and included a copy of his first article, "Images Latentes"; he received a warm reply, thanking him for the information about himself and "for the interesting article which I will study and think about."

The last letter thanks Brassaï for

the two most excellent photographs from the series "Paris de Nuit" and for the two snaps. I have sent them off for reproduction this day and send you a proof later.

It is very kind of you to send me these photographs and very thoughtful, and I shall prize them as from one who has done much to raise night photography to a fine art. . . .

I hope your exhibition in London is going favorably. . . .

Brassaï, in his article "My Memories of E. Atget, P. H. Emerson and Alfred Stieglitz," *Camera*, January, 1969, wrote he did not discover what a "most attractive and disconcerting figure in photography" Emerson had been until he came across a very bad and inaccurate translation of my first article on the man. .

Brassaï wrote:

It demanded incredible courage for Emerson to make this dramatic public confession. Following it, he bought back all the copies of his work he could trace, destroyed them and resigned from the Camera Club. It may be imagined with what feelings I read these revelations about the life of my English distributor of medals. But one sentence in Nancy Newhall's monograph surprised me: "The shock," she writes, "was so brutal, the wound so deep that up to the time of his death he never changed his mind. . . ."

Did he really never change his mind? Then what was the meaning of this distribution of medals at the drop of a hat? And to the end of his life? With the vigilante interest he showed for photography? The praises he expressed to the young photographer I was in 1933? And this at a distance of 44 years from his disillusionment?

"I appreciated the value of your photographs, for they come from a man who has contributed a great deal to raising night photography to the status of a fine art." Suddenly, these words of praise, which at the time had barely affected me, took on from the mouth of this man who had renounced photography an indescribable weight and depth of meaning. Did Emerson in fact change his mind again? Had my pictures been capable of persuading him that photography could sometimes reach the status of art after all? How I regret now having misunderstood this man, having regarded him as a visionary, an eccentric! And how I would love to know what he thought of my essay, "Images Latentes." All I have is that sentence in one of his letters. "And thank you also for the interesting article which I shall study and think about. . . ." I had myself echoed Emerson's view that photography was not an art form, but I had done so without the slightest regret—indeed I had found joy in doing so, as though I had wished to say, "So photography is not an art? So much the better! Thank God! It is something better than art! It rules out subjectivity, the artist's arbitrariness; through photography it is at last possible to attain divine, total objectivity". . . .

What did Emerson think of my article? Was he shocked? Or did it act on his tormented soul as a cathartic, a purge, a redemption of his doubts and obsessions? . . .

"Emerson and Stieglitz," recalls Nancy Newhall, "only met once, in strange circumstances in London in 1904. Stieglitz was very ill, almost at death's door. . . .He insisted on speaking to Emerson. Later he recalled, as if from a dream, that a man had come, had sat down by his bed, had listened to what he said and had then gone quietly away."

I, too, sometimes feel that Stieglitz and Emerson—my two great friends that I never met, but who noticed me and took a lively interest in what I did—come back to me as though in a dream, shake my hand without saying a word and go away quietly into the great silence and great nighttime of oblivion.

In his last letter to Stieglitz, Emerson is concerned about the Chicago Salon: all the judges seem to have been "Britishers," and he fears the Scots are "stealing the American's birthright." Also some Scot has claimed, in the Philadelphia *Camera*, that Hill founded *landscape* photography.

> Photography over here has gone to the dogs. . . . The Royal Photographic Society is probably wrecked through unaware asses—Now a Viennese scribbler—has joined them, one Schwarze who wrote a book full of errors on Hill. Where are the real Americans and why don't they go for these rascals?. . .
>
> I have been confined to my room for a year and a half with lumbago, but have managed to finish my history of Pictorial Photography and hope to see it published this year.
>
> How is your health? Do you make any photographs now?
>
> I had to move down here on a/c of my rheumatism.

Stieglitz wrote back:

October 9, 1933

> . . . I often wondered were you still what is called "here." I'm glad to know you are—as for Chicago and Judges and Photography I must confess that ages ago I gave up looking at any photographic magazines or meeting men of the so-called photographic world—or ever going to any of their worse than stupid exhibitions. Charlie Chaplin, Eisenstein, and a few stray photographers occasionally drop in to see me.
>
> . . . So you see I'm not popular and am pretty much an exile in my own country and an exile amongst photographers as well. And find people don't change. . . .

November 7, 1933*

> . . . Yes, I know all about humbugs. They are in the increase in all fields. Racketeering as it is called in our country is the American Religion. You have finished your book on Pictorial Photography. Good, I hope I'll live long enough to see it. Whether I'll agree or not will be inconsequential for I know it will be an honest and interesting piece of work. . . .
>
> . . . Am kept busy building windmills of a very superior type that have no market in the world of Ford and Co. . . . [goes on to remark how poor he is] I had to quit subscribing to the *London Sportsman* which I read religiously for 62 years—I do love a real racehorse. . . .
>
> . . . Not long ago I had your portfolio of gravures in my hands

*Same letter, new page.

also your book on Naturalistic Photography. Both took me back many years and both seem still alive.

Stieglitz is exaggerating: at that time *America and Alfred Stieglitz*, a compendium of what some twenty-five poets, critics, historians and artists such as William Carlos Williams, Sherwood Anderson, Lewis Mumford, Seligmann, Dove, Marin, Hartley, Demuth, Paul Strand, Gertrude Stein and others thought of the influence of Stieglitz on their own worlds, was being rushed through the press to meet January 1, 1934, his seventieth birthday.

Among the "few stray photographers" who dropped in that year was Henri Cartier-Bresson; Stieglitz offered him a show if he would learn to make good prints, but Henri scoffed at the idea—all —all that went out with the late and unlamented Pictorialists. Another was Ansel Adams; after going through his portfolio very carefully twice and tying the bows neatly, Stieglitz looked up with those deep black eyes and said, "Some of the most beautiful photographs I've ever seen." And gave him a show in 1936.

There was a whole new fight on in photography. Stieglitz knew about it but wasn't much impressed. Since its most intense activities were in America, it seems probable that Emerson knew little or nothing about it. One movement comprised the "Purists"— photographers pure to the bone and true to Emerson's teachings in everything except focus. They were making inexhaustible beauty out of extreme sharpness, every passage like a phrase of music exquisitely played. Group f.64 was as loose and informal as the Photo-Secession and lasted only about two years, but it was the culmination of the world reaction against the degradation of the Pictorialists. Its ideals were Stieglitz and Strand—or what they knew of them, which in those days was not much. Edward Weston was more a symbol than an active member; Ansel Adams and Willard Van Dyke constituted themselves "the sanitation department," Imogen Cunningham and several others merely contributing their support and their prints to exhibitions. Brett Weston was a later member. Dorothea Lange, with her first photographs of the Depression—the bread lines and later the migrants—was ad-

mired by the whole group; she was, in America, one of the first leaders of the Documentary movement, along with Walker Evans. "Documentary," which could hardly avoid Communist overtones in view of the worldwide Depression, was fairly international, some of its best movies coming from Britain, France and Russia, as well as America.

During the 1920s, there had arisen a new "pictorialism": imitation by Man Ray, an American, and L. Moholy Nagy, a Hungarian, of the effects achieved by Picasso and others by photographic means—solarization, laying various objects on sensitive paper for their shadows (Rayographs for Man Ray, shadowgraphs for Moholy, Schadographs for the earliest experimenter of them all, Christian Schad).

Now came journalism, with the *Berliner Illustrirte Zeitung, Vu, Life, Look*, and many others. But by then Emerson was dying and Stieglitz indifferent; both had been devoted to beauty as well as truth.

Stieglitz on his black days said he had used a thousand-horsepower engine to move a pebble an inch. And described An American Place as "where he lay in state." He was alone there when he suffered the heart attack of which he died, in July, 1946.

Ralph Waldo Emerson died deeply beloved and sincerely mourned across the world; he had helped thousands, his rejection of the Transcendentalists had been gentle, his quiet humor had endeared him to many who disagreed with him. And Hawthorne reported that there was always a glitter, a light about him, when he walked abroad. Peter Henry Emerson may indeed have had the glitter and the light, but he did not have the kindliness, the kingliness, the gentleness of his distant cousin. Nor, perhaps, the stature—though that could be debatable in terms of his eventual influence on thousands of photographers, whether they knew his name or not. He had made, with his invective powers, many enemies.

Let us hope Emerson still had devoted friends and family during his last years. And gatherings perhaps as gay as he recalls to an unknown friend, "D. B.," who copied from a letter the following passage which Emerson includes in the last letter to Stieglitz, September 27, 1933:

Can you recall one of our numerous lunches at Frascati's with poor old Dallmeyer when you showed me some horrible faked American photos* which were creating a temporary craze and I pronounced them meretricious: it was at the old table under the skylight where we then spent many a happy hour. You may recall on that occasion I said "The American School was merely naturalistic photography and all the better for it. And I can see by your article (a short one I wrote in Photo News Jan last. D.B.) you say the same. If American photographers had never touched the salon filth of the "bi-gum" frauds, they would be further ahead but they have done the right thing now to chuck the 'Orsley**—Sutcliffe—cum Lambert frauds—You will be able to tell them of the inner workings of all this gigantic fraud on this side. . . ."

*J. C. Strauss.
**Hinton.

The obituaries report that, after a three-year illness, Emerson died at Falmouth on May 12, 1936—the day before his eightieth birthday. May that room at "Elmo" have had windows looking out on the views he loved: a busy harbor, a cove where yachts furled their sails at sunset, a beach where the fishermen, in the early morning, cleaned their shining catch in a cloud of shrieking gulls, rocks where the sea crashed, or a marsh alive with flighting birds. May he still have had his keen eyes and ears, for his beloved wild lights and music, and a fine telescope and pair of field glasses, long after his fingers were too stiff to hold a pen or focus a camera, which had been his mighty instruments.

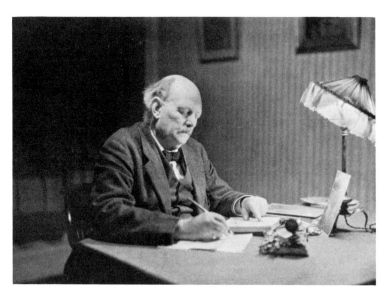

Dr. P. H. Emerson to his nephew W. C. Emerson —
The photo was taken in my study Feb. 11, 1925,
where I am writing the History of Artistic Photography—PHE

There is a poetry of photography
as there is of painting and literature . . .
The seers who see deeply, they are the poets!

PART TWO

P. H. Emerson: His photographs accompanied by excerpts
from his albums and *Naturalistic Photography*

THE SCIENTISTS

. . . in all their walks nature is full of interest to them; they find wisdom in a pond, they revel in a marsh, or they travel to a far country for the sake of rare birds' eggs, or spend days and nights in the laboratories to solve new chemical problems, or organize expeditions to study unusual phenomena of the heavenly bodies. The man uneducated in science finds no interest in a drop of muddy water, he finds nothing wonderful in the vegetation of the countryside, he passes unheeded the rarest birds, and the rainbow and storm cloud and the blazing comet, all alike to him, have no interest, he is blind to them, or if he sees them at all, it is through a glass, darkly.

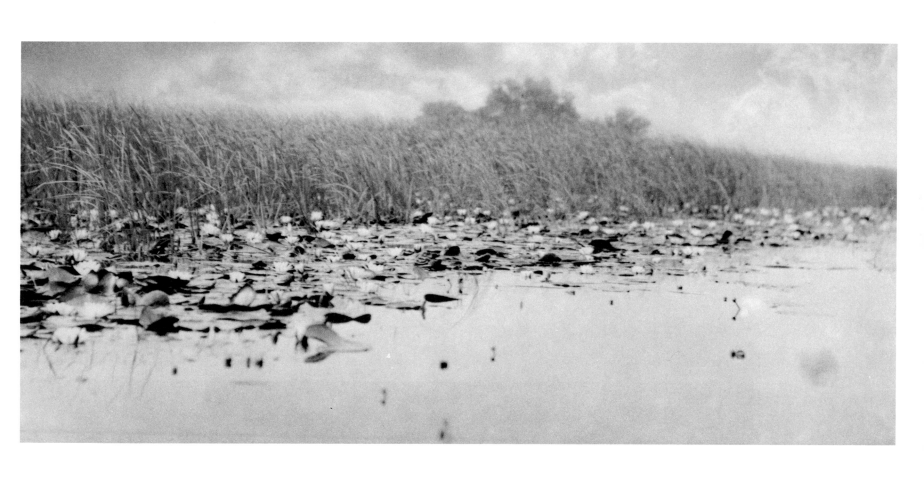

THE ARTIST

. . . only after long and close observation do the scales drop from his eyes and he sees a beautiful pose, even in a child digging up potatoes, or a man throwing a hammer or running a race, or he sees subtle beauties of colour in a reed-bed, or poetry and pathos in an old peasant stooping under a load of sticks, and this is far more difficult to see than it is to learn to see the scientific truths, and that is why there are so few real artists and poets and so many more scientific men. Art, alas, cannot be learned like science, hard work will not necessarily make an artist.

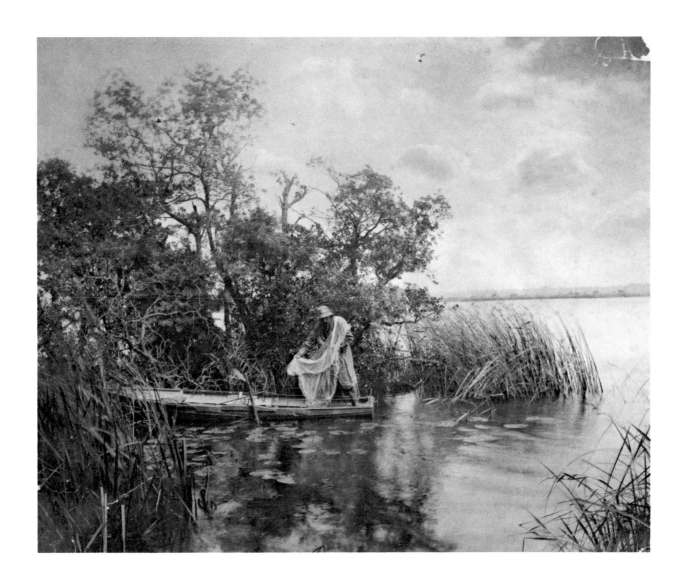

...nature is full of pictures, and they are to be found in what appears to the uninitiated the most unlikely places. Let the honest student then choose some district with which he is in sympathy, and let him go there quietly and spend a few months, or even weeks if he cannot spare months, and let him day and night study the effects of nature, and try to produce *one picture* of his own, which shall show an honest attempt to probe the mysteries of nature and art, one picture which shall show the author has something to say and knows how to say it, as perhaps no other living person could say it; that is something to have accomplished. Remember that your photograph is a rough index of your mind; it is a sort of rough confession on paper.

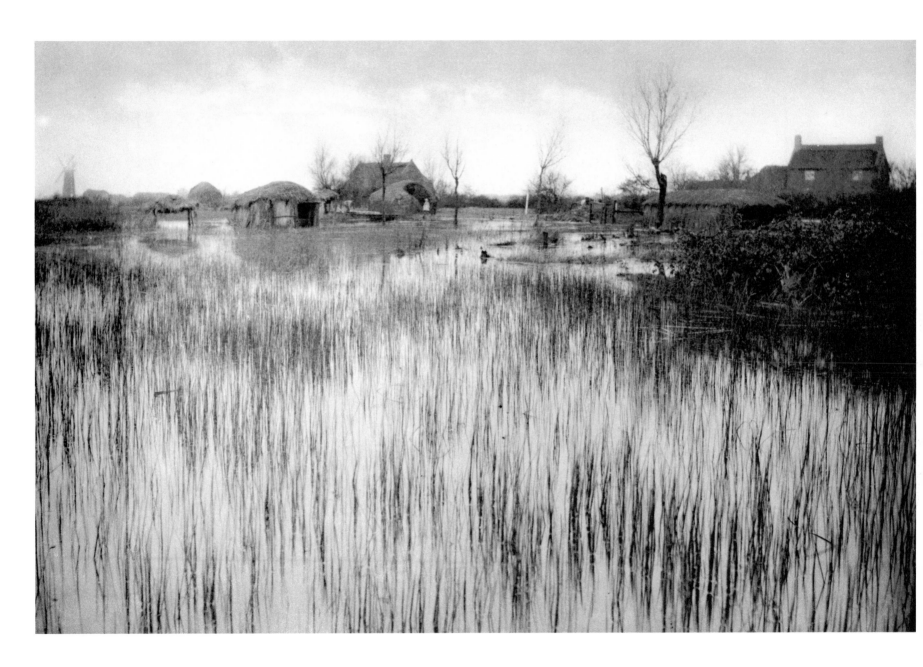

. . . the student should try to express his subject as it has never been expressed before . . .

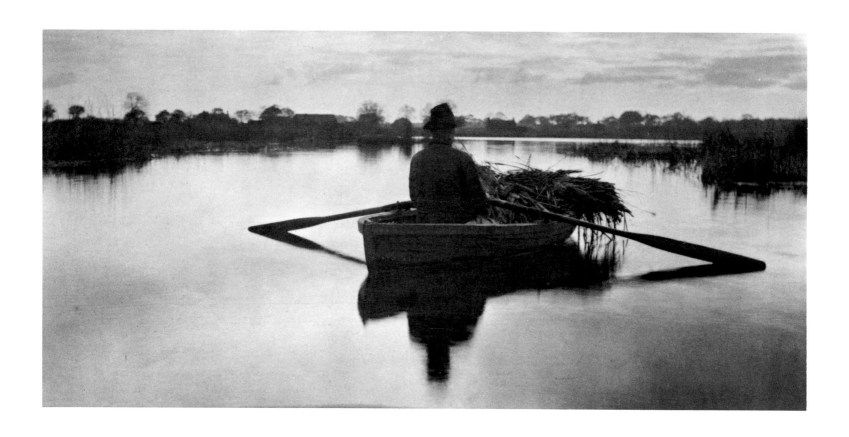

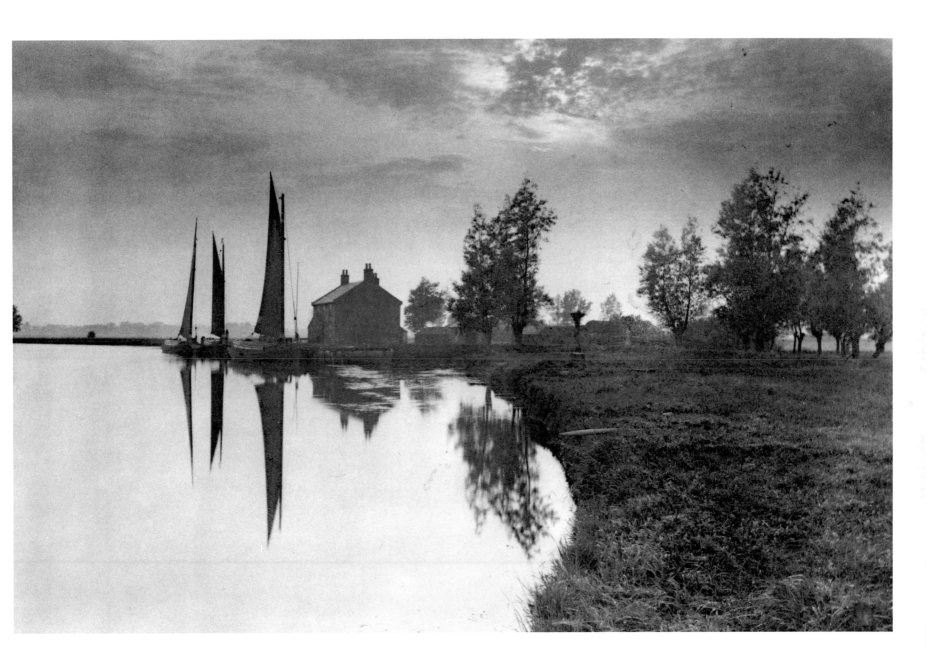

Cantley Wherries Waiting for the Turn of the Tide 147

. . . we must first see the picture in nature and be struck by its beauty so that we cannot rest until we have secured it on our plate . . .

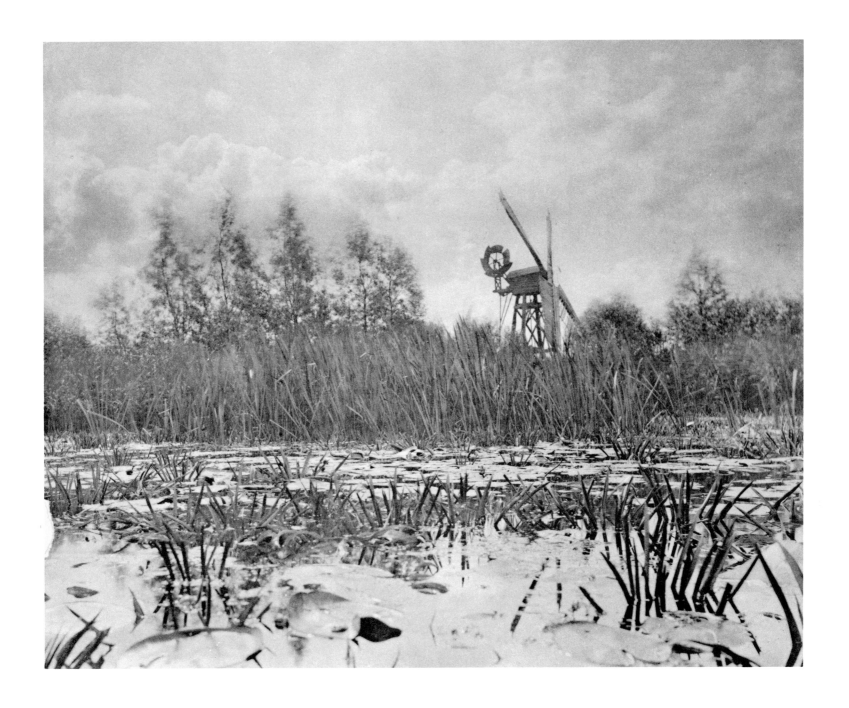

Rockland Broad 149

In Norfolk there are still to be found many beautiful cottages . . . But they are daily becoming fewer . . . we give a row of old cottages, the white walls beautifully subdued by the grey-day-lighting.

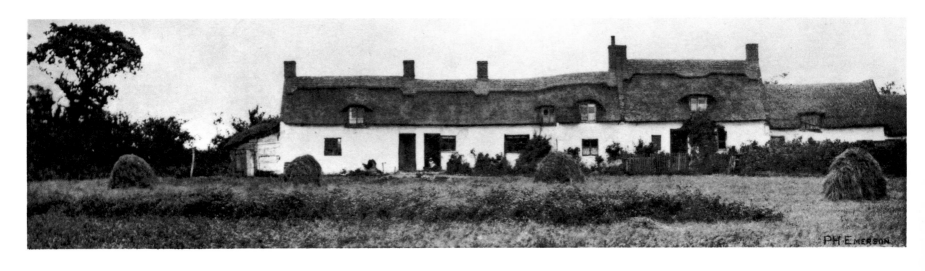

Fisherfolk and Amphibians

. . .their lives may be said to be ruled by the tides . . .

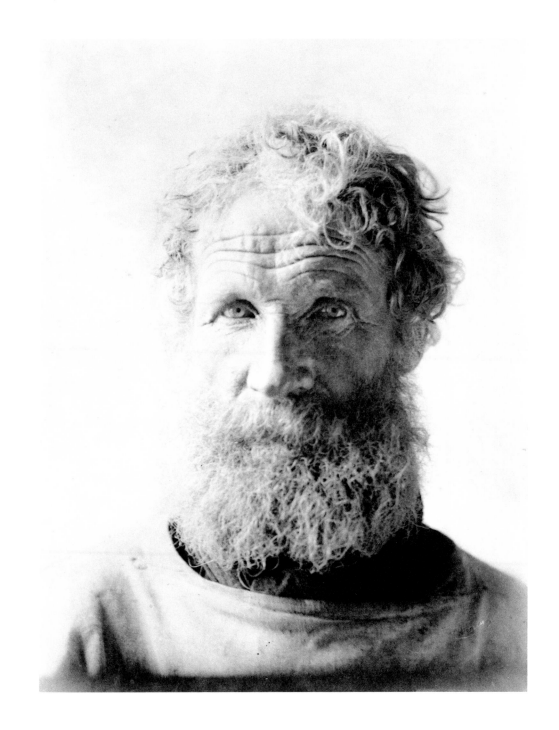

Now in Norfolk and Suffolk the very peasantry are imbued with a devotion to the seafaring life, and hence the great yearly exodus of the peasantry as "Half-and-halfers." As this love of adventure is not satisfied by the short cruises in the smacks, we often find that, after a few voyages, these sailors will go on a foreign-bound vessel, and sail for the Spanish Main, or some other "furrin part." If you talk to them of their past voyages, their eyes will brighten, their faces flush with enthusiasm; and their whole being will alter and glow with excitement as they describe the wonders they have seen in the "Chiney Sea," at "Stockholom," or at "Walperaiso."

Of course, one of the strongest characteristics of all East Anglians from time immemorial has been their love of the sea, their good seamanship, and courage in battle. At one time the demand for East Anglian sailors was notorious, and their loyalty to their country is often recorded by their voluntarily manning ships and fighting the King's battles.

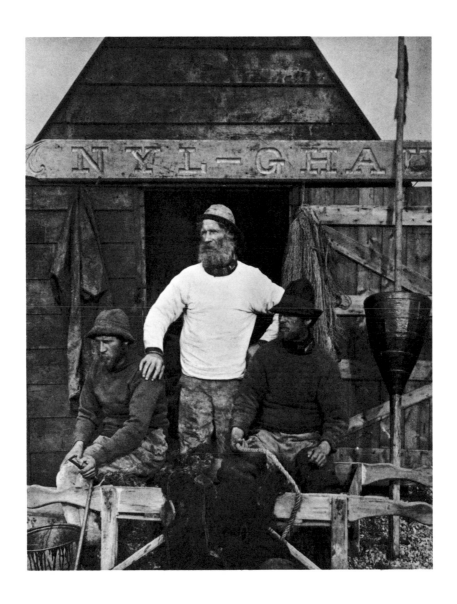

(Three men in front of shack) 155

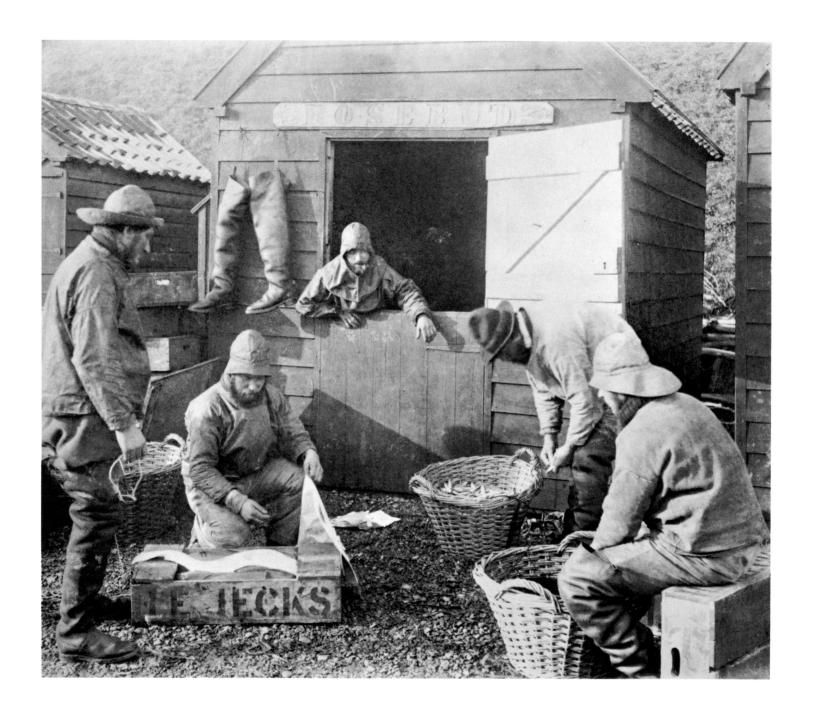

156 (*Packing the catch*)

Fishing Calendar:

January-February: Shrimp or smelts. Sole in deep water during cold months.

June, July, August: Trawling for soles, plaice, codlings, whitings, crabs and sometimes lobsters.

September: Mackerel—nets cast east-west just before dawn to "strike for the daylight." Cod, sprats. Oyster dredging rare.

October: Herring come late. Cod frequent again.

Winter: Stand by to crew life boats.

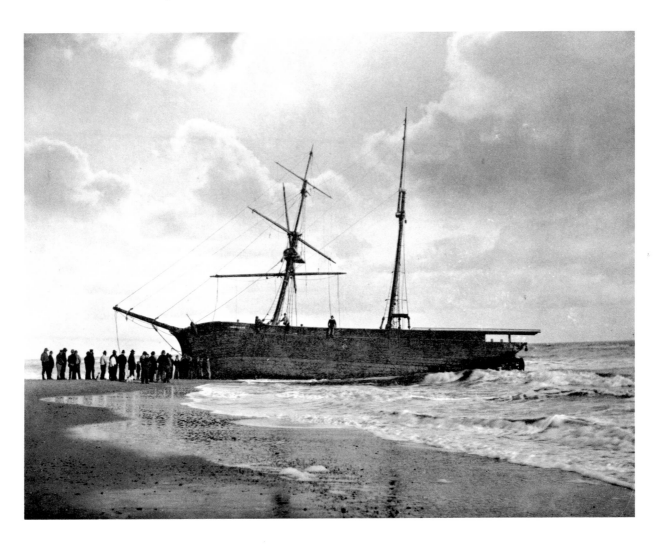

The Monster Eel

It was a good evening for darting fish—the water was "sheer" [clear]; as Old Josh guided out from the reeds, pushing with dextrous strokes of his quant [pole] into the middle of the broad.

Peering into the depths, he saw a bubble rise—his arm instantly flashed in the sunshine; there was a splash as the barbed dart broke the surface of the water, the shaft trembled in his hand, and he knew full well he had darted his quarry, and "something like" was his prize.

He pulled up the dart with a huge eel wriggled round its prongs. Josh had got the "warmin" this stroke.

Striking the end of the boat deftly with the shaft of his pick, the eel—a monster—fell on the flat bottom-board and coiled up, looking like a black

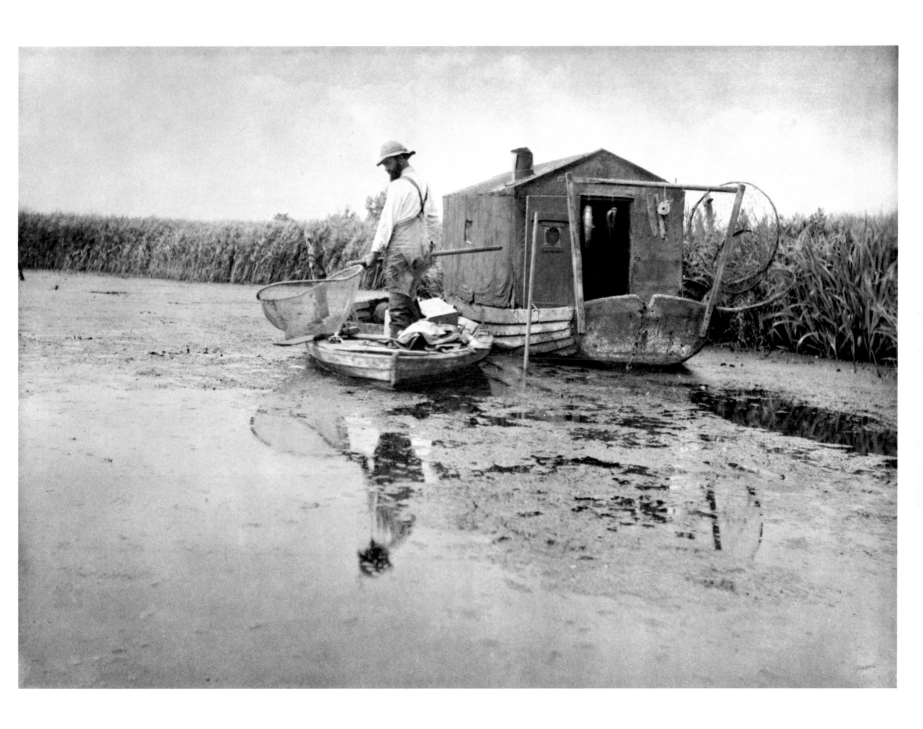

snake ready to spring. Josh was a bit of a philosopher and naturalist. He sat down quietly and eyed his victim, who returned his scrutiny with evil-looking countenance.

"He be a wopper," muttered Josh, as the eel raised his head and came towards him with wicked-looking eyes.

"That won't do, though," he thought, taking up a piece of wood and striking the eel three hard blows on the tail, resuming his seat with an air of well-merited rest. The eel wriggled a little, its flat, broad head lying serpent-wise on the bottom of the boat.

"Thet's done fur him," muttered Josh complacently. Still the eel gazed wickedly at him from his bead-like eyes.

Josh determined to examine his prize more critically, so, kneeling in his boat, he scrutinized his capture, his thick, brown fingers hanging carelessly within three inches of the "wopper's" mouth.

Suddenly the evil eyes beamed maliciously, the snake-like mouth opened wide, the shiny neck curved, and the serpent's head darted at Josh's finger. But Josh was too quick, "Noa, you doan't, my bewty." Then drawing out his large clasp knife, he crushed its head with his heel and divided the spinal cord.

"Thet will do for his bacin," said Josh, thoughtfully, as he replaced his knife in his huge pocket. "But he be a sharp shot, the warmin' he know; thet he dew," he soliloquised, rising and shoving off to his ark-like houseboat moored in the gladen* beds.

*gladdon, gladden: bulrushes.

160

On reaching his eel-ketch, Josh brought forth his rusty scales into the well, and hooked on the eel. "Six pound and a harf! I knowed he was a wopper," he said aloud, with a tinge of pride. "Now let's see the warmin's masure," he continued, drawing a dirty tape from his pocket, and applying it carefully to the wriggling body. "Forty-tree inches. Hum! an' gude masure, tew," finished the man of science.

Going into his cabin, Josh fastened the eel's head to a hook over his primitive fireplace, and began to flay his booty with zealous care. As he flayed, he moved back step by step until his broad shoulders were to be seen in the doorway. The eel and its skin reached from one end of his houseboat to the other.

After the skin was removed, Josh got down an old jar, and taking out a handful of salt, he rubbed it into the flesh. The dead eel wriggled worse than ever.

"The warmin'!" Josh exclaimed, in astonishment; then, addressing the eel, "Fare to me, bor!, you're rare wicious."

Taking up his knife, the experimental Josh placed it within the eel's lips, and the jaw of that flayed and salted "water-wiper," with its spinal cord cut asunder, closed with a snap upon the thin blade, gripping it fast.

"By goms, what a wicious warmin'!" exclaimed Josh, in admiration, as he withdrew the knife-blade, and proceeded to cut the body into sections for his frying pan in which melted lard was already bubbling.

"He died wicious, but he ate wery nice," was Josh's epitaph.

Here we have an old Broadman and his daughter out in their flat-bottomed boat on a hot July afternoon, about to drop a bow-net into a likely corner of the Broad to catch some tench, that most edible of fish, firm and glutinous —the sole of the fresh waters.

The net, deftly braided by the girl's skilled fingers, has been bent by the old man to hoops of split hazel, and set taut by sticks of the same, notched at each end to fit the outer hoops, thus holding them wide apart, and forming a firm cylindrical cage. From each end springs a cone-shaped inner net, which, tapering to the centre of the cage, has an opening at its apex; these openings are the entrances to the trap; a string fastened to the hoop at the opposite ends holds each one in position. A very large fish can easily push its way into these openings, but a small one would have much difficuly in getting out again, even if it managed to find the hole. The old man is putting a stone in the net to keep it on the bottom.

The bow-net is practically the only means of catching tench, as, though occasionally by the angler in quest of other fish, they bite at a bait so rarely that one can never depend on getting any with rod and line. We have been told by old Broadmen that in July tench may be taken on a hook baited with the small white flower of an aquatic plant which grows in tangled masses from the muddy bottom of the Broads, and also with white daisy buds just about to open; they say that good sport is to be obtained at times with these baits but we have never tried the plan. Bunches of the former are often put inside the bow-net to attract the tench, which are said to be very fond of it. Tench lie up in the mud in winter, and are often transfixed by the eel-spears when the men are picking. In hot summer weather they swim along under the banks or in among the weeds and waterlilies. They seem to like to rub against things, and this taste accounts for the ease with which they find their way into the bow-net; rubbing their backs against the meshes of the narrowing entrance appears an irresistible pleasure. A net dropped in a lucky spot may be lifted next day with a score of fine fish in it, and we have heard of even larger catches.

T. F. Goodall

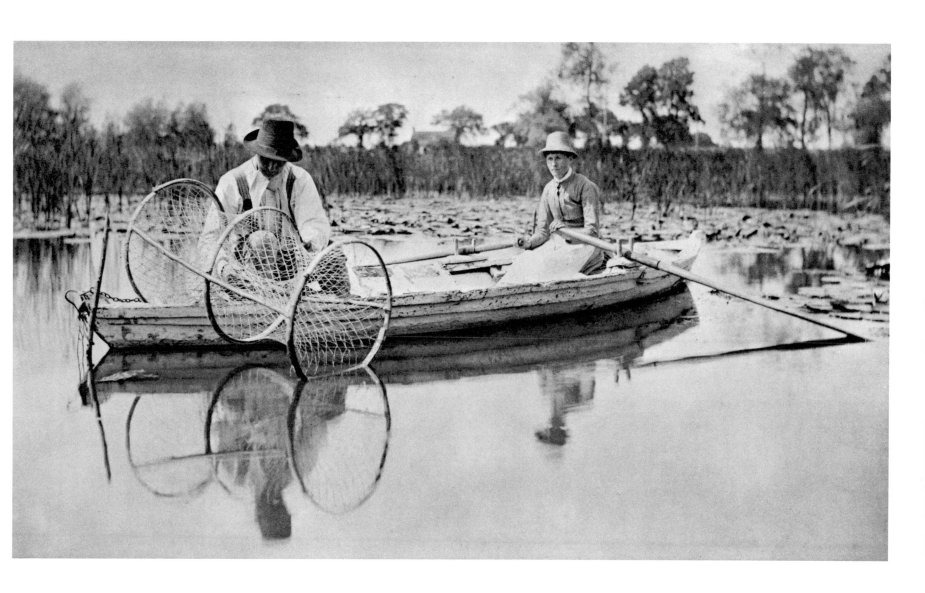

Every one of the amphibians is a small-boat sailor. You may see the boys at seven and eight sailing over the lagoon in an old coble with a bit of torn sail, navigating the rickety, leaky old craft with the science of a *voyageur*.

In this way they all get to love their boats...

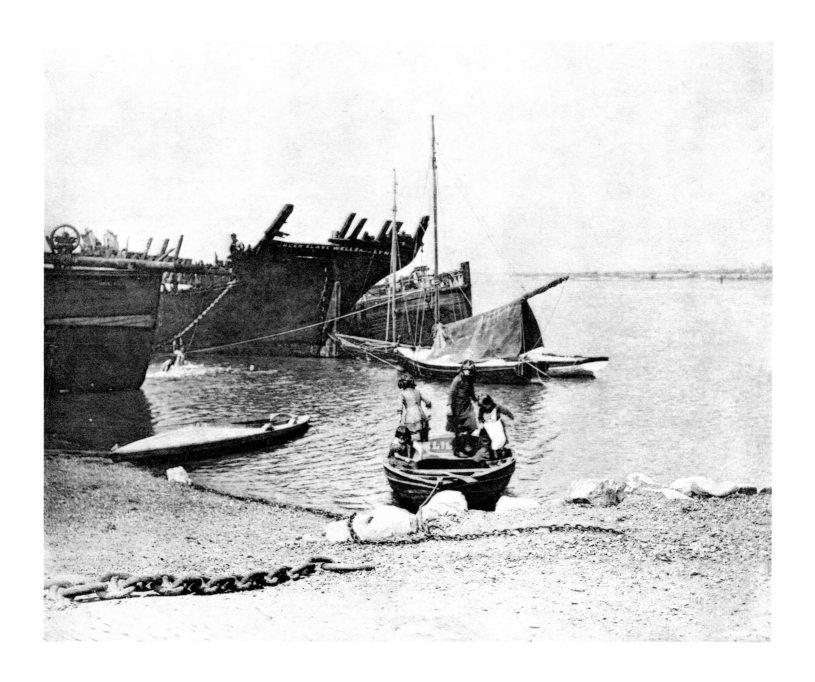

Here is the Broadman's cottage, perched on a low hill overlooking the Broad. From his door, over which is trained a creeper, down to the sedgy border of the mere, extends his patch of garden, in which rise banks green with celery and rows of blossoming potatoes, straggly peas and scarlet-runners; whilst here and there are scattered patches of potherbs destined to season the coot stew. Near the cottage door some straw bee-hives, around which the bees hum in the summer sun. In a little dike is moored his boat with the sail up; he is getting ready his eel-nets. And at eventide will be seen sailing down the Broad towards his eel-cabin, which is moored in another dike near by.

His mother and wife, two kindly souls, welcome us to the cottage. This is the sanctuary of this idyllic Bohemian. Over the tall mantel-shelf is hung the well-kept gun; in a corner are liggers, trimmers, and a broken bow-net; in another corner stand his oars and meak. Thus lives the lake-dweller, surrounded

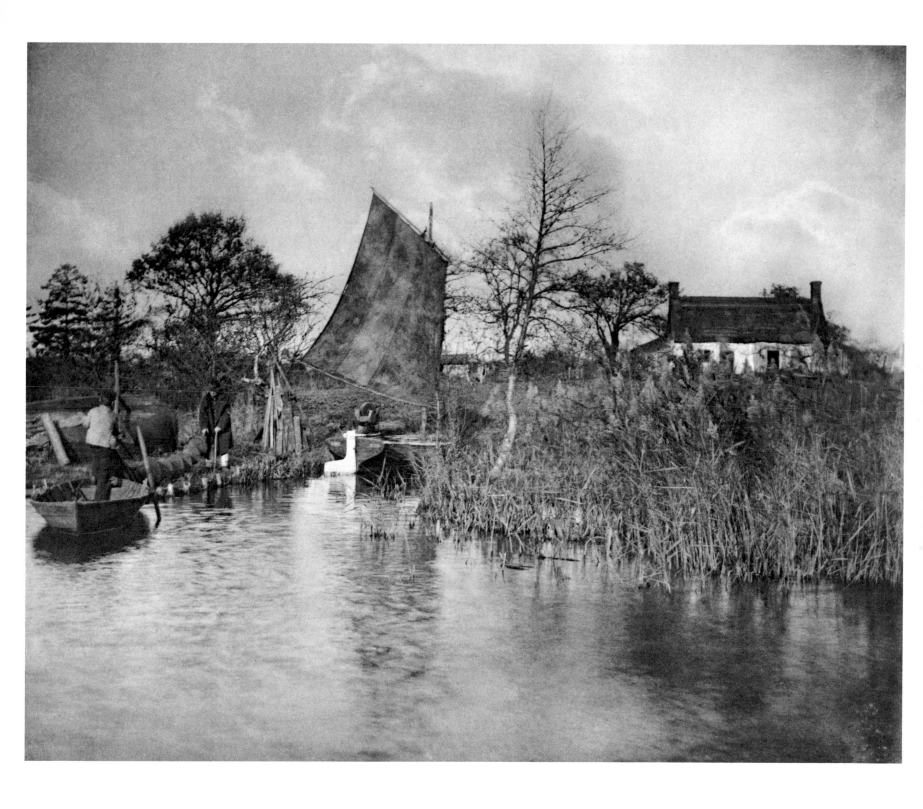

The Broadman's Cottage 167

by his tools and weapons. His women folk are shrewd and intelligent, although the old woman believes in witchcraft...

Through the diamond-shaped panes of the window is seen all around a rich cordon of variegated trees, the dark alders blending harmoniously with the light-green willows. Within the cordon is a wide border of rush, forming a beautiful border to the placid pool. To the right extends a long vista of yellow and white waterlilies fading away into the reed . . . In front of the cottage sail gracefully a couple of swans, in whose wake follows a flotilla of the Broadman's ducks. The placid water is ruffled at intervals by punts laden with keepers or reapers. On the doorstep the chickens cluck as they pick up the scattered grain.

The Broadman's life is full of pleasant variety, even as the ever-changing picture gallery which the seasons offer. With the fall of the leaf the rush turns to golden yellow, the alders put on a velvety coat of purple, and the lake is of the deepest blue. Now comes the frost, and the Broad is a sheet of ice, while the landscape round is hushed into stillness in its snowy cape; the sky is leaden, and the air is rent by the cries of snipe and plover, of gull and curlew.

Let us listen to the Broadman—this labourer, waterman, sportsman, naturalist and philosopher—as he tells us of his battle for life. With August shooting begins. In the early morning, with his dog and gun, he sets off in his marsh-boat, and goes paddling gently round the rush, killing perhaps a water-hen, perhaps a coot for his dinner. All day long he will be mowing the marsh-hay, and at nightfall you will hear the clink of his oar over the still waters as he rows down to his eel-cabin. Here, after setting up his net and lighting his pipe, he sits in his cabin with the door ajar, now and again having to lower the rope on which the net is stretched, to allow the passage of a belated boat or wherry. The night is disturbed by the cries of wild-fowl, and now and then the *ignis fatuus* (will o' the wisp) in its fiery glory shoots across the landscape. Through the long watches sits our friend, smoking his pipe and watching his net.

When mowing the marsh-hay is over, after the hay is poled and stacked, he turns his attention to the gladdon, which has already begun to show the

yellow leaf. He is now seen daily in his huge marsh-boat with his meak, cutting and sheaving the long leaves, which he sells at a good profit.

As the winter draws on he dries and packs his eel-nets, locks his cabin door, and those haunts will know him no more until the following summer. Now, at eventide, you will see him in his boat with dog and gun waiting for the flight of duck and plover; there he will sit patiently until the darkness sends him home, generally with a bird or two for his supper.

When the first ice covers the Broad he is up betimes, and with his whole family, in an old hulk, you will see him busy breaking and gathering the thin ice, which he afterwards sells to the Yarmouth smacksmen. A little later he is to be seen, in tall marsh boots standing in the icy water, and cutting the reed with which he makes his fences and thatches his roof. In early spring he devotes himself to babbing for eels . . . His own garden also occupies his attention; the marrow-pea and scarlet runner are planted and cared for, and later on the swarming of bees is not neglected.

Thus, from the beginning to the end of the year, he lives a life bound by no hours, and subject to no master save nature . . .

The wife, too, has not been idle. The fowls cluck no more, but there is silver in the purse; those cheeses we noticed on the shelf, which were made by her, are gone; and the bees miss their honey; but the old stocking is fuller and heavier than before. And now we pledge the honest Broadman and his wife and family in their own excellent home-brewed beer, wishing them a long life, for a happy one it is.

One can hardly imagine the Broads without wherries. They are to be seen moored at every staithe [dock], as well as in the most sequestered bights, often giving no sign of life save that of the galley fire, whose smoke curls lazily upwards. If it be summer time, the skipper's family, dog and all, will be seen on deck from morn till night. At nearly every bend of the rivers the brown mainsail, filled by the breeze, will quickly carry the curious craft out of your

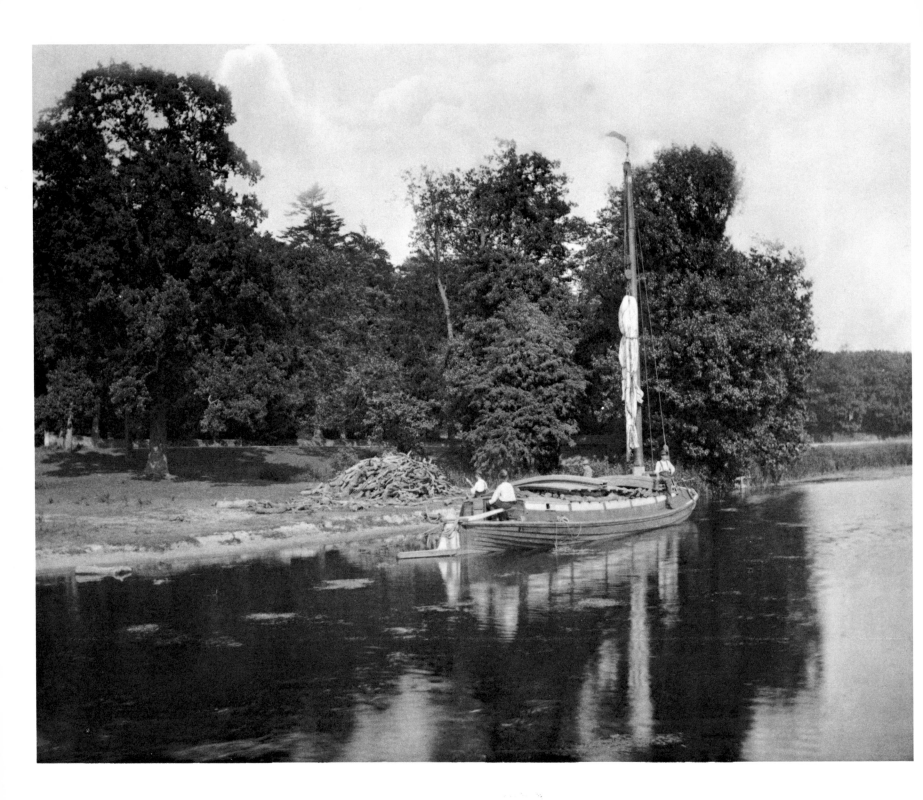

170 *The River Bure at Coltishall*

sight, whilst you are wondering whence appeared this picturesque barge, and whither it is bound . . .

The rig is a mainsail rig, the sail and gaff being raised by one rope by means of a windlass; and so heavy are these that it is considered quite a feat for a man to raise the sail completely without stopping. This is often a matter for modest bets . . .

The railways have taken away much of the work of the wherries, but there is still a great number employed on the different rivers. Lately a good many pleasure wherries have been built. They are very comfortable, and are the best boats for cruising on the Broads, as they draw from two to three feet of water, and sailing as they do very close to the wind, they are most handy for navigating the district . . .

The chief cargoes are coal, sugar, groceries, several kinds of manure, horns and bone, and timber. The wherry in our picture has been loaded with blocks of wood, which are destined for Yarmouth, there to be used as fuel for smoking herrings . . .

The wherrymen are a fine set of men, and require all their strength for their work. It is a regular occupation, and the men, jealous of outsiders, do not care to take any crew not brought up to the work from boyhood. They are very respectable, drink little, and have a wondrous fellow-feeling for each other. They carry very little beer with them but drink cold tea to quench their thirst. When they arrive at a waterside tavern, however, they assemble in the tap-room and enjoy their beer. This is usually when there is a "shoulder-breeze" on—in other words, when wind and tide are unfavorable, and they must use the quant. They are sportsmen in their own way, and can be seen eel-picking as they sail along, or tolling for pike. In the evening, when at rest, they fish for eels or bream. In winter, they carry a gun, and with their dog, manage to provide themselves with plover and other wild fowl . . .

Some of the wherries are so old that it is quite possible there still remain vessels which old Crome painted in some of his pictures.

It is always pleasant to sail with a light breeze in these narrow waterways, where you must handle your boat as if it were a thing of silk and threads . . .

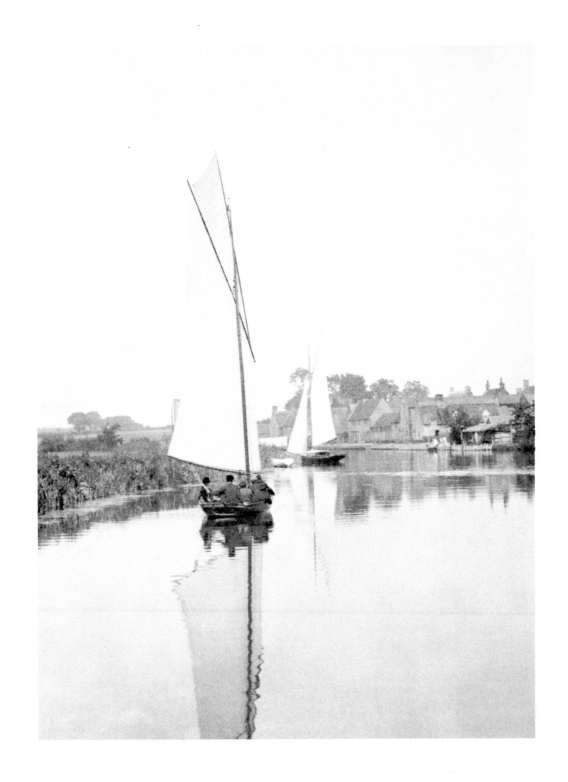

With the first breath of spring the boat-yards and sheds become busy scenes. Masts and spars are scraped and varnished, blocks oiled, sails, ropes, and rigging overhauled, spliced, and mended. In some old orchard where the fresh fair blossom—white with the faintest rose-madder flush—is exquisitely relieved against the blue ruffled surface of the secluded Broad, may be seen a crafty-looking waterman contemplating with critical eye the swelling line of the new keel which he has just riveted on to the boat lying bottom upwards on the grass, supported with rollers and weather-beaten fish-boxes. He chuckles as he thinks how the extra two inches and the fuller curve toward the bow will prevent her making lee-way and hold her up when she comes about, and in fact just enable him to beat that rival who always managed to beat him last year at every "frolic." Perhaps he would not look so pleased if he could peep in at the shed near the bridge, where the rival—doors locked against all prying neighbours—has spent his winter hours in raising the gunwale of his boat, and making a taller mast to set the new large suit of sails daily expected home from the Yarmouth sailmaker. And so they go on at every village, each scheming something new to increase the speed of his craft and gain the coveted cup colours.

By Whitsuntide most of the boats are launched. Trial cruises are sailed, to make sure that everything is in proper trim. The performances of the various craft are noted and discussed, much boastful talk is heard, and speculation runs high among the amphibious yokels. In the evenings, amid the smoky atmosphere of the taproom at some village inn, many a tongue, loosened under the influence of a glass or two of ale, utters loud challenges to sail for vague amounts, and drops to sudden silence on the production of coin by some one in the company, who requests that it may be covered with an equal sum . . .

And now, a fresh breeze blowing, not too strong to set all sail, with every promise of a good day's sport, the newly-painted competing craft arrive, their white, well-set sails gleaming in the sunlight. Spectators gather on the banks and throng the space in front of the old-fashioned inn . . .

Four boats, lying head to wind, are moored to numbered stakes on the opposite bank of the river, the station of each boat having been settled by draw-

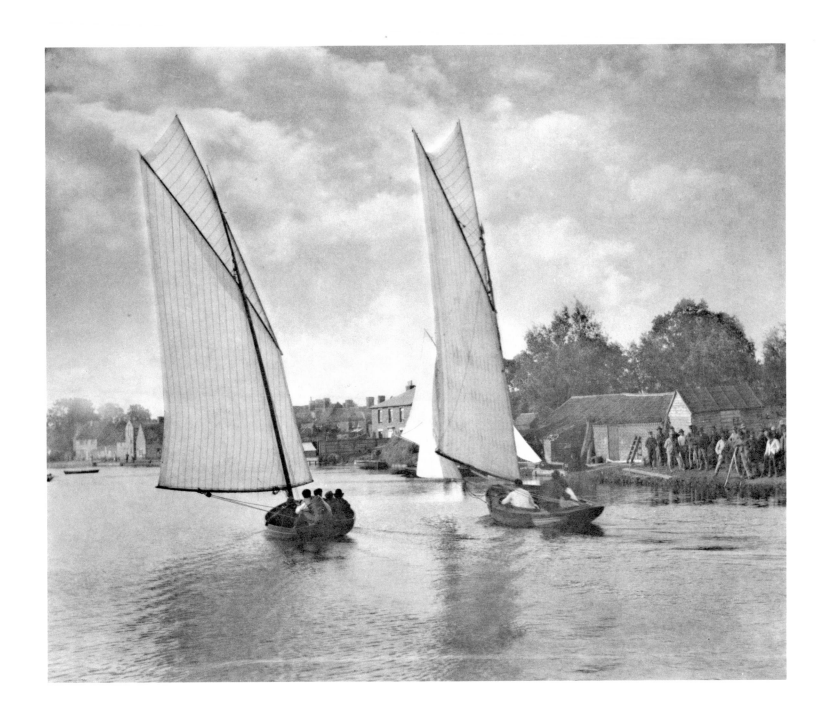

A Sailing Match 175

ing lots from a hat. All the crew being ready, the signal to start is given with an old fowling-gun; jibs are pulled a-weather, main sheets eased off, and, with helms up, the heads pay off from the bank, the sails fill, and the boats, quickly gathering way with wind a-beam, skim swiftly down the river on the ebb tide, towards the buoy with a red flag stuck in it, round which they have to turn. Smartly they go about, leaving the flag on the starboard hand . . .

Passing the starting-place and the critical crowd on the staithe, they creep round the point, close hauled, into the other reach, where wind as well as tide is against them. It is a "dead noser" to the buoy, and the crews crouch low down under the gunwales, crawling over to the weather side each time their boat comes about. The steersman, bending forward, intently watches the luff of the sails, just keeping them full, and allowing the boat to shoot a little to windward with every puff. Pretty is the sight as the well-trimmed craft make short quick tacks from bank to bank, the sails fluttering just a moment as they lose the breeze in stays; the jib, first catching the wind a-weather, pays the bow off till the shaking mainsail fills again, and the boat darts away on her course . . .

The gun is again fired as the *Waterhen* reaches her stake, and her crew receive congratulations on their unexpected and cleverly-won victory. *Violet* manages to get ahead to *Teddy-boy* once more on the run home, but the skipper of the latter claims second prize on account of the foul . . .

An excited crowd gathers round the umpire, fiercely arguing; every one talks at once; louder and more angry grows the din, till bloodshed is only averted by the signal firing for the next race.

The sailing matches over, a short race is contested in rowing craft of local types—dinghies, gun punts, and flat-bottomed reed-boats—the energy of the scullers being far more conspicuous than their training. A swimming match and mirth-moving duck-hunt conclude the sports on the river, after which the inn is besieged by a thirsty throng. With jugs of foaming ale the revellers squeeze into the taproom, some to argue, some to dance hornpipes to the never-changing tune supplied by a squeaking fiddle. Much drinking and some fighting ends the day.

T. F. Goodall

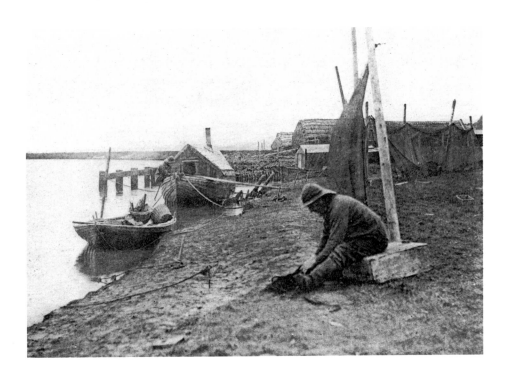

BREYDON SMELTERS

Before the end of the August wane the smelter's old houseboats had taken up their stations. Any nightfall after those peaceful days you might have seen the yellow firelight streaming from their doorways, and shadows flickering to and fro as they sat and joked cheerily on the rough wooden lockers that served them as beds by night; whilst the "boys" fried the "auffol" (offal)—as they distinguish all fish taken in their nets except smelts—the desired quarry.

By day their black-pitched roofs cut the low sky line leading the eye up to the rows of posts, across which their kutch-stained nets hung stretched to dry . . .

There sat the fishermen, like four cormorants, staring into their rowing boats laden with nets and gear, all talking and laughing. They wanted the ebb to run down a bit more. "Plenty of fish a-coming," exclaimed the patriarch of the party; "I can smell 'em." So could I. That repulsively clammy odour that betrays the passage of a shoal of fish was in the air; the smelt smell is, however, of finer quality than the bream bouquet. I believe armchair naturalists

contradict this fact. I can assure them they are wrong. I can smell a shoal of fish as easily as a rose.

A flock of starlings flew down and alighted on the rond opposite, and one of the smelters drew up to me.

"Will you shoot some on 'em for us, governor?"

"Starlings—what for?" I asked a one-eyed man.

"To make a pie."

"Are they good?"

"Good? Yes, sir. Skin 'em, and soak 'em in salt and water and cut their tails off."

I shot twelve with two barrels, and presented them to Cyclops. He stowed them away in the houseboat.

At length another—the "Old Crab"—arose; he had a rough-hewn face like a South Sea Island sculpture with bleared eyes. He entered his boat, throwing the line to the Cyclops, his partner in the strange vicissitudes of a smelter's life.

Seating himself comfortably, he began rowing across the river paying out the hundred and eighty yards of net, the Cyclops trudging slowly along the river wall with the line. Having pulled across the stream, the old fisherman eased to paddling . . . He was a good hour paddling slowly and with effort . . .

The Cyclops stumped down the bank until he reached an old swill [fish basket] stranded in the mud; then he stopped, exactly opposite his partner . . . The first sail away from Yarmouth was already visible across the rond when the Old Crab began to row towards the Cyclops. When within twenty yards of the rond, he climbed out of his boat, stepping into the water, pushing his craft before him to the shore, pulling the line after him. For they only draw the nets into the boats in the neaps—it requires three men for that job.

Mooring his boat close to the salting, he hobbled up the slippery bank and stood on the rond, Cyclops having meanwhile drawn in his line and fixed the trammel stake firmly into the mud. I drew up like a gull on the lookout for "auffol" . . .

Bending double, the old man started hauling, the line cutting his shoulder, crushing the sea-asters and hawk-weed beneath his heavy-heeled boots as he

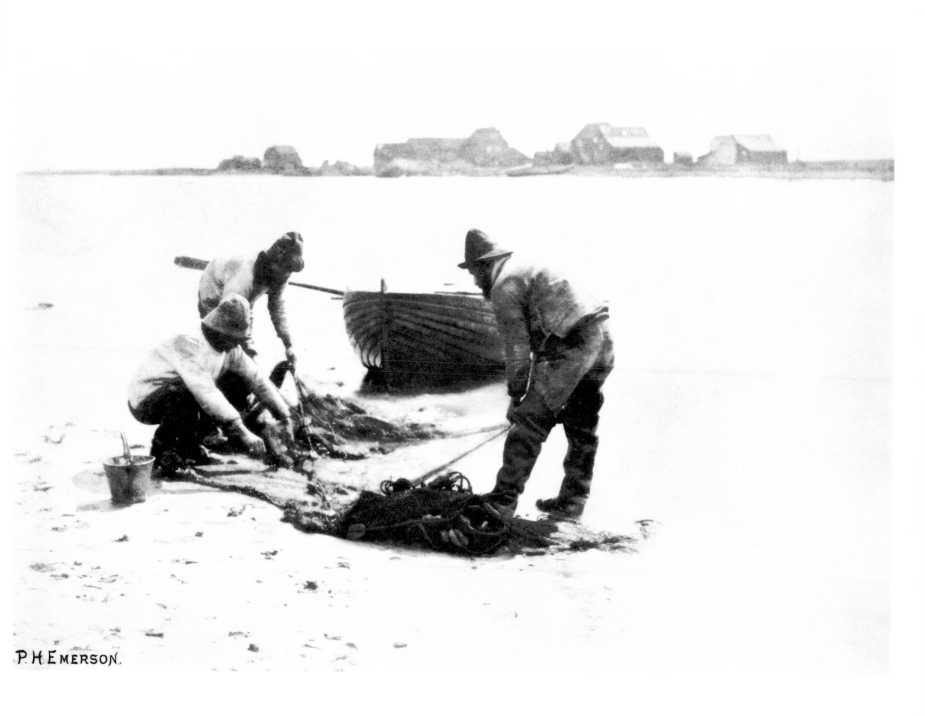

P.H.EMERSON.

plodded in a straight line across the rond. When the corks described a segment of a circle, curving gracefully against the line of the shore, they both began to haul in the "lint" slowly and with peculiar care, one standing upright, the other stooping against the picturesque background of windmills and cottages that loomed on the verge of the marshes.

As they reached the poke, there was a gleam in the sunshine, and the first smelt was drawn from the meshes and cast into a pail. Hauling in carefully, they recovered the belly of the net, and dragged it, dripping with sea water, festooned with seaweed, and gleaming with fish, on to the mud...

The air was full of the scent of freshly-cut cucumber. I have smelt it right across the river when they have been cleaning their nets to windward of me.

At the end of this task, the Old Crab straightened himself with a grunt and counted twenty-one smelts.

"Too much wind, too much wind," he complained; "That fare no good smelting in a wind...Well, I ha' taken twenty to forty score at a draw...

"Wull I sell you any? Take what you like, sir. Smelts two shillun' the score. Take the auffol, if you'll have it, for them starlings."

The "auffol" comprised six codlings, two eels, a few shrimps, four sprat, and a fish a little larger than a sprat, which he called by a name since forgotten.

The Cyclops selected the smelts from the "auffol," and went down to the water to wash their mouths carefully.

"What's that for?" I asked curiously.

"Ef you doan't dew that, sir, directly they're caught, yow can never get 'em clean" . . .

"Thar," he says, handing them to me in the pail; "doan't yow go and mix them with the other fish, or they'll go bad."

The Crab joined in here:

"You'll enjoy 'em. Smelts be on'y good when fresh taken. Them Lonnoners doan't know what smelt be like. They presarves them in ice. Now, directly you put a smelt inter ice, that go bad. If you was ter take a piece of ice an' put it inter a smelt, directly that ha' done melting, the smelt would be bad."

I ejaculated and went off with my booty. Our larder was low. They were cleaned at once; and that evening I rolled them in flour and beaten egg, and

fried them in oil over a quick fire. Smelts and codling *à la Juive.* They were, as my man said, "up to the nine score"...

It was one o'clock in the morning when I finished reading, and as usual I turned out to have a look at the night. The *Maid of the Mist* was rocking gently with the ebbing tide. A clear, still night saluted me; Pegasus gleaming brightly in the eastern sky, first attracting my gaze. Across Breydon I could see the eight lights of Yarmouth on the water-line...

Eels were smacking all around in the starlit water. The sharp cough of sheep came across the marshes; a dog barked hoarsely at a marsh homestead, and I could hear rats feeding in the mud under our stern. A deep cough from the smelter's craft told me some one was awake in there—the ever-restless "Old Crab," I suspected.

Peaceful as was the night, the air was filled with the murmur of life, as myriads of fish, flesh and fowl fought their fierce battles in the air and water and on the earth. The horizon was shrouded in vapour, but at the zenith the constellations shone and blazed brightly with varied colours, the mist encircling the larger stars with delicate wreaths. I was lost in admiration and wonderment as I sat on the dew-spangled cabin roof looking up into the purple sky. Our world is exquisitely beautiful, and life joyous to the brave and the true-hearted. It is useless sighing for the knowledge that is withheld. Verily, as Heine has said, a fool is waiting the answer of the great mystery that the Lords of life and death have hidden from us. A slamming of doors and the sound of gruff voices broke the spell—the smelter obscured my thoughts—the atom eclipsed the infinite—and I went below.

MATERIA MEDICA

A few fishermen had gathered at the bar, and foremost among them was the Harnsee [Norfolk for *heron:* according to Emerson, "one of the greatest living authorities on eels, that slippery quarry of our waters. Silver-bellies, snigs, grigs, and eel-pouts, he knew them all, and their habits"]. The conversation turned on "rheumatics," that common ailment of the watermen.

"Wal, I hev carried a tater in my pocket since Christmas, an' it [seems] to

do me no good; the tater waste, but tha rheumatecs doan't go," said Larin, a hardy, swarthy, determined looking young shrimper.

"An' them magnatic stones far to me nishing fooleries," continued a stout old eel-catcher.

"Them magnatic belts work better," broke in the Harnsee dogmatically, with his harsh voice; "but after all fares to be nothing like the fat o' a good silver eel, jest prick 'im an let the fat run out afore the fire, an' rub it inter the jints; I hev cured miself like that, an' so hev my missis."

"Wal," rejoined the shrimper, "I hev found a little black rosin, as much as hold on a shillun', twice a week dew some good; wenus turps rubbed on the jints do good, but carrying them nishing pigs' left fore trotters and taters an brimstone fare ter me silly."

"Dew yow take them mustard seeds neow?" asked the Harnsee superciliously, turning to Larin.

The earnest Larin answered, "Wal, I took 'em nine morning, and thar was no damned use in it!"

"Eh, old matey! what dew yow think about these'n cures?" asked Larin, turning to an old sailor who had served in the coast guard.

"What dew I think? On'y wiper's oil will cure all yore scrumatics. We used ter get 'em off tha sandhills in California—wiper's oil for scrumatics, an' turps rags for pushes (boils)."

"Fares to me hosses' oil cure quickest," interrupted Pintail, the little gunner, who had just come in with a brace of widgeon and a mallard in one hand. "Hosses' oil is good stuff, ah! werry good stuff," acquiesced each patient, gravely shaking his head.

The landlord had been listening attentively all the time, nodding his head as each speaker in turn scored a point; but his turn was to come, and he added obsequiously—

"Wal, 'tain't for me to say any one thing is nor better than another; but my father afore me suffered terrible from scrumatics, an' so dew the missis there, and we allust say in our family, don't we, Jane?" —at which Jane nodded in acquiescence, —"that a wee drop o' gin the furst thing in the mornin', an' a wee

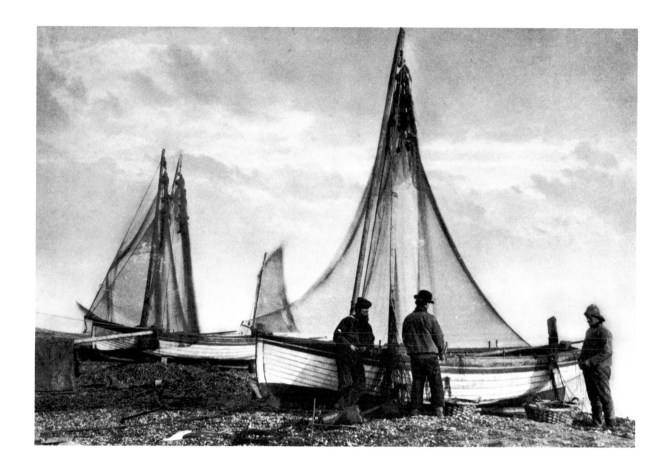

drop at dinner, an' a drop or two at night, fare the best cure for them scru-matics." Then he slapped the counter with his right hand, clicked his teeth, compressed his lips, and struck an attitude of superb defiance.

The fisher folk looked at each other, then at the floor, and some muttered, "Ay, ay; thet fares sensible anyhow."

But the little gunner's eyes twinkled merrily, as he said, "Well, Gammer, gie us a drop now."

The landlord looked at him like a point of interrogation, answering hur-riedly, "Half-quartern," and serving him.

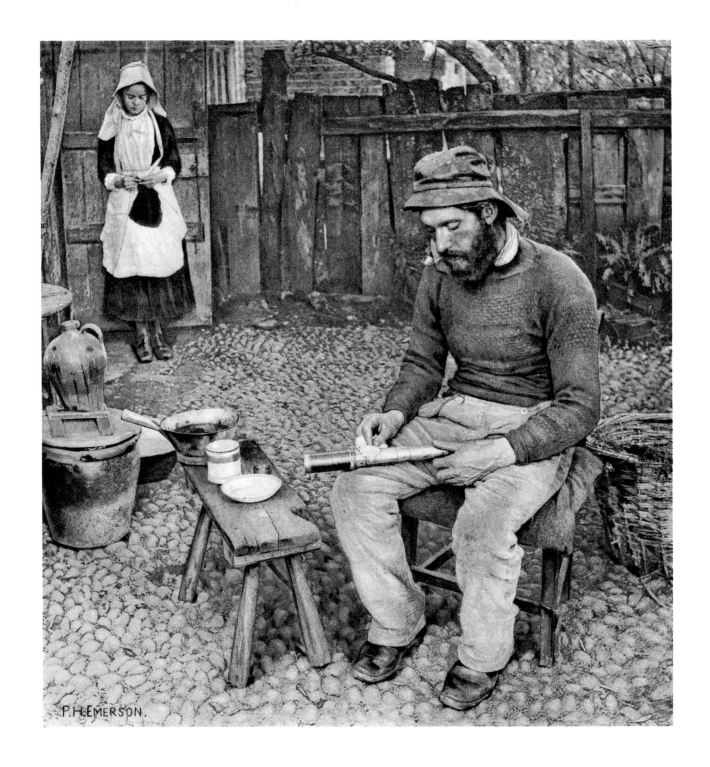

184 *A Fisherman at Home*

The artist must be in sympathy with his subject, "entrer dans la même peau," as the French say. He must have no preconceived notion of how he is going to do a subject, but take all his suggestions from nature and humbly follow them, and lovingly portray them.

This is the only true way for the photographer to work; he must have the camera ready, focussed and arranged, and when he sees his model in an *unconscious* and beautiful pose, he must snap the shutter . . .

It is preferable that all out-door portraits be taken on a grey day, or in the shade if the sun be shining.

The wild winds and chill days of October have killed the fen flowers. No longer blooms the yellow-iris or the meadow-sweet, no scent is wafted from the marsh-myrtle or sweet-sedge, but beauty, sublime beauty, still reigns.

To the left stretch masses of golden-ochred rush, to the right the rich greens of the marshes, and throughout winds the river, a vein of the deepest cobalt, while overhead roll masses of snow-white cumuli flying before the wild west wind. Along the marsh wall comes a group of labourers returning from their short day's work. Typical specimens these of the Norfolk peasant,—wiry in body, pleasant in manner, intelligent in mind. Their lot, though hard, is not unpleasant. Much of their work is that of an agricultural labourer, but in this part of Norfolk it is more varied than in ordinary agricultural districts. They have just returned from cutting the reed. Protected by their long marsh-boots, they may be classed as "waders," for they spend much of their time standing in water up to their boot-tops. Nevertheless they are happy and healthy. The octogenarian who is down the bank lacing his boot, is one of those whose life is a puzzle to the physiologist, for he has been exposed to all kinds of weather all his life; he has been badly fed, has drunk spirits enough to float a wherry, and chewed bad tobacco enough to load it. Nevertheless he blithely carries his six-and-eighty years. The two young men carry meaks,—short scythes much in vogue in the Broads. A healthy merry crew they stride along . . . Now it is a flock of golden plover which darkens the sky overhead and attracts their attention, now they stop to gather mushrooms to eke out their slender fare. The girl's quick eye spies some king-cups which are blooming here curiously out of season, and she stoops to pick the beautiful flowers, mindful of her kind old mother. So homeward go these Norfolk peasants; a naturalist in his way each one of them.

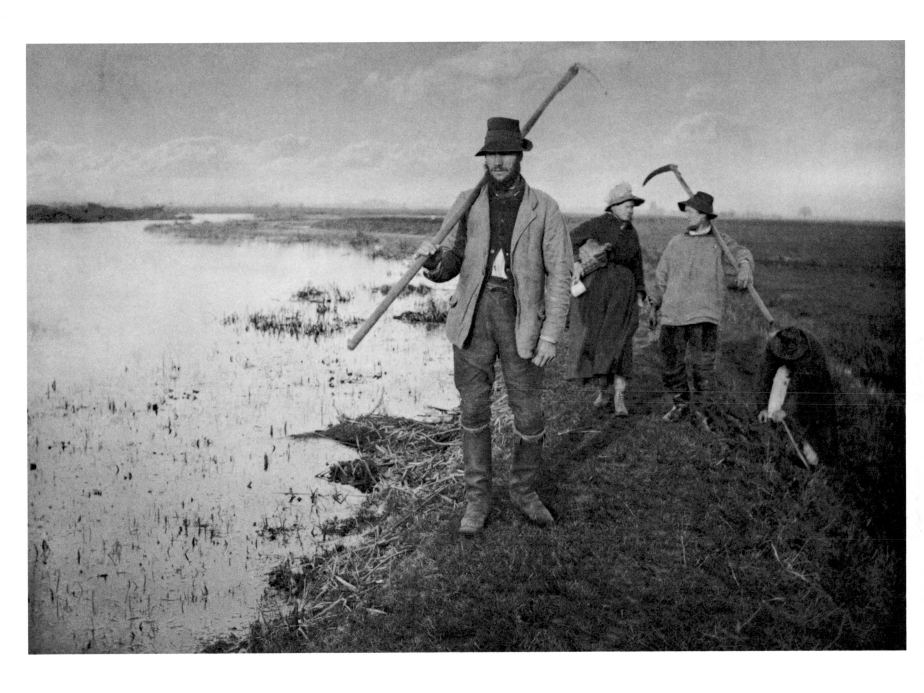

Coming Home from the Marshes 187

"... an awful abortion representing a man plowing uphill with a pair of horses. The man's foot was as long as the horse's head and the whole picture so gloriously 'Naturalistic,' i.e., 'fuzzy,' or 'focussed with judgment' that it was denounced as an imposture."—D. Harbord, *American Amateur Photographer*, Jan., 1890.

I append a few of the press notices written *at the time* upon the "imposture," and leave your readers to discover the imposter, who is a mere nobody, and who was long ago consigned to a well-deserved oblivion which even *his* busybody character could not break through:

> "Among the other examples strangely interesting from their unusual merit, are 'A Stiff Pull'..."—*The Queen*

> "Mr. Emerson has also been fortunate enough to gain the silver medal in the country-house class, for a very spirited study of plowing." —*Topeal Times*

> "To Mr. Emerson's picture, 'A Stiff Pull,' a silver medal has worthily been given. This is a very artistic production. The horses are tugging the plow uphill and the plowman is pushing with all his might to help them in their labours. The clouds aid the composition by carrying the eye to the extreme right of the picture, which is the summit of the hill so eagerly sought for by both horses and man. The whole is a most successful production of difficult action, and is one of the most striking pictures in the room." —*The Camera*

> "P. H. Emerson's delightful platinotype picture, 'A Stiff Pull,' which worthily deserves the silver medal awarded to it..."—*The Artist*

> "Another silver medal for 'A Stiff Pull,' where there is delicious sense of air and humidity, as well as beautiful tone and clearness without hardness." —*The Bazaar*

> "This picture ['A Stiff Pull'], though not technically perfect, is very artistic. There is a great deal of 'go' in the old plowman breasting the hill with his team; and though out of focus, the whole picture is full of life and vigor, and is on the whole, while by no means a bad photograph, a very good picture." —*Amateur Photographer*

I may add that it has been highly spoken of since, for it is one of the best plates in my work *Pictures of East Anglian Life.*

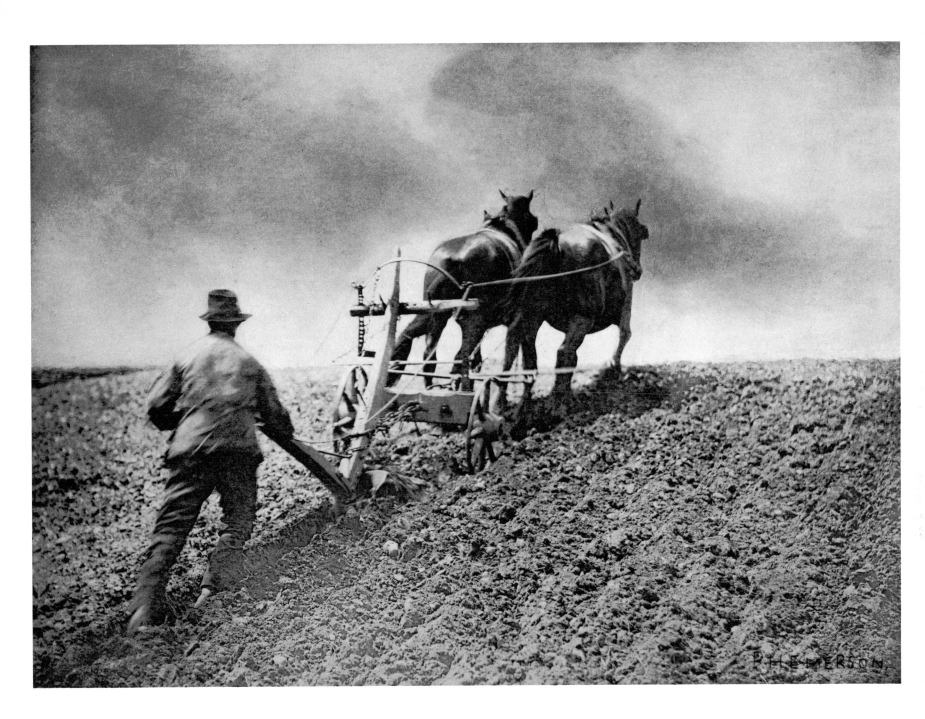

Sheep are the embodiment of pastoral landscape. Take them as you will, shorn and grazing in summertime by the sluggish river, shaggy and nibbling in the flowery marsh in spring, cooped up between hurdles among the root-crops in autumn, or huddled together in the snow in winter, they always look beautiful.

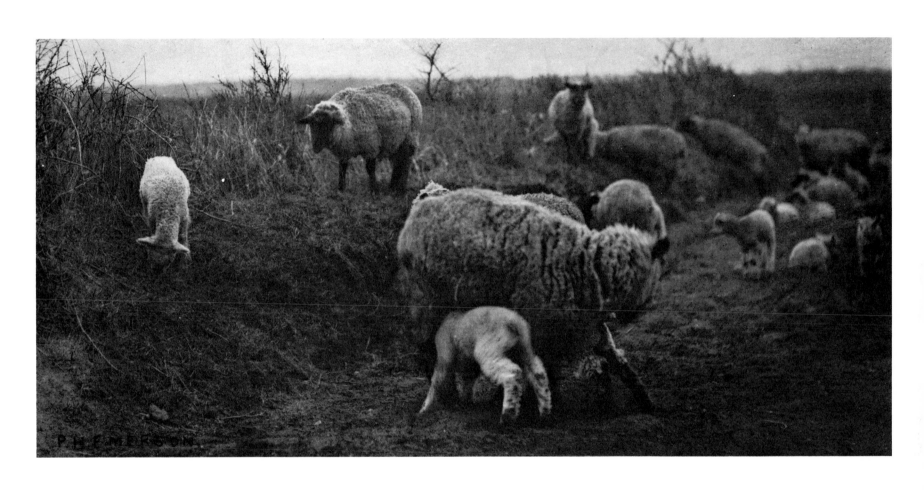

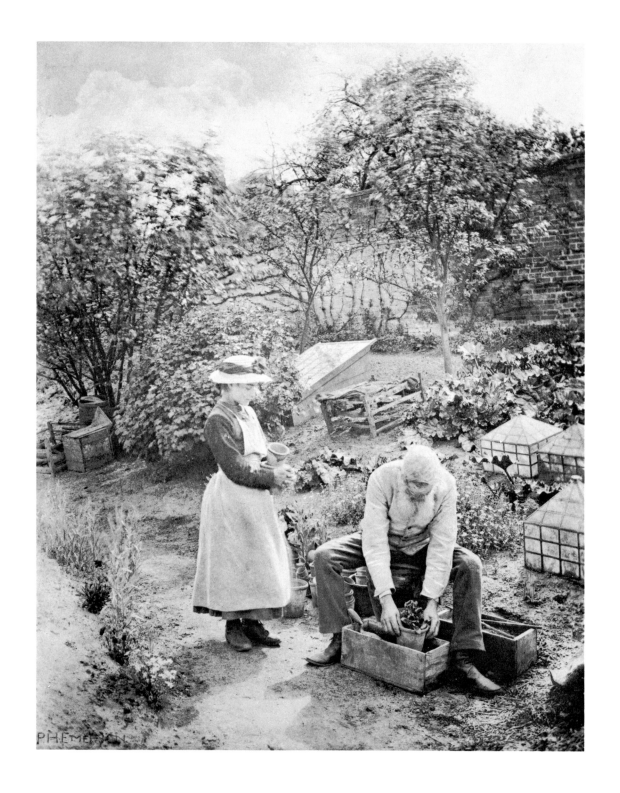

192 *A Garden End*

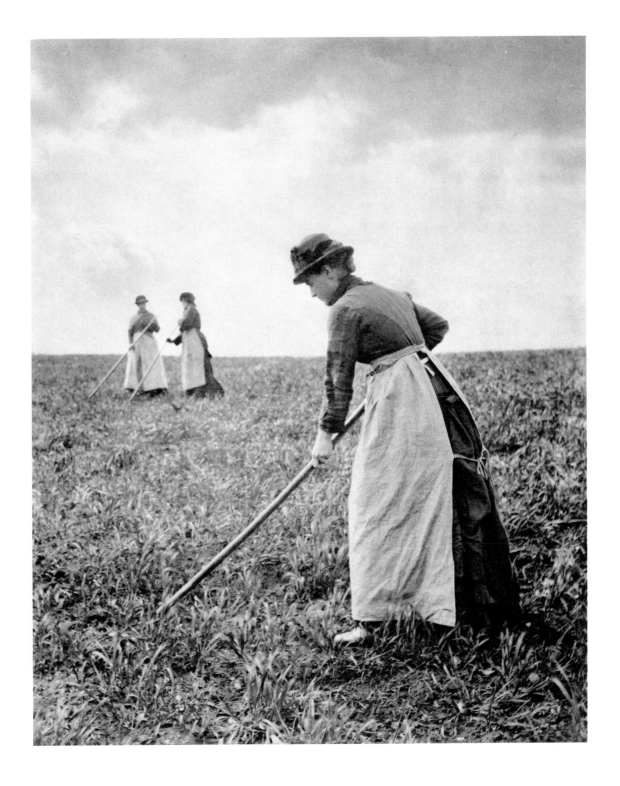

(Women raking) 193

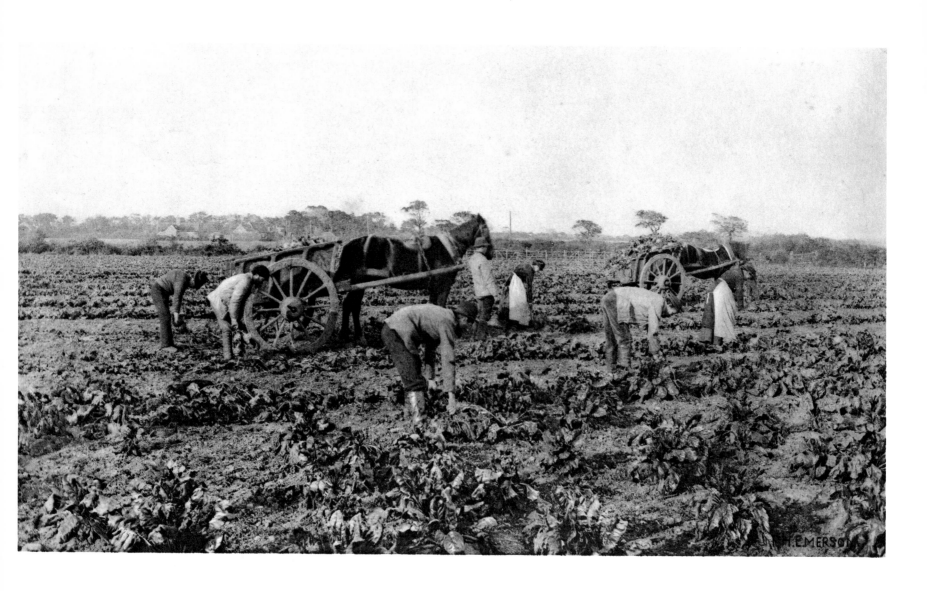

194 *The Mangold Harvest*

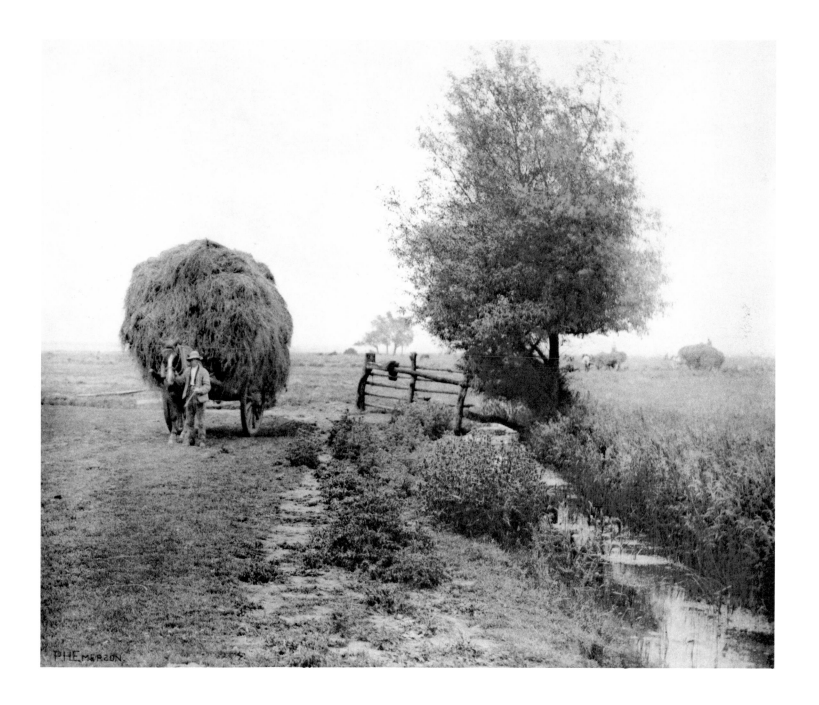

When the land shall all be built upon and enclosed, and the peasant is no more, then may old England go grovel before the world.

SONG, with fiddle accompaniment:
"I ken hadge an' I ken ditche,
I ken mouw an' I ken pietch,
Sa gayly oah!"

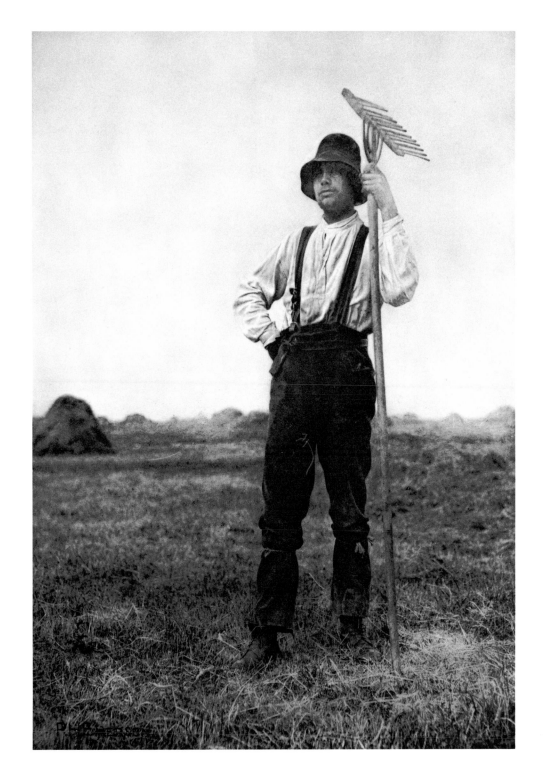

Haymaker with Rake 197

Long since have passed the days of the barley-sele; long since the barley-bird, as the nightingale is locally called, has ceased to sing its pure song in the night-watches; the young blades have escaped the nibbling rabbits, and now the full-grown plants, ears loaded and ripe, while the pheasants strut among the rich crop and steal the grain, the rabbits sit in the shade of the long stalks, and the hares and rats suck the life juices. In the early morning—for it is but five o'clock—comes the farmer with his men, all armed with scythes, to cut the crop. The farmer has his gun and dog ready for shooting rabbits, while the landlord's keeper stands by to see that none of the thieving birds are mistaken for the four-footed rodents. The men go along two abreast, sweeping down the grain in good six-foot strokes, stopping every now and then to sharpen their scythes. Bang! goes the farmer's gun, followed by a squeak as a "bunny" rolls over, sending a deathbed message to his surviving relatives in the form of a few hairs borne away on the breeze. The work goes on until half-past seven, when the men go off to breakfast for which half an hour is allowed. Eight o'clock finds them all at work again, and by noon long runs of barley lie on the field. The labourers now go to the hedge-side or seek the shade of the elm-trees nearby, and enjoy their well-earned hour of rest, during which they eat their mid-day meal, while we go back with the farmer to the farm for our meal of home-brewed ale and bread and cheese . . .

On our return we determined to take a plate during one of the short rests so frequent in this hard labour. Here one man is honing his scythe, while another, his face streaming with perspiration, has taken off his hat with which to fan himself, and stretches forth his hand to his mate, who, leaving his rake in the field, has brought the bottle of "home-brewed," with which they will all quench their thirst. Through the hot day they will work under the broiling summer sun until 4:30 p.m., when they rest and have tea, or "fourses" . . . After half an hour's rest they again fall to, and work hard til seven in the evening, when it is a common sight to meet gangs of these tired labourers going home with scythes and rakes, empty bottles and baskets and probably a few rabbits killed that day in the fields.

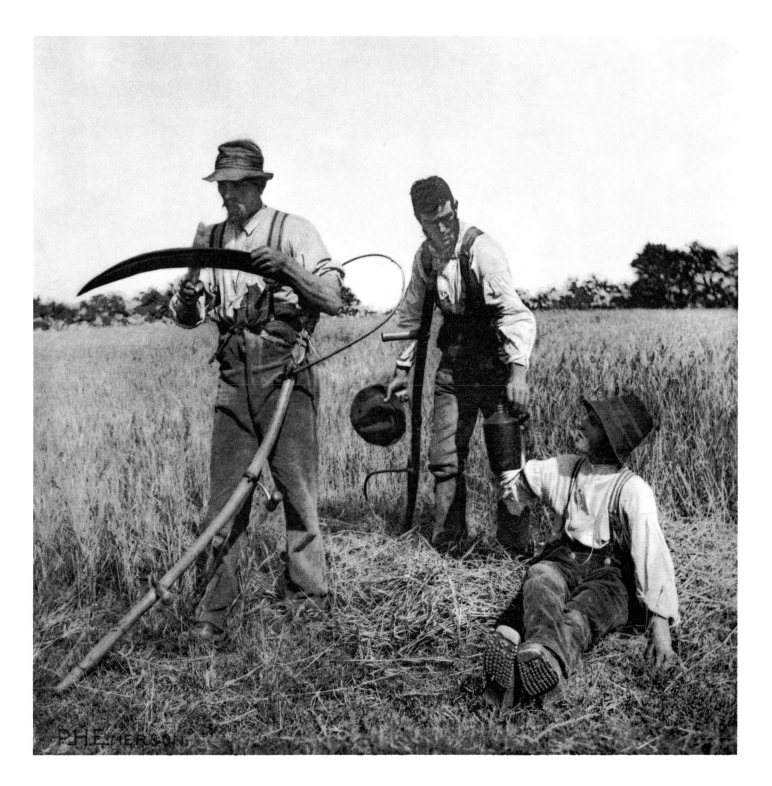

By far the most valuable product of the swamps and marshes adjacent to the Broads, is the crop cut yearly from the reed-beds . . . The cutting and harvesting of the reed afford profitable work to the Broadman, marshman, or farmhand during the winter months, when other work is scarce; and whenever the weather permits, they may be seen busily plying the meak amid the tall yellow masses, or bringing the loaded marsh-boat across the Broad . . .

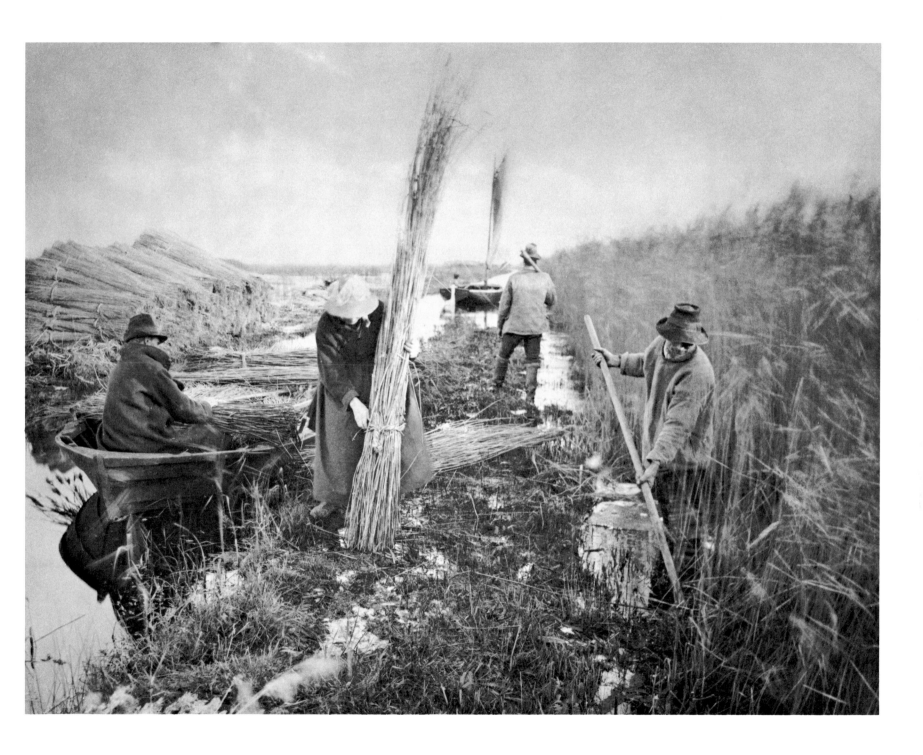

"Towing reed" illustrates the usual method of getting the loaded boat along the narrow arteries which intersect the marshes and afford communication with the reed-bed. Sturdy of frame and strong-featured is this tower.

The reed harvest does not commence until close on Christmas, when the sap is thoroughly dried from the stems, and must be discontinued as soon as the young shoots sprout early in April, for then it is impossible to cut the old crop without injury to the new ...

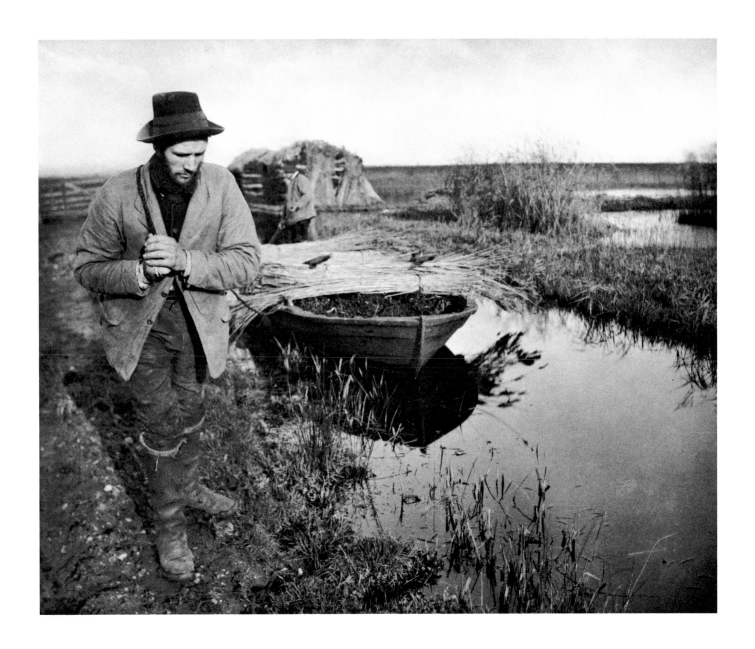

A reed thatch, of proper thickness, will remain impervious to the weather for fifty years, or if the pitch of the roof be steep, so that the water has no chance to lie upon it, it will last eighty years or longer. "Long-reed"—the best shooves of which will measure nine feet in height—is used extensively by builders for the party walls of dwellings and for the ceilings of rooms, being nailed between laths and floor-joists for the latter, and between battens for the former purpose . . . Imbedded in plaster, and sealed from the air, there is no end to the durability of reed; in dwellings which have been demolished after an existence of three centuries, the reed has been found intact and sound as when it left the rick.

T. F. Goodall

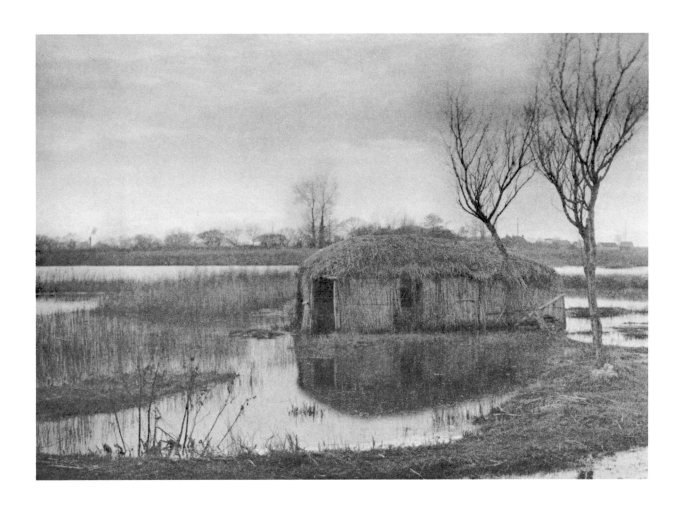

A Reed Boathouse 205

Many of the plants included under schoof-stuff have in earlier times had much more honorable offices than that of littering stables, or even "kivering beet." The iris, the lily of France, is said to have been the national flower in that country since, at the battle of Tolbiac, the victorious soldiers of Clovis crowned themselves with its blossoms—suitable emblem for the Franks, who came from a marshy home. The red berries of this plant come in beautiful succession to the yellow blossoms... The leaves of the sweet flag were much in vogue for strewing the floors of churches and dwelling-houses, and it is said one of the charges against Cardinal Wolsey was his extravagance in the matter of rushes. This seems to us ridiculous, and we cannot help thinking it a pity that the whole nation did not in this respect emulate the great Cardinal's nicety, for then we should not read Erasmus' description of how "the floors of the houses were generally made with loam, strewn with rushes, constantly put on fresh without removing the old, concealing fish bones, broken victuals, and other filth," and England would probably have been spared the severe epidemics of the middle ages.

The bur reed, again, was valued for its seeds, of which rosary beads were made. The natural order to which the bolder belong contains also many other plants which are, and have been, very useful to man; of these perhaps the most notable is the Egyptian papyrus. According to Wilkinson, chaplets of papyrus and other flowers as well as the lotus were used on festive occasions, and he says these two plants constituted the sole aliment of the peasantry in Egypt's early days. The same family at the present day affords material for making boats in Abyssinia and South America, and we read of similar use in ancient Egypt. De Gubernatis says: *"On prétend que le navire sur lequel Isis s'embarqua pour aller à la recherche de membres d'Osiris, était construit avec des roseaux de papyrus, et que les crocodiles, par respect pour la déesse, n'osaient s'en approcher."* . . . The art of paper-making from the Egyptian "bolder" was most interesting. The rind was removed from the stalks, and the pitch cut into thin layers; these layers were glued together at right angles and subjected to pressure, and thus simply was made that paper which for thousands of years has withstood the trying climate of Egypt.

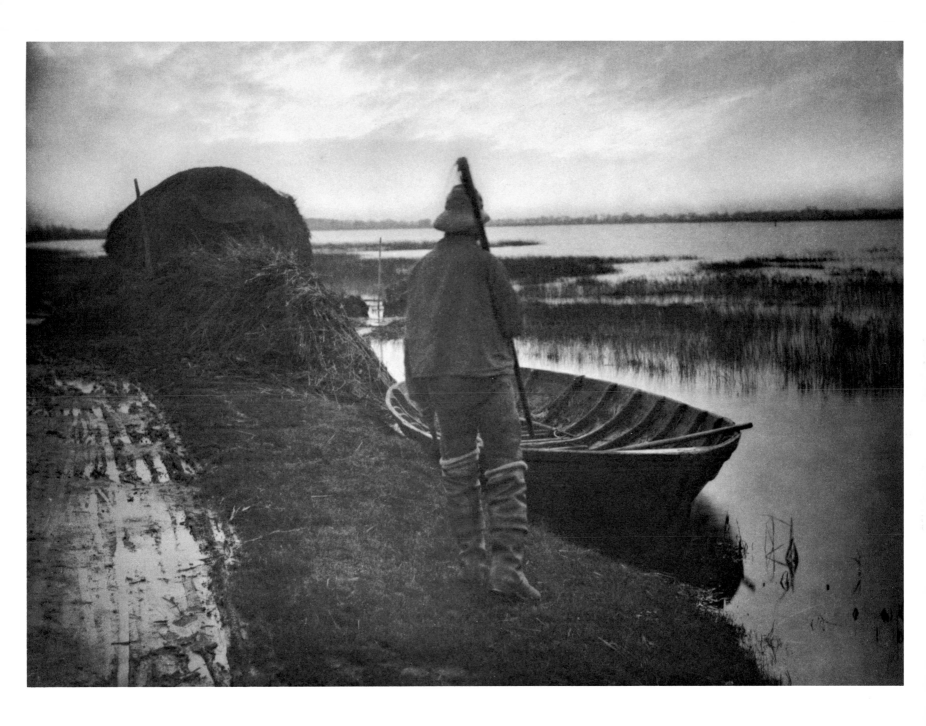

. . . the more we have studied the peasant life from our point of view the more fearful does it appear to us. A terrible struggle for the bare necessities of life . . . if his health fails, his family starves . . . The cottages in out plate are tenanted by peasants more prosperous than some we know, yet even here, what a life! The scanty cubic space filled with airpoisoned by the organic exhalations of the eight human beings we saw sitting in the one room, where the hard-worked mother . . . was preparing a coarse meal for the delicate children. Pure air and good food they needed, and neither could they get . . . The day was biting cold, but we were glad to get out once more into the air, and escape from that ill-smelling dwelling.

In our plate we see the young mother crossing a slippery ice-glazed plank which bridges the frozen dyke . . . to call her husband to his dinner. He too has been ill with fever.

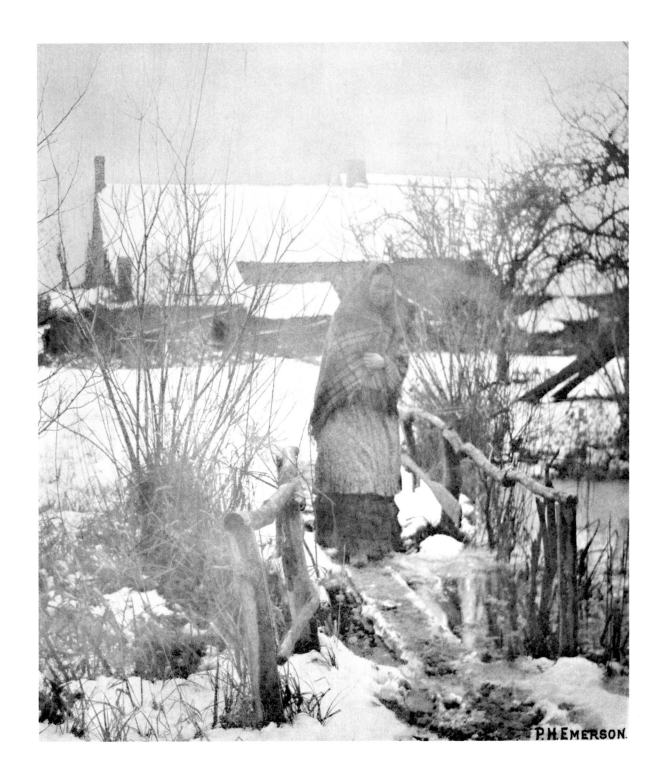

The student should feel that there never was such a ploughman, or such a poacher, or such an old man, or such a beautiful girl as he is picturing.

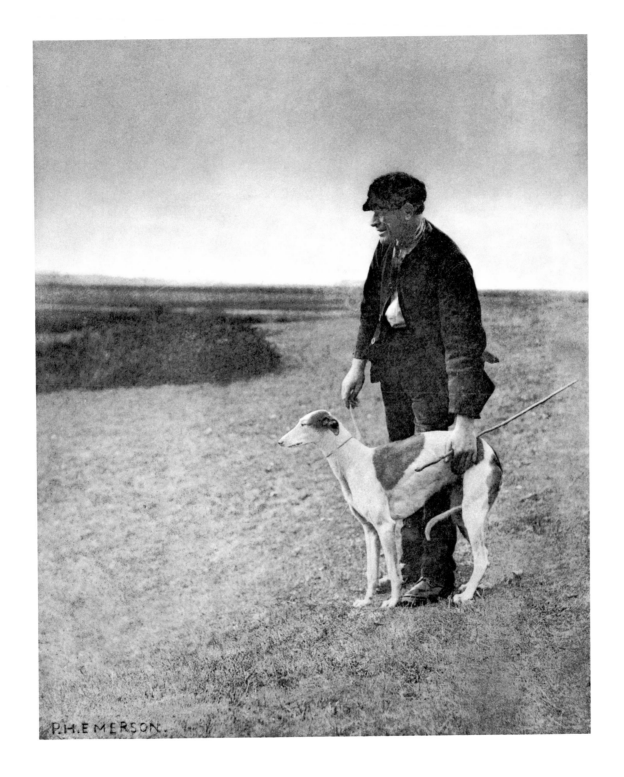

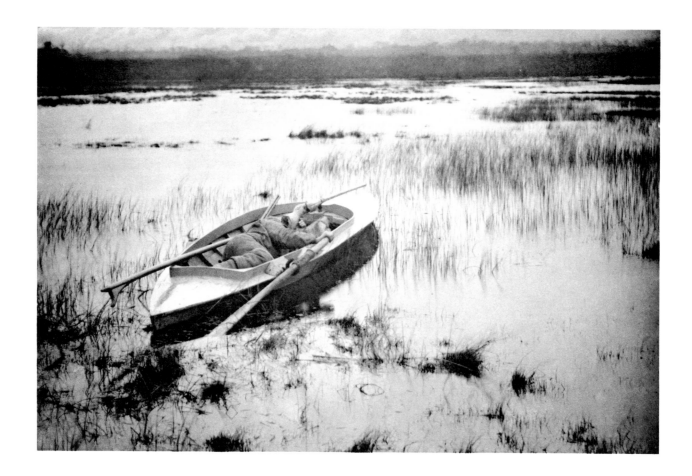

We are going out gunning. Dick often goes and brings home golden plover, curlew, redshanks, and sometimes a mallard for our larder; but fowls are still scarce, so that the professional gunners do not fare better then we. I stick to my rifle; I never did and never shall care for a shot-gun. Rifle-shooting has too much fascination: there is a terseness, directness, and subtleness I like in a rifle. When I fire with a shot-gun I feel as if several persons were taking a hand in the game, and I never know which shot kills; but with a bullet it is hit or miss. Pintail has come up. He twinkles his little eyes, and says some good fowl have come in from the sea, and he means to get them. He takes off his hat, runs his hand with three fingers through his brindled locks, then replaces his hat with a slap, and says determinedly—

"Yes, I mean ter hev the warmin' on the flood. I mean ter lay around tha lumps; they'll go thar tha last."

Dick paddles off up one drain, Pintail up another, and I scull up a third, for I am not yet an expert sculler, for it requires great practice to lie full length in a shallow punt and propel yourself with one scull. As I steal silently along the drain, my rifle lying at half-cock on my right, I raise my grey cap above the boat and peep ahead. My heart gives a bound, a flock of curlew is feeding on the glistening mud. They tell very large and dark against the light, so I take a second peek to make sure. Yes, there is no mistaking those profiles, there are nine of them. The tide is with me and I scarcely work the scull. I could hear a pin drop, so keen are my senses; but all I hear is the water splashing softly around the punt. The steering worries me, for the drain is not five yards wide; and though my punt only draws a few inches of water, she may stick on the "putty." Two gulls alight and join the curlews, this makes me still more careful, for the gull is sharper-witted than the curlew. I am now within a hundred yards of the fowls, when suddenly the gulls stopped feeding, and eyed the punt suspiciously. I stop paddling and lie perfectly still, the gulls resume their meal, and the curlews are all unconscious. Working up cautiously I approach to within sixty yards—that was an exciting moment! Pushing the oar into the soft mud, I anchored the boat, and lying prone, cocked my rifle, and thrust the barrel over the deck of the punt. One gull heard the click of the trigger, and with a scream of warning to his mate, gave a short jump into the air and flew off, quickly followed by his companion. The curlews stopped eating, raised their long pointed bills, and looked askance at the punt; but they were easily satisfied, and they resumed their meal. I was filled with excitement, and raising the rifle to my shoulder, took deliberate aim at the closest bird, and waited for two or three to get in line with it. But one bird sharper than the rest saw the barrel move, and he piped and flew into the air as I fired. When the smoke cleared I saw my bird lying dead on the mud.

WILD-FOWLING

Most of the professional gunners live at Yarmouth, where the wide expanse of Breydon—a favorite resort of wild-fowl—affords ample scope for the pursuit of their calling. All through the shooting season they row off at earliest dawn from the old quays and boat-houses of the North-end, or Cobham Island, and disappear into the mist and gloom of this great tidal water; and at intervals the loud roar of the big swivel gun, long-echoing through the air, quickly followed perhaps by the sharp lesser reports of the cripple-stopper, giving a *coup de grace* to the wounded birds. At times, when other waters are closed by the frost, sensational bags are still made on Breydon, a lucky shot discharged amongst a mass of various fowl, thickly congregated on an ice-floe, killing or crippling them by scores . . .

No boat is handier, or more perfectly adapted to its special purpose, than the gun-punt. The draught of water being only a few inches, the shallowest places are easily accessible to it. The bottom is flat from side to side, but

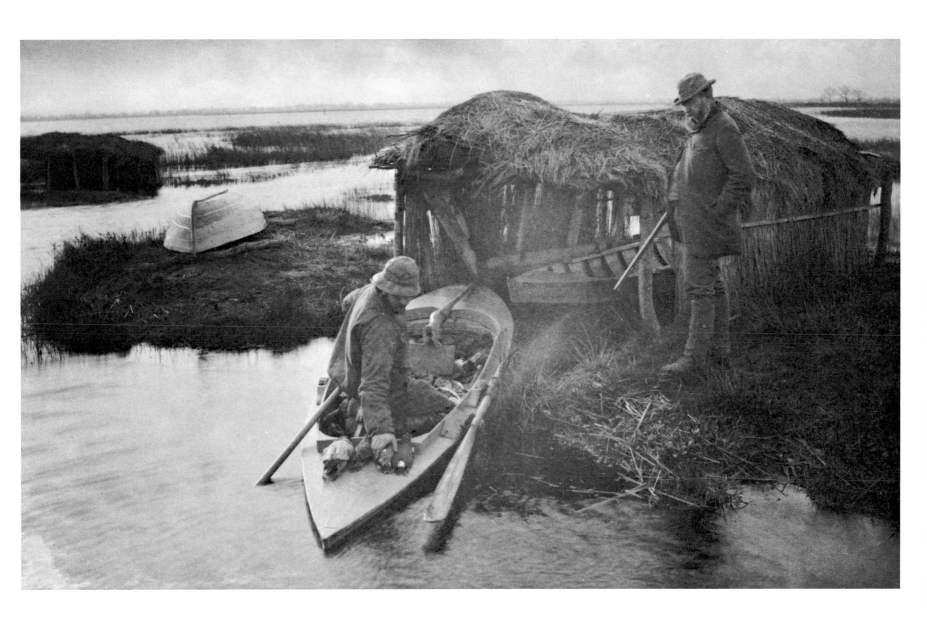

curved slightly from stem to stern, like the line of a skate-blade. The sides, which converge to a point at either end, are flat, and slope outward at a slight angle—the floor of the boat being of less area than the top. As may be seen in the pictures, the centre only of the boat is open, the ends being covered with a gently sloping deck. A first-class gun-punt has very subtle lines, and can only be built properly by the most intelligent of boat-wrights, and perhaps only by one who is himself a gunner. The punt can be sailed, rowed, quanted or sculled, is light and fast, while its exceedingly low freeboard offers a minimum of resistance to wind and wave when the weather is boisterous. Under the decked gently sloping deck. A first-class gun-punt has very subtle lines, and can only be built properly by the most intelligent of boat-wrights, and perhaps only by the gunner . . .

Boat and gun are painted a leaden grey, or, as the men will tell you, "the colour of the water," invisibility being the most desired attribute of the wild-fowler . . .

In the other picture our fowler is returning to the boat-shelter where he houses his punt. Another sportsman has come to have a look at the few birds he has bagged, and to compare notes as to the events of the morning.

Most of the sport-loving natives use a gun of some sort, and many of them are good shots at wild-fowl. At the evening flight, the birds suffer most heavily, for then every weapon is at work. Having finished his tea, the yokel strolls from his cottage with an old single-barrel, of ancient date and doubtful lock-action, under his arm; standing in his garden, behind some hedge-row, or at a field gate, he watches for the flighting duck or plover. The marshman, pulling on his boots, strides across the sedgy swamp, and makes a cover with a few "schoofs" of reed hard by some stagnant pulk in which he knows the fowl are wont to alight. The Broadman paddles off and hides amid a clump of rush, or in the shadow of a bank, where he noiselessly watches and listens.

As the sun disappears the birds seek their nocturnal feeding-grounds, and

"flighting" begins. The air is filled with sounds of beating wings. Now a bunch of mallard, swift-flying teal, or half-fowl, now a bewildering flight of tumbling, dodging lapwings or a line of golden plover whizzes by, high overhead or near enough to tempt a shot which thins the ranks. The banging of shoulder-guns is heard at frequent intervals all around, while now and again the loud boom of the swivel gun reaches from the distant Broad. As the night increases, tongues of flame are seen darting straight towards the sky, long before the arrival of the distant report.

With such a fiery ordeal to pass nightly, one marvels that there are so many wild-fowl still left; but, after smelling powder a time or two, the birds get very circumspect, and, unless the wind be too strong, take care to fly at a safe altitude until they arrive over the spot where they mean to alight.

T. F. Goodall

. . . The water is a little too high for good sport, but now and then, from some little tufty island snipe will rise with sharp startled cry, and that odd jerky flight so trying to the skill of the gunner. A teal or mallard too, will be walked up, and the dogs will certainly hunt out some water-hens from their hiding-places. Some sportsmen may object to the breed of the dog in the foreground. Well, in spite of his looks, he will fetch duck or snipe in a style which might make any professed retriever jealous. He, like his master, is taking a day's holiday from the more serious business of the farm. Minding stock is his business, sport his pleasure. We have seen him course, turn, and kill a hare in one field in the cleverest manner. He delights to follow the gun, and well repays his master for the care bestowed on his education.

. . .The nature of the ground to be traversed, if ground it can be called—for the favorite haunt of the snipe is something between land and water, a spongy

vegetable mass marking the transition from mere to marsh—makes the utmost caution necessary to avoid sinking into the many holes and soft places which abound. Woe to the unlucky snipe-shooter who, trusting in his tall water-boots, tries to cross some treacherous flooded bog, warily groping for the hard stubs to rest his feet on, if he makes a false step! Knee-deep already, should he tread on a soft place now, the water pours over the tops of his boots, instantly filling them. This we know from experience to be a most uncomfortable predicament. He must struggle out as best he can, pull off his water-logged boots, and pour out the muddy contents of each before he can proceed any farther. Crossing the numerous dykes which intersect the marshes is also often a matter of much risk and difficulty. It is simple enough where there happens to be a plank across, but often the only bridge consists of a rough-hewn and very shaky branch of a tree, perhaps not more than four or five inches in thickness, partly submerged in the centre. As a support in crossing this frail structure is used an alder pole, found lying ready on the bank. When anyone wants to pass over, he rests one end of this prop on the bottom of the dyke, and, firmly grasping the other end with one hand, steadies himself upon it during the passage. Having successfully accomplished this balancing feat, and reached the farther side, he throws the pole back for the next man . . .

Sometimes the marshes seem covered with snipe, and they rise perhaps a dozen at a time, bewildering the sportsman, who cannot make up his mind at which to fire. Next day, over the same ground, he may not put up a single bird . . . A goodly number nest here, and all through the summer months may be heard that musical laughing note, peculiar to their breeding season, which they give out as they drop swiftly through the air whilst hovering over the marsh where lies their home.

T. F. Goodall

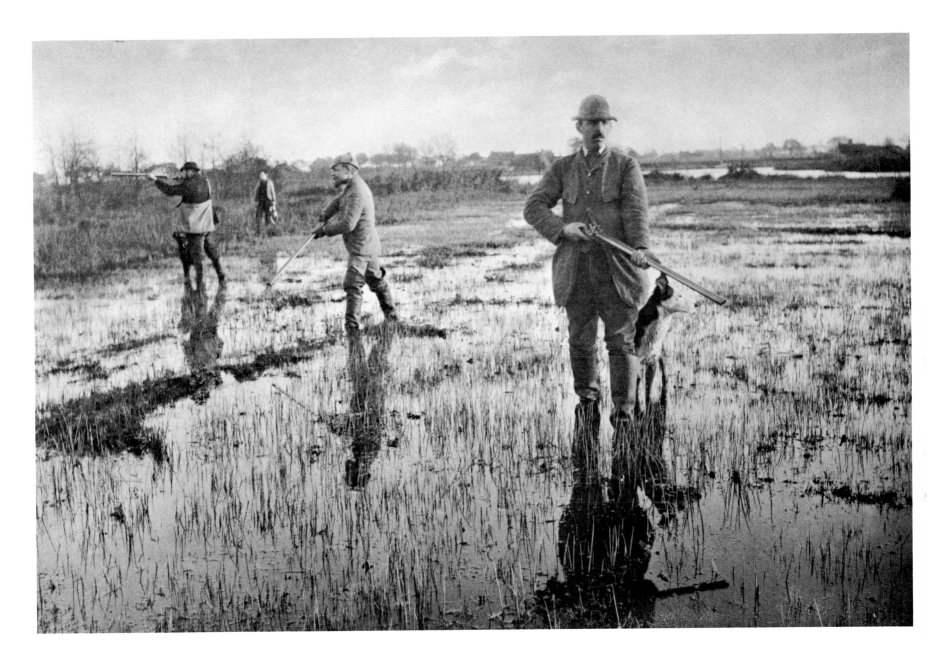

"Whan tha sun coam a peepin ovar the hills,
An' that pleow-boay whistled ovar tha fields,
Than tha huntsman tew his dogs marrily did sah,
'Tally ho! Tally ho! Tally ho!'"

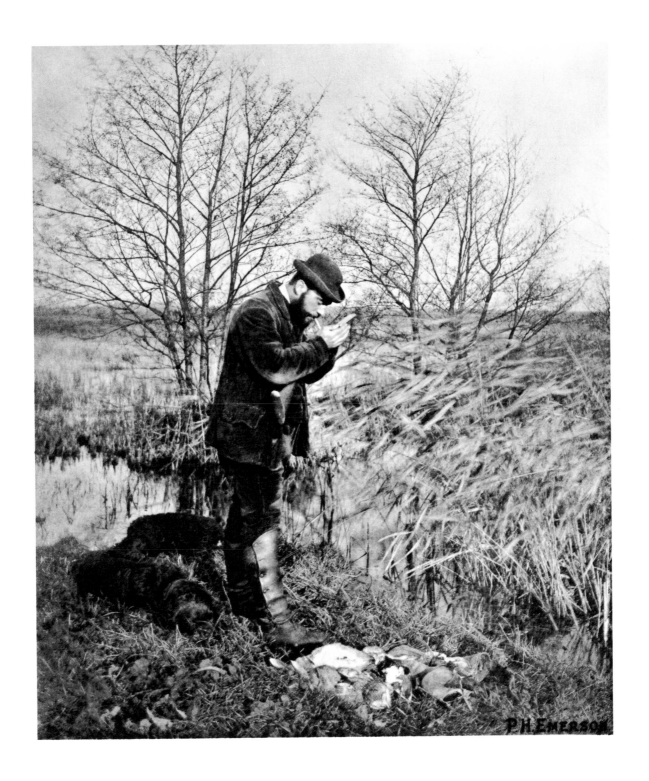

An evening in June, on Breydon flats at low water. The setting sun gleams like burnished gold on the glass windows of our houseboat lying anchored on one of the opalescent streams that thread this moist fairyland of green sea weed and pinkish mud . . . the channel winding through forests of shipping and quays bordering the sea-stained town that rises from a tongue of sand stretching between the river and the ocean. At a distance the quaint gabled roofs appear, cutting the sky like a ridge of sea-shells, so full of colour are the old red-tiled houses, tarred sheds and brown sails, all glowing in a misty atmosphere. As the yellow sunlight gilds the landscape ere it is lost in the night, the water in our little drain, where there is scarce sea-room to turn a skiff, lies motionless, reflecting the soft clouds floating overhead . . . Here and there are pools left by the tide, mirrors wherein the clouds peek and pass by . . . The damp freshness of the evening soothes: we seem to float through a dreamy land of mists soaked with the most delicate dyes.

"By God, it's wonderful!" I cried.

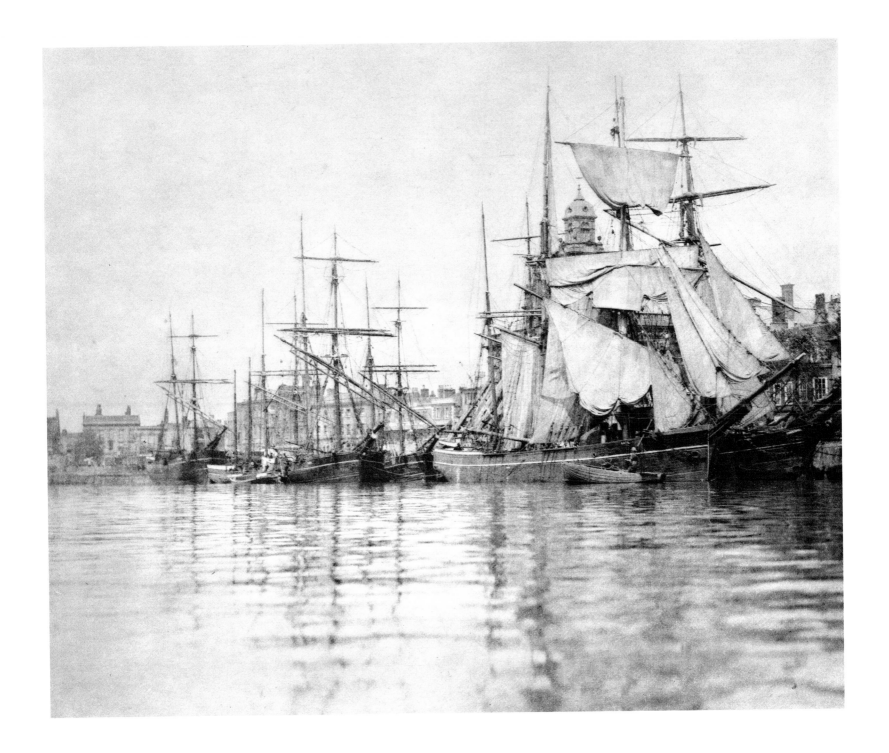

Yarmouth from Breydon Water 223

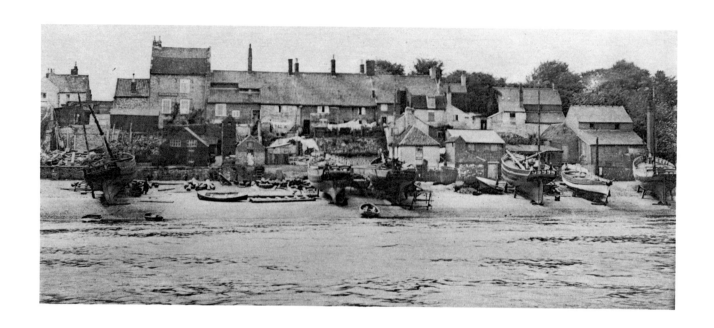

224 *A Corner of Old Yarmouth*

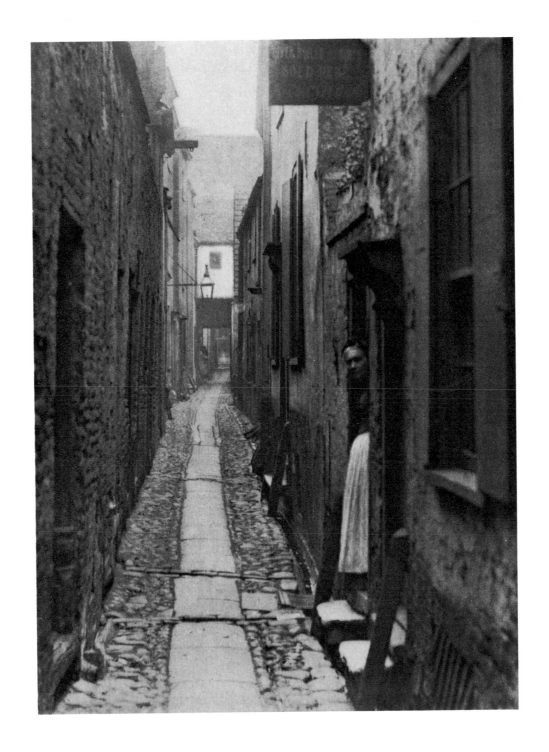

A Yarmouth Row 225

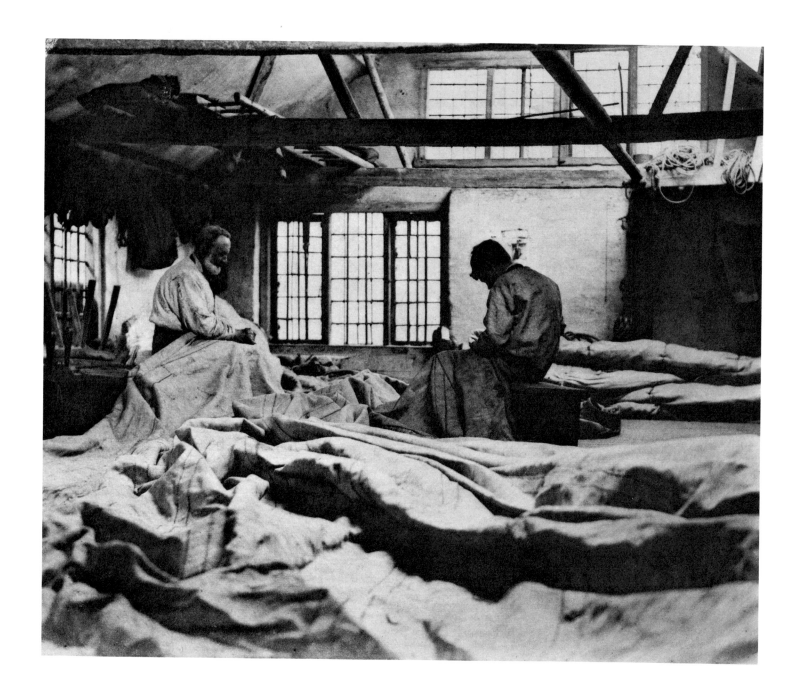

226 *In a Sail Loft*

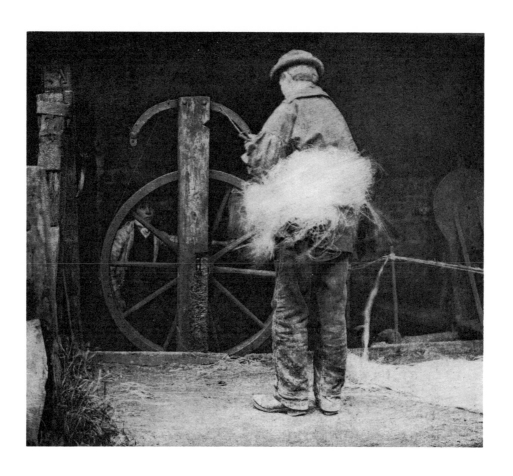

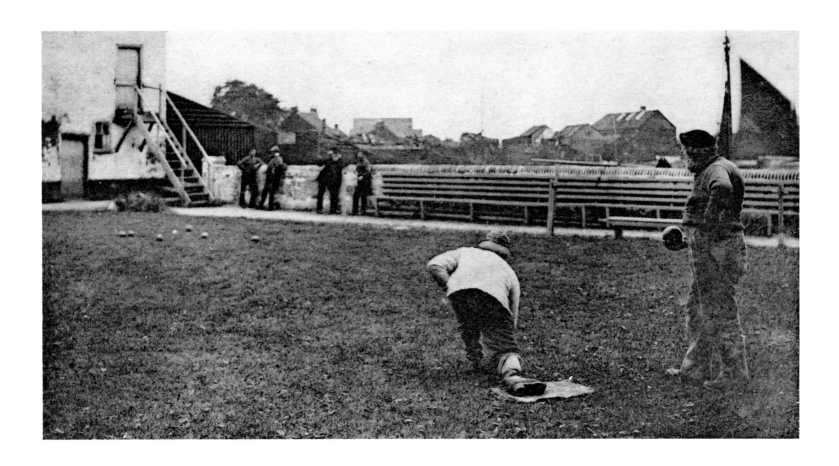

Pushing with lowered mast through the gloomy and austere bridges, we passed a picturesque corner of Old Yarmouth, lighted up by the morning sunshine, discovering groups of fishermen clad in blue guernseys, all smoking clay pipes as they watched the sailing craft go through this narrow neck of water that joins the Broads and Breydon Water. As we passed the bowling green, a row of blue caps bobbed up over the black fence gazing at us, some old friends hailing vociferously and running down to help us moor. Just off the green, the Harnsee, splendid in new sealskin cap, blue guernsey, duffel breeches and tall polished boots, was mopping out his gun-punt . . .

The tide was running swiftly, eight jolly knots an hour, carrying a boatload of laughing girls up Breydon, past the codling fishers moored in midstream. Everywhere were signs of coming winter—loafing yachting hands, their

yachts laid up under tarpaulins; and all around luggers taking in ballast, for the fishing had already begun, and the herring harvest was being garnered. We soon followed the laughing girls across Breydon with a fair wind behind us . . .

The water grew choppy at the junction of the Waverney and the Yare, and we had to tack, so discovering the roofs of the smelter's houseboats peeping over the ronds. Some of them were cleaning their nets as we dropped sail and moored . . .

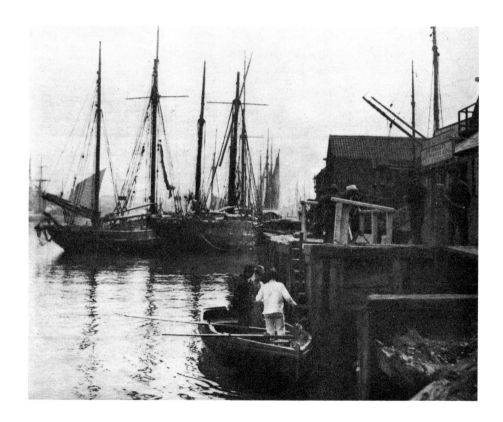

. . . the equinoctials still rocked and moaned through the trees on the low hills above us.

After taking in all reefs, we started with lowered peak, sailing before the wind . . . for the New Mills through the Grand Canal of the old city, a waterway delightful in colour, but malodorous. We had hardly passed under Thorpe Bridge before a soaking rainstorm burst upon us, driving the crew into their oily suits. Thus clumsily attired, we quanted through the silver rain-shafts, the unwonted appearance of a pleasure craft in these purlieus drawing towsled heads to the windows and black-faced stokers to the quaysides.

"Here comes the Noah's Ark," cried a coal heaver, sheltering under a sack, worn capote-wise, but the grave old malsters and the apathetic flour-men merely gazed at us with wonderment. Urchins on the bridge jeered, and drabble-tailed factory girls begged us to take them for a ride. The dark moat with its rich red walls, green with ivy-leaved toad-flax, seemed endless. We shot bridge after bridge, hoping each would be the last, but it was long ere the white walls of the New Mills gleamed before us, when we moored to a beacon; but the smell coming from the window of a warehouse, which we found to be full of stinking bones, drove us nearer to the dark arches of the Mill, where the water was once again clear.

"It can be drunk in winter, but it is only good for washing up now," volunteered a civil wherryman lying up alongside.

The gale was still roaring above us, but we felt nothing of it; we were lying, as it were, at the bottom of a pit, the storm raging over the mouth with the noise of a blast furnace.

We quanted back through this dismal land of factories, sawmills, tanneries, breweries and gasworks, and when we moored at last against a garden bank near the Cathedral, Jim ejaculated thankfully—

"I'm glad ter get back ter something green."

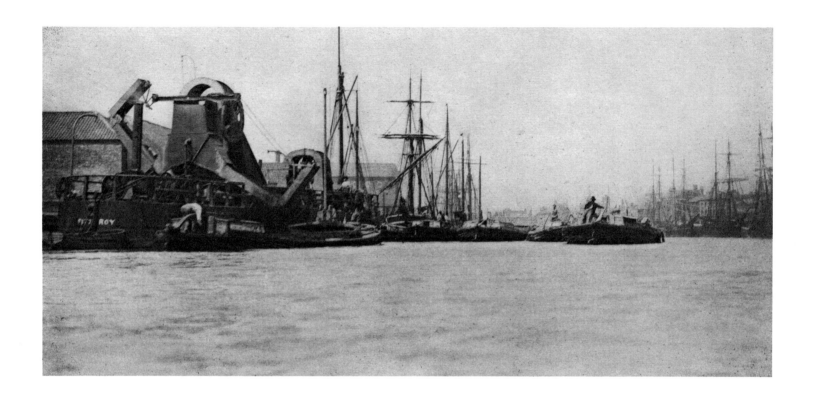

Snowy weather always makes me as lively as new wine. We sat smoking our pipes, when a sudden hail storm poured down upon us, playing pretty music on the roof; then followed snow, with north-easterly squalls. In half an hour the marshes were white, the landscape hushed, and the river running a silver thread through the glittering snow carpet—for the moon had risen, discovering flocks of snipe, field-fares, starlings and peewits, feeding greedily in the newly fallen snow...I went for a two hours' walk in the moonlit snowy landscape, for such a scene is dear to me beyond expression. The silent, pure, radiant beauty of the world at such an hour seems to fill your life. It was a strange sight to see those birds feeding and fighting greedily in the white midnight. I returned a little after twelve o'clock, glowing from the biting snow and hail-squalls encountered in my walk; but the birds and myself had injoyed a scene that the sleeping towns-folk at Beccles never saw in their wildest dreams. I lay in bed still listening to the snow-squalls, sweeping against my windows with the swishing as of heavy embroidered garments or the tapping of leaves upon the pane; at the same time the wind blew overhead roaring hoarsely like an angry furnace, rocking the boat like a cradle. The moon lit up my cabin like a tropical night, and I sat up in bed at times and looked out upon the glittering landscape, chequered with clouds blown swiftly over the face of the moon...

It was freezing hard, but still I could hear the roar of the water over the weir. It would be some time before we should lose that music.

234 *A Frosty Morning at Coltishall*

FROST

When I got full awake I found the windows frosted with fantastic pictures, each a fairy scene of decoration. As I lay in bed I realized man's constant struggle with cold and death. Here was King Frost again ready to freeze our life's blood, and we would surrender. For without, the landscape was white, and even now, at half-past six, the thermometer stood at 19°. All about us was a cold dead world; we alone were warm and living, and by our own energy we had to breathe life into the ship. We began by warming our pipes, the tobacco smelling delicious in the keen air. Then, raking the cold ashes out of the icy grate, we piled in fuel, applied a match, and were rewarded by clear sharp cracklings as the frigid iron began to warm. Next we broke the icy fetters of our windows; and having boiled the kettle, we ate a hurried breakfast, smiling upon the wintry scene as we gazed out of a little window framing an exquisite picture—a patch of amber-stalked reeds drooping with rimy tassels . . .

As the sun rose, a ball of orange fire, it shed a new light upon the rime, turning the marshes to a fresh, greenish, vegetable-like colour. As we walked along, crunching the crystals underfoot, a crackling of ice and rustling of reed-stalks attracted my attention. We ran to the spot, and saw a monster pike dart off into the deep water, the rime-tasselled reeds quivering in his trail. An hour after sunrise the air felt so warm...that I could lie in comfort on the cabin roof, watching a marshman shooting snipes with his old-fashioned flint-lock to be retrieved by his spaniel. The heavy air prevented the smoke from his discharge from rising quickly, so that every time he fired he ducked down to look for his bird beneath the little cloud. Neither he nor the birds seemed to heed the steam mills, for they had already begun to pump the water from the drains. As I watched this simple sportsman, the marshes facing us became a pale lemon colour, the yellow turning green as the clouds passed over the sun's face. Here was the effect Turner tried to render in his well-known "Frosty Morning," but he exaggerated the yellow. Sooth to tell, neither his perceptions were delicate enough, nor his hand deft enough, to express such a wonderful phenomenon. But such an effect is rarely to be seen, as I can testify. On the river wall dead thistles were drooping with the weight of silvery frost-

ing, and the bare trees growing around a marsh farm gleamed like burnished silver upon a grey background. The tide was flowing, carrying fields of thin sheet-ice on its bosom—rough and frosted windows from which the sun was reflected . . .

The bare coppices were noisy with chattering jays, and a frozen pond on the marshes was black with rooks walking clumsily upon the ice and feeding upon some food they found in the little crevasses. They behaved so awkwardly that Jim remarked—"Their skates won't bite."

. . . the Broad was nearly frozen over. As the night was closing in, and our hands were numb with cold from sailing, and our plankways like glass, we moored against a rond opposite the site of the lonely house where gipsy Borrow spent his last days. Methinks, had he been alive, he would have come on aboard and drunk a bottle of Madeira with us whilst he talked of the *Chals*. After making up, we studded our mutton with garlic teeth *à l'Italienne*, and later on the naked bone attested the keenness of our appetites.

The sky looked frosty, and the ice in the reed-beds was making a most curious and musical sound as it ground up and down with the tide among the reed-stalks. The sound of these pan-pipes recalled the hum of insects on a tropical night—a wild, irregular music, suggestive of broken metallic strings, that played harmoniously on occasion, but generally gave forth a fantastic, wilful, discordant song. Not even the steam-tug breaking a channel to the dredger for the lighters drowned the wild music. We began to navigate the jagged edged channel filled with ice-floes, wishing to get across the broad . . . it was difficult to trace the channel, for the havoc made in the ice-field by the icers had caused the broken floes to shift and destroy the channel. It was unpleasant to hear the sharp jagged blocks grinding against the boat's ribs, and we did not bless the icers who were busy all round us gathering the cold harvest into old ships' boats, broken-down wherries, and dismasted smacks, scooping up the broken pieces, tossing them in their holds with the sound of broken china.

238 *A Winter Pastoral*

Fierce storms of snow and sleet sweep across the common, and blow in straggly groups the home-returning crows and flighting ducks. In the winter evening yellow and red sunsets glow, bathing in golden splendour the corn, and casting long dancing shadows on the waves from the home-returning fishing-boats. On the ice-covered dikes the urchips skate, and the eel-pickers secure their slimy spoil. At eventide the village streets are empty, but from cottage homes steal forth glowing lights and savory smells of broiling fish and fragrant tobacco.

(Wintry village) 241

In the late winter the snow silently falls, and the gorgeous beauty of the common is shrouded in a veil of fairest white. Many of the low-lying gorse bushes become snowy hillocks, whilst others are relieved in sharpest contrast against the spotless snow or leaden sky.

Now the wild horses' spirit is tamed; cold and subdued, their winter fur all ragged, they huddle together, and collect under the lee-side of hedges, against gates, or in the hollows between the hummocks. Then it is that we meet the hardy longshoremen returning home at midday almost men of ice, with icicles from their tall sea-boots and from their grisly beards. Then, too, does the angry North Sea beat this doomed shore with thundering waves, and year by year devours the land.

The next morning I left for London...But that fog-buried city—London—nearly suffocated me, and the wan faces of the people, stalking like ghosts over the snow beneath the yellow mephitic fog, suggested a hell peopled by phantoms of the former inhabitants.

It was cold and stuffy in the houses, and I immediately fell a victim to a "cold." I resolved them and there to leave the city forever.

...I returned to the ship. We passed through a decorative panorama such as winter alone can produce, for in snow and rime Nature is oftener artistically right than wrong, Mr. Whistler notwithstanding. Sooth to tell, the more one sees of natural effects the more one is persuaded that Nature sings oftener in harmony than many a painter would have us believe.

As we rushed on through the beautiful wintry landscape, the wheels on the rails played a shrill music, recalling the voice of some gigantic cicada or the cries of some strange wild animal. On our way we passed ash-trees with bunches of seeds hanging from their snowy branches, looking like bats where the mists were thick. As we shot swiftly through plantations, the snow lying on exposed branches gleamed here and there with flashes as of steel bayonets. These bright patches of light seemed to give a fuller expression to the sense of loneliness and mystery that enshrouds a wood.

In driving from Lowestoft to Outlon I passed a churchyard, the bent gravedigger filling a new grave. The recent carriage marks were sharp cut on the frozen road. The sun was setting behind the gravedigger a gorgeous yellow on a hard tinny sky. The sun's fulvous light flashed from the glass globes of everlastings, and seemed a ladder of light to lead the eye to heaven. This vision was a strange contrast to the cold iron earth and snowy ground. The everlastings and gravestones were a sad satire in their ephemeral significance beside the cold graves and frigid snows. They stood like man beside the everlasting nay.

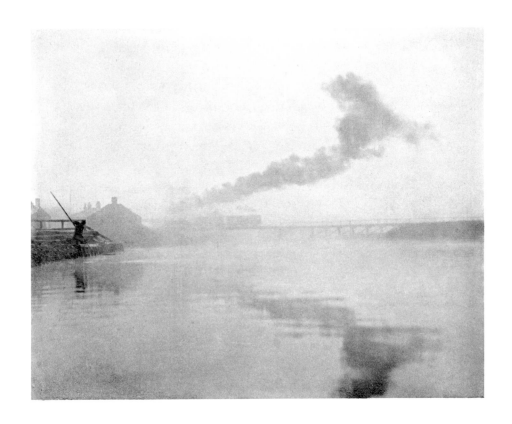

As you wander on the lush marshland on a still summer night beneath the starlit sky, you will hear all around you the voices of the night—singing birds. The canary-like warbler babbles in joyous song from yon sallow islet in antiphone to the sweeter-voiced and more precise reed-warbler, who makes the reed-bed ring with his song; suddenly, close by you, sounds the mysterious clicking of the grasshopper warbler, and whilst you are listening, wondering at the strange song, a nighthawk flutters by the reed-bed shrieking, and startling a water-rail, that begins to whistle softly, "whiö, whiö." Then follows a lull, and you hear mice working in the stuff by your side; and as you listen a corn creak begins his cheap-jack-like vesper on yonder green marsh; but his distant voice is chorused by the harsh "frank-frank" of a heron, and the plaintive plovers calling "three hillocks a week, week arter week," as they gleam to and fro in the rising moonlight, awaking the red-legs that fly round and round their nest whistling "a-love, a-love," and you stop bewitched with the wild marsh notes, a droning snipe wheels round in the starsome sky, laughing wildly as he drops down the air over his sitting mate. Then there comes a lull, mayhap, and suddenly a cuckoo begins to call from yonder planting reflected in the still mere...and the cuckoo seems to waken the ring dove that begins to croon to the moon gliding through the trees of the waterside carr, where you may hear the watery tribe of teal and duck whistling and crackling to the moon. And a marsh-owl screams, and the frogs begin their intermittent chorus, hushing mayhap, just as a water-hen calls a loud cr-r-ook, or a coot flies from his nest with cries driven forth by a hungry stoat. A horse snuffles near you, and again peace descends on the marshland, and only the cry of the sea is heard away over the sand dunes. But a scarce-moving cygnet passing slowly up the river like a ghost recalls you to the fulness of the tide of life by night, and a bird's cry in a stoat's grip recalls the tragedies of the night. Even when the marshes are frozen, the voices of the night are not hushed. "Frank" still calls, peewits wail, and flighting fowl fill the cold night with their voices. And you go home assured that nothing is constant but change, nothing certain but death.

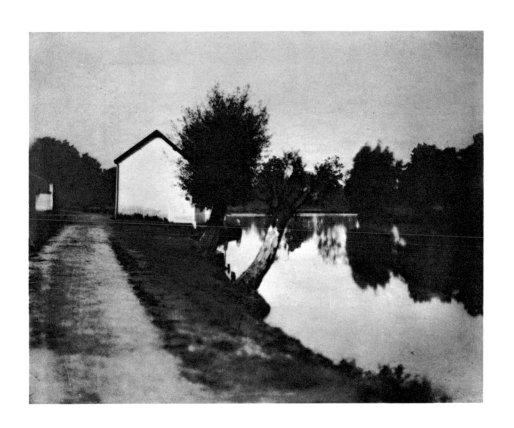

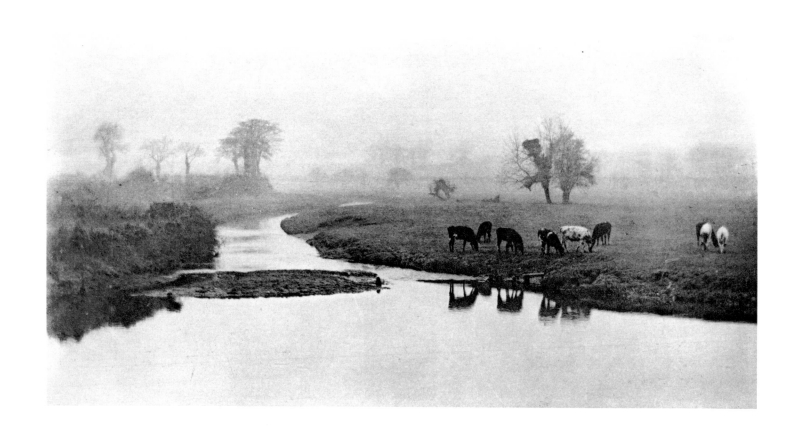

248 (Cattle in mist)

SAILING ON THE YARE — A MISTY NIGHT

The mushroom or eel moon was "getting" as they would say in Norfolk; but the day was still warm, with a slight westerly breeze, as we hoisted our sail bound for Norwich. Soon after starting a fine rain began to fall, powdering the grass-blades with soft droplets, and bedewing the marshes that stretched far and wide about the misty clumps of sallow looming like veiled islands upon a misty sea. Far away on the verge of the landscape wind-mills and trees lazily stretched their arms against the grey sky as if wakening from a soft vapour-intoxicating sleep . . .

In such soft scenes the toil of man seems to become easy and pleasant, the ditches on the marshes dig more easily, and the wherries seem to float through the landscape and melt softly out of sight. The very smoke is reluctant to rise from the cottages hidden in a dreaming clump of elms where the old church bells have just struck the noontide hour with muffled voices. We sailed dream-

ily all day without adventure, but toward evening we witnessed a curious and beautiful phenomenon. Just before sunset a current of air blew from the east, bending on itself the upper part of a column of smoke rising from a brick kiln. Immediately a heavy dew began to fall and collect upon the marshes, suggesting in places pools of water that appeared to grow quickly, spreading and widening, until, lo! the marshes resembled broads extending right up to the marsh walls. A man with a cart drove through the water-like mist, the bullocks crowding up to him as he passed along throwing out lumps of cake on the marshes.

Pearly in the vapourly landscape, six bronzed men were poling the last of the marsh hay that had been left on the ronds during the more pressing toil for harvest.

. . .The landscape seemed asleep, save where the smoke from the burning lime-kiln floated lazily through the air, shadowing an angler trudging home in the yellow splendour of the sinking sun.

Then pillars of mist began to rise from the river, and we sailed solemnly through an ever-thickening expanse of sea-like fog gathering on marsh and river burying the herds and flocks. Already the cows stood dewlap deep in the rising flood...the sleeping windmills but just showed their heads over the grey sea. The moon arose silently growing like a flower in the night, a silver grey ball slowly flushing to a golden tinge. Higher and higher rose the grey sea, so that only the vane of a passing wherry was visible as we glided past each other on the hidden river. The sense of spaciousness and breadth was unpaintable, indescribable, wonderful. When we reached Cantley, through the grey world shone the inn lights, streaming yellow over the cold water where we dropped our anchors, or ever we went below with faces bedewed with the soft exhalations wherein the mushroom moon grows mysteriously.

BIRDS' SLEEP

If you have listened to the voices of the night season after season, and you do not look about you keenly, you may infer that birds never sleep, and go away

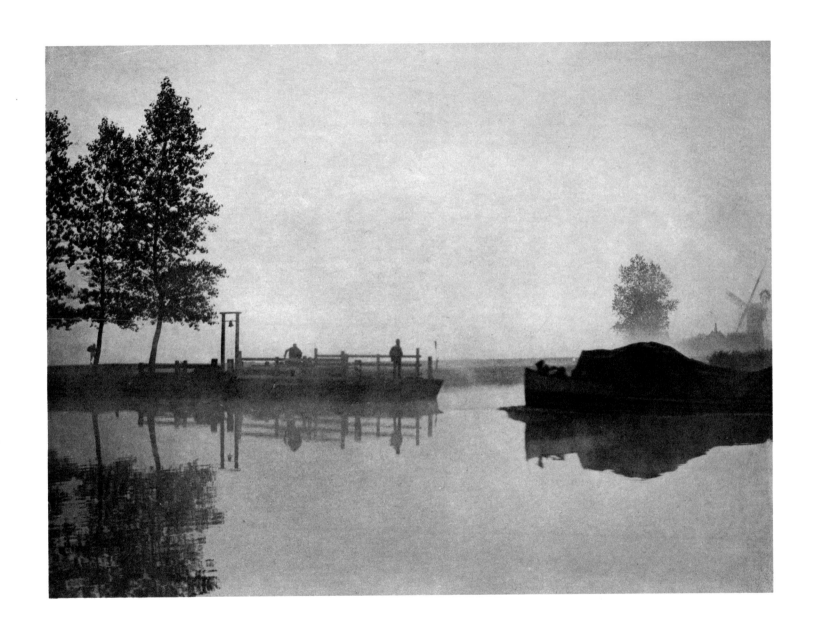

Buckenham Ferry 251

like many a philosopher, having seen but one side of the two-faced shield. For birds do sleep. Need I tell you that the lark sleeps in a grassy form on the marsh bottom, as you may know by her dung. The wagtails and peewits, too, sleep on the marshes, whilst the little "blackcaps" roost where the rats forage in the sedge and rush, dreaming perhaps of the harriers* that roost on the wall, or heaps of poled litter that dot the marshlands, or on the dry "hills," as the slightest elevations in the marshland are called, for all things go by comparison. Every hedgerow, too, is filled with sleeping finches; most empty holes in trees have their living tenant, either wren or tit, and the lower branches of trees afford minstrel thrushes a cosy bed, while the reed-beds are warm dormitories for reed-warbler and reed-pheasant, for rail, coot, and water-hen, and on the open water is a soft bed for fowls and swans, that you may see with their heads curled over their soft backs, floating like ships anchored upon an idle mere. All things must sleep, as all things must die, and these are the two sureties of life.

SOUNDS IN FOG

. . . the vapour got thicker and the willows seemed asleep. It is marvellous how clearly sounds can be distinguished in such weather—we could hear the clank of oars on the Broad, voices in the distant marshes, and an accordion playing in the village accompanied by the silvery laughter of girls; but all these sounds seemed ghost-like. One felt as if the formless, silent grey world around us was peopled with phantoms whose voices sounded clearly though afar off.

I consulted the Broadsman's wind gauge. He had moored an old boat to a stake in the middle of the broad, and was able to tell by the number of turns the rope had taken round the stake how the wind had blown during the night. It was still blowing from the nor'west, so I went casting *à la Nottingham* for pike. The tide was on the flood, and all things were propitious. I was fortunate in getting a nice basket of fish, but nothing of weight. It was exhilarating and real sport, the spoon glancing thwart the frothy waves like a seagull, the tugging and floundering of the fish, the wind playing its double music, a soft undertone in the ear and a loud concerto without raging with all the strength

*hawks, here; elsewhere, hounds, smaller than foxhounds, used by hunters for small game.

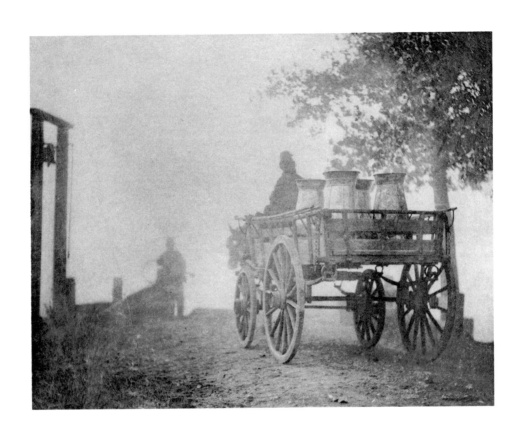

and spirit of contention through the sallow and reed bushes. Above all the roar the wind wailed shrilly through a ruined windmill. The songs of the wind are typical of life, where men contend and women weep . . .

The green sky last night was said to presage wind, and tradition spoke truly, for by evening a heavy gale was blowing . . .

THE GALE

. . . All day the wind blew hard, the sky piebald with black nimbi and patches of yellow cloud. It looked tragic and threatening, resembling in places the colours of a mouldering corpse. . . All night the wind roared and the rigging rattled, so that we could not sleep. In the morning the gale blew fiercer, and sleet fell. The sky was wild with yellowish cumuli and gloomy nimbi. As the day went on the gale increased in strength, backing the waters up in the rivers, flooding the ronds, hoisting the floating hovers, and overflowing the low marshes. The weather was too coarse for shooting, but there would be plenty of fowl after the gale.

The wind seems to make the landscape pallid. . . The wildness was increased by the passage of a flock of Kentish crows, blown across the sky with hoarse cawings. During the night the gale abated, the wind blew lumpier and in gusts. In the morning the gale was dying, and flocks of teal and mallard flew over, some alighting on the broad nearby. By noon the gale was dead, and the peace after the long roar of the storm by day and night was strange and welcome. Then we counted the dead after the fight. The willow trees stood almost leafless against the low grey sky, the reed eaves were frayed and torn, the lily leaves crushed and bruised, the gladen discoloured and broken down, and the lush green marsh covered with flood water. The face of the landscape was piteous, but these passionate outbursts helped clear the air. The dead weeds that had hitherto been floating about the broad were swept out of sight into the pulks (small ponds).

.

In the morning Jim looked wisely at the face of the sky and said—"The wind is against the law; it will turn easterly." Before ten o'clock his prophecy was fulfilled . . .

At sunset the sky was a beautiful light blue colour; the effect was peculiar, for all that night we could not get rid of the impression that we had a day sky with a night landscape.

.

On the 22nd followed another peculiar phenomenon, a remarkably low tide . . . At low water I rowed around to see the effect of the ebb. It was not beautiful . . . It is not well to pry too deeply into Nature's secrets. Much beauty is born in corruption . . .

.

It was the last day but one of October, and the snow had not quite gone . . . At ten o'clock the little black spiders began to spin overhead, dropping their gossamer threads. The breeze was blowing from the south-west at the time, and true to their *warning* it changed to the east . . . a cool breeze, recalling the purity of Arctic snows, blew upon our faces, and the rooks began to call with soft, sharp notes, such as one hears in early spring. All the birds seem brighter and sprightlier to-day—coots were calling with reed-like notes, water rails squealing and snipe smacking. Tedder [a fisherman friend?] was eel-picking, smoking his pipe, and prodding the soft bottom leisurely with light, graceful thrusts, his boat swinging about with the tide. Wood-pigeons flashed to and fro against a rich background of oaks, needley firs, sycamores, yellowish green alders, and reddish-brown reed tassels. From the brick-yard across the broad dense clouds of smoke floated softly up in the delicate springlike sky. It was the last placid smile of Nature before the death of winter.

The evening was one of the most delightful I remember. Just before sunset flocks of starling arrived from their feeding grounds, wheeling overhead, sounding like millions of delicate shuttles at work. They resembled black patches swimming in a blue bath of liquid air . . . accompanied by a silky sound of rustling wings, as, following their leader, they flew round in ever-narrowing circles until they dropped into the reed-beds to dream of the Elysian fields they had deserted.

The love of Nature is strong in them. As children they watch their favorite birds for hours, mimic their songs, and observe their habits. They gather wild flowers, and take them home; nearly all the cottage windows, too, are decorated with flowering plants, and in the smallest garden a few flowers are carefully tended.

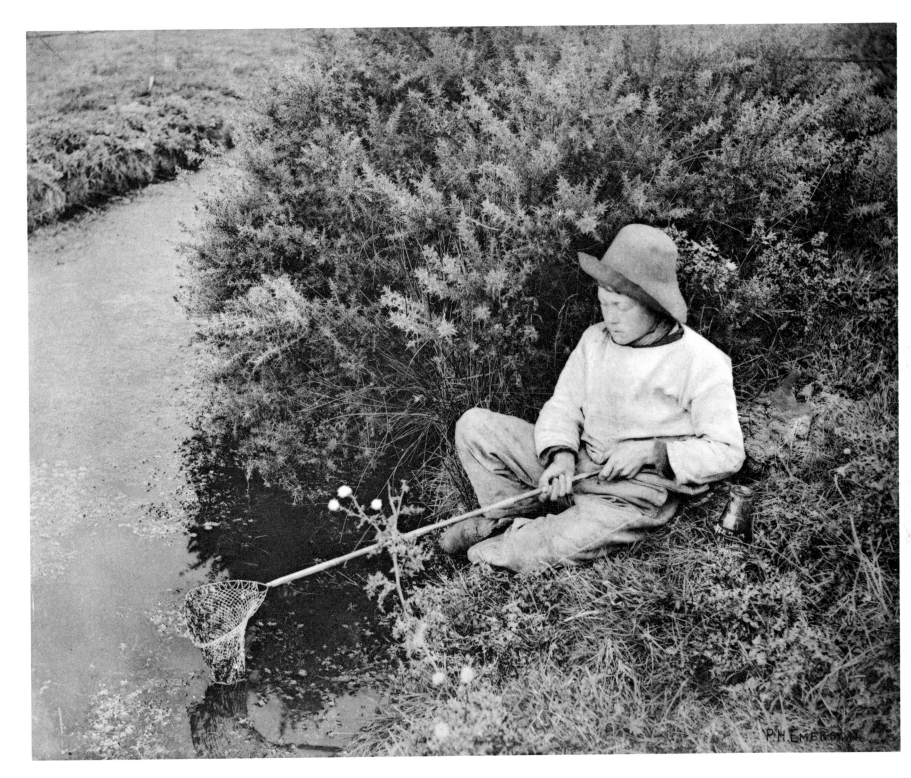

Young Boy Fishing 257

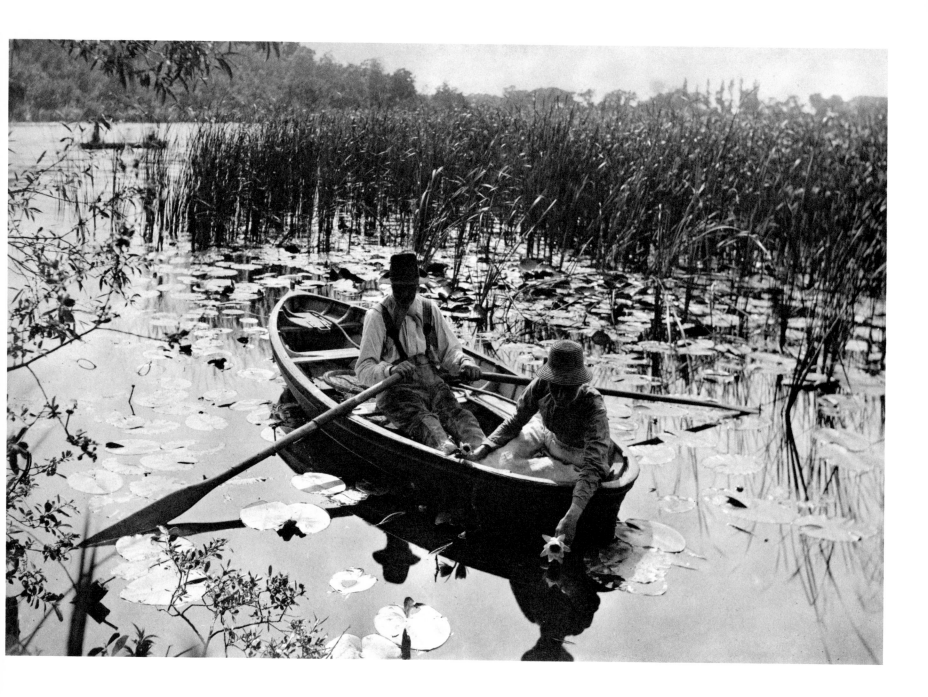

258 *Gathering Waterlilies*

The nearer we get to Nature the sweeter will be our lives, and never shall we attain to the true secret of happiness until we identify ourselves as a part of Nature.

CHRONOLOGY

1856 Born May 13 on father's sugar plantation, La Palma, Cuba. Father American, mother English. Christened Pedro Enrique. Proved when very young to be born naturalist, as well as athlete.

1864 Due to father's ill health, moved to Wilmington, Delaware.

1867 Younger sister Jane died of typhoid; father, returning to Cuba during dry spells, caught dysentery, hastening his death. Mother returned to Cuba with Enrique and younger brother Just William.

1868 Cuban Rebellion (1868-1878). Mother took sons back to Wilmington and Philadelphia. Henry placed in "military academy" where sports ranked higher than studies.

1869 Mother decided to go home to England. Urged to avoid Eton, Harrow, etc., and send her boys to Cranleigh School. Henry shocked to discover how spotty his schooling had been; determined to excel in all things.

1874 By graduation, stood second as Scholar, was made Senior Prefect and elected simultaneously captain of both cricket and football teams; played title roles in *Hamlet* and *Macbeth*, won many prizes and honors in scholarship and athletics.

Ambition being scientific exploration, chose medicine as useful profession. Entered King's College, London, medical branch of Cambridge University, to study for M.C.R.S. degree (Member of Royal College of Surgeons, equivalent to American M.D.) Soon captain of rugby team, founder of cricket club, editor of college magazine, president of debating society. Wrote satires on opera and Royal Academy. Enjoyed London night life and undergraduate rags. Surprised everyone by winning theological prize.

1879 Received M.C.R.S., vacationed in Switzerland. Entered Clare College, Cambridge, to work for Natural Science Tripos; college career continually interrupted—friends asking him to serve as *locum tenens* or for a month or two at Queen Charlotte's Hospital. Urged to compete for vacant post of Assistant House Physician at King's; won. Long and late hours.

1880 King's closed for repairs in summer. Emerson to Norway. Returned to be Full House Physician—24-hour job, grueling and responsible; enjoyed it.

November: back at Clare's, learned scientific year away had disqualified him for Tripos. Immediately took up general A.B. and M.B. (Bachelor of Medicine, stiffer and higher degree than M.C.R.S.).

1881 Married Edith Amy Ainsworth, daughter of surgeon and Grey Lady of nursing sisterhood; honeymoon in Grasmere. Dashed off first book, *Paul Ray at the Hospital*, in two weeks. Mother died; spent rest of vacation helping settle her affairs.

Passed Generals at Christmas. Took wife and two nieces to Italy. As physician and naturalist, shocked by "unnatural" art of "decadent" civilizations. Convert to wing of Impressionism called Naturalism; began to study art history for confirmation of "truth to Nature" principle.

1882 Bought first camera; excited by "truth and beauty" of ground-glass image. Studied photography under same F.R.S. (Fellow of Royal Academy, then highest scientific honor) who was teaching him physics and chemistry. Photographed everything, anywhere, in any light; constant experiments.

Paul Ray published by private subscription. Son Leonard born, first of five children: Sylvia, 1884; Gladys, 1885; Zoë, 1893; Ralf, 1897.

Sent first photographs, a few in platinotype, to Pall Mall Exhibition, held annually by Photographic Society of Great Britain. One of two platinum prints shown.

As mother's executor, went to Cuba on family affairs.

1883 Returned February. Served distinguished professor as *locum tenens*—first and last actual practice.

May: passed botany "special" alone in first class.

June: Received A.B. degree.

August: took family to Southwold, Suffolk; first look at East Anglia; flying trip to its ancient seaport, Great Yarmouth. Photographed with mounting excitement.

Joined Photographic Society (later the Royal); exhibited "instantaneous" photographs. Disgusted by fakery, sentimentalists, arid sharpness, crowded floor-to-ceiling installation.

1884 Appointed to Sambroke Medical Registrarship; another year at King's, to supervise clinical clerks, coach them and students, take most difficult cases himself. Became interested in hygiene, or state medicine; joined several liberal organizations.

Moved family to cottage on Southwold Common. Began taking notes and photographing landscape, peasants, fisherfolk.

Passed second, or medical part of M.B.

1885 Won first important photographic prize, *Amateur Photographer*'s "Amateur Photographers at Home" competition. Began writing for *Amateur Photographer*: laying foundations for aesthetic revolution; in June, extolled "The Ground Glass Image"; in October, outlined "An Ideal Photographic Exhibition."

Passed surgical, or final examination, wrote thesis, received M.B.

To celebrate, hired a yacht with brother and cruised Norfolk Broads for first time. Made some of most poetic photographs. There met T. F. Goodall, landscape painter, also a Naturalist; became close friends.

Refused two partnerhsips; having private income, could afford to wait. Already vacillating between private consultancy in London or going on with photography and writing. Shared houseboat on Broads with Goodall, photographing and sketching, talking about art.

Founded with Captain Abney and other eminent amateurs the Camera Club of London, for amateurs only.

1886　Elected to Council of the Royal to represent amateurs.

March: read before Camera Club "Photography: A Pictorial Art," his opening gun. Read "Photography" in Priory Hall, Great Yarmouth, outlining development and many uses, ending with its "noblest use" as a fine art. Showed slides of own photographs of East Anglia. Standing ovation.

Letter suggesting exhibitions be divided into (1) technical, judged by authorities in each field, (2) fine art, judged by professional artists.

May: issued in limited edition large gravure of "Gathering Water-lilies."

Easter, July, September: back on Broads, photographing, writing, finishing small portfolio of gravures, *Idyls of the Norfolk Broads*, and large album, *Life and Landscape on the Norfolk Broads*, 40 platinum prints with text by Goodall and himself.

Decision to leave medicine regretted by profession.

1887　*Life and Landscape* hailed as "epoch-making." In spring, photographed the river Lea for centenary edition of Izaak Walton's *Compleat Angler*. Bought old wherry; had it transformed to yacht.

July: finished *Pictures of East Anglian Life*—documentary study for which he had photographed, interviewed and researched four years. Joined Goodall on Bredon Water; immediately began *Wild Life on a Tidal Water*.

As sole judge of *Amateur Photographer*'s "Holiday Work" contest, gave first prize to young unknown, Alfred Stieglitz, then studying in Berlin.

1888　Studied sculpture with J. Havard Thomas three months. Began *Naturalistic Photography for Students of the Art*, as both answer to critics and guide to followers.

1889　*Naturalistic Photography*, "bombshell dropped at a tea party," roused vitriolic abuse and ecstatic praise; second edition rushed into print; gradually recognized as standard work.

As correspondent to *American Amateur Photographer*, wrote frank series "Our English Letter"; irked some sacred cows.

1890　*Wild Life on a Tidal Water* published; much praised.

Studied photoengraving with W. L. Colls; had already set up his own press. Future albums etched and printed by himself.

May: Hurter and Driffield, chemists and amateur photographers, published their findings on immutable ratio between exposure, density and development. Emerson had believed a tone could be made darker or lighter at will; H&D proved tones always in same relation to each other. Further shaken by conversation with great artist [Whistler?] and by prints of Hokusai. Boarded wherry for long-planned year's cruise on Broads. After three and a half months' study and experiment, all proving H&D correct, decided he must be first to deny his claim that photography was potentially a great art form. Wrote pamphlet "The Death of Naturalistic Photography."

1891　January: all editors carried announcement. Reaction in general not gleeful but regretful.

Back aboard wherry, photographed, worked on several purely literary projects such as *English Idyls*, begun in 1888; *A Son of the Fens*, typical biography told in dialect; *East Coast Yarns*, also in dialect; notes for *Birds, Beasts and Fishes of the Norfolk Broads*; journal of cruise which became text, with photographs, *On English Lagoons*.

Cruise cut short two weeks by foul weather.

Collaborated with Goodall on *Notes on Perspective Drawing and Vision*, showing differences between eye and lens.

Moved to island off north Wales. Too damp; suffered rheumatic fever. Nevertheless collected material largely unknown for *Welsh Fairy Tales* and *Tales from Welsh Wales*.

To southeast England; found Ramsgate dull and ugly. Nearby at Broadstairs took charming house, Claringbold, whose gardens inspired him to win two prizes awarded by Royal Horticultural Society.

1892　"Photography Not Art," showing how much of photography is mechanical, published in *Photographic News*.

The Linked Ring, international society of artistic photographers, formed by former enemies and followers.

1893　*On English Lagoons*, plates etched and printed by himself, much admired. Wrote, at request of the Royal, philosophical treatise on "Naturalistic Photography" (in which he still believed); called to Florida by death of brother, asked Dallmeyer to read address for him.

Made first portrait with Dallmeyer's new long-focus lens.

Challenged to take up sports again: rowed long routes over open sea; founded Broadstairs Rowing Club; organized spirited regatta. Won, with timid partner, a race through rough seas—his last athletic feat.

Began novel, *Caoba, the Guerrilla Chief*, from memories of Cuban Rebellion. Published 1897, soon in second printing.

Served on Royal Photographic Society jury.

1895　Awarded by the Royal its highest honor, the Progress medal, first ever given for artistic achievement.

Marsh Leaves, last and most exquisite album, published.

Moved to Lowestoft.

1896　Inquiry from American cousin about ancestors started friends' urging him to undertake family genealogy.

Moved to the Nook, Oulton Broad.

1897 Attended Photographic Convention; led steamerful of photographers through Oulton Broad.

1898 *The English Emersons* published by private subscription. Railed against "penal servitude," waste of time and money.

1899 Third edition of *Naturalistic Photography* published in New York; passages about photography as art cut and emphatically rewritten in the negative; several recent lectures added. Again, praised.

1900 Retrospective Exhibition at the Royal; none of 141 made after 1891 except long-focus-lens portrait.

Read address "Bubbles" before International Photographic Conference. Derided as "bubbles" trends toward "fuzzytypes and gum plasters," urged on pure photography.

1901– Gradually forgotten as Linked Ring, annual London Salon and Photo-
1924 grams of the Year took over in London; in New York, storm center was Alfred Stieglitz, with *Camera Notes*, the Photo-Secession, *Camera Work* and gallery "291." Now and then expostulated against role as founder being ignored.

Said to be working in stereo and writing adventure stories and rule books for billiards.

1924 Decided to write "true history" of artistic photography; wrote all noted photographers for fine prints of new work. Stieglitz refused: had long believed there was only one fine print, no matter how many were made, and these he seldom sold, exhibited only in own galleries, never allowed to be reproduced; sent Emerson only gravures of earlier work and reviews of latest work—portraits, equivalents, etc. Emerson could not believe raves; persisted for nearly a year. Medal, roll of honor, threats, blandishments, nothing moved Stieglitz.

1933 Wrote Stieglitz that in spite of rheumatism and being confined to his room for a year with lumbago, he had finished the history. Stieglitz wrote back that whether he himself agreed was inconsequential; he knew the book would be honest and vital.

1936 Died May 12, a day before his eightieth birthday. The MS has disappeared.

BIBLIOGRAPHY

Books by P. H. Emerson

Life and Landscape on the Norfolk Broads. London: Sampson Low, Marston, Searle and Rivington, 1886.

Co-author: T. F. Goodall. Illustrated with 40 platinotypes by P. H. Emerson. Limited to 100 deluxe and 750 ordinary copies.
Review: *The Amateur Photographer*, March 25, 1887, p. 145 (unsigned).

Pictures from Life in Field and Fen. London: G. Bell and Sons, 1887. A portfolio of 20 photogravures with introduction and article by P. H. Emerson. Limited to 50 deluxe and 500 ordinary copies.

Idyls of the Norfolk Broads. London: The Autotype Company, 1888. A portfolio of 12 photogravures with introductory article by P. H. Emerson. Limited to 150 deluxe and 600 ordinary copies.

Pictures of East Anglian Life. London: Sampson Low, Marston, Searle and Rivington, 1888.
Illustrated with 32 photogravures by P. H. Emerson. Limited to 75 deluxe and 500 ordinary copies.
Emerson gave a copy of this work to every English photographic society. He pasted on the inside cover a broadside "To the Student," dated September 1889, keying the plates to *Naturalistic Photography*. This special edition contains a new plate, "Mending the Old Wherry," photo-etched by himself, to replace the worn plate, "A Way Across the Marshes." The broadside was subsequently withdrawn by the author.
Review: *The American Amateur Photographer*, October 1890, pp. 408-09.

The Compleat Angler, by Izaak Walton. 100th edition. London: Sampson Low and Co., 1888.
Two volumes, bound separately or as one. Vol. I, plates 2-28, are photogravures by P. H. Emerson. Limited to 50 copies. A variant, issued in two volumes, royal quarto, with illustrations on India paper, limited to 250 copies.

Naturalistic Photography for Students of the Art. London: Sampson Low, Marston, Searle and Rivington, 1889.
Not illustrated. Facsimile reprint by Arno Press, New York, 1973.
Reviews: *The British Journal of Photography*, March 20, 1889, p. 221 (unsigned); *ibid.*, March 29, 1889, p. 221 (by J. Traill Taylor?); *The Photographic Journal*, March 29, 1889, p. 76 (unsigned); *Wilson's Photographic Magazine*, 26, 1889, p. 320 (unsigned); *The Photographic Times*, 20, 1890, pp. 222-24, 236-37, 247-51 (by W. J. Stillman); *The British Journal Photographic Almanac*, 1890, p. 591 (by J. Traill Taylor).

The Death of Naturalistic Photography. Privately published, 1890.
Not illustrated. Eight-page pamphlet, cover title. Facsimile reprints:
in Beaumont Newhall, ed., *On Photography*, Watkins Glen, N.Y.,
1956, pp. 123-32; with facsimile reprint of *Naturalistic Photography*,
third edition, Arno Press, New York, 1973.

Naturalistic Photography for Students of the Art. Second edition, revised.
London: Sampson Low, Marston. Searle and Rivington, 1890. Also
published by E. & F. Spon, New York, 1890. Not illustrated. Fac-
simile reprint, with introduction by Peter Pollack. Amphoto, New
York, 1972.
Review: *The American Amateur Photographer*, March 1890, p. 115
(unsigned).

Wild Life on a Tidal Water. London: Sampson Low and Co., 1890.
Illustrated with 30 photogravures by P. H. Emerson. Limited to 100
deluxe and 300 ordinary copies.

Notes on Perspective Drawing and Vision. London: W. Hall & Lovitt,
1891. Co-author, T. F. Goodall.

On English Lagoons. London: D. Nutt, 1893.
Deluxe edition of 100 copies illustrated with 15 photogravures by
P. H. Emerson. Ordinary unlimited edition not illustrated.

Marsh Leaves. London: D. Nutt, 1895.
Illustrated with 16 photogravures by P. H. Emerson, limited to 100
deluxe, 200 ordinary copies. Popular, revised, unlimited edition
not illustrated.

The English Emersons. Privately published, 1898.
Not illustrated, limited to 50 deluxe copies.

English Idyls. London: Sampson Low and Co., 1899.
Not illustrated. Limited to 25 copies.

Naturalistic Photography for Students of the Art. Third edition, revised,
enlarged and rewritten in parts. London: Dawbarn and Ward, 1899.
Review: *The British Journal of Photography*, 46, 1899, p. 763.
Also published by The Scovill & Adams Company of New York, 1899.
Not illustrated. Facsimile reprint: Arno Press, New York, 1973.

Articles by P. H. Emerson

"An Ideal Photographic Exhibition." *The Amateur Photographer*, October
23, 1885, pp. 461-62.

"The Ground Glass Picture." *The Amateur Photographer*, July 17, 1885,
pp. 230-31.

"Photography as a Pictorial Art." *The Amateur Photographer*, March 19,
1886, pp. 138-39. Read by Emerson before the Camera Club, London,
March 11, 1886.

"Photography: A Lecture Delivered at the Priory Hall, Great Yarmouth."
The Amateur Photographer, April 2, 1886, pp. 163-64; April 9, 1886,
pp. 175-76.

"A Lecture on Photography." *The Photographic News*, April 9, 1886,
pp. 228-30. Abstract of the lecture delivered at Yarmouth, March
23, 1886.

"Judging at Photographic Exhibitions." *The Photographic News*, April 9,
1886, p. 235.

"Exhibitions." *The International Annual of Anthony's Photographic
Bulletin*, 1888, pp. 178-80.

"A Photographer's Dream." *The Yearbook of Photography*, 1888, pp.
113-15.

"Science and Art." *The Photographic News*, May 3, 1889, pp. 294-96.
Reprinted in *Naturalistic Photography*, third edition, Appendix A,
pp. 67-79; in Nathan Lyons, ed., *Photographers on Photography*,
Prentice-Hall, Englewood Cliffs, N.J., 1960, pp. 60-66.

Letter to the Editor. *The Photographic News*, June 7, 1889, pp. 380-82.

"Our English Letter." *The American Amateur Photographer*, August 1889
through April 1890.

"Photography as a 'Basis' for Art(?) Works." *International Annual of
Anthony's Photographic Bulletin*, 1889, pp. 84-86.

"Photography Not Art." *The Photographic Quarterly*, 19, 1889, p. 214.

Letter. *The American Amateur Photographer,* January 1890, p. 26.

Letter. *The American Amateur Photographer,* March 1890, p. 114.

Letter to the Editor, with George Davison. *The American Amateur Photographer,* March 1890, pp. 112-13.

"Julia Margaret Cameron." *Sun Artists,* No. 5, October 1890, pp. 33-42.

"Naturalistic Photography." Lecture at the Royal Photographic Society. *The Photographic Journal,* March 28, 1893, pp. 156-67.

"What Is a Naturalistic Photograph?" *The American Annual of Photography,* 1895, pp. 122-25.

"Bubbles." *Photograms of the Year,* 1900, pp. 35-42; *Wilson's Photographic Magazine,* 37, September 1903, pp. 388-91.

Gravures Published Separately by P. H. Emerson

"Gathering Water Lilies." 14 1/4″ x 11″. London: The Autotype Co., 1886. Limited to 150 copies on India paper and 1,000 copies on plate paper.

"Breezy Marshland." 15″ x 21″. Publisher not known, n.d.

"The Haysel." 22 1/2″ x 17 1/2″. London: Typographic Etching Co., 1888. Limited to 100 copies on India paper and 400 copies on fine plate paper.

Correspondence

P. H. Emerson to Alfred Stieglitz, 1888-1933. Yale University, Beinecke Library, Stieglitz Archive.

Articles on P.H. Emerson

Editorial notes and correspondence regarding the nomination of P. H. Emerson to the Council of the Royal Photographic Society. *The Amateur Photographer,* January 15, 1886, pp. 25, 27.

"Everson's [sic] Lecture at Yarmouth." *The Photographic News,* March 26, 1886, p. 208.

Harrison, W. Jerome, "The Naturalistic School of Photography." *The International Annual of Anthony's Photographic Bulletin,* 1888, pp. 253-55.

Chamberlain, Houston Stewart, "Naturalistic Photography," Letter to the Editor. *The Amateur Photographer,* May 17, 1889, pp. 322-23.

"In Search of the Naturalistics," Letter to the Editor. *The Amateur Photographer,* May 17, 1889, p. 322.

"Nemo," "Naturalistic Photography," Letter to the Editor. *The Amateur Photographer,* May 31, 1889, p. 352.

Hepworth, T. C., Letter to the Editor. *The Photographic News,* June 11, 1889, p. 397.

Robinson, H. P., Letter to the Editor. *The Photographic News,* June 11, 1889, p. 396.

Sawyer, Lydell, Letter to the Editor. *The Photographic News,* June 11, 1889, pp. 396-97.

Robinson, H. P., "Definition." *The Photographic News,* August 9, 1889, pp. 513-14.

Review of *Picture Making by Photography,* second revised edition, by H. P. Robinson (with chapter attacking Emerson's *Naturalistic Photography*). *The British Journal of Photography,* August 16, 1889, pp. 542-43.

Robinson, H. P., Letter to the Editor. *The British Journal of Photography,* August 30, 1889, p. 579.

Balfour, Graham, Letter to the Editor. *The British Journal of Photography,* September 6, 1889, p. 595.

Davison, George, Letter to the Editor. *The British Journal of Photography,* September 13, 1889, pp. 610-11.

Robinson, H. P., Letter to the Editor. *The British Journal of Photography,* September 13, 1889, p. 610.

———, "Naturalistic Photography," Letter to the Editor. *The British Journal of Photography,* October 4, 1889, p. 658.

———, "So Natural!" *The British Journal Photographic Almanac,* 1889, pp. 381-83.

Harbord, D., Letter to the Editor. *The American Amateur Photographer,* January 1890, p. 25.

Editorial note on resignation of P. H. Emerson as English correspondent. *The American Amateur Photographer,* May 1890, p. 189.

Burton, W. K. "Sharp All Over." *Year Book of Photography and Photographic News Almanac,* 1890, pp. 55-58.

"Exit Emerson." *The Amateur Photographer,* January 30, 1891, p. 71.

Bolas, Thomas, "Dr. Emerson and His Teachings." *The American Amateur Photographer,* February 1891, p. 65.

Robinson, H. P., "Expression in Landscape." *American Annual of Photography,* 1895, pp. 168-73.

"Dinner to P. H. Emerson." *The British Journal of Photography,* October 13, 1899, p. 650.

Dallmeyer, T. R. "Dr. P. H. Emerson: A Brief Sketch." *The Photogram,* 6, 1899, pp. 354-56.

Note on P. H. Emerson's paper, "Bubbles," his third edition of *Naturalistic Photography* and his one-man show at the Royal Photographic Society. *Photograms of the Year, 1900,* p. 64.

French, Wilfred A., "Honored by Dr. Emerson." *Photo-Era,* 54, 1925, p. 85.

"Death of Dr. P. H. Emerson, M.B., B.A., a Photographic Pioneer." *The British Journal of Photography,* July 3, 1936, p. 426.

Woods, L. T., Letter to the Editor. *The British Journal of Photography,* July 17, 1936, p. 459.

"Obituary: Dr. P. H. Emerson, B.A., M.B., F.R.P.S." *The Photographic Journal,* August 1936, p. 476.

Newhall, Nancy, "P. H. Emerson: Artist; Photographer; Writer." *The Complete Photographer,* 4, No. 23, 1942, pp. 1484-88. With bibliography. Reprinted in *The Encyclopedia of Photography,* Vol. 7, The Greystone Press, New York, 1963, pp. 1254-57.

———. "Emerson's Bombshell." *Photography,* 1, No. 2, Winter 1947, pp. 50-52, 110-18.

Newhall, Beaumont, and Nancy Newhall, "Peter Henry Emerson." *Masters of Photography,* George Braziller, New York, 1958, pp. 54-59.

Brassaï (Gyula Halasz), "My Memories of E. Atget, P. H. Emerson, and Alfred Stieglitz." *Camera,* January 1969, pp. 4, 13, 21, 27, 37.

Jay, Bill, "Dr. P. H. Emerson." *Album,* March 1970, pp. 2-10.

Kahan, Robert S., and J. B. Colson, "Peter Henry Emerson." *The Library Chronicle of the University of Texas,* N.S., 5, September 1972, pp. 69-75. With annotated bibliography.

Turner, Peter, and Richard Wood, *P. H. Emerson: Photographer of Norfolk,* Gordon Frazier, London, 1974 (in press).

Acknowledgments

First of all, as indicated by the Dedication, to Beaumont Newhall, instantly answering from his files and library any question of name, fact or date this biography turned up. To Diana Edkins, who did much research for me at Yale and in New York, Rochester and Washington; her xeroxes and copies were invaluable. To Georgia O'Keeffe, for her permission to use the Stieglitz photographs reproduced herein and to quote from Emerson's letters to Stieglitz. To Bill Jay, for the loan of the fine sepia prints he used in his Emerson article in *Album*. To The Alfred Stieglitz Archive, Collection of American Literature, Beinecke Rare Book and Manuscript Library, Yale University, and to Donald Gallup for xeroxes of the entire group of Emerson-Stieglitz letters now in the Stieglitz Archive. To the late Colonel Sir Ralf Emerson for an important letter or two; we planned much more correspondence when he came from Nigeria and I from California, but he was probably as deeply involved in other projects as I was. To Margaret Harker, formerly President of the Royal Photographic Society, and Philip Hepworth, City and County Librarian of Norwich, England, for their efforts to find Emerson's descendants and what happened to his papers and collections. To Dorothy Norman, for her help and understanding during the two years I was working on a biography of Alfred Stieglitz and for her recent book *Alfred Stieglitz; An American Seer*, especially its chronologies. To the staffs of the Museum of Modern Art and the George Eastman House, for all kinds of assistance. To J. W. Borcoman, Curator of Photography at the National Gallery of Art, Canada, to whom we owe the pollarded willows on the River Ash. To Alan Fern, of the Library of Congress, for access to the rare Emerson portfolios. To Patricia Fuller, for her excellent compiling of the bibliography. To Michael Hoffman, publisher of *Aperture*, for his patience, his efforts to help in research and his remarkable realization of my hopes and designs for this book. And, last but no means least, to Arlene Richardson, who typed my rather difficult manuscript, with all its quotes and handwritten notes, and even the photographs-and-words section, in its unusual format, with clarity and distinction.

N. N.

In addition to the foregoing acknowledgments the publisher wishes to express gratitude to Samuel Wagstaff for making available important examples of Emerson's photographs; to Graphics International, Ltd., Washington, D.C., for furnishing a print for the cover; to The Stieglitz Archive, Collection of American Literature, Yale University, for permission to reproduce Emerson-Stieglitz correspondence; to Richard Benson for making the printer's negatives; to Bert Clarke for supervising production at the printer's; to Jane Bierhorst for the design; to Beaumont Newhall for his advice and encouragement at all times. These valuable services were rendered to the publisher after the untimely death of Nancy Newhall in August 1974 at Jackson Hole, Wyoming. Every effort has been made to fulfill her instructions and wishes.